ATHERT OF
EXCLUSION

THE ART OF

EXCLUSION

Representing Blacks in the Nineteenth Century

ALBERT BOIME

Smithsonian Institution Press • Washington and London

Designed by Linda McKnight
Edited by Debra Bertram and Joanne Reams

Cover: Eastman Johnson, *A Ride for Liberty: The Fugitive Slaves*, ca. 1862–63. The Brooklyn Museum. Gift of Gwendolyn O. L. Conkling.

 Library of Congress Cataloging-in-Publication Data
Boime, Albert.
 The art of exclusion representing blacks in the nineteenth century / Albert Boime.
 p. cm.
 Bibliography: p.
 Includes index.
 ISBN 0-87474-254-4.—ISBN 0-87474-257-9 (pbk.)
 1. African-Americans in art. 2. Art, American. 3. Art, Modern—19th century—United States. I. Title.
N8232.B57 1989
704.9'499730496073—dc19 89–4213

British Library Cataloging-in-Publication Data available
Manufactured in the United States of America
96 95 94 93 92 91 90 5 4 3 ´2 1
∞ The paper used in this publication meets the minimum requirements of the American National Standard for Permanence of Paper for Printed Library Materials Z39.48–1984

CONTENTS

LIST OF ILLUSTRATIONS

CHAPTER 3

CHAPTER 4

CHAPTER 6

PREFACE

Few scholars in the humanities and social sciences would disagree with the contention that art helps shape ideas, define social attitudes, and fix stereotypes. Prejudices, fears, hopes, and every type of moral assumption are channeled through images that serve as instruments of persuasion and control. Sometimes, however, the unexpected novelty of an image and/or its masterful presentation distract from its social content and may even make it unrecognizable in the immediate sense. This factor of unrecognizability is often used by defenders of a "pure" art to argue that art has its own autonomous development and lies outside the boundary of political and social inquiry.

But one set of images, whether involving the magisterial talents of a recognized old master or the commercial aims of a hack illustrator, settles the question by demonstrating that all visually rendered ideas inevitably ally themselves with linguistic principles and may be studied as "text," embody opinion, and, ultimately, reinforce institutional priorities. This is the category of images of people of color in the nineteenth century, whose content and formal qualities were regulated by the dialectical tension between slavery and its abolition. The African slave trade, beginning in the midfifteenth century and continuing for the next four hundred years, was one of the most important phenomenons in the history of the modern world, and no single human being attempting to make a verbal or visual statement about it could be free from bias. One of the most grotesque inconsis-

tencies in the development of the Americas was the idea that a uto-
pian enterprise could be founded on the backs of slaves. The most
benign as well as the most vicious representation of a black person
by a white North American artist would have to have worked
through this gross contradiction.

With notable exceptions, such imagery was invariably executed
by privileged white artists attached to one or another of the prevail-
ing views for or against slavery. In cases where the pictorial or the-
matic viewpoint is unclear or not overtly expressed, rather than
plead art's autonomy we would have to presuppose the artist's un-
dergoing a process of adaptation to historical transition and/or his
or her ambivalence in the face of change and unyielding racist atti-
tudes. The widespread exploitation of blacks in mercantile economies
made the slave issue international in scope, and despite variations in
the treatment of slaves, there were many common links among the
nineteenth-century producers of pictures of black people. Just as
English abolitionists provided the model for later reformers in other
parts of the world, so artists in various geographical centers inevita-
bly affected by abolitionism participated in its historical progress.

Generally, we should not expect to find ideological subtleties
or radical suggestions in these works, but rather we should look for
the broad themes familiar to both partisans and opponents of the in-
stitution of slavery: firstly, the inhumanity of the system and its de-
humanizing effect on both slave master and slave; secondly, the
question of black people's competency and their capacity to integrate
into the dominant society; thirdly, their potential to rise above their
"brute" status and attain the level of "spiritual" enlightenment. These
issues had been fundamental components of the abolitionist debate
since the end of the eighteenth century, and in one form or another
they constituted the thematic perimeters of most images of blacks
throughout the next century.

In what follows, I intend to argue through selected case studies
the ways in which images of black people exemplify the strategies of
cultural practice in addressing societal conditions. These examples of
visual culture, predominantly by advantaged members of their respec-
tive societies, nevertheless tell us much about how both the oppres-
sors and the oppressed struggled for recognition, power, and control
over their lives. Those in power inevitably exaggerate the threat of
those in their thrall and in overreacting betray their tenuous ideo-
logical underpinnings. As an agent of ideological practice, visual ex-
pression often participates in the overreaction and thus discloses the
fragile character of the very system it seeks to reinforce.

The most decisive event in this process of getting at the roots of
the paradoxical pervasiveness in Western art of the "invisible man"

was my discovery of the book by Freeman Henry Morris Murray, the first black American art historian. Murray approached the imagery of black people not from the point of view of the refined aesthete or connoisseur but with an eye to the survival of black Americans at the time of World War I. Almost totally neglected in the history of art, Murray's penetrating criticism helped me resolve a lingering ambivalence I had about a white scholar doing a study from the perspective of the black victim. By bringing to light Murray's work, I was adding a substantial chapter to modern art history and at the same time monitoring my perspective with the insights of a black scholar with whom I engaged in a kind of dialogue. Naturally, I am aware that it is still the same camera—albeit with a different lens—and that the final picture is my personal construction.

For this project I needed the help of specialists from a number of fields, and I was fortunate to have been able to draw on the talents and the knowledge of outstanding scholars who made decisive contributions to my study. I wish especially to thank the following: Sanda Agalidi, Marimar Benítez, Annette Blaugrund, Jim Burchfield, Doreen M. Colón Camacho, Samuel B. Cherson, Judy Coffin, Viven Fryd, Francine Farr, Teshome Gabriel, Ray Giles, Jacqueline Hicks, Leah Lipton, Karen Mason, Merl M. Moore, Gary B. Nash, Cammie Naylor, Frank J. Orland, Bernard Reilly, Joanna Roche, Pablo Rene Ruiz, James Smalls, Clare Spark, Haydee Venegas, Richard Williams, and Peter H. Wood. I have also drawn on the resources of several institutions and wish to thank their representatives: William Hennessey, director, and Karen M. Goering, acting executive director, both of the University of Kentucky Art Museum; Carol Verble, reference librarian of the Missouri Historical Society; Ron D. Bryant of the Kentucky Historical Society; Miriam E. Joseph, reference librarian of Saint Louis University; John Ross of the St. Louis Public Library; John F. King, park ranger at the Old Courthouse, St. Louis; Elizabeth Broun, Lois Fink, George Gurney, and Margaret Harmon, all of the National Museum of American Art, Smithsonian Institution; Harry Katz, Library of the Boston Athenaeum; Kenneth Heidelberg, U.S. Department of the Interior, Boston African American National Historic Site; Leatrice M. Kemp, Rochester Museum and Science Center, Tritobia H. Benjamin, director, Gallery of Art, Howard University; Deborah Davis Grazier, Mattatuck Museum, Waterbury, Connecticut; and John H. Dryflout, curator, Saint-Gaudens National Historic Site, Cornish, New Hampshire. I owe a deep debt to my editor, Amy Pastan, for her confidence in the project and the constant help and encouragement she has given me. I also wish to thank my copyeditor, Debra Bertram, who went way beyond the normal functions to improve the quality and content of the manuscript. She put

a huge amount of work and thought into this volume. I should like, too, to thank Joanne Reams, my production editor, for her expert scrutiny and patience in the final leg of the journey leading to publication. Finally, I am grateful to the Smithsonian Institution for a Regents Fellowship in 1988, which enabled me to complete the research for this book.

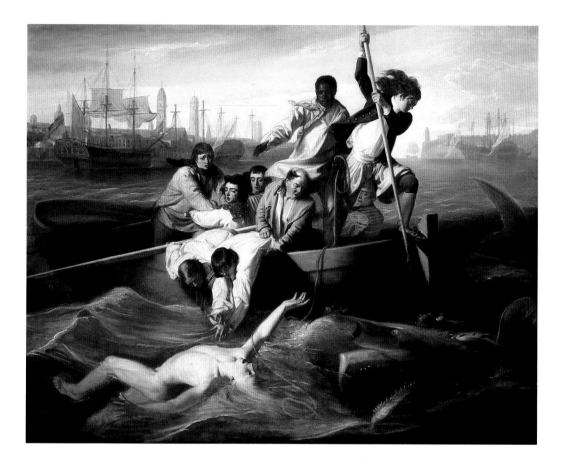

John Singleton Copley,
Watson and the Shark,
1778. Fig. 2–5.

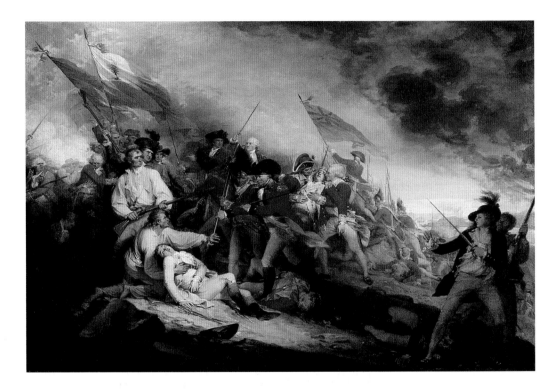

John Trumbull, *Battle of
Bunker's Hill*, 1786.
Copyright Yale University
Art Gallery. Fig. 2–7.

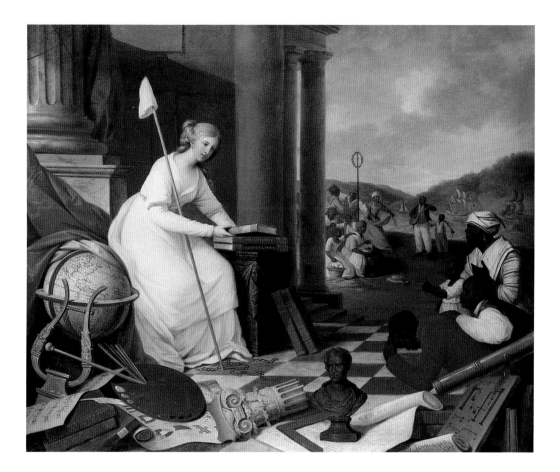

Samuel Jennings, *Liberty Displaying the Arts and Sciences*, 1792. Fig. 2–8.

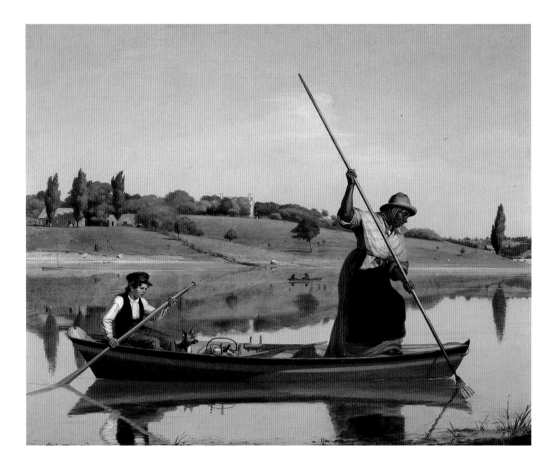

William Sidney Mount,
Eel Spearing at Setauket,
1845. Fig. 4–8.

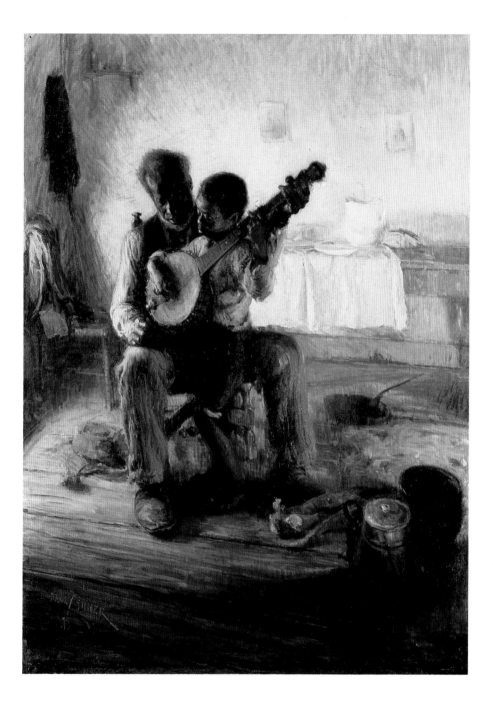

Henry Ossawa Tanner,
The Banjo Lesson, 1893.
Fig. 4–11.

Thomas Eakins, *Negro Boy
Dancing*, 1878. The Metro-
politan Museum of Art,
Fletcher Fund, 1925.
(25. 97. 1). Fig. 4–12.

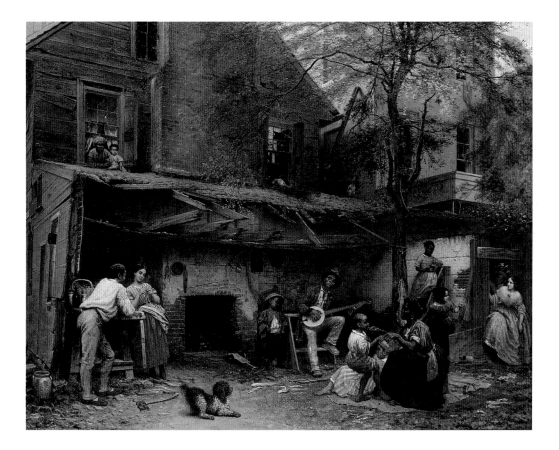

Eastman Johnson, *Life at
the South*, 1859. Courtesy
of the New-York Historical
Society, New York City.
Fig. 4–17.

Eastman Johnson, *The
Chimney Corner*, 1863.
Fig. 4–23.

INTRODUCTION
The Art of Darkness

Negro is the Spanish and Portuguese word for the color *black*. Black is a pigment indispensable to artistic practice. Once the color black was applied to an ethnic group then peoples were differentiated like the colors arrayed on a palette, with *negro* at one end of the scale and *blanco* (*branco* in Portuguese) at the other. There are no gray areas in the content of stereotypes. It may not be coincidental that it was a radical artists' group in the nineteenth century that formulated for the first time the idea of a "rainbow coalition" based on the various shades of their palette. They were a group of dissidents in Düsseldorf who rallied around the concept of a union of all ethnic, national, and political groupings consistent with the progressive aims of the 1848 revolution in Germany, and they called themselves the *Malkasten*, or "Paint-Box."[1]

But theirs was an exceptional belief. Throughout the nineteenth century it was the idea of the opposition of black and white (and red and white in North America as well) that fired the energies of painters and sculptors. For example, Delacroix's trip to North Africa proved to be a turning point in his career, stimulating his visual imagination with vivid colorations and exotic subjects. The relation of this imaginative breakthrough to the idea of white dominance is seen in his annotation to a study of a black man washing his horse: "the Negro just as black and glistening."[2] The confusion of formalistic categories with ideological biases is a singular phenome-

non in the history of art that has been sorely neglected. The racial opposition of black and white derives from the color scale; the famous *chiaroscuro*, or light and dark polarity, is intimately associated with the religious dualism of Good and Evil; and the compositional isolation of figures or inanimate motifs that is so central to the semiotics of Western art becomes decoded as exclusionary in the political sense.

In 1837 the diplomat and historian, Frédéric Portal, published what became an influential book on color symbolism in which he singles out black for its negative associations:

> Symbol of evil and falsity, black is not a color, but rather the negation of all nuances and what they represent. Thus red represents divine love; but united to black it represents infernal love, egotism, hatred and all the passions of degraded man.

For Portal it is a color symbolic "of error, of nothingness . . . black is the negation of light, it has been attributed to the author of all evil and falsity."[3] Although the book, being the work of an amateur and dilettante, could have been dismissed, it was rescued from possible oblivion by Paillot de Montabert, one of the most influential writers on art practice of the period. Using Portal as a guide, he wrote a manual for artists in which the symbolic contrasts of white and black are developed:

> White is the symbol of Divinity or God;
> Black is the symbol of the evil spirit or the demon.
> White is the symbol of light . . .
> Black is the symbol of darkness and darkness expresses all evils.
> White is the emblem of harmony;
> Black is the emblem of chaos.
> White signifies supreme beauty;
> Black ugliness.
> White signifies perfection;
> Black signifies vice.
> White is the symbol of innocence,
> Black that of guilt, sin, and moral degradation.
> White, a positive color, indicates happiness.
> Black, a negative color, indicates misfortune.
> The battle between good and evil is symbolically expressed
> By the opposition of white and black.[4]

Let us take the example of Manet's *Olympia* to observe how decora-

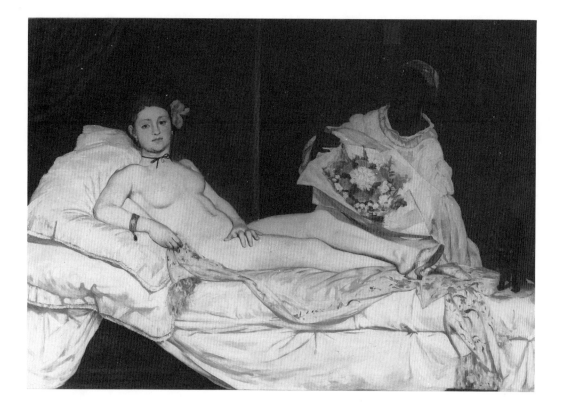

Fig. 1–1. Edouard Manet, *Olympia*, 1863.

tive oppositions of black and white, or alternative passages of light and dark, are translated into ideological statements about race, class, and gender (Fig. 1–1).[5] This familiar work has been examined from every possible perspective, with no piece of evidence left unquestioned or taken for granted—with one exception. The juxtaposition of the light-skinned courtesan with the dark-skinned servingmaid was picked up by Manet's contemporaries as a pretext for pictorial oppositions of light and dark, and hardly anyone has questioned this proposition since. It is true that Manet, anxious to eliminate shadow from his painting space, hit upon an ingenious solution for achieving dramatic contrast without chiaroscuro by the interaction of the maid and the courtesan. But this in itself declares that black and white racial divisions had already been conventionalized in terms of the painter's palette.

Thus black and white, dark and light, were signifiers in a double sense—a dual signification still retained in the phrase "people of color." But this implies a sign in a larger linguistic system, and here the interpreters of signs need to expand on the standard formalist reading. Firstly, Manet gives us one of the fundamental aspects of the black person's oppressed status in the Western

world—a unique relationship established with whites. The domestic role of the black maid shows at once that she is custodian of Olympia's daily routine, thus freeing the courtesan for her entrepreneurial activities. If nothing else, the maid indicates the status of her mistress, which is always a notch above her own. Secondly, the dialectic of Manet's black and white symbolism inevitably points to the colonial enterprises of the Second Empire. The West Indian maid (identified by her headdress) has been induced to come to Paris for work, and she has been impressed into the service of a high-class prostitute whose very existence depends upon the signs of status that go right to the heart of imperial darkness. The juxtaposition of the courtesan and the exoticized black servant point inescapably to a world-embracing political system. Olympia is not only triumphant over her admiring client presenting the floral gift, but also over the colonialized Other who mediates between them.

At the same time, Manet plays with the racial mythologies built around differences in skin color. Well aware of the purely optical character of color, Manet also knew that it carried conclusions about one's position in the social structure. A French memoir of 1777 on the security of the West Indian colonies declared that the distinction between black and white was "the principal foundation of the subordination of the slave, namely, that his color has made him into a slave and that nothing can make him the equal of his master."[6] But in *Olympia* Manet reverses the traditional associations by identifying whiteness with the prostitute, somewhat akin to Melville and the symbolism surrounding his white whale.

In *Moby Dick*, Melville devotes an entire chapter to the symbolic character of white, observing that it is the traditional color of purity and justice; of joy, sovereignty, and holiness; and that it gives Europeans "ideal mastership over every dusky tribe."[7] Elsewhere he notes that to the members of the *Pequod*'s crew the race of the African Daggoo "is the undeniable dark side of mankind—devilish dark at that."[8] But at the heart of whiteness there is a basic and contradictory evil that manifests itself in the horror of Moby Dick. Melville then reverses the conventional color coding, making the whiteness of the "hideous" albino whale stand for supernatural malevolence, as if "whiter than white" equalled a negative "dark." The wide body of Moby Dick thus becomes a panoramic screen for the projection of the darkest fantasies of the white human imagination. Yet Melville still sees the world in terms of the polar categories, now identifying with the hunted, now with the hunter. Indeed, color reversals and their ironic polarities pervade the narrative: annoyed at a crowd of bystanders leering at him and Queequeg, Ishmael wonders if "a white man were anything more dignified than a white-washed negro."[9] Pip's blackness is "brilliant, for even black-

ness has its brilliancy."[10] Ishmael sees the whale hunter "as much a savage as an Iroquois," and Ahab's peculiar relationships with the crew of "mongrel renegades, and castaways, and cannibals" and his reversion to primitivism on the high seas make him the agent of destruction.[11] Melville is both Ahab and the whale, personifying creation with categories devoid of human individuality. Both he and Manet manipulated color symbolism as an instrument of irony, but did so on the basis of the traditional religious cosmologies that envisioned existence as the clash between the children of light and the pagan or infidel children of darkness.

There probably never was a time when artists used black without symbolic or ethnic significance. This may seem like an extraordinary statement today given the familiar use of black for shadow or outline, but here again the entrenched associations of this color with religious and ethical values make it virtually impossible to isolate its function in an exclusively technical sense. In ancient Egypt black signified fecundity, related to the fertilizing silt of the Nile, and this connection with the soil has also been kept in black's association with death and the grave. Alchemists associated black with prime matter and latent power. The very origin of black as a pigment may be traced to the earth and its products: it was collected from the smoke of oil lamps (lamp black), from the incomplete combustion of vegetable matter (vegetable black), and from roasting the bones, horns, and ivory tusks of dead bipeds and quadrupeds (bone and ivory black).

Black was associated with earth in the ancient doctrine of the four elements, considered as the basis of all material conditions (fire, air, water, and earth). Fixed relations between the four elements and their associative colors were established through the application of this schema to the notion of the four temperaments. The predominance of black bile assigned to the individual a melancholic disposition, taking the form of an evil passion or a divine gift, depending on the degree of the other humors. The particular temperament or constitution of every individual was legible from the facial complexion, that is, the color of the skin. The predominance of black bile gave the skin a "swarthy" appearance. Hence "emotional expressiveness" in art took the form of skin coloration in the early history of Western art, as well as of the grotesque and caricatured physiognomies that dehumanized various ethnic and social groups in the service of oppression. When an organization of blacks from New York appealed for equal suffrage in 1860, they noted bitterly that every facet of Northern opinion had been mobilized against them and addressed the public with this painful reminder: "What American artist has not caricatured us?"

One of these artists was the eminent genre painter, William

Sidney Mount, who earned a substantial income from the reproductions of his grinning black musicians. His formula for painting blacks consisted mainly of earth pigments: "In painting a Negro, the principal colors are *Vandyke brown, Terre Verte, Indian Red, Vermilion, Madder Lake,* Yellow Ochre, and a trifle Burnt Sienna."[12] The result was an artificial, chocolaty look consistent with his stereotypes.

The place occupied by the color black in the imagination and the imagery of the Western world between the fourth and fourteenth centuries testifies to the contradictions and anxieties of the early Christian mind-set. The idea that black is the color of Satan and sin establishes the doctrinal fact that God is white and the harbinger of light. Light and whiteness dispel the terrors of midnight. Despite Saint Augustine's warning against identifying color and physical appearance with spiritual realities, blackness became an indispensable component of Christian cosmology and eschatology: the sign of every antagonist of the church and of church doctrine, including the church itself before it was purified of heresies. Eventually the allegorical and anagogical interpretations were applied to specific ethnic groups, embracing the "Ethiopian" (generic for African) and the dark-skinned Muslim who threatened the holy gates of Christendom. Thus in the Caucasian-dominated culture of the West, color symbolism served to reinforce the assumptions that whiteness connotes virtue and purity and blackness wickedness and impurity.[13]

The degree to which even blacks themselves assimilated these signifiers of their oppressors—thus justifying their own status as victims—is shown in the testimony of an ex-slave confronting every obstacle in the attempt to procure the freedom of the rest of his family, still held in bondage:

> I need not say, what the reader has already seen, that my life so far had been one of joy succeeding sorrow, and sorrow following joy; of hope, of despair; of bright prospects, of gloom; and of as many hues as ever appear on the varied sky, from the black of midnight, or the deep brown of a tempest, to the bright warm glow of a clear noon day.[14]

No doubt reading the sky for its weather forecast always produced psychological associations, but the fact remains that these associations were somehow transferred to a people whose color was only skin deep.

It would be absurd to argue that such symbolism accounts for the Christian and Muslim conviction that black Africans were "born to be slaves," but it seems likely that Manichaean forms of thought were in place to justify new patterns of enslavement

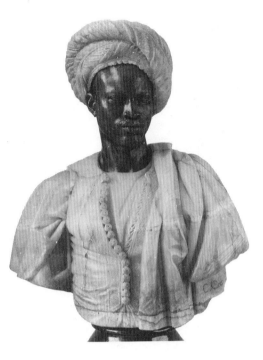

Fig. 1–2. Charles Cordier, *Negro in Algerian Costume*, 1857.

shaped by economic pressures in the age of trans-Saharan trade and transoceanic exploration. It was the African's color of skin that became his or her defining characteristic, with all its associations in Western culture of gloom, defilement, baseness, and wretchedness. This paved the way for the objectification of black people, for the stereotyping that shifted the connotative meanings to a denotative level and categorically fixed the "meaning" of black skin. Shortly after the Civil War, William Wells Brown, a black writer, reflected on the illogicality of basing caste on color. For him "slavery has been the cause of all the prejudice against the negro. Wherever the blacks are ill treated on account of their color, it is because of their identity with a race that has long worn the chain of slavery. Is there anything in black, that it should be hated?"[15] His message was to "change the condition" and thereby dissociate color from caste.

Brown wrote at the moment when scientific racism began to develop a new strategy to buttress the religious cosmogonies depicting the struggle between Christ and Satan, the spiritual and the carnal, good and evil, as a conflict between black and white. Anthropological studies in the wake of Darwin's *Descent of Man* entered the conceptual processes of sculptors living in imperial societies, whose representations of ethnic types tended to be less stereotyped in order to achieve a more practical understanding of appropriate administrative control (Fig. 1–2). In this sense, Manet's

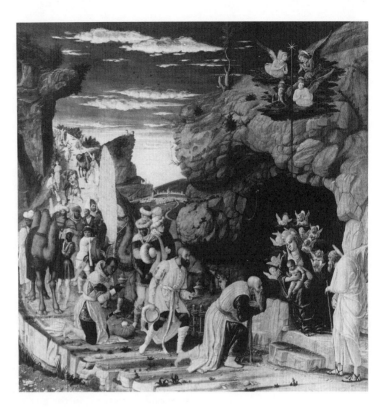

Fig. 1–3. Andrea Mantegna, *Adoration of the Magi*, 1464.

portrait of the maid continued the traditional contribution of the artist to the visual formulation of official racism. David Brion Davis has observed that most Europeans probably received "their first subliminal impressions of Negroes in the local church or cathedral," which helped shape a mentality that justified enslavement of millions of Africans.[16] The peculiar role of ethnic representations in the pictorial schema coincides with the expansion of Europe, the gradual reconquest of Spain, the increasing contact with Africa, and the nascent racism exemplified in official anti-Semitism. From this perspective, the net effect of the artist's participation in codifying the iconographic environment has been devastating.

Two examples from the copious miscellany of material are Renaissance depictions of the Magi–Wise Men and the personification of Africa as one of the "Four Corners of the Earth."[17] The pervasive appearance of the black Wise Man in paintings of the Adoration of the Magi from the second half of the fifteenth century through the first half of the next century signifies an element of realism coinciding with the missionary expeditions to Africa and the beginnings of the slave trade. In these depictions the black man of royalty garbed in munificent splendor comes to pay homage to the founder of

Fig. 1–4. William Blake, *Europe Supported by Africa and America*, 1793.

Christianity amid the squalor of the manger. One does not have to be a Freudian to perceive the wish fantasy inherent in this image. Instead of missionaries and slavers invading the black man's lands and plundering its wealth and subjugating its people by force, a noble and "wise" black ruler comes of his own volition to the white man's land and lays down his wealth and his power at the feet of the Christ child. (In some critical theological writings, however, the black Magus is defined as a defeated Ethiopian.[18]) His recognition of the superiority of the Christian religion is his ticket of admission to the august company from which he had been heretofore excluded. Even in these depictions, however, the painters found ways of giving him subordinate status: either he stands to the rear of the other two kings or genuflects at a further remove from the infant Christ, as in the famous example of Mantegna's *Adoration* in the Uffizi (Fig. 1–3).

In the Allegory of the Four Continents, codified by Ripa in his handbook of 1600, Africa is personified by a black woman in a formal sign system that developed out of the Age of Exploration and the burgeoning traffic in slaves. Here one would expect to find the black in a defined and regular role equal to the other three personi-

fications, but in fact subtle modifications in posture and costume in relation to her sisters assign her to subordinate status, strikingly noticeable in the later period (Figs. 1–4 and 1–5).

The subtle transformation of the theme is especially visible in the commission of the *Four Continents* for the United States Customs House, New York City, by its architect, Cass Gilbert.[19] Gilbert meant the structure to be of immense symbolic significance, commensurate with its major economic function of collecting revenues on imported goods—the primary source of federal income at the turn of the century. Gilbert's sculptural project was consistent with the pervasive imperial dream of the four corners of the globe pouring their wealth into the metropolitan center. The sculptor whom Gilbert chose for the task, Daniel Chester French, contrasted his different groups in hierarchical fashion, expressing the chauvinism and racism typical of the elite of the day. America is represented as lively and alert, advancing to meet the challenge of the future (with

Fig. 1–5. Jean-Baptiste Carpeaux, *The Four Parts of the World*, 1872.

Fig. 1–6. Daniel Chester French, *America*, 1907. Courtesy of the New-York Historical Society, New York.

a worker at her feet spinning the wheel of commerce), while Africa is almost caricaturely depicted as slumped over in deep slumber (Figs. 1–6 and 1–7).

Above all, both the iconography of the Magi and the four corners of the world metonymically embrace the totality of Western religious and secular experience in which we find black people figuring prominently as pillars of support. This tacit acknowledgment of their role in the foundation and maintenance of modern society had to be submerged in an ideological system of exclusion and subordination to justify the circumstances of the sordid payoff for their contribution. Accordingly, artists proved to be compliant allies in inventing visual and iconographic equivalents to the texts of incipient racism.

A vivid reminder of this is the cover of Frank Leslie's special issue for the Centennial Exposition in Philadelphia in 1876 (Fig. 1–8).[20] Here the allegorical Four Continents are shown on the edge of a precipice overlooking the American Scene. America leans on the shoulder of Europe and points out the extraordinary progress of the new nation incarnated by all the advances of modern technology—railroad, steamship, telegraph, and modern architectural triumphs such as the Capitol and Exposition buildings. Lower down in the pyramidal grouping, Asia starts at the sight with amazement,

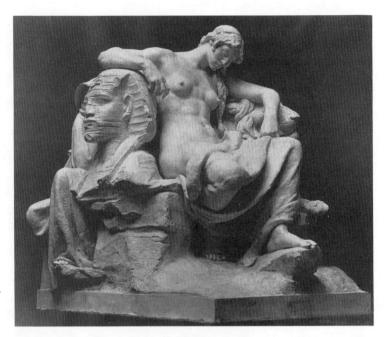

Fig. 1–7. Daniel Chester French, *Africa*, 1904. Courtesy of the New-York Historical Society, New York.

while at the lowest register Africa drops overwhelmed to the ground on one knee, shielding her eyes from the blinding light of modern civilization. To make sure that no reader misses the point, a globe of the world stands behind the group and reflects its most intense light in the Northern Hemisphere, gradually shading as it crosses the European continent and culminating in absolute darkness on the map of Africa directly behind its allegorical avatar.

This emblem of white supremacy in the context of the 1876 Centennial corresponds to the actual status of blacks at the fair, where they were deliberately neglected; their only appearance was in a concession piece entitled The South that was organized by white businessmen from Atlanta, a plantationlike setup in which blacks sang melodies and played quaint instruments. The black abolitionist Frederick Douglass, invited to address the crowd on the speaker's platform, was blocked by the police from climbing the stand.[21] Thus the degraded position of Africa on the Exposition book cover had its counterpart in the reality of the Afro-American at the event. Furthermore, while Africa's "darkness" on the cover justifies the bringing of the light of "civilization" to her doorstep, her exposed breast inadvertently suggests that she is available sexually—that is, ripe for the plucking in the name of Empire. In illustrations like this one, the West reveals through its rapine instincts that beneath the seeming dazzle of its civilization lies a truly

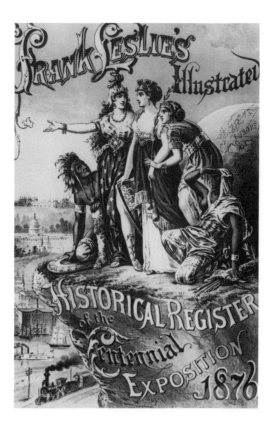

Fig. 1–8. Cover of Frank Leslie's *Illustrated Historical Register of the Centennial Exposition 1876.*

"dark" barbarism that it has projected onto peoples of color to justify their pacification. This is the horror expressed by Conrad's *Heart of Darkness* and Melville's white whale.

Artists' contributions in the nineteenth century to the racial mythologies built around differences in skin color and physical features of subordinate peoples, as well as the attempts to find graphic expression for the Christianization and liberation of their descendants, are the subjects of the following chapters. I will show how the power and the privilege enjoyed almost exclusively by whites was rationalized by a wide range of Western artists in their images of blacks. Perhaps this study will also throw light upon the seemingly anachronistic fact—as John Hope Franklin reminds us—that in our own time color remains the "sole determinant of power in South Africa."[22]

TRIANGULAR TRADE AND TRIANGULAR COMPOSITIONS

My study uses the social history of art to disclose the thematic and visual categories that encoded the representation of black people in the nineteenth century. I have argued that a sign system had been put into place to supplement written texts rationalizing slavery and was inseparable from them. The dissolution of that system and the appearance of variant models coincided with the dissolution of the slave system in Western experience. One of my case studies is the work of Puerto Rican painter Francisco Oller (1833–1917), who, between 1868 and 1893, devoted three major paintings to themes centering on the fate of black people in his society.[1] Oller descended from the upper bourgeoisie, studied in Europe, and even participated for a time in the impressionist movement alongside his close friends, Pissarro and Cézanne. But he returned to his native land to join the struggle for autonomy. In the period he painted his three works, Puerto Rican society experienced the impact of abolition and its shocking reverberations in the aftermath. It is not accidental that the three pictures draw upon the basic thematic categories, outlined in the Preface, that were in wide currency at that time: the brutality of slavery and its dehumanizing influences on both oppressor and oppressed, the questioning of black people's ability to integrate wholly into the majority culture, and their capacity to attain Christian salvation. Already essential points of debate at the end of the eighteenth century, these issues constituted the thematic focus of

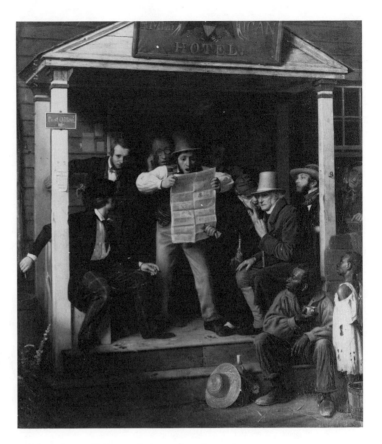

Fig. 2–1. Richard Caton
Woodville, *War News from
Mexico*, 1848.

most representations of black people in the nineteenth century as well.

Before taking up the particular conditions of Oller's work in
Chapters 3 and 4, I want to show here a few classical examples, and
some exceptions, of the visual encoding of hierarchy and exclusion.
(It should be understood that the system I am examining was opera-
tive in the minds of artists primarily when they depicted blacks and
whites together in the same visual space.) Richard Caton Woodville's
War News from Mexico, painted in 1848, may be understood as an
allegory of power and status (Fig. 2–1).[2] Woodville portrays an ex-
cited group of townsmen clustered around a man who is reading a
newspaper marked "EXTRA" on the front porch of a Greek Revival
structure. The newspaper is the focus of the scene, both narratively
and pictorially; it occupies the compositional center and provides
the information that elicits the auditors' various responses. The rec-
tangular shape of the paper is in turn enclosed within the larger rec-
tangle of the porch, surmounted by a pediment with a sign bearing
the words "American Hotel." Within this repeating rectangular con-
figuration, a secondary triangular shape is established by the seated

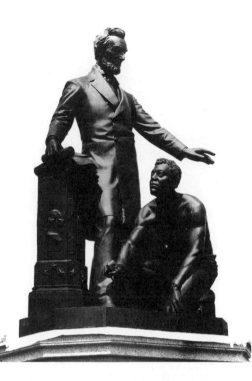

Fig. 2–2. Thomas Ball,
Emancipation Group,
1874.

figures on either side of the standing reader. On his left-hand side,
the diagonal extends beyond the portico and is terminated by two
black figures, a man who sits uncomprehendingly on the bottom step
of the porch, and a young girl, who also wonders what all the ex-
citement is about. Both of them, and a white woman standing at the
far right, lie outside the rectangular structure enclosing the white
male patriarchy and, by inference, outside the protective container
labeled "American Hotel." They have been consigned to the bottom
of the social, as well as the visual, pyramid.

 A second example of such visual encoding, belonging to the
post–Civil War era, enjoyed enormous popularity as public monu-
ments go. Thomas Ball's *Emancipation Group*, unveiled in Washing-
ton, D.C., in 1875, so appealed to Northerners that two years later
a replica of it was ordered for the city of Boston (Fig. 2–2). Ball de-
picts a towering Abraham Lincoln bidding a kneeling slave with bro-
ken wrist-manacles to rise. Lincoln's arms are outstretched in a pro-
phetic gesture and thus form a protective pyramidal envelope that
embraces the genuflecting black. The back of the newly freed man
delineates a sharp slope that reinforces the diagonal of Lincoln's left
arm and ultimately the larger configuration of the standing emancipa-
tor. Once again the conventional geometries have been deployed for
ideological purposes, with the black portrayed as a downgraded,

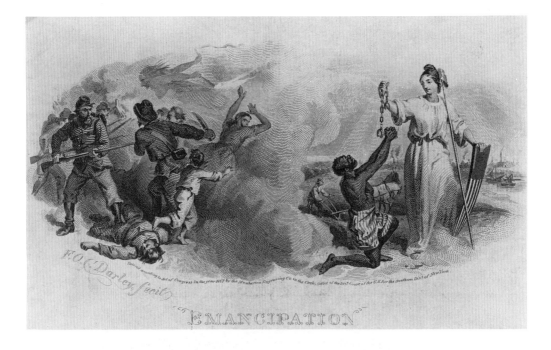

Fig. 2–3. Felix Octavius Carr Darley, *Emancipation*, 1867.

passive creature subject to the whims of an upright, benevolent master. Lincoln assumes a Christlike stance of benediction or of healing, as if he were commanding a leper to rise.

This coding signals that white men have emancipated slaves of their own free will, so that the freedpeople are now wholly in their debt. Of course this is a total fabrication; Lincoln promulgated the Emancipation Proclamation only after the Confiscation and Military Acts of 1862 had made emancipation a *fait accompli* and when he had dire need of black manpower to fill the ranks of the Union Army. But by demeaning the contribution of black people to their own emancipation and creating the fiction of a "bestowal" of freedom, such thinking allowed the white majority to forgo confessing their sins regarding slavery, to preserve the image of themselves as a basically democratic people, to avoid the nightmarish thought that they were goaded into abolishing slavery by black power, and, finally, to fantasize about black people's continued dependence upon white paternalism. So powerful was the need to maintain these fictions that it reveals itself in contemporary popular imagery, such as greenback designs by Felix Octavius Carr Darley (Fig. 2–3). Here the theme of emancipation is accompanied by scenes of militant Yankee trappers and industrious white farmers, and one lone black kneels in passive acknowledgment of white philanthropy.

Frederick MacMonnies's later monumental group, *The Navy*, created for the Brooklyn Memorial Arch at the entrance to Prospect

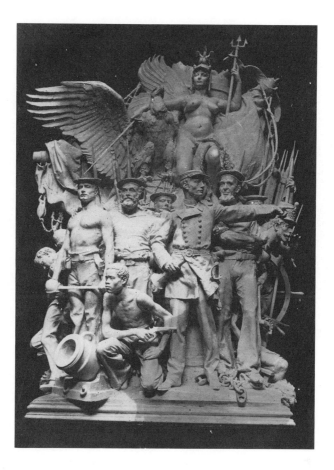

Fig. 2–4. Frederick
MacMonnies, *The Navy*,
1900.

Park, at first glance seems to reverse the stereotypical pattern (Fig.
2–4). He gives us a stalwart crew of sailors awaiting their fate on
the deck of a sinking vessel. Although the composition is typically
framed by the inevitable pyramidal envelope, in this case surmounted
by an allegorical nude accompanied by an eagle with wings out-
spread, the entire group is crowded together in solidarity and ex-
presses the same tense, alert attitude, including a black sailor who
holds a pistol as he gazes watchfully at the horizon. Physically and
mentally, the solitary black appears the equal of every other member
of the crew. But his one distinctive trait is crucial: he kneels in the
lowest register of the sculptural pyramid while everyone else is
shown standing, thus closing off the hierarchical order that begins
with the allegorical personification and descends through the crew's
most "earthbound" member. A far cry from Ball's stultified figure, the
token black representative remains mired at the bottom of the visual
and actual hierarchy.
 Next I want to examine two exceptions to both the thematic

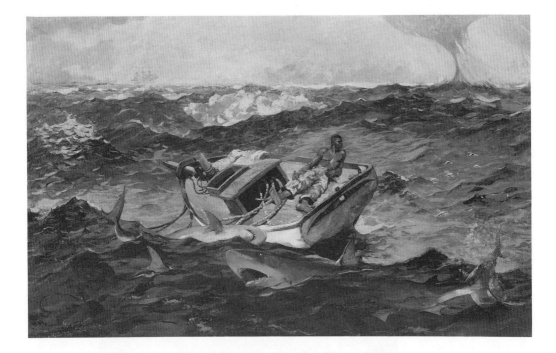

Fig. 2–6. Winslow Homer, *Gulf Stream*, 1899. The Metropolitan Museum of Art, Wolfe Fund, 1906. Catharine Lorillard Wolfe Collection. (06.1234)

and visual vocabularies that I have just articulated. These two are well known and bracket chronologically the period under study to help clarify the general tendency: John Singleton Copley's drama of *Watson and the Shark* (1778), which unfolds in Cuba's Havana Harbor, and Winslow Homer's *Gulf Stream* (1899), which depicts a helpless sailor drifting amid perilous circumstances near Key West, Florida (Figs. 2–5 and 2–6). Both pictures are by North American painters asserting statements about black people in the West Indies—a crucial leg in the triangular trade. But one glorifies them in the guise of the "noble savage," whereas the other focuses on their perennial dilemma in a racist world.

Watson and the Shark depicts an incident that occurred in 1749, when young Brook Watson was attacked by a shark while swimming in Havana Harbor.[3] Nine men, most of them sailors, are crowded in a lifeboat, frantically engaged in rescuing the youth. All aboard the craft seem to have their distinct function within the operation: one shouts orders to two others leaning over the side to grab Watson, one navigates, three others row, one holds a towline, a harpooner poises his weapon to strike the shark. The harpooner's action dynamically establishes the right-hand slope of the pyramidal composition, with the end of the harpoon serving as a vertex. Just to his right the black man holds the towline, occupying the key location in the design close to the vertex. The towline that the black

man holds reels off down the side of the boat and enwraps Watson's right arm, establishing a direct connection with the white victim and giving the black man a potentially primary role in the rescue operation.[4] The compositional base is formed by the helpless, mangled body of Watson and the ferocious shark. Hence in this work a genuine reversal has taken place in which the victim, a white man, occupies the lower register and one of his rescuers, a black man, inhabits the topmost portion.

To see how strikingly different Copley's conception was for the time we may examine the work of his compatriot and fellow expatriate, John Trumbull (Fig. 2–7). Trumbull's *Battle of Bunker's Hill*, one of a series of pictures devoted to the American Revolution, apotheosizes the Pyrrhic victory of the British at Breed's Hill (an incident notoriously misnamed). The entire composition falls within the contours of a right triangle, with the primary action occurring in the left and central sections. At the extreme right—the vertex of the composition—two figures appear to be fleeing the scene, a white man carrying a sword and, behind him, a black man with a musket. Trumbull described the pair as "a young American, wounded in the sword hand . . . attended by a faithful negro; but seeing his general fall, hesitates whether to save himself, or . . . to return and assist in saving a life, more precious to his country than his own."[5] Trumbull makes the white man a heroic signifier, in contrast with the black, whom he shields almost to the point of eclipse. The black, identified as Peter Salem, appears to be fleeing the scene at the furthest extreme of the composition, when in fact it was Salem who shot Major Pitcairn, the English officer, and provided a decisive moment in the contest. Salem then climbed the redoubt and shouted, "The day is ours!"[6] Trumbull's representation devalues Salem's role spatially as well as thematically by dethroning him from his perch and relegating him to the most inferior part of the composition. In this way Trumbull helped "read" him out of the event, just as black participation generally has been read out of American history. Even when the intention was to express goodwill to blacks, as in the case of Samuel Jennings's abolitionist allegory of *Liberty Displaying the Arts and Sciences*, the artist could not override the dictates of the powerful convention assigning blacks to a position of inferiority within the canonical-conical design (Fig. 2–8).

Thus Copley's transposition of the paradigm would seem to be a novel departure from the norm, suggesting a social as well as pictorial radicalism and adding manifestly to the unorthodox character of the picture. Yet when we look more closely at the picture, some curious features emerge. For one thing, the black man is more neatly attired and gestures more elegantly than the others, clearly distinguishing him from his fellow sailors, and for another, his action is

the only one that does not participate in the vigorous convergence toward Watson. All the rest struggle to reach the injured youth or perform energetically in his behalf, whereas the black man stands passively holding the rope, seemingly for others to take up at the proper moment. Unlike the other sailors, he stretches his free arm out away from the action in a stylized gesture, perhaps to balance himself, but it does not engage with the concentrated movements of his colleagues. The ambiguity of his position among the other crew members is thus pronounced, and it is not surprising that critics of the period called attention to this discrepancy and wondered at his curious role within the design.[7] One of them remarked, "It would not be unnatural to place a woman in the attitude of the *black*. . . . But he, instead of being terrified, ought in our opinion to be busy. He has thrown a rope over to the boy. It is held, unsailorlike, between the second and third finger of the left hand and he makes no use of it."[8] Apparently the majestic black man functions as a servant, waiting to hand the rope to the others when called upon to do so; at best he registers a sense of compassion for the hapless Watson.

The picture was painted at the very beginnings of the English abolitionist movement spearheaded by Granville Sharp, whose profound influence on William Wilberforce in the next decade would in turn be felt by Puerto Rican abolitionists nearly one hundred years later. A Whig agitator for reform, Sharp won a court ruling in 1772 declaring judicially that no law in Great Britain permitted slavery, thus allowing any slave who set foot on the soil of Great Britain to become automatically free. This occurred ten years after England had practically secured a monopoly on the slave trade.[9] Earlier, England developed an enormous smuggling operation designed to deprive the customhouse in Cuba—perhaps the major slaving entrepôt in the Atlantic world—of duties on imported slaves. A great deal of illicit trading went on between 1740 and 1750, embracing the period of Watson's participation in mercantile affairs in Cuba. By the 1770s, the Quakers and other dissidents began speaking out for abolition, and the first motion on the subject in Parliament was moved by David Hartley in 1776 on the grounds that "the Slave-trade was contrary to the laws of God, and the rights of men."[10] The motion failed, but it could hardly have been missed that the Declaration of Independence, proclaimed that same year, made numerous—albeit indirect—allusions to slavery in connection with George III's colonial policies.

These early stirrings in behalf of the abolitionist cause gave particular meaning to Copley's picture. It was Brook Watson himself, now an immensely wealthy merchant and Tory leader, who purchased the painting and dictated its subject. At that time, the Tories and the Whigs were engaged in a bitter controversy over the Ameri-

can Revolution, and the question of repression and slavery in a broad sense became a burning issue. The issue cut across party lines, however, with such notorious Tories as Samuel Johnson and Edmund Burke opposing slavery. Thus opponents of the revolution who simultaneously wished to parade as defenders of liberty exploited the slave question as a safe outlet for their views. Naturally, as the movement gathered momentum and threatened to make abolition a reality, some of them changed their tune.

Orphaned at an early age, Watson was sent to Boston in the late 1740s in care of a relative named Levens, who was engaged in some type of smuggling venture. Levens sent the youth on a voyage to the West Indies on a trading vessel—a regularly scheduled trip that he outfitted. The historian Samuel Isham asserted that Watson's youth was spent in the slave trade, a claim disputed by Watson's biographer J. Clarence Webster.[11] Nevertheless, it was often the case that trading vessels departing from Boston and winding up in the West Indies traveled the route of the *Middle Passage*—through that part of the Atlantic Ocean between Africa and the West Indies designated the symbolic leg of the *triangular trade* in slaves. Vessels left Boston Harbor carrying rum to trade for African slaves, and then headed for the West Indies to exchange their human cargo for sugar and molasses, so essential to the New England economy.[12]

Inevitably, Boston merchants engaged in smuggling in reaction to the harsh trading restrictions imposed on them by the mother country. Great Britain intended the Navigation Acts of the seventeenth century to secure certain colonial exports for their exclusive use and to discourage colonial consumption of foreign products. Thus, the options of the colonial merchants for turning a profit were severely circumscribed. Resourceful individuals engaged in illicit trade with Spanish and French colonies in the West Indies to earn credits to pay for British goods and maintain a favorable balance of payments.[13]

West Indian colony planters found the cultivation of sugarcane so profitable that they chose to devote whatever land they owned to its production, neglecting to raise the foodstuffs necessary to feed their families and slaves. The island planters were also in desperate need of timber for building and barrel staves for their sugar and molasses, which Yankee traders were only too happy to supply. They brought to the islands huge cargoes of timber and dried fish—two otherwise unmarketable commodities that New Englanders possessed in great abundance. To feed their slaves, the islanders bought, at bargain prices, the dried and broken bits of cod unfit for other markets.

The drive for increased profit prompted Boston merchants such as Levens to augment their fortunes outside the empire, especially if they wished to avoid the onerous duty on foreign molasses obtained

from the Spanish and French colonies. Great Britain intended these
duties, imposed by the Molasses Act of 1733, to force North Ameri-
cans to depend on the British islands for their entire supply. By the
early 1730s, however, Boston and Newport had established their
own rum distilleries, which consumed such vast amounts of cheap
molasses that they could not be adequately supplied by the British
colonies. Their merchants then engaged in an aggressive smuggling
trade that not only included lumber and dried fish but African slaves
as well, which they purchased with rum distilled from West Indian
molasses.[14] Given the prevalence of illicit trade during this period, it
is quite likely that Levens participated in smuggling commodities and
slaves. Watson's own lifelong interest in the exporting of dried fish
to the islands suggests that he picked up this end of the business
from his Boston mentor.

It was during a moment of recreation on one of these trading
voyages that Watson was attacked by a shark and lost the lower half
of his right leg. After recovering from his ordeal, Watson learned
that Levens had gone bankrupt and disappeared. Following a series
of new adventures, the youth eventually turned up in Nova Scotia
as secretary to Lt. Col. Monckton of the British army. Joshua Wins-
low, chief commissary to Monckton's army, so admired the industri-
ous Watson that he hired him for his department. In 1759 Watson
returned to London and joined the mercantile company of Joshua
Mauger, who had earned a fortune at Halifax both as a victualing
agent for the troops and as a distiller and leading smuggler in the
province. Watson and Mauger now conducted a large trade, chiefly
with North America. Next, Watson entered into partnership with
Robert Rashleigh, exporting goods to the colonies and to the East
and West Indies. He prospered in business and began to maneuver
for position in the Tory ranks. In 1779 he helped organize the
corps of light-horse volunteers, who aided in the suppression of the
Gordon Riots in 1780—an event involving the massive protest of the
underclass against the economic burden resulting from the Revolu-
tionary War.

Since his business trips took him regularly to the American
colonies, Watson agreed to serve as a secret agent there just before
the outbreak of the revolution. He traveled about actively proclaim-
ing himself a liberal and a friend of the colonists, while secretly
relaying information to the British government. Copley would have
been well aware of Watson's role as spy, since their economic inter-
ests so closely overlapped. Copley was married to Susanna Clarke,
daughter of Boston's leading importer, whose relatives occupied key
commercial posts and were dependent for their income and status on
close relations with England. Of the three Massachusetts firms desig-
nated as consignees for the British East India Company, one be-

longed to Copley's in-laws and the other two to their relatives. One of these companies belonged to Joshua Winslow, the uncle of Susanna Clarke Copley, who had hired Watson when he was the chief commissary to Monckton's army.[15] Winslow's company served as the Boston representative for the London exporting firm of Watson and Rashleigh. During the summer of 1773, Watson met often with Copley's brother-in-law, Jonathan Clarke, as well as with the other consignees, to coordinate plans for shipping tea to America. This set the stage for the momentous episode known as the Boston Tea Party, an event that traumatized Susanna Copley's family and forced Copley to move permanently to London.[16] While Copley later insisted on his political neutrality, his economic interests were bound up so closely with the Tories that we must see the definitive break with his homeland as a political act of opposition.

Meanwhile, Watson continued to make his way in the Tory ranks. At the time Copley painted *Watson and the Shark*, there was bitter strife between the Tories and the Whigs, the latter being in those days the party of reform. Alderman John Wilkes, the dynamic and controversial leader of the Whig Party, whose followers used as their rallying cry the slogan "Wilkes and Liberty!", had been elected

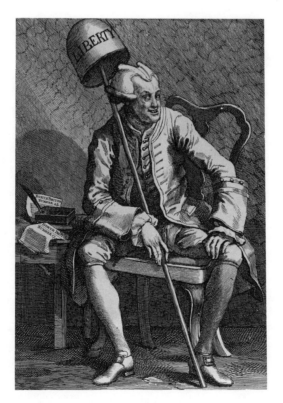

Fig. 2–9. William Hogarth,
John Wilkes Esq., 1763.

Lord Mayor of London during 1774–75 and used his prestigious position to advance the claims of the colonists (Fig. 2–9). As opposed to Watson, Wilkes sided with the colonists and even encouraged their revolt. In this he was constantly at odds with Tories, especially those who happened to be successful London merchants like Watson, one of Wilkes's favorite targets. Indeed, the mirthful postwar *Criticisms on the Rolliad*, a Whig satire written by Wilkes's partisans, makes Watson and his wooden leg the butt of a witticism that concludes: "The best of workmen, nor the best of wood / Had scarce supply'd him with a head so good."[17]

Wilkes had long since become the hero of the smugglers and the merchants of Boston, who organized the Sons of Liberty opposing the Stamp and Townshend Acts. In 1768 they made a direct bid for his support, writing with such deferential reverence that it is clear they had idolized him for some time. Wilkes maintained a regular correspondence with the group through the early 1770s, steadfastly proclaiming his friendship for the colonies. As he wrote to William Palfrey, the secretary of the Boston Sons of Liberty: "The cause of liberty in America as well as here shall always have in me a

Fig. 2–10. John Singleton Copley, *The Deplorable State of America*, 1765.

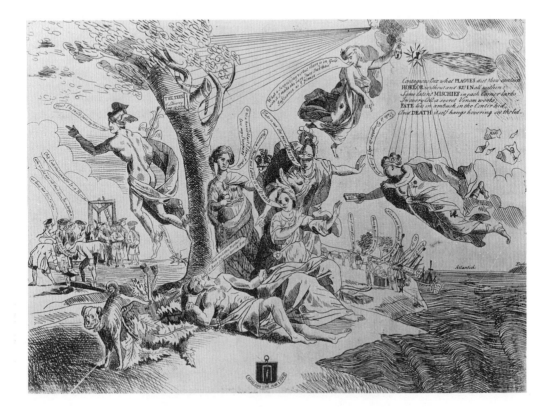

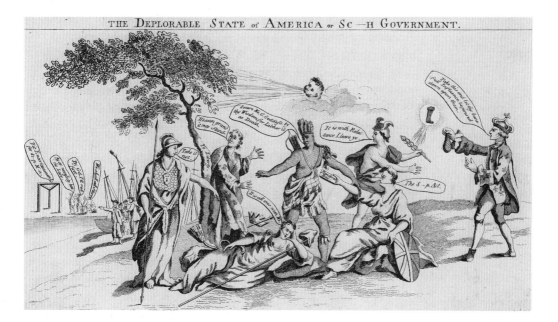

THE DEPLORABLE STATE OF AMERICA or SC—H GOVERNMENT.

Fig. 2–11. Anonymous, *The Deplorable State of America*, 1765. Courtesy of the New-York Historical Society, New York City.

zealous advocate, and where my little influence extends, it shall be employed in the promotion of it." Palfrey wrote him later that year to reassure him that "the Sons of Freedom will love and honor you, while you persevere in that best of causes." Immediately after the Boston Massacre, the town's Freeholders organized a committee to inform Wilkes of the entire episode and to keep him posted on certain people "plotting the ruin of our Constitution and Liberties."[18]

Thus it is not surprising that on both sides of the Atlantic, Tories such as Watson and Copley scapegoated Wilkes as the source of their domestic and foreign problems. Significantly, Copley manifested his dislike of Wilkes in his work. The painter eliminated a symbolic reference to the liberal leader in a satirical print that he designed as a response to an English engraving attacking the Stamp Act—an image he otherwise picked over generously for ideas (Fig. 2–10).[19] The English caricature *Deplorable State of America* showed an allegory of Liberty lying prostrate on the ground, sighing, "It is all over with me," while a staff surmounted by a Liberty Cap, the popular symbol for Wilkes, falls from her grasp (Fig. 2–11).[20] Copley's version took over all the symbolic trappings with the exception of the Liberty Cap allusion to Wilkes, and it is essentially a much more conservative formulation than its predecessor. Copley substituted for the personification of Liberty a Native American who exclaims, as Britannia hands Pandora's Box (i.e., the Stamp Act) to an Indian woman (her "daughter"), "and canst thou Mother! O have pity this horrid box." Although both cartoons oppose the Stamp Act and the

collusion of foreign powers in its imposition, the earlier is more con-
cerned with the impact on domestic and internal reform in England
itself, whereas Copley's is preoccupied with the damaging impact on
the colonial relations between Mother Country and her mercantile
offspring. The English illustrator agitates for internal liberal reform
in general, which naturally embraces the question of the liberty of
the colonies, but Copley's concern is much more narrowly confined
to the status quo.

Since "liberty" and "slavery" were terms bandied about by the
American colonial elite to insure their continued prosperity, the To-
ries had to establish that they were not tyrants bent on suppressing
the colonies' freedom. The question of black servitude arose in this
context and disturbed both parties alike. Many Whigs supported
and profited from slavery, whereas die-hard Tories like Samuel John-
son bitterly attacked it. Johnson, in fact, delighted in laying bare the
contradiction in the ideology of the colonists. He greeted the news
of the Declaration of Independence with the announcement: "How is
it that we hear the loudest yelps for liberty among the drivers of Ne-
groes?"[21]

The egregious inconsistency of Americans' demand for freedom
while at the same time they were maintaining slavery exposed the
colonists to devastating critiques both at home and from abroad.
Samuel Hopkins wrote in his *Dialogue Concerning the Slavery of Afri-
cans* of the "inconsistence with ourselves, in holding of so many
hundreds of thousands of blacks in slavery, who have an equal right
to freedom with ourselves, while we are maintaining this struggle for
our own and our children's liberty."[22] Even slaves themselves
plunged into the debate: one group in Massachusetts wrote point-
edly in 1777 "that every principle from which America has acted in
the course of her unhappy difficulties with Great Britain, pleads
stronger than a thousand arguments in favor of your humble peti-
tioners."[23] Thus the strident attacks from British critics joined a
growing domestic outcry of black and white indignation over the
contradiction between American ideology and practice involving
black people. This contradiction profoundly embarrassed the Ameri-
can cause, as John Jay recorded: "To contend for liberty and to deny
that blessing to others involves an inconsistency not to be excused."[24]

The colonists' concern for international opinion is reflected in
the Pennsylvania Executive Council's suggestion to the Assembly in
1778 that the importation of slaves be prohibited as a first step to-
ward eventual abolition, a move, it claimed, that would boost Ameri-
can prestige among Europeans "who are astonished to see a people
eager for liberty holding negroes in bondage." The same year New
Jersey's governor urged the state legislature to provide for eventual
abolition on the grounds that slavery violated the principles of

Christianity and was especially "odious and disgraceful" for a people pretending to love liberty.[25]

But it was particularly in Massachusetts, where resistance to British authority had been the sharpest and the most ideological, that the conflict between revolutionary ideals and slavery in practice hit home most directly. Dr. Jeremy Belknap of Boston recalled: "The inconsistency of pleading for our own rights and liberties, whilst we encouraged the subjugation of others, was very apparent; and from that time, both slavery and the slave-trade began to be discountenanced." As the colonial crisis headed for a showdown earlier in the decade, New Englanders grew ever more self-conscious about their schizophrenic position. Abigail Adams wrote John in 1774 that it was iniquitous "to fight ourselves for what we are daily robbing and plundering from those who have as good a right to freedom as we have."[26]

Massachusetts town meetings began to link their protests against royal usurpation with pleas that slavery be abolished. In September 1776, two months after the Declaration of Independence (which made no mention of slavery), the State House of Representatives climaxed this swelling chorus of sentiment with the resolution that slavery violated the natural rights of man and was "utterly inconsistent with the avowed principles in which this and other States have carried on their struggle for liberty." Several slaves in Massachusetts collected money among themselves and successfully sued for their freedom; John Adams defended several bondsmen in such cases with the argument of "the rights of mankind, which was the fashionable word at that time."[27]

But perhaps the case was argued most eloquently by a black slave, whose poem illuminating the gross contradiction was published in the New London *Gazette* on 1 May 1772:

> Is not all oppression vile?
> When you attempt your freedom to defend,
> Is reason yours, and partially your friend?
> Be not deceiv'd—for reason pleads for all
> Who by invasion and oppression fall.
> I live a slave, and am inslav'd by those
> Who yet pretend with reason to oppose
> All schemes oppressive; and the gods invoke
> to Curse with thunders the invaders yoke.
> O mighty God! let conscience seize the mind
> Of inconsistent men, who wish to find

A partial god to vindicate their cause,
And plead their freedom, while they break its laws.[28]

Yet slavery did continue in the Massachusetts Commonwealth long past the production of Copley's picture, and, indeed, in the very year of its execution even the status of freedmen and freedwomen proved troublesome for the colonists. Massachusetts's proposed state constitution—based on the formula for its militia act of 22 January 1776, which debarred blacks and Native Americans from the army[29]—excluded "negroes, Indians and mulattoes" from the suffrage, demonstrating that public sentiment was far from unanimous on the question of political rights for emancipated slaves. Thus it was easy for Tory critics and their colonial sympathizers to forge a wedge between their opponents by exploiting the crisis of conscience over colonial principles and practices. Tory writers taunted the rebels of '76 with charges of hypocrisy and developed strategies for discrediting the colonists' cry of oppression by associating it with black slavery. In 1776 theologian Samuel Hopkins observed that the slavery of which the colonists complained was "lighter than a feather" compared with the suffering of blacks. These arguments were used to neutralize the shibboleth of "Tyranny," on the one hand, and to demonstrate that the colonists themselves were "tyrants" on the other. This criticism had its effect in causing discontent and unease among a growing number of Americans sensitive to the accusations of inconsistency in holding slaves while resisting a British plot to enslave the colonies.[30]

The Tory critics contributed to this divisive strategy not only through the printing press and the rumor mill, but also through the active recruitment and organization of black slaves in the colonies. The English promised freedom for every runaway slave who joined their army and navy. Indeed, Jefferson's rough draft for the Declaration of Independence included a paragraph—later omitted—condemning George III for instigating the slaves "to rise in arms among us, and to purchase that liberty of which *He* deprived them, by murdering the people upon whom he also obtruded them; thus paying off former crimes committed against the liberties of one people, with crimes which he urges them to commit against the *lives* of another." This bit of doubletalk not only offended the southern delegation because of its allusion to slavery; its faulty logic and conspicuous distortion made it easy to dismiss.

But Jefferson did have an actual historical situation in mind, although he interpreted it to suit his own ideological predisposition. In November 1775, Lord Dunmore, the governor-general of Virginia, issued a proclamation at Norfolk offering freedom to slaves who

would join the British army. As an early English historian under-
stood it:

> In letters which had been laid before the English Parliament, and pub-
> lished to the whole world, he [Lord Dunmore] had represented the
> planters as ambitious, selfish men, pursuing their own interest and ad-
> vancement at the expense of their poorer countrymen, and as being
> ready to make every sacrifice of honesty and principle, and he had said
> more privately that, since they were so anxious for liberty,—for more
> freedom than was consistent with the free institutions of the Mother
> Country and the charter of the Colony,—that since they were so eager
> to abolish a fanciful slavery in a dependence on Great Britain, he
> would try how they liked abolition of real slavery, by setting free all
> their negroes and indentured servants, who were, in fact, little better
> than *white* slaves.[31]

Dunmore's plan miscarried, but the implications of it had not been
lost on the colonists. A large contingent of blacks served under his
leadership, and when he was finally forced to set sail for England in
1776 he took these volunteers with them. Their presence in England
enhanced the British accusations of inconsistency between colonial
ideals and practice and demonstrated the more liberal attitude to
blacks in the mother country.

The Tories continued to appeal to slave unrest, feeding rumors
of servile insurrection that spread panic among slaveholders in areas
like the Hudson Valley, and the disruption of civil war and British
occupation provided blacks with opportunities for escape or for
joining ranks with the Tories. In turn these pressures, plus the
shortage of manpower on the colonists' side, contributed to a shift in
sentiment on the slave issue, especially in the North. Various states
encouraged the emancipation of slaves for military service, with some
slaves allowed to fill in as substitutes for their masters. In the end
thousands of blacks, both slave and free, were to fight under Wash-
ington's command and took part in every major battle of the War of
Independence. But their participation occurred mainly in response to
the British policy of declaring free all slaves who joined their side.

Watson and the Shark similarly demonstrates a Tory attempt to
show sympathy for authentically repressed people at the height of
Tory antagonism to the American Revolution. Through it, Copley
and Watson sent the message that opposition to the rebellion was
not identical with opposition to "regulated" freedom. Watson gave
the idea of the picture to Copley and probably monitored the work-
in-progress. One pencil sketch for the crew, squared for transfer-
ence, shows a white in the place occupied in the final version by
the black. Such a major change at this stage was probably dictated
by the patron.[32] The picture thus represents the design of a conser-

vative painter for his conservative client in response to the political attacks of Whig opponents whose own involvement in slavery belied their stated defense of American independence. Watson, moreover, emphasizes his profound association with the New World in the work, not just as an armchair spectator or tourist, but as someone who had experienced it in the raw. It is as if Watson was declaiming, "I know more about this world than smug, self-righteous Whigs: I have been there and I have suffered there." His vision of the New World had not yet been vitiated by trivia like tea and taxes and was regulated "humanely" by a privileged white minority. It is no wonder that while the black man in Copley's picture has been treated sympathetically and plays an emblematic role in the general design, he comes off mainly as an exotic servant who awaits his master's next move.

The answer to this ambiguity lies in the conservative instincts of painter and patron. During the early parliamentary debates over abolition in the period 1789–92, Alderman Watson reacted in fright to the possibility of immediate abolition. He opposed it on the grounds that it would gravely compromise London trade and thereby bring ruin upon the entire nation. He presented a petition from business associates in the West Indies warning of the disastrous economic consequences of abolition and stressed the links between the slave trade and British commerce in general. For example, Newfoundland sold a vast quantity of "inferior fish" to West Indian planters for their slaves that "was quite unfit for any other market." Thus he reasoned that destruction of the slave trade would undermine every other branch of English commerce. At one point, Watson could even judge the slave trade to be "merciful and humane." He urged as a substitute for abolition gradual emancipation and "wholesome regulations."[33]

William Dunlap, a painter and historian who studied under Benjamin West when Copley lived in London, bitterly commented on the relationship of Watson and Copley, the latter of whom, once he had removed himself to England, was "no longer an American painter in feeling; and his choice of subjects for historical composition, was decided by the circumstances of the time, or by employers." Then, citing the example of *Watson and the Shark*, Dunlap indicted the former

as arrayed with our enemies in opposition to our independence, and with the enemies of God and man in opposition to the abolitionists of the slave-trade in the English House of Commons. Before he avowedly joined the standard of Britain, the traitor ingratiated himself with many leading Americans, obtained as much information of their designs as he could, and transmitted it to his chosen masters. In the character of legislator, his argument in support of the trade in human flesh was that it would injure the market for refuse-fish of the English fisheries to abol-

ish it—those refuse-fish being purchased by the West India planters for their slaves. To immortalize such a man was the pencil of Copley employed.[34]

At the same time, Watson clearly perceived the slave trade in a somewhat different light when he commissioned Copley to paint the picture in 1778. Then, as Irma Jaffe concludes, Watson sought some form of symbolic salvation and redemption, evident in the pictorial sources and biblical allusions.[35] Many New Englanders, with their Puritan upbringing, understood the troubles of the period as a form of divine retribution for holding human beings in bondage. Samuel Hopkins noted in his *Dialogue Concerning the Slavery of Africans* that "if the slavery in which we hold the blacks, is wrong; it is a very great and public sin; and therefore a sin which God is now testifying against in the calamities he has brought upon us, consequently must be reformed, before we can reasonably expect deliverance, or sincerely ask for it."[36] Deacon Benjamin Colman of Newburyport even went so far as to suggest that the British authorities close the port of Boston because the town had been the first to engage in the slave trade.[37]

Watson had himself represented as a victim of divine wrath for his own involvement in slave trading. He commissioned *Watson and the Shark* in the very period when Tories and Loyalists chided the colonists for their inconsistent position on freedom and slavery, thus holding himself up as an example and a warning of the impending punishment awaiting Americans who would not abandon their present path. This viewpoint required the inversion of the normal hierarchical dependence, turning the social pyramid upside down with himself in the position of victim and the black man in the position of master. It may not be coincidental that the hapless body of Watson closely resembles the prostrate victim at the left of Paul Revere's engraved broadside of the *Bloody Massacre*—the representation of the Boston Massacre whose first victim was a black man named Crispus Attucks (Fig. 2–12). A former slave, Attucks led the rebellious colonists against the redcoats, and it is likely that he is the corpse resembling the wounded Watson. Attucks was described as being exceptionally tall, and Revere's victim fits this description. (Copley certainly knew this engraving, since it was plagiarized from a design by his stepbrother Henry Pelham, who published it—almost an exact duplicate—two weeks after Revere's came out.) In this sense Watson replaces the martyred Attucks, who has been resurrected in the form of the black man standing in the boat.

Watson conceived of the theme for other didactic purposes as well: he was proud of having overcome his disability and wanted to emphasize his understanding of others stigmatized by physical or so-

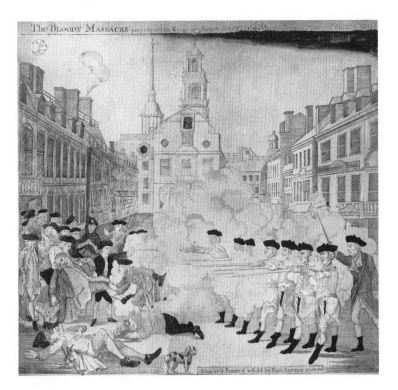

Fig. 2–12. Paul Revere,
Bloody Massacre, 1770.

cial handicaps. When he died, he bequeathed the picture to Christ's Hospital, a school in London founded for the education of poor children. He wrote in his will that he hoped it would be hung in the hospital "as holding out a most useful lesson to youth." Watson thus posed as a role model for the downtrodden—an example of triumph over disability when individuals and nations act in solidarity.

The colonies, however, are shown metaphorically as "shark-infested waters," a dangerous breeding ground for revolutionary ideas that threaten the youth of the New World. When Copley first learned of the outbreak of war in Boston in 1777, images of blood and gore instantly sprang to his mind. He wrote his wife that "the ground will be deluged with the blood of its inhabitants before peace will again assure its domain in the country." Two years earlier he wrote his stepbrother that "Ocians [sic] of blood will be shed to humble a people which they never will subdue."[38] Yet in the painting it is the British who come to Watson's rescue and deliver him from the jaws of evil. Watson thus assumes the role of martyr and mediator in the cause of peace, interposing his body between the Old and New Worlds. Watson could fulfill this role because he literally had one foot in the New World and one in the Old.

Both Watson and Copley wished to see the New World's po-

tential develop in a stable world ruled over by the mother country, and they perceived the possible loss of America as a tragic event. Watson's severed leg emblematizes this possibility; as Ann Uhry Abrams has shown, severed limbs were a common symbol for a dismembered British empire or a disunified state. At the same time, the gruesome bite of the shark had long been associated with the system of slavery. Indeed, the expression "to be thrown to the sharks" grew out of its grisly practices. Blacks who died en route were thrown overboard, and those who saw their fate as hopeless often jumped overboard, thus serving as "shark bait." Occasionally a dead black was deliberately used as bait to lure sharks when food was scarce, ironically feeding the sharks to enable the crews to survive. In this cannibalistic cycle, the slavers literally devoured their own slaves like greedy sharks. As Peter H. Wood has suggested, this powerful image of the African "caught between the devil and the deep blue sea" provided a powerful stimulus for writers and artists. In 1732 an English travel anthology published an unforgettable description of the shark:

> If a man happens to fall overboard, and these monsters are at hand, they soon make him their prey; and I have often observ'd, that when we threw a dead slave into the sea . . . one shark would bite off a leg, and another an arm, whilst others sunk down with the body.[39]

The links between the severed leg as metaphor for the dismembered nation and the cruelties of slavery converge on the interposed body of Watson. While the representation of Watson reverses the traditional hierarchical relationship of white and black, Watson still maintains his hold over the black, who "serves" him the rope. That is, the black rescuer remains "mastered" by Watson despite the reversal. This association is further sustained by the homologous relationship of Watson and the shark. The attacker's and the victim's eyes and mouths are depicted analogously, wide open in fright and jaws agape. Furthermore, the forms enclosing both Watson with his outstretched arm and the shark's head mirror each other like two animated scalene triangles clashing head-on. They in turn constitute a triangular subset of the larger triadic configuration. Thus Watson and the shark are shown to be equivalent entities, and both in fact are under attack in a kind of cyclical visual allegory akin to "Big Fish Eats Little Fish." It may be recalled that in his business dealings and his espionage, Watson connived and intrigued like a shark.[40] In this sense Watson, like Melville, is simultaneously hunter and victim, and this dialectical relationship should be understood as a pictorial solution to his need to redeem himself—Jonah-like—from his guilty past. Watson reaches upward for aid with his right arm, while his

black counterpart reaches downward with his right in a parallel ges-
ture that establishes their need for each other. While the gap is un-
bridgeable pictorially and in fact, Watson asks in effect for forgive-
ness and receives it metaphorically from the victims he himself has
greedily devoured. Thus the shark within him has been exorcised,
and, by extension, the shark-infested waters of the colonial append-
age are cleared. But the actual hierarchy remains untouched in both
New and Old Worlds.

Conceptually, Watson's fate and the black man's resurrection of
him are intertwined, with the condemned relegated to the lower reg-
ister of the composition and the newly emancipated at the top. But
this is an abstract formulation consciously established to counter and
expose colonial hypocrisy. Watson, and probably Copley as well,
did not wish for immediate abolition and certainly not for political
rights for blacks, but only for a vague kind of paternalism disguised
by the phrase "natural rights of man." On this abstract plane the
black man could be permitted to exist as a sign, but his actual par-
ticipation in the structure was to be minimized.[41] Hence, his curious
ambiguity in the composition: while occupying the key location, he
actually functions as little more than a peg on which to hang the
towline. His expression attests to his concern for the fate of the
youth, but he does not act. Thinkers as sophisticated as Jefferson
gave more credence to the black man's "moral sense" than to his in-
telligence, putting more emphasis on his feelings than on his reflec-
tions. Given this retrogressive position, it is understandable that in
Copley's painting the black—despite his prominent position—
remains an invisible man whose capacity to act in the real world is
blocked. In the end, he functions as a decorative adjunct to the
composition, as empty of potential action as the rhetorical shallow-
ness of the colonists and the inflated bombast of their Tory critics.

If the black man in Copley's picture embodies an intellectual abstrac-
tion of the libertarian viewpoint, Homer's besieged fisherman is an
allegory of black people's victimization at the end of the nineteenth
century. *Gulf Stream* depicts a solitary black man modeled with a
powerful physique but lying flat on his back on the deck of a fish-
ing boat already damaged by a squall, threatened by sharks on the
one hand and an advancing tropical storm on the other. Alain Locke
claims that this work was influential in breaking with artistic stereo-
types of "the cotton-patch and back-porch tradition" and "began the
artistic emancipation of the Negro subject in American art." Indeed,
the work remains a testament to Homer's capacity to empathize with
the marginalized in modern culture.[42] All his life Homer was attracted
to people of color, and he frequently painted them on visits to the
southern United States and the West Indies. Like Copley and his in-

laws, Homer was a Bostonian whose ancestors had been merchants actively engaged in overseas trade. One seventeenth-century forebear was born in Bristol—a major slave-trading port—and captained a trading vessel that operated out of London. Both his grandfather and father ran an import-export business, and his maternal grandfather was a merchant in the West Indies trade.[43] Homer's attachment to the West Indies and their black inhabitants originated out of the family's mercantile contacts but assumed a deeper significance under the impact of the Civil War and Reconstruction. His *Shackled Slave* of ca. 1863 does not expose the bondsman to the spectator's gaze for either entertainment or compassion but shows him oblivious to the outside world and suffering alone.[44]

Homer painted *Gulf Stream* shortly after the Spanish-American War, which made the United States a power in the West Indies. The United States now had to reconcile its institutionalized racism with multiracial societies in Cuba and Puerto Rico. The issue of race was actively discussed by Americans in the 1890s, further complicated by the waves of immigrants then pouring upon the eastern seaboard. The philosophy of social Darwinism dominated ruling-class thought in this era and was exploited by racists to give a scientific veneer to their belief system. In 1891 Francis A. Walker, a leading northern economist and a former superintendent of the U.S. Census, used the latest figures on the black population to demonstrate that blacks were increasing at a rate substantially below that of the whites and were concentrating in a diminishing area of the deep South. He concluded that blacks were biologically unsuited for all but the most tropical regions of the United States.[45] The 1890 census coincided with the full impact of Darwinism on American thought, and thus its statistical evidence on blacks was seen to support the doctrine of "the survival of the fittest" in the competitive struggle for existence of the contending social groups. As a result, the 1890s saw an unparalleled outburst of racist speculation on the impending disappearance of the American Negro. From both reputable and disreputable sources came confident predictions of black extinction through natural processes, and those who wished to consign an entire race to oblivion could scarcely conceal their satisfaction.[46]

A thoroughgoing and detailed exposition of how and why blacks were losing out in the struggle for existence emerged in the 1890s from Frederick L. Hoffman, a German-born insurance statistician who made a careful study of Negro mortality. His findings had a wide influence both because they were presented under the prestigious imprint of the American Economic Association and because Hoffman's foreign birth made him supposedly unbiased. His book, *Race Traits and Tendencies of the American Negro*, published in 1896, developed into one of the most influential expositions of the race

question to appear in the nineteenth century. It became a precious source of information for anti-Negro writers and had the practical effect of helping to convince most white insurance companies that blacks were an unacceptable actuarial risk. Hoffman presented the case for black degeneracy and impending extinction with all the callous insensitivity typical of quantified social research in that period. His comparison of Negroes to Indians as a "vanishing race" provided solace to white supremacists in the epoch of American imperialism.[47]

Rayford W. Logan has surveyed the end of the nineteenth century when black people, after their short-lived breathing space during Reconstruction, were relegated by the federal institutions and the vast majority of Americans to the dustheap. Starting in 1877, with Hayes's withdrawal of the remaining federal troops in South Carolina and Louisiana, the commitment of the nation to giving equal rights to its black citizens had virtually come to an end. Indeed, except for brief periods of relief during the populist revolt of the 1890s and the Spanish-American War, the last quarter of the century—and in particular, the last decade—marked the nadir of black people's quest for equal rights. African-Americans were segregated, systematically deprived of their civil rights, and lynched in increasing numbers: for example, eighty-seven blacks perished in this fashion the year Homer painted his picture. A series of indifferent presidents, a conservative Supreme Court, and a probusiness Congress facilitated the consolidation of white supremacy in the South, and the sum total of their actions constituted a systematic attempt to neutralize black political power. The formation of a new coalition of Republicans and southern Democrats conspired to defeat major voting legislation for blacks in return for solidarity on economic policies favoring business investments and industrial growth in the North.

At the outset of the last decade, Henry Cabot Lodge, Republican representative from Massachusetts, introduced a bill on 26 June 1890 for federal supervision of federal elections in the South. He produced evidence of a widespread conspiracy to deprive black people of their electoral franchise, citing alarming statistics showing to what degree elections in the South did not correspond to the will of the people. The strident debates over the bill were pervaded by exaggerated accusations labeling it a "Force Bill," and by typical states-rights rhetoric asserting that the South could handle the black question on its own without interference from the federal government. As a result of these efforts, the bill, which just squeaked by the House, was defeated in the Senate on 26 January 1891.[48]

The biggest blow was the legal sanctioning of the Jim Crow separation of black and white cultures in 1896. Practically all the relevant decisions of the United States Supreme Court from Reconstruction to the end of the century nullified or curtailed those rights

of blacks that the Reconstruction "Radicals" believed they had written into laws and into the Constitution. But the culmination of this negative development came in 1896 with the ruling on *Plessy v. Ferguson*:

> If the two races are to meet upon terms of social equality, it must be the result of natural affinities, a mutual appreciation of each other's merits and a voluntary consent of individuals . . . If one race be inferior to the other socially, the Constitution of the United States cannot put them upon the same plane. The distinction between the two races, which was founded in the color of the two races, must always exist so long as white men are distinct from the other color.

Hence *Plessy v. Ferguson*, as late as 1896, incorporated into one of the most unjust rulings of the Court the chromatic distinctions between black and white, upon which it sanctioned the doctrine of "separate but equal accommodations."

In addition to the domestic attempt to disenfranchise blacks, growing American imperialism gave an international sanction to its discriminatory policy. The Spanish-American War was followed by the assumption by the United States of trusteeship for the "little brown brother" in the Philippines and for white, colored, and black Puerto Ricans, as well as its taking on the role of protector for white, colored, and black Cubans. This policy momentarily diverted attention from additional denials of constitutional rights to African-Americans. American imperialism justified itself, however, on racial and moral grounds; one writer for example urged permanent American intervention in Cuba in 1898 to prevent the domination of the whites by the blacks. On the other hand, there were some who tried to distinguish the blacks of the newly acquired territories from their domestic counterparts and advised a different approach.[49] The emergence of social Darwinism and the mad scramble for African colonies facilitated the acceptance of the inherent inferiority of black peoples. In the graphic arts, this international discrimination is most visible in the satirical magazines burgeoning in the last decade of the century, which mercilessly lampooned blacks and colonialized culture, thereby providing a foundation for a category of popular imagery that persisted deep into the twentieth century (Fig. 2–13).

Ironically, the outbreak of the Spanish-American War in 1898 allowed black soldiers to enlist once again in the service of their country, helping to liberate Cubans from Spanish "tyranny." Four black regiments fought in the war, including one that charged up San Juan Hill, and the feelings of temporary solidarity between the races that the war inspired gave blacks a much needed shot in the arm. But that same year Louisiana passed its notorious Grandfather Clause, which restricted the franchise of African-American citizens,

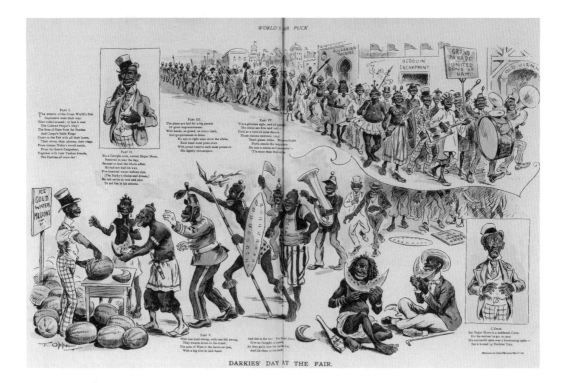

Fig. 2–13. Frederick Opper, *Darkies' Day at the Fair* from *World's Fair Puck*, 1893.

and in Wilmington, South Carolina, two days after the Congressional elections, a race riot broke out in which a score of blacks were killed, resulting in a mass exodus of blacks from the city.

Blacks were also vilified in Congress; in April 1898, David A. De Armond of Missouri described them as being "almost too ignorant to eat, scarcely wise enough to breathe, mere existing human machines." John Sharp Williams of Mississippi gave a classic denunciation of the black race, when he declared on 20 December 1898:

> You could ship-wreck 10,000 illiterate white Americans on a desert island, and in three weeks they would have a fairly good government, conceived and administered upon fairly democratic lines. You could ship-wreck 10,000 negroes, every one of whom was a graduate of Harvard University, and in less than three years, they would have retrograded governmentally; half of the men would have been killed, and the other half would have two wives apiece.[50]

This fantastic hodgepodge of traditional racist projections conjures up the white association of blacks and "ship-wreck" in a period when their hopes were indeed dashed against the shoals of a hostile nation.

The metaphorical allusion to disaster at sea was employed in an-

other sense by the powerful black leader Booker T. Washington. In some ways, the decline in status of blacks had been given an inadvertent shove by Washington in his famous Atlanta Compromise Speech on 18 September 1895. Washington essentially renounced the drive for "social equality," conceding a provisional subordinate political position for southern blacks until they got on their feet through education and by gaining the skills needed to earn a living. Washington suggested that education and wealth would bring political rights, advocating in effect Guizot's *juste milieu* formula of "*Enrichissez-vous!*"

Washington's speech may have been diplomatically astute in a time of racial stress, but African-American progressives like W. E. B. Du Bois and William Monroe Trotter were outraged by what they considered "the way backward." This factionalization of the black community was disregarded by the reigning elite, who now elevated Washington as the spokesperson for American blacks. Washington's speech stressed the need for blacks to share in the industrial progress signified at the Cotton States' International Exposition, and he gave as his self-help analogy the story of "a ship lost at sea for many days" suddenly being sighted by a friendly vessel. And he continued:

> From the mast of the unfortunate vessel was seen a signal: "Water, water; we die of thirst!" The answer from the friendly vessel at once came back: "Cast down your bucket where you are." A second time the signal, "Water, water; send us water!" ran up from the distressed vessel, and was answered: "Cast down your bucket where you are." The captain of the distressed vessel, at last heeding the injunction, cast down his bucket, and it came up full of fresh, sparkling water from the mouth of the Amazon River. To those of my race who depend on bettering their condition in a foreign land, or who underestimate the importance of cultivating friendly relations with the Southern white man, who is their next door neighbor, I would say: "Cast down your bucket where you are"—cast it down in making friends in every manly way of the people of all races by whom we are surrounded.[51]

Homer would have carefully followed the events at the Cotton States' International Exposition, including Washington's highly publicized address, because he himself had participated in the Atlanta exposition. He sent his painting *Upland Cotton*, which depicted two black women collecting the pods—a subject he clearly earmarked for the international fair, as it focused on the concern of the cotton industry with finding new markets to sustain growth.[52] Homer was particularly attached to this work and closely monitored its reviews and the public response to it. Although he first painted *Upland Cotton* in 1879, he returned to it again in 1895, evidently revising it in time for the show.[53] The work links blacks and cotton in the southern

United States, just as *Gulf Stream* would link blacks and sugar in
the British West Indies. Here Homer testifies to his critical under-
standing of the relationship of economics to the plight of black peo-
ple and to their survival. Thus he would have been responsive to
similes of shipwreck and survival uttered by both friend and foe of
black reform in the 1890s.

The positive intellectual energy informing Homer's production
derived from the eloquent thought and writing of Frederick
Douglass, the black abolitionist, statesman, and suffragist who died
the year Booker T. Washington delivered his Atlanta speech.
Douglass was fond of using nautical metaphors, especially at Repub-
lican conventions: at one he declared that "the Republican party is
the ship and all else is the sea," and at another, speaking of blacks,
he said, "We may be many as the waves, but we are one as the
sea."[54] In one early, prescient address meeting the challenge of the
racist ethnologists, Douglass joined this metaphor to the endurance
of the black people in the face of every conceivable hardship:

> The history of the Negro race proves them to be wonderfully adapted
> to all countries, all climates, and all conditions. Their tenacity of life,
> their powers of endurance, their malleable toughness, would almost
> imply especial interposition on their behalf. The ten thousand horrors
> of slavery, striking hard upon the sensitive soul, have bruised, and bat-
> tered, and stung, but have not killed. The poor bondman lifts a smiling
> face above the surface of a sea of agonies, *hoping on, hoping ever*.[55]

Nearly forty years later, Douglass had lost none of his sense of out-
rage, but his tone became more strident and bitter. The occasion for
his anger was the discrimination against blacks at the World's Co-
lumbian Exposition at Chicago in 1893. He and Ida Wells felt the
need to publish a special pamphlet, *The Reason Why the Colored
American Is Not in the World's Columbian Exposition*.[56] Africans on
display on the midway were confounded with African-Americans,
which gave rise to racist speculation on the political and economic
situation of American blacks being the result of their "savage" ori-
gins. Douglass denounced the organizers of the exposition for bring-
ing Dahomeans to Chicago "to exhibit the Negro as a repulsive sav-
age" and "to act the monkey."[57] He seized the opportunity of the
controversial Colored Jubilee Day to call attention to the flagrant
contradiction between the outrages committed against people of
color and the flaunting of "American liberty and civilization" at the
fair. He pointed out that the appalling exploitation of blacks was
being rationalized by the same anthropological arguments that were
being advanced at the world's fairs in the name of empire.[58] He again

made use of a nautical metaphor, this time to condemn the enemies of black progress:

> A ship rotting at anchor meets with no resistance, but when she sets sail on the sea, she has to buffet opposing billows. The enemies of the Negro see that he is making progress and they naturally wish to stop him and keep him in just what they consider his proper place.[59]

Homer needed Douglass's input to fortify his undertaking of the subject for *Gulf Stream*. Douglass's depiction of blacks' oppressed condition was further confirmed for the artist by his visit to the Bahamas in the 1890s. The islands' blacks were mired in a poverty and an ignorance from which they could not extricate themselves. Property qualifications denied most of them the vote, and they continued to be ruled by the white minority. The general rate of population increase was less than one percent a year in that period, and in many of the islands it declined. Sponging was the backbone of the Bahamian economy, but the lot of the Negro sponge fishermen was decidedly grim. A writer for the *Freeman*, a Bahamian journal, noted "the steady deterioration in the physique of the men and their families as a consequence of the low standard of living which the accursed system imposes upon them."[60]

Another view of the black man's plight on the islands was discussed by W. C. Church, the author of a travel article in the *Century Magazine* of February 1887, which Homer illustrated with reproductions of his watercolors done during his first trip to the Caribbean in 1885.[61] It is a light, frothy piece aimed at enriching the steamship companies, but it carries a fascinating subtext on the impact of environmental and hereditary pressures on the islanders. Church begins with a historical survey, recalling the extinction of the indigenous people under the oppressive Spanish yoke. He pointedly asserts that "the light which guided Columbus" turned out to be "an omen of disaster and death." Fourteen years later, he remarks, the entire race had disappeared.

Elsewhere in his text he notes that blacks, who in 1887 constituted four-fifths of the present population, possess "something of their [the Indians'] spirit." Although he is referring to a similarity in personality and psychological traits, his thoughts keep wandering back to the idea of social degeneracy and survival. He observes, for example, that black people suffer disproportionately from consumption, the most prevalent disease on the islands, probably because they spend so much of their time in the water earning their livelihood and are forced to inhabit rude huts. On the other hand, he claims that interracial marriages have been forging a new race, and

that color prejudice is not a major social problem on the islands. While he waffles on the issue of miscegenation, he quickly declares that the biggest factor in overcoming race prejudice is wealth. After citing examples of wealthy people of color on the islands, he concludes that prosperity would do for blacks in the United States what it accomplished for some of the islanders. In this he appealed to Northerners who could blithely ignore the condition of impoverished masses by parading examples of the exceptions—the same group that received Booker T. Washington's speech with unreserved enthusiasm eight years later.

But perhaps Church's most revealing comment appears in the context of his discussion of sharks as a potential risk to vacationers in the tropics. He tries to discountenance the stories of maneaters and at one point declares: "The sharks are not inviting, but there is a tradition that they do not take kindly to black flesh."[62] This rather cryptic comment should be set against the almost legendary association of blacks and sharks in the literature on slavery, so that we may see that the tradition is precisely the opposite of what he claims. The deliberate irony and ambiguity of the statement sheds light on the encoding of his article, for it actually suggests something to the effect that "sharks are as intelligent as whites" and therefore your friends.

When Homer painted his *Gulf Stream* twelve years later, he made use of the material reproduced in the article—especially the *Fishing for Sharks*—and would have had a deeper perspective on the environmental and hereditary arguments feeding the virulent antiblack propaganda spewing forth in the 1890s. Once again black people were beset on all sides by greedy sharks, as the gains and the optimism generated by the Reconstruction era had been shipwrecked on the reefs of bigotry. In addition to this explicit allusion to the historical association of sharks and slaves, Homer gives us another in the image of the stalks of sugarcane rising out of the hold of the sloop and trailing down into water. Peter Wood has rightfully called attention to this generally overlooked feature. Sugarcane would have been a common sight aboard fishing craft in the Gulf Stream, "both as a cargo and as a source of nourishment."[63] Yet Homer's conspicuous representation of the stalks, way out of proportion to the boat and its lone passenger, assumes a symbolic connotation in its intimate relationship to the history of slavery in the West Indies. It was after all for the sake of meeting the voracious demand for sugar by European markets that slaves were wrenched from their homeland and transplanted to the New World. But at the time when Homer painted the picture it would have taken on yet another level of meaning: America's imperialist ambitions—culminating with the Spanish-American War of 1898—devolved on the Hawaiian Islands, the Philippines, Cuba, and Puerto Rico, all of them rich sugar-

producing territories and all of them worked by people of color soon to suffer from the discriminatory policies of a racist society.[64]

Thus Homer's black fisherman is caught in a powerful dilemma, prostrate on a dismasted, drifting sloop, already having been severely buffeted by a violent hurricane. Could it get any worse? Yes, for now he is trapped between hungry sharks on one side and an approaching squall on the other. But having experienced one shock after another, his reaction to this dilemma is to calmly await his fate. It is a comment on the times that some critics of the period read this air of resignation as "sullen laziness" and apathy. Close inspection of the figure reveals that he is very much awake and alert to the dangers; while lying on his back he props himself up tautly on his elbows to survey the perils confronting him.

It is this transition state that perplexed the critics and made prospective buyers uneasy. Despite the multiple dangers confronting him, the central figure betrays no fright and gazes on the hazards with the indifference of a human being who has lived through all this before. Nevertheless, the outcome remains in doubt, which is why clients pressed Homer's dealer to learn of the eventual fate of the picture's protagonist. Homer responded sarcastically: "You can tell these ladies that the unfortunate negro who now is so dazed and parboiled, will be rescued & returned to his friends and home, & ever after live happily."[65] Homer's ironic tone carries with it the masculinized aura of the Victorian male who admired risk-taking situations remote from the realm of "ladies," but it also signifies the opposite of what is stated. What is essential here is that the image depicts a situation in *suspension*—a vulnerable human being jeopardized on all sides by forces beyond his control. Homer's realism spells out the situation of blacks in contemporary America without supplying a happy ending.

All the ingredients of Copley's picture are present: a boat foundering in a hostile aquatic environment ruled by a malevolent shark and the centrality of the black man. But if the protagonist's reaction to peril is again passive, he now constitutes both the thematic and the compositional focus. Homer's black is both hero and victim, collapsing the old categories of triangular formalism into a powerfully condensed metaphor of implicit power blocked on all sides. The black man is no longer an empty intellectual abstraction, but a force whose potential is thwarted by roadblocks set up everywhere to neutralize it.[66] While Copley painted his work during the earliest stage of abolitionist thinking, Homer's was painted in the aftermath of the legal recognition of African-Americans' rights. Copley's figure stands upright and outside the main action; Homer's lies prostrate and well inside the triangulated danger zone. Powerless blacks could be assigned a prominent theoretical position; once power was as-

sumed, a color-line had to be drawn to keep them separate. Homer's image thus conveys the paradoxical destiny of "freed" black people in modern society. For the white Homer, however, the image was "progressive" insofar as he located the perils outside the locus of black culture instead of the other way around—as in the South, where the specter of black "domination" was invoked to keep the status quo. Triangulation had helped prepare the ground for ghetto-ization.

CHAPTER 3

THE REVULSION TO CRUELTY

D uring the interval between Copley's transcendental image and Homer's concept of utter hopelessness, nineteenth-century painters attempted to deal more directly with the institutional issues associated with slavery and its abolition. Neither Copley's idealized servant nor Homer's stolid fisherman could be found on this plane of existence, and artists sought pictorial strategies for dealing with the perceived reality. Above all, these images tend to indict the cruelty and the inhumanity of the institution of slavery. The one component of slavery upon which conservatives, radicals, and liberals could always agree was the inhumane condition under which the slaves existed. Early abolitionists stressed the moral issue and took pains to enumerate the instances of sadistic treatment, the application of instruments of torture, and the expressions of discrimination in colonial policy.

The reality of the slave system for liberals was the institutionalized cruelty caught by the Puerto Rican painter Francisco Oller, whose *Flogged Negro* was perceived by one critic as "eloquent testimony of abolitionist propaganda" (Fig. 3–1). Based on an actual incident later reported by the historian Coll y Toste,[1] it shows a slave bound facedown on a ladderlike construction while a black overseer (*mayorduomo, mayorale*) swings his whip in the air. In the middle ground the local bailiff looks down to avoid witnessing the spectacle. On the right-hand side, the slave's wife pleads on her knees before the owner of the plantation (*hacendado*) to call off the torture;

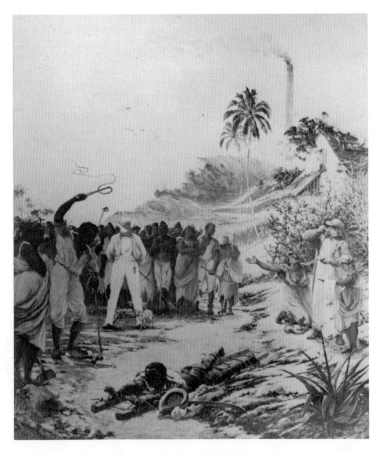

Fig. 3–1. Francisco Oller y Cestero, *Punition d'un nègre esclave dans une plantation aux Antilles* or *The Flogged Negro*, 1868.

seemingly oblivious, he calmly sips his coffee while a young mulatto woman waits on him. In the distant background, smoke rises from the chimney of the sugar mill (*ingenio*), thus providing the necessary context for understanding the exploitation of slaves in Puerto Rico.

In a frequent method of flogging on the Caribbean islands, known as *boca abajo* (mouth downward), the slave was forced to lie facedown on the ground (Fig. 3–2).[2] The incident reported by Coll y Toste occurred in the *hacienda* La Vega, near Arecibo. Slaves were ordered to fasten the victim to four poles on the ground and expose his shoulders. The overseer then lashed his shoulders with great fury, each blow wringing a piercing cry from the slave. This is the scene Oller depicted, also emphasizing the dehumanized expression of the sadistic *mayorale* and the shame and indifference of the *hacendados*. Here Oller indicts the brutality of the island's slave system and points to its long history of sadistic acts and oppression.

An unexpected source of similar imagery is William Blake, who

Fig. 3–2. *Punishing Slaves in Cuba*, 1868.

in fact made several significant contributions to the antislavery agitation of his time.[3] His poem "Little Black Boy" appeared during the early phase of the drive against the trade, and his *Visions of the Daughters of Albion*, which touched on all forms of slavery, came out the year the bill for abolition was defeated in Parliament (1793). During the interval he began work on a series of illustrations for a book describing the brutal slave conditions in the South American colony of Dutch Guiana. Blake engraved at least sixteen of the plates—including almost all of those dealing with slavery in the colony—for the book by Capt. John Gabriel Stedman published in 1796, *Narrative of a Five Years' Expedition against the Revolted Negroes of Surinam*. Stedman was a mercenary in the Dutch colonial army sent to Guiana to suppress the *cimarrones* or *maroons*, rebel slaves who had fled the plantations and survived by plundering their former masters and escaping to the forested regions nearby. Although Stedman accepted the institution of slavery and defended it, he was nevertheless shocked by the brutalities he witnessed in Guiana. He made several sketches of tortured slaves, which Blake engraved for the book.

Stedman was especially horrified by merciless floggings of the slaves: one female was sentenced to two hundred lashes, then condemned to drag a chain several yards in length, one end of which was locked around her ankle and the other affixed to a weight of at least one hundred pounds. Blake engraved two such cases, *Flagellation of a Female Samboe Slave*, showing a young woman bound by her hands to the branch of a tree, her body lacerated by the stroke of a whip, and *The Execution of Breaking on the Rack*, showing a

Fig. 3–3. William Blake,
*The Execution of Breaking
on the Rack*, 1793.

black executioner compelled to break the bones of a rebel slave who
is tied outstretched on the ground to a cruciform rack (Fig. 3–3).[4]
To add to the horror, the slave's left hand has been chopped off and
is shown at the lower right of the engraving. The reform-minded
Blake was above all motivated by his outrage.

Perhaps one of the most telling examples of slave torture is a
study by the French painter Géricault, who projected in the early
1820s a monumental depiction of the slave trade, *The African Slave
Trade* (Fig. 3–4). It was designed to be a pendant to his better-
known *Raft of the Medusa* (Fig. 3–5). Both works carried allusions
to the French colony of Senegal recently restored to France by Eng-
land. The Congress of Vienna, which under the influence of Eng-
land decreed the abolition of the slave trade, returned to France the
West African colony taken by the English during the Napoleonic
wars. In 1816 the French government organized an expedition to re-
cover the colony and install its own administration. Senegal consti-
tuted the symbolic focus of French colonial ambitions in West Africa;
France extracted from the colony its rice, cotton, and gum and in
turn exported to it finished cloth goods and tools. In addition, Sen-
egal remained notorious as a major clearing point for slave traffic,

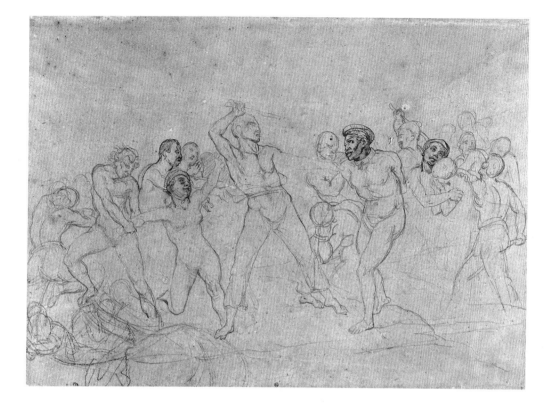

Fig. 3–4. Théodore Géricault, *The African Slave Trade*, ca. 1822–23.

outlawed by Napoleon during the Hundred Days and confirmed by the Restoration government in 1817. The demand for slaves in the West Indies and the southern United States, however, made clandestine traffic worth the risk, and the profits permitted large-scale bribery. Although the issue of slavery is only superficially discussed in connection with Géricault's painting, it is in fact fundamental to an understanding of its constructed meaning.

On 17 June 1816 an expedition of four ships under the command of Capt. Hugues Duroys de Chaumareys, operating the frigate *Medusa*, left from the island of Aix with the new governor of the colony, civil servants, military personnel, agriculturalists, and settlers. Chaumareys, a former *émigre*, was given command of his ship through the favoritism of the Restoration government but in fact had little sailing experience. He ultimately ran his ship aground on the reefs of Arguin just off the African coast. When attempts to get the ship afloat failed, the captain decided to use the lifeboats and make for shore. Due to his general negligence, however, it was discovered that there were too few lifeboats for the passengers, and it was de-

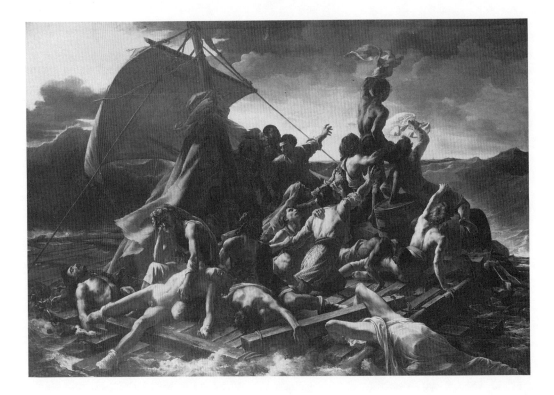

Fig. 3–5. Théodore Géricault, *The Raft of the Medusa*, 1818–19.

cided to construct a raft for the remaining 152 persons and tow it with the lifeboats. But after only a few hours of pulling the raft, Chaumareys gave the order to cut the guy wires connecting it with the boats.

The raft was left adrift somewhere off the coast of Africa without instruments for navigation and without food. The ensuing nightmare resulted from panic and the brute instinct of survival; although the raft was afloat for only twelve days (5–17 July), at the end of that period only fifteen survivors were rescued, five of whom died shortly afterward. The *Medusa* eventually became a full-blown scandal, calling into question the policies of the Restoration government.[5]

Géricault was profoundly moved by this event and joined in the liberal opposition to the government's handling of the case. Here was an instance of innocent people suffering because of political negligence, with implications for colonial policies and slavery as well. Inspired in part by Copley's composition, which was widely circulated in a popular engraving, Géricault created a dynamic pyramid of survivors striving to signal the rescue ship on the horizon. The composition is capped by a black man, who is the topmost figure on the human pyramid. While the presence of black military personnel on the raft was documented by the survivors, the exalted lo-

cation of the black man was a subjective decision made by the artist.
One of the surviving crew members was the black soldier Jean
Charles, and it was undoubtedly this man whom Géricault chose to
make the focus of his design. Unlike the Copley, however,
Géricault's figure is the most active member of the group and be-
comes the compositional and thematic hub of the picture.

The composition propels along a trajectory of history as well as
of salvation. History is conceived of as an irreversible and momen-
tous impulse in the direction of social progress. Progress in this dy-
namically channeled movement requires the emancipation of the most
oppressed member of society, now removed from the bottom of the
social pyramid and installed on the summit—the point of deliver-
ance. French society is synecdochically represented by the ship-
wrecked crew on a broken-down raft, who must give their support
to the black member who alone can save them. Society can be free
only when all of its members are free. Géricault does not shrink from
making the historicist critique of society leveled by many contempo-
rary bourgeois intellectuals, who attempted to preserve the achieve-
ments of the French Revolution as the definitive and canonical basis
of future middle-class development and as a rationale for current
gains. The important humanists like St. Simon and Fourier, the intel-
lectuals argued, did not exclude any human being from their utopian
schemes, nor did they consider further violent revolution necessary
for the realization of the decent society. This openness of the post-
Napoleonic bourgeois intellectuals would soon be supplanted by the
shallow apologia of capitalism that sets in at the beginning of the
July Monarchy, but in Géricault's work we can still read a historicist
investigation rigorously and truthfully carried out, with the disclo-
sure of all the contradictions inherent in the notion of "progress."

A midnineteenth-century critic, Alfred Deberle, wrote that in
The Raft of the Medusa "there are neither blacks nor whites, neither
masters or slaves."[6] He was one of the first to make the connection in
print between Géricault's picture and the issue of slavery. The expe-
dition to Senegal was bound up with the question, since the aboli-
tion of slave traffic forced consideration of eventual emancipation.
One of the survivors of the *Medusa*, the ship's engineer Alexandre
Corréard, who together with the surgeon Jean-Baptiste Henri
Savigny documented the tragic fate of the *Medusa* and provided Gé-
ricault with first-hand testimony, was an abolitionist in close touch
with English Quaker groups. In the second edition of the account of
the voyage to Senegal he appended a discussion of French colonial
policy, arguing for immediate and thorough abolition of the slave
trade and the odious smuggling practices. This addition had been
necessitated by the fact that the new governor of Senegal, Schmaltz,
had allowed slave traffic to resume in the colony.[7] Corréard felt that

elimination of this traffic was the only means to secure genuine colonial prosperity for France. But to achieve "all the advantages of [France's] ancient commerce,"

> Let there be no more secret enterprises; no more connivance at fraudulent traffic, no more unhappy Negroes snatched away from their families; no more tears shed on the sad African soil, so long the witness of so many afflictions; no more human victims, dragged to the altars of the shameful, and insatiable divinities, which have already devoured such numbers: consequently, let there be no more grounds for hearing in the English Parliament, voices boldly impeaching our good faith, attacking the national honour, and positively asserting that France maintains in her African possessions, the system of the slave trade in the same manner as she did before she consented to its abolition.[8]

Corréard's position was the liberal, gradualist road to reform, leading the blacks "to social order and to happiness, by our moral superiority, instead of dragging them under scourges and chains to misery and death." By subjugating them through benefits and making use of their numbers as wage workers, "we shall have raised our commercial prosperity on the greatest interest of those who have been the voluntary instruments of it, and above all, we shall have expiated . . . this immense crime of the outrages, with which we so long afflicted humanity."[9]

Corréard's plea for abolition and his reminder of the position of the English Parliament demonstrates his participation in the liberal wing of French politics during the early years of the Restoration. As in England, French liberals advocated the abolition of slavery in the French colonies. Britain's bold initiative in abolishing the slave trade in 1807 put tremendous pressure on France and Spain, its closest rivals in the trade. Powerful lobby groups represented in Parliament by Wilberforce had begun to spark the conscience of a public accustomed to hearing about the tyrannical French emperor, who at that time declared himself in favor of slavery and, in his treatment of Toussaint L'Ouverture, evinced a violent Negrophobia. Another lobbyist instrumental in passing the bill was Thomas Clarkson, who had been active in the movement since the early 1780s. He was an indefatigable opponent of slavery and labored hard against a wall of vested interests extending the length and breadth of the British Empire. Clarkson was the Ralph Nader of his day, speaking out on the contradictions of the proslavery arguments and interviewing relatives and neighbors of slavers to get at the facts.

In 1808 Clarkson brought out his well-documented history of the abolitionist movement in England, *The History of the Rise, Progress, & Accomplishment of the Abolition of the African Slave-Trade*. While the moral grounds were always at the forefront of the discussion, it is clear that the official English decision in favor of abolition

was based on economic considerations. By 1807 British trade no longer relied on the West Indies as before, and English entrepreneurs wanted to expand their interests in West Africa and seek new avenues of wealth other than the unwieldy system of slavery. Legitimate trade and manufacture could not thrive in areas where slave trading was still active, since African merchants and chiefs found it more profitable to export slaves than to exploit indigenous resources.

The ecumenical British abolitionists, often belonging to the evangelical, dissenting class whence the entrepreneurs sprang, exerted pressure on their government to use its power to extend the prohibition beyond its own territory. Here the inability of English legitimate trade to compete successfully in slave-holding territories provided an influential material interest in support of the moral argument.[10] Cuba's rising importance in sugar production threatened to destroy the sugar industry in India, Mauritius, and the British West Indies, and British West Indian planters were openly prepared to exact abolition from Spain as the price of British assistance to the Spanish in their war against Bonaparte. The English looked to low prices of sugar and the "cheering prospects" of East Indian supply to strike the fatal blow at the slave trade, whereas the hopes of the Cuban slave owners rested on their obtaining a monopoly on the sugar market. By 1820 most of the maritime nations of Western Europe and the United States had taken legislative action against the trade, sometimes as the result of direct British pressure. But it was one thing to enact legislation and quite another to guarantee its enforcement. Puerto Rican abolitionists pointed out with bitter irony how Spain had callously accepted £220,000 from England to cease slave trading and, while continuing to pay lip service to abolition, allowed its practice to continue.

Of the other major slave-trading states, only France had anything like the British incentive to enforce the laws, but its suspicion of Britain and its own vested interests forestalled its effectiveness in this area. During the Restoration, both the powerful Ministry of Marine and the Ministry of Finances prevented the laws from having a real bite, and the trade continued in Reunion and in the West Indian possessions of Guadeloupe and Martinique.[11] The French government refused to enter into an alliance with England to treat the slave trade as an act of piracy that would give them just cause to deny haven to slavers, intercept them on the high seas, and block products of colonies participating in the trade.

In the end, Britain's action did not immediately alter the state of the system: in actual fact the volume of the transatlantic slave traffic grew substantially in the years after 1807 because of the accelerating demand in the Americas, generated by the intensification of the plantation economy in Cuba and Brazil, and by the success rate of cotton cultivation in the southern United States. Merchants of other

countries hastened to fill the gap left by the British, and slave imports continued to expand until they peaked in the early 1840s.

Against this background of tacit toleration of the now illegal trade, French liberals began to make the issue a critical plank in their programmatic attack on the government. One group organized under the Quaker-like rubric Société de la Morale Chrétienne (a descendant of the older Société des Amis des Noirs) and included liberal members of Vernet's circle such as General Foy and the duc de Broglie. While the French members represented a propertied elite who espoused social order and never really became as impassioned as their evangelical Protestant counterparts in England, their commitment to abolition should nevertheless not be underestimated. Benjamin Constant brought the issue before the Chamber of Deputies in 1817, and his ally was the duc de Broglie.[12]

The year 1822 was a watershed in French agitation; with intelligence gathered from the English abolitionists and encouragement from the new liberal government in Spain, elite members of the Liberal Party like the duc de Broglie, Benjamin Constant, and Comte d'Argout took the fight to both chambers.[13] The same year the Society of Friends, or Quakers, in England published material in the French language dedicated to Comte d'Argout, ordered at their annual meeting on 25 May 1822 and addressed to "their brothers in France, Spain, The Netherlands, and Portugal in behalf of our African brothers." The Friends bemoaned the fact that while the practice had been condemned at the Congress of Vienna, and France and other countries had passed legislation against the trade, it not only continued to be carried on by the subjects of these countries but had become even more extensive and cruel than before. They described how the *négrier*, or slaver, would procure criminal associates for high wages and await the arrival of "the unfortunate objects of his cruelty, burdened with the weight of iron shackles, bent under the heavy yoke, and herded like animals until they reach the place of embarcation."[14]

Also in 1822 Wilberforce wrote an open letter to Czar Alexander on the slave trade, or *traite des noirs* as it was translated into French.[15] He noted with alarm the revival and the growth of the institution; that while most English colonialists resided in the mother country, the French and Spanish lived on their plantations and thus participated more directly in the traffic. Nevertheless, all plantation proprietors had a stake in slave traffic and were making their voices heard in the various parliaments. Wilberforce recalled that Napoleon made it one of his priorities during the Hundred Days to abolish the trade, but the hopes of the liberals in London and Paris vanished with Waterloo.

Wilberforce declared that it was especially France that had dis-

appointed the hopes and the promises of the international abolition-
ist movement. France had turned its back on its own ordinances,
laws, and treaties that formally condemned the trade, and French
ports were encumbered with slave ships, whose arrival in French
colonies was publicly broadcast. Speculators were invited openly to
invest in the commerce, and corporate entities had been formed to
distribute the dividends declared by the enterprise.

Wilberforce cited the scandalous tragedy of the slave ship *Le
Rodeur*, a French vessel that sailed from Le Havre on 24 January
1819 and reached the African coast on 14 March.[16] One hundred
and sixty blacks were crammed in the ship's hull as the ship
now made for Guadeloupe on 6 April. During the course of the voy-
age the blacks developed a contagious eye infection, and the ship's
surgeon recommended exposure to the open air. This the captain re-
fused to consider, which led to an outbreak among the prisoners.
The captain shot and hanged as examples several of those who muti-
nied, while others jumped overboard. The ophthalmalia also affected
the crew, until at last only one sailor was able to navigate the vessel.
Just before it reached port, the captain ordered that thirty-six blacks
who had become totally blind be thrown overboard to save food and
also to enable him to collect insurance. Among those surviving the
voyage, thirty-nine blacks and twelve of the whites lost their sight,
five including the captain lost one eye, and the rest sustained severe
damage.

These details were published in November 1819 in a scientific
journal by an oculist who treated some of the survivors, and whose
main purpose was to serve as a clinical case study of the causes and
remedies of the affliction. The following year the same ship and the
same captain, who went unpunished, sailed on another voyage to
the same destination. Wilberforce found it hard to swallow that such
a ship could set sail as late as 1819 from one of the most populous
and commercial ports of France just four years after the country had
decreed the immediate and definitive abolition of slave trading. He
opined that the suppression of information about the trade facilitated
its maintenance, and that if public opinion in France had been
alerted the trade could never have survived. Wilberforce then ad-
dressed his remarks to the French, reminding them of the old rivalry
between England and France. Once a gallant Frenchman described
the English as "a nation of shopkeepers," but now it was his coun-
trymen who were avid for wealth and who had submerged their glo-
rious tradition in greed. Wilberforce then asked them, "How will it
look if England got credit for abolishing the slave trade while France
continued it?" He pleaded with his audience to protest this blot "on
the national character." But he was also realistic in realizing that it
would be difficult for France to abolish the trade under the influ-

ence of England, and thus he admonished the czar to pressure all the contracting parties at the Congress of Vienna to fulfill their pledges.

The momentum of the year's agitation was sustained by the duc de Broglie's historic speech before the Chamber of Peers on 28 March. Using data sent him by Wilberforce, de Broglie established that the slave traffic went on unabated after the official abolition (Napoleon's decree of 29 March 1815, confirmed by Louis XVIII on 30 July of the same year). He demanded its immediate suppression and a strengthening of the laws against it already on the books. He acknowledged that many people suspected the intentions of the English, feeling that abolition was a gross deception perpetrated to exalt their commerce at the expense of the French. De Broglie countered this by asserting that English commercial interests had always opposed abolition.

Between 30 July 1815 and 30 July 1821 there were innumerable infractions of the laws in the ports of Le Havre, Nantes, and Bordeaux. French ships sailing from these ports were observed anchored on the Senegal River and being loaded with slave cargo, a fact verified by the government. In September 1819 Baron Mackau was sent from Paris to Senegal to investigate assertions by the English prime minister that slavery was flourishing there. Mackau's report of 1820 to the minister of marine confirmed the assertions by an abolitionist pamphlet published in London, *Exposé de faits relatifs à la traite des noirs dans le voisinage du Sénégal*, claiming that French ships engaged in slave traffic at Senegal from 25 January to 15 July 1818. As late as May 1819, the vessel *L'Auguste* sailed from the trading post of Saint-Louis at Senegal with twelve slaves aboard.

De Broglie claimed that all of this had been carried out with the tacit approval of the government. He mentioned the case of *Le Rodeur*, pointing out that the first edition of the article on the case had been withdrawn, and a second was placed on the market that suppressed critical details of the incident relating to the slave traffic. De Broglie echoed Wilberforce's contention that it was primarily the public's ignorance of the facts that distinguished the French and English positions. English public opinion had been prepared for many years by extensive debate in Parliament and hundreds of testimonies, as well as by the production of graphic illustrations widely circulated to publicize the horrors of the slave trade. Engravings and drawings depicted blacks confined like sardines in the oppressive depths of slave ships and the brutal tortures used to crush their mental and physical life. At one point, English public opinion became so indignant that over three hundred thousand persons boycotted colonial products—the kind of event impossible in France given the stonewalling of the actual atrocities.

De Broglie observed that merchants in the ports were cleverly

exploiting the fact that it was Napoleon who had promulgated the decree prohibiting slavery, declaring the decree an "antinational" act against legitimism. This fit well with Restoration logic; since slavery was a policy of the old regime it was appropriate for the regime of Louis XVIII. De Broglie noted that these same merchants reaped tremendous profits that evaded taxation; they would purchase black bodies at Senegal for 350 francs and resell them in the colonies for 1,650 francs. The "merchandise" would be grotesquely disguised under the code word *mulets*, the French word for mules; inventories of expeditions from Le Havre regularly carried this term, one of which listed the purchase price of each mule at 500 francs and the sale price at 2,750 francs.[17]

De Broglie observed that current government fines were absurdly low and that confiscation of ships and cargoes lacked teeth because insurance covered the losses. He advocated capital punishment or long imprisonment for slavers; otherwise, France ran the awesome risk of doing the dirty work for the colonies of other countries. Since commerce in slaves was legally prohibited, slaves were actually worse off than before: more people were crammed into smaller holds of ships and tortured, slavers approached by other vessels threw their human cargo overboard like contraband, sick slaves were disposed of like spoiled merchandise. Although de Broglie insisted on more humane treatment of slaves in the colonies, like Corréard and the liberal opposition in general he rejected immediate enfranchisement in favor of gradual emancipation at the end of ten years or partial and progressive emancipation.

De Broglie further lauded the pioneer efforts of the English Sharp, Wilberforce, and Clarkson in their struggle against the trade and admonished all French liberals to follow their example.[18] Clarkson himself contributed to the recent debate through the French translation of his later book on the slave question, also published in London in 1822: *Le cri des africains, contre les européens, leurs oppresseurs, ou coup d'oeil sur le commerce homicide appelé traite des noirs*. Here he attacked all the standard racist arguments to justify the trade, recounting in detail the sickening conditions of the interior of the holds and the types of sadistic torture inflicted on the victims. He demonstrated that slavers had recourse only to the most hardened and ruthless collaborators, and that the trade itself dehumanized the participants and inured them to the suffering of others. Clarkson finished his study with accounts of *Le Rodeur* and an earlier case of analogous barbarism, that of the ship *Zong* in 1780. The *Zong*, an English slaver, lacked sufficient water for both crew and slaves, many of whom became ill. Insurance for slavers in that period did not cover slaves perishing as a result of improper conditions aboard the ship, but it did protect slaves lost at sea during stormy

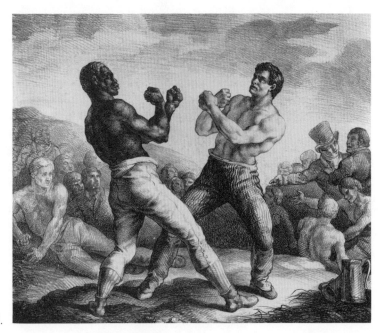

Fig. 3–6. Théodore Géri-
cault, *The Boxers*, 1818.
Avery Collection.
1923.1107. Copyright
1989 The Art Institute of
Chicago, all rights reserved.

weather or other providential events. Captain Collingwood therefore
ordered sick slaves thrown overboard, a total of 132. The first day
fifty-four were thrown into the sea, and forty-two the next; rain fell
for the next few days and provided water supplies, but Collingwood
still insisted on eliminating the remaining ill. Many of these slaves
leapt overboard of their own accord, refusing to be touched by the
crew.

Thus it is clear that abundant material on the slave trade and its
abolition was available to the liberal middle class, and that the issue
was a fundamental plank in the program of the opposition. Géricault
undoubtedly had access to much of this material: Clarkson's discus-
sion in the third chapter of his book on the manner in which
trapped Africans were herded toward the slave ships decisively af-
fected the artist's project of 1822–23, entitled *Traite des noirs*.[19]
Géricault's project is understandable when we recall de Broglie's call
to inform the French public and his praise for the English illustra-
tions that publicized the atrocities of the trade.

Géricault's unfinished work, known to us primarily from
sketches, attests to his awareness of the abolitionist literature and
the antislavery debate. Black people recur frequently in his work, in-
cluding a lithograph of a boxing match between a black and a white
in which the sharp confrontation surely goes beyond the formal con-
ditions of the sport (Fig. 3–6).[20] He planned the *Traite des noirs* as a

major composition on the scale of *The Raft of the Medusa*, and Clément claimed that it held special significance for the painter.[21] Significantly, the studies date from around the time of his return from England, where he had gone in 1820 to promote the roadshow of his work at private galleries in London and Dublin. The fact that the trip to England is bracketed by *The Raft of the Medusa* and *The African Slave Trade* suggests that the exhibition of the picture was timed to coincide with the flurry of antislavery agitation in that period. They attest to the influence of the stormy abolitionist debates on his work in the period 1818–22. The showing of the painting in London and Géricault's subsequent plans for a monumental pendant depicting the cruelties of the slave trade point strongly to his contact with English abolitionist circles during his visit in 1820–21.[22]

His project for *The African Slave Trade* starts from the more recent controversy and demonstrates a higher level of awareness of the slave question. It shows the "human caravan" described by Clarkson and Wilberforce known as the *coffle* that, commencing from the interior of Africa, traverses the country to the banks of the Senegal River. The movement of the prisoners, encumbered by chains linking the right leg of one person alternatively with the right of another, was excruciatingly painful and slow. In Géricault's study the *coffle* has just reached the banks of the river where canoes are waiting to transport the slaves to the ships anchored off the coast at the river's mouth. The central figure is a black prisoner with his hands bound behind his back and an iron collar fastened around his neck. A slave driver at his right swings his rod overhead in the process of flogging him. At the left, a woman who is being dragged off to the canoes attempts to hold her ground while pleading with the slave driver not to beat the bound victim. Wilberforce and Clarkson referred in their writings repeatedly to the inhumane division of the slave families, with women and children often separated from the male parent.[23] They knew that the underlying strategy was to demoralize the family members and prevent collusion. Another critical feature of Géricault's project further indicates his knowledge of the writings of Wilberforce and Clarkson: the facial expressions of the victims and their oppressors. Although the main study is a fairly rough sketch, therein are three carefully completed heads of black prisoners, one female and two males. Their physiognomies attest to their humanity and their vulnerability: they reveal compassion for one another in consoling gestures and expressions, with the central male gazing at his taskmaster with an expression of pity mingled with perplexity. By contrast, the heads of the slavers—although less realized—are all bestial; the eyes are lozenge-shaped and lack pupils, and the mouths are turned down in malevolent grimaces. This sharply drawn contrast between the inhumane and inhuman slavers

Fig. 3–7. George Morland,
The Slave Trade, 1791.

and the intelligent, deep-suffering slaves invoked the observations of abolitionists that participants in the *traite* lose their moral sense and devolve into "monsters."

As in the case of *The Raft of the Medusa*, Géricault took over some of the formal and narrative features of his project from an English prototype, this time George Morland's *African Slave Trade* (Fig. 3–7). Originally painted around 1789, it was given wide currency at home and abroad by numerous reproductions and was surely one of the works de Broglie had in mind when he referred to the propagandistic value of English prints in the campaign against slave traffic. One version was published in Paris in 1794 to commemorate the National Convention's decree of the abolition of slavery. Géricault's study has in common with the Morland the specific setting on the river's edge and the central motif of the black prisoner and his sadistic torturer. But a close examination of the two works shows them to be worlds apart: in the Morland, the two black protagonists wring their hands in anguish and ooze the melodramatic sentiment of a Greuze, whereas their white captors appear almost "gentlemanly" in their comportment. On the right-hand side, a fashionably dressed slaver politely "invites" the woman into the boat, while in the back-

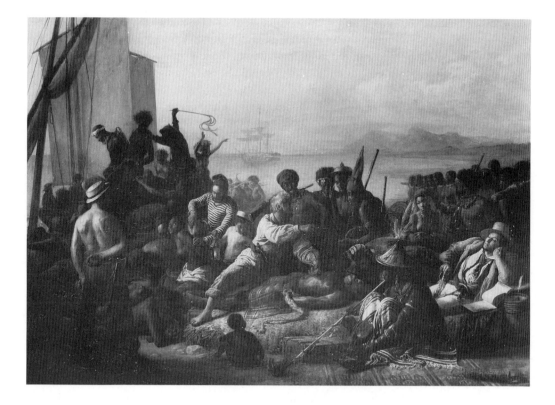

Fig. 3–8. François-Auguste Biard, *The Slave Trade*, 1840.

ground the captain of the slave ship negotiates with an African chief who wears a cruel expression on his face. Morland's treatment of the theme is anecdotal, like the works of Wilkie, and is qualified by his limited knowledge of the actual conditions and by his ideological conservatism. Géricault, on the other hand, with the benefits of increased information and firsthand reports, makes us feel the agonizing and tragic consequences of the slave trade for its victims. Consistent with his desire to make the beholder identify with his subject, he organizes the composition to bring the viewer closeup to the action and experience something of the emotional impact of being herded into the slave ships.

Géricault's work affected the most well-known artist in France specializing in subjects connected with the slave trade: François-Auguste Biard.[24] His popular *Slave Trade*, dated 1840, was widely reproduced, wholly and in part, and must have been known to Oller and others who depicted similar subjects (Fig. 3–8). Originally educated for the priesthood, Biard shared the moral outrage of the abolitionists but painted his images with a particular market in mind. His approach was frankly propagandistic and commercial—he was

more intent on cataloging slavery's abuses than on getting at the human drama stressed in Géricault and Oller. His work shows an almost encyclopedic treatment of the known atrocities and sadistic brutalities endured by African slaves: flogging, branding, manacling with iron collars and wrist shackles, family separation, and the objectification and systematic degrading of the individual's personhood. As an English critic perceptively noted: "It is remarkable, indeed, how the worst moral features of the traffic in human blood have been combined and illustrated, so as to make up the tale."[25]

Biard's visual lists of the cruelties of the slave trade were a manifestation of his mania for collecting ethnographic artifacts. The rise of anthropology and colonial expansion encouraged the ambitions of a certain class of artists who, like Biard, were commissioned for expeditions to record the topography, the flora and fauna, and the activities of the indigenous peoples. Biard fancied himself an ethnographer as well as an artist, and he systematically collected utilitarian objects during his travels, including a wide selection of torture instruments used by slavers. These he delighted in showing to the scientists and artists who frequented his worldly salon.

Details like the iron shackles were no doubt drawn from Clarkson's book on the history of the slave trade, and the vignettes of cruelty were based on the abolitionist literature and engravings. At the upper left, an African overseer pushes one slave on board a canoe while flogging him with a cat-o'-nine-tails. Below, in the middle ground, a slaver prepares to brand a kneeling female slave with a hot iron, and in the center a black man has been forced to lie down on his back while one slaver sits on him and another pries open his mouth to inspect his teeth. The former bargains at the same time with the African chiefs, who are thus equally implicated in the transaction. The cold indifference of both black and white traders to the suffering of the slaves is epitomized in the European accountant who waits impatiently to record the transaction in his ledger. When the work exhibited in the Royal Academy in 1840, the *Athenaeum*'s critic remarked that the ledger contained "a fearful record of human agony"[26]—an apt description of Biard's picture itself.

Actually, the painting, a compendium of stereotypes culled from the voluminous writings of the abolitionists, contributes to the deindividualizing of the slaves. Many of the faces are caricatured, including the African warrior in the center of the composition with his ferocious grimace. Slavers and chieftains alike are a sordid bunch; the only sympathetic face is a voluptuous female at the right, who is clearly the property of one of the chiefs. She hangs her head in a resignation consistent with the feminine ideal of helplessness current in the 1830s. While also enslaved, she suggests erotic possession as opposed to dumb servitude. Of course, the sexual component im-

plied in the possession of human bodies was a basic concern of the abolitionists and an erotic fantasy expressed in both art and literature. Biard, like many of his colleagues of the July Monarchy, was fascinated by female slavery and painted several harems. Like the omnipresent images of slave markets and seraglios in Near Eastern and North African settings motivated by the government's colonizing of Algeria, Biard's slave-trade picture carried clues to the taste of contemporary middle-class males.

Biard's paintings of the slave trade follow the progress of abolition in France; for example, his *Liberation of Slavery on Board a Slaver Captured by a French Ship of War* traces the influence of the agitation of the duc de Broglie and Comte d'Argout, who entered the ranks of the government under the July Monarchy. Louis-Philippe stood behind the treaties of 30 November 1831 and 22 March 1833, which enabled the vessels of one country to intercept a suspected ship carrying the flag of another. But Louis-Philippe and his followers were too busy suppressing the rights of the proletariat— commonly referred to as "slaves" by left-wing writers of the period— to allow the rhetoric of liberty to sway them toward ultimate emancipation in the colonies. It remained for the republican regime that followed the overthrow of the July Monarchy to free the slaves, an event also recorded by Biard in his *Proclamation of the Abolition of Slavery in the Colonies* (1849). As one of its first measures, the provisional government abolished slavery in all French territory on 27 April 1848. The *Proclamation* is a classic emancipation scene in which the slaves exalt their white liberators on bended knee.[27]

The French caricaturist Honoré Daumier used the image of the flogged Negro in an ironic way to point up the economic conditions undermining the trade (Fig. 3–9). The sugarcane industry was being threatened by competition from French beet sugar, first developed during the Napoleonic wars. Daumier's lithograph of 1839 shows a lanky *colon* brandishing a whip above his fat African slave, who sits immobile before a sugarcane field. The caption reads: "Maitre . . . moi pouvoir plus travailler ti canne! . . . pendant que ti français manger li sucre de tí betterave, moi avoir engraissi, moi pouvoir plus bougis de tout." This may be translated as follows: "Master . . . me caint work y' cane no mo'! . . . while y' French eat de sugar of yo' beets, me have gotten fat, me caint move at all no mo'."[28] Slavery, as the basis of sugar production on the plantations, could not justify itself with the success of beet sugar. Additionally, the beet root growers and the industries depending upon them, especially in the Département du Nord, launched a passionate campaign against their colonial competition by joining the abolitionists, arguing that slavery was inhumane and required the costly expense of billeting troops in the Antilles.[29] The colonials, however, naturally resented any kind of

Fig. 3–9. Honoré Daumier, *Maitre, moi pouvoir plus travailler ti canne!* 1839.

change that threatened their privileged way of life; Daumier wished to emphasize their hardened resistance to the economic and moral arguments against slavery. Thus he relied on the familiar image of the slave master flogging his bondsman. The cartoon, supporting the beet farmers, underscores the anachronistic character of the master-slave relationship in light of the new economic developments while at the same time guarding the stereotypical image of the indolent, dull-witted African as the sign of inferiority.

The following year the English artist Turner depicted the horrors of the slave trade and its anomalous presence in modern life (Fig. 3–10). *The Slave Ship*, which caused a sensation at the Royal Academy exhibition in 1840 (the same in which Biard's *Slave Trade* appeared), shows a fiery sunset on the Atlantic, with a violent storm approaching; near the horizon a ship rocks to and fro on the waves, through which a nearby trough is formed by two ridges of enormous swell and highlighted by the sun's reflection. This trough is actually a pictorial metaphor for a tomb, since the entire near area is filled with the flailing limbs of slaves who have been ruthlessly thrown overboard. The helpless condition of the victims is underscored by the shackles around the ankle of one foot thrust above the waves. At the right, fantastic sea monsters devour the jettisoned human cargo—still another motif on slavery informed by Copley's *Watson and the Shark*.

In 1839 a new edition of Clarkson's *History of the Rise, Progress,*

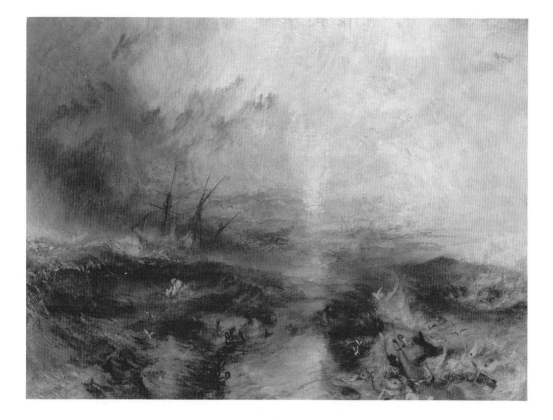

Fig. 3–10. Joseph Mallord William Turner, *Slavers Throwing Overboard the Dead and Dying: Typhoon Coming On (The Slave Ship)*, 1840. Courtesy, Museum of Fine Arts, Boston. Henry Lillie Pierce Fund.

& Accomplishment of the Abolition of the African Slave-Trade appeared that included an account of the notorious case of the slave ship *Zong*.[30] On 19 March 1783 an African who escaped the *Zong* called on Granville Sharp with a horrifying story.[31] One hundred and thirty-two slaves had been thrown alive into the sea from the English slaver. The *Zong* had lost its way; sixty slaves and seven crew members had died of an epidemic, and the water supply was running uncomfortably, if not dangerously, low. As the rest of the slaves were in poor health, it was clear that many would die before the voyage was over and the survivors would fetch low prices in Jamaica. The loss would then fall on the owner; but if they were jettisoned on any pretext concerning the safety of the ship or if they perished due to providential circumstances, the insurance underwriters would pay. The slaves were thrown alive into the sea in three groups; the last thirty-six knew what was in store for them and resisted. Twenty-six were shackled and thrown overboard; the last ten broke away and leaped into the sea themselves. One caught a rope trailing from the ship, pulled himself on board, and somehow survived to bring the story back to Sharp.

The appalling incident accelerated the union of the abolitionists and became a classical case study of the horrors of the slave trade. Thomas Fowell Buxton, Wilberforce's successor as parliamentary spokesperson for abolition since the 1820s, also published an account of the incident in his 1839–40 publication, *The African Slave Trade and Its Remedy*.[32] Buxton's efforts during the 1830s—pushed by an insurrection in Jamaica in December 1831—realized the dream of his predecessor for emancipation in the colonies. Building on the work of Clarkson and Wilberforce, he helped steer through Parliament in 1833 an act "for the abolition of slavery throughout the British colonies." British taxpayers had to come up with twenty million pounds sterling to compensate the planters, and a seven-year apprenticeship for slaves was arranged as transitional preparation for emancipation. The House of Commons, however, was not content with this concession to planters and succeeded in cutting two years off this period, with the result that slavery was finally abolished in the English colonies in August 1838.

By that time, Buxton was disillusioned with the fact that the slave trade in general had not diminished in accordance with expectations. The Spanish, French, Portuguese, and Brazilians continued to carry on the trade and to maintain the murderous seizure of slaves, the painful march to the coast, the torments between the decks of slave ships, the dreaded "seasoning" on the coast, and, finally, the abominable cruelties of the colonial masters. Buxton's emphasis on the "commerce" of slavery and his sensational writing style paralleled the work of Biard, whose *Slave Trade* was presented to Buxton in commemoration of abolition in the West Indies.[33] In his book he noted with outrage: "In no species of merchandise is there such a waste of the raw material, as in the merchandise of man. In what other trade do two-thirds of the goods perish, in order that one-third may reach the market?"[34] Buxton's formulation, although sustained by a profound humanistic commitment, reflected his commercial interests in Africa. He had long felt that Africa would be far more profitable for England if the trade in slavery were abolished and Africans encouraged with English capital to exploit the "boundless" mineral and agricultural resources of West Africa. His purpose in attacking those who maintained the trade, and his stress upon substituting legitimate commerce in Africa, was meant to protect and promote British trade interests. In July 1839 he founded the Society for the Extinction of the Slave Trade and the Civilization of Africa with the double view of diffusing Christianity among the African peoples and uniting to the suppression of the slave trade "the pursuit of private enterprize [sic] and profit."[35]

Much of the Quaker antislavery activity was bound up with ties of intermarriage and with industrial and business interests. Buxton

was not a Friend himself, but his mother belonged to the Quaker
Hanbury family, founder of a tobacco empire prior to the American
Revolution, who had subsequently turned to banking, brewing, and
iron before eventually taking up chocolate. Buxton's wife was also
from a Quaker abolitionist family with extensive banking interests.
Buxton joined the brewing firm of Truman, Hanbury & Co. in 1808
and helped consolidate the Hanbury iron business with both the
iron and banking interests of the Lloyd dynasty and the banking
and brewing interests of the Barclay group. Later he was associated
with the major insurance firm founded by Samuel Gurney, Alexander
Baring, and Sir Moses Montefiore. Thus Buxton's position on the
slave question was in large part associated with his wide network of
business contacts.[36]

Turner's presentation of the *Slave Ship* in 1840 stems directly
from the abolitionists' activity in the previous decade and takes as its
subject their emphasis on the ruthlessness of the trade as well as the
single case study that exemplified their arguments. The major sources
for Turner were the atrocity stories based on the *Zong* case circulat-
ing in London before and during the World's Anti-Slavery Conven-
tion of 1840, a convention presided over by none other than
Thomas Clarkson.[37] Turner's depiction of leg shackles was borrowed
directly from one of Clarkson's illustrations for *The History of the
Rise, Progress, & Accomplishment of the Abolition of the African Slave-
Trade* (Fig. 3–11).[38] At the same time, the painting folds into its vi-
sual and thematic structure the economic issues peculiar to England's
industrial development around 1840. Turner exhibited his picture
with an extract from his long poem *Fallacies of Hope*, which alludes
to the sordid economic conditions of the slave trade:

> Aloft all hands, strike the top-masts and belay;
> Yon angry setting sun and fierce-edged clouds
> Declare the Typhon's coming.
> Before it sweep your decks, throw overboard
> The dead and dying—ne'er heed their chains
> Hope, Hope, fallacious Hope!
> Where is thy market now?

Turner's blazing sunset, like the motif of *The Fighting Temeraire*, is
meant to symbolize the passing of an outmoded institution in the
context of the new industrialized state. *The Slave Ship* belongs to the
period of Turner's close examination of the impact of industrializa-
tion that included such productions as *Snow Storm—Steamboat off a
Harbour's Mouth* and *Rain, Steam and Speed—The Great Western Rail-
way*. Thus Turner could afford to attack the institution then reced-

ing in the distance for British commerce; but rather than point out the abuses still perpetrated in the West Indian colonies, Turner focused on an incident that had occurred in the previous century and was familiar to all. As a result, his image reduced to melodrama the tragic circumstances of the *Zong* and allowed the theme to be almost totally lost amid the artifices of pigment.

Slavery was no longer the most burning issue for the industrial classes who patronized Turner. Now the threat came from the laboring classes in the urban slums. In September 1830 Chartists interrupted an assembly of Buxton and his followers in Norwich, compelling the meeting to disperse. It was clear to English workers that the British ruling class preferred saving Africans at the expense of the indigenous poor. Buxton wrote his colleague shortly after the Chartist break-in:

> What with the Chartists at Norwich, and the Times newspaper, and the Edinburgh Review, and the bitter Resolutions of the Liverpool Anti-slavery Society, and the recognition of Texas, and the threatened admission of slave-grown sugar, clouds seem to be gathering round about us.[39]

Given Buxton's business preoccupations, it is understandable that he could not or would not make the imaginative leap to see the analogy between the plantation slave and the factory worker. While English society increasingly condemned the institution of slavery, it sanctioned policies of labor discipline approximating the plantation model. Already in the eighteenth century, Wedgwood used a warning bell to summon employees to work at 5:45 AM, and they toiled until dark under constant surveillance and control. Wilberforce counted himself among the opponents of organized labor and helped kill all proposed legislation on trade unionism. Wilberforce also opposed domestic dissent that embraced large segments of the working population, and in 1818 he approved suspension of the habeas corpus. His support of the reactionary Suspension Bill prompted Sir Francis Burdett to inquire why Wilberforce should be shocked by African enslavement and not be shocked by a law that allowed Englishmen to be seized and treated like African slaves. Abolitionists who were unaware of the conditions of English workers or had a blind spot concerning the parallel with their own condemnations of slavery had only to read the tracts of their West Indian antagonists, who had been hammering away at this theme since the 1770s. Just four years after the exhibition of Turner's painting, Friedrich Engels would draw this parallel between slave and oppressed worker in his epochal *Condition of the Working Class in England*.[40]

French conservatives had no difficulty making the connection

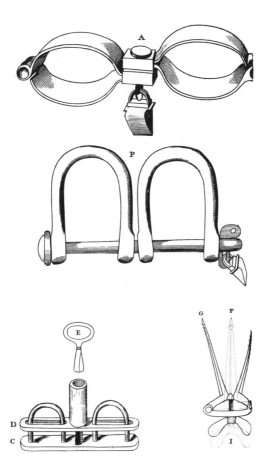

Fig. 3–11. *Slave Shackles*, 1808.

between slaves abroad and the proletariat at home, as expressed by a French writer in the *Journal des débats* in 1831:

> Every manufacturer lives in his factory like the colonial planter in the midst of his slaves . . . and the subversion of Lyons is a sort of insurrection of San Domingo. . . . The barbarians who menace society are neither in the Caucasus nor in the steppes of Tartary; they are in the suburbs of our industrial cities.[41]

French radicals and conservatives could agree on the parallel, and thus it was left to the French Provisional Republic of 1848, concerned with emancipating both the underclasses at home and the enslaved abroad, to finally outlaw slavery in the French colonies. Under the influence of the energetic Victor Schoelcher the abolition of slavery was decreed on 4 March by the minister of marine and colonies, and whipping and corporal punishment were abrogated in Guadeloupe on 25 April.

French emancipation influenced the course of slavery every-
where, but it was felt most deeply in the West Indies, where it pre-
cipitated revolts and conspiracies among slaves of Spanish and Dan-
ish colonies. Hoping to prevent the rebel movement in nearby
islands from spreading to Puerto Rico, Governor Juan Prim published
a reactionary Proclamation against the African Race (*Bando contra la
raza africana*). The horrible edict, aimed at intimidating both freed
and enslaved blacks, stipulated that all offenses committed by per-
sons of African descent residing in Puerto Rico would be tried by
court-martial. All blacks raising a weapon against whites, however
justified the aggression, would be executed if slave and have their
right hand cut off if free. Free black people would also be executed
in circumstances where whites suffered a wound as a result of the
"aggression." Slave conspiracies of July and August were dealt with
summarily as a result of the edict; their leaders were executed and
every black involved was sentenced to one hundred lashes. It was
not until the end of November, following the restoration of order in
the neighboring Caribbean islands, that the new governor of Puerto
Rico, Juan de la Pezuela, cancelled the antiblack measures put into
effect by Prim and issued a proclamation more responsive to the new
conditions in the West Indies and promising future liberty for the
slaves.[42]

Schoelcher, France's most radical abolitionist, had traveled on a
sales trip for his father—a porcelain manufacturer—through some of
the Caribbean islands during the years 1840–41. His observations
on plantation slavery abuses were published in two volumes in
1843. While before the trip he had limited his defense of the African
to support for the enforcement of the interdiction of the slave trade,
he was now converted into an ardent abolitionist. His new position
is tersely proclaimed on the title page of his book: "Slavery can be
no more humanely regulated than murder." Schoelcher moreover de-
clared his solidarity with the English emancipators, referring specifi-
cally to the labors of Clarkson and Wilberforce.[43]

Although Schoelcher remained in Puerto Rico only three
months, he gave evidence of remarkable powers of observation and
an ability to probe beyond mere appearance. He noted that Puerto
Rican slaves were totally at the mercy of planters and bent from years
of servitude. During the period of the sugar harvest (*zafra*), the
slaves left for the fields at 3:00 AM and worked until 8 or 9:00 PM.
Their only compensation was "the pleasure of eating the cane." Not
once did they receive a full twenty-four hours of relief, and they
had to work even on Sundays and holidays for at least two hours in
the morning and often two hours in the evening as well. Labor was
enforced with a whip and stimulated by a whip: "Le fouet, le fouet
partout et toujours." He observed the various instruments of torture

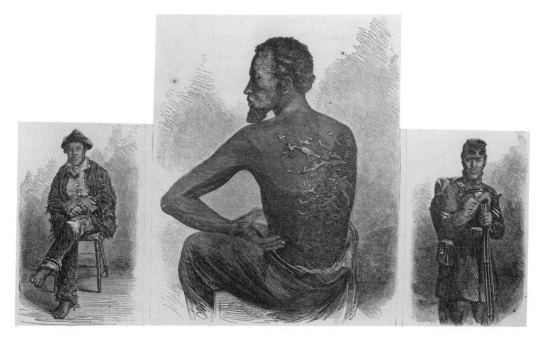

Fig. 3–12. Unknown, *A Typical Negro*, 1863.

used by the overseers (*mayordomos*), such as the pillory and the iron collar (*sepo*). The slaves' degradation and humiliation was an outrage to Schoelcher, who writes that they had to venerate master and overseer "like parents."[44]

He notes that the Spanish slave code allowed for manumission, but planters used their money and power to block it. Although slaves had the right to a small plot of land (*conuco*) to raise and sell their own produce, the long hours spent toiling for the planters prevented them from earning the income necessary to begin the manumission process. Thus the rules and regulations concerning the purchasing of a slave's freedom were a mockery. Contrary to the opinion of other observers, Schoelcher felt that the relatively poor state of the plantations in Puerto Rico in comparison with those of Cuba or Jamaica prevented a more benevolent treatment of slaves. He argues that the *hacienda* owner (*hacendado*) had to force his limited slavery resources to the maximum level of production just to stave off bankruptcy. This is why working hours were inhumanely extended and the slaves' living conditions were inferior to those "accorded the dogs of France."

Schoelcher quotes from Friar Inigo Abbad y Lasierra, who wrote the first important history of Puerto Rico, *Historia geográfica, civil y natural de la isla de San Juan Bautista de Puerto Rico* (1788).[45] Friar Abbad describes the situation of the blacks under the slave system of production with startling frankness:

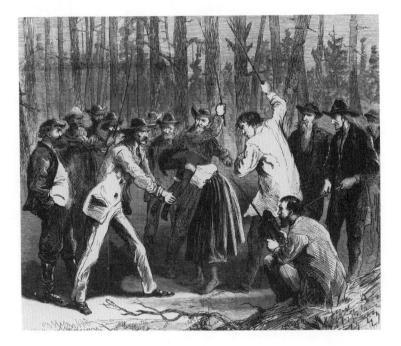

Fig. 3–13. Thomas Nast, *Whipping a Negro Girl in North Carolina by "Unreconstructed" Johnsonians,* 1867.

> When all is said and done there is nothing more ignominious on the is-
> land than to be a black or one of their descendants: a white insults
> any of them with impunity and in the most contemptible terms; some
> masters treat them with despicable harshness, getting pleasure out of
> keeping the tyrant's rod always raised and thereby causing disloyalty,
> desertion, and suicide. . . . Deprived of everything, he is condemned to
> continuous labor, always subject to experiencing the cruelty of his
> greedy or fierce master.[46]

It was not until 1873 that slavery was abolished in Puerto Rico; the
slave-owning minority sought every possible expedient to perpetuate
the regime of privilege that guaranteed them the forced labor of large
contingents of workers.

In 1866 Friar Abbad's *Historia* appeared in a new edition anno-
tated by José Julián de Acosta y Calbo—one of Puerto Rico's leading
nineteenth-century abolitionists. Among those he mentions in his ac-
knowledgments are his friends Román Baldorioty de Castro, R. E.
Betances, and D. Segundo Ruiz Belvis, also major reformists of the
period. Their support for the abolition of slavery was one of the
high points of nineteenth-century Puerto Rican liberalism, which fur-
ther asserted the rights of the Puerto Rican people to self-government.[47]

Acosta read the work of Wilberforce, Augustin Cochin, William
Ellery Channing, and Harriet Beecher Stowe, and he deeply admired

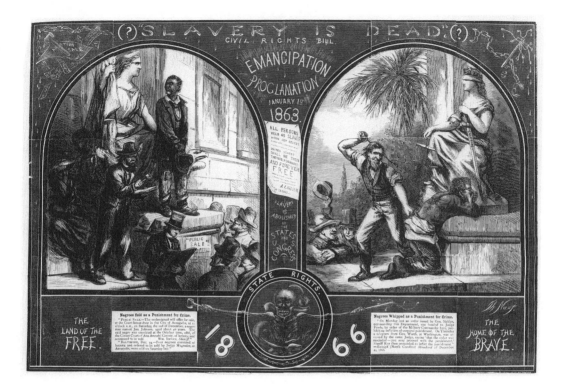

Fig. 3–14. Thomas Nast, "*Slavery Is Dead?*" 1867.

Abraham Lincoln.[48] He and his fellow reformers were inspired by the events leading up to and including the Civil War, which profoundly affected Spain's colonial policies in the West Indies.[49] From the time of the French Revolution of 1848 and its impact on slavery in the Caribbean islands, North America had undergone a series of major events touching on the slave issue. American abolitionists like William Lloyd Garrison condemned the hypocrisy of slaveholders who habitually expressed sympathy with rebels in European countries. They unmasked the cant of the day asserting a theoretical human equality, which coexisted with black slavery and racial discrimination. In 1849 there were fifteen free and fifteen slave states, giving the South equal representation with the North in the Senate. The application of California for statehood precipitated a crisis; in 1850 Whigs and Democrats in Congress worked out a compromise bill that included the notorious Fugitive Slave Act calling for the forced return of escaped slaves to the South. Even free blacks accused of being runaways lost all rights if unable to prove their status. The paranoia in the wake of 1848 led to innumerable abuses of the Fugitive Slave Act and contributed to make the gulf between North and South impassable in the 1850s. The Dred Scott decision, in which the Supreme Court judged that a slave's travels on free Northern soil

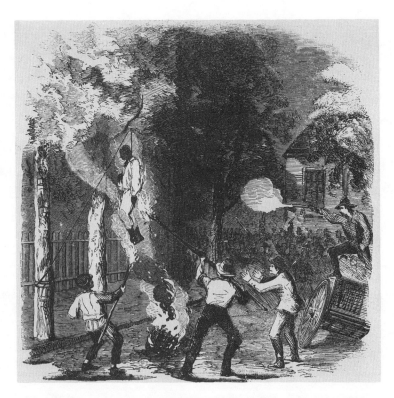

Fig. 3–15. *Hanging a Negro in Clarkson Street,* 1863.

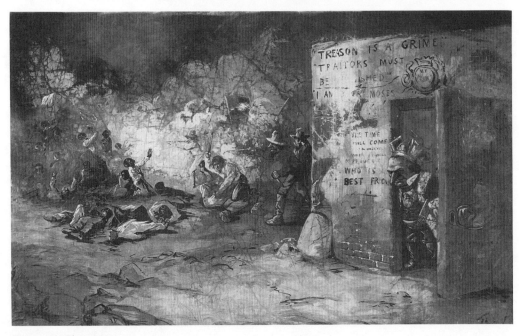

Fig. 3–16. Thomas Nast, *The Massacre at New Orleans,* 1867.

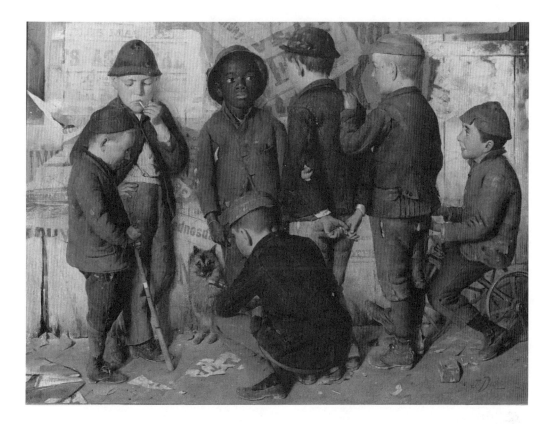

Fig. 3–17. Joseph Decker,
The Accused, 1886.

had not given him his freedom, convinced the North that the South
now had a judicial loophole to extend slavery throughout the
Union, for it deprived Congress of the power to exclude the institu-
tion from any territory.

Scenes of cruelty to black people in the United States both be-
fore and during the Civil War also focused on flogging. As else-
where, the slave system in the United States was dominated by the
authority of master and overseer. Although mutilation and branding
were outlawed, whipping with a leather strap on the naked body
was a commonplace form of discipline. Harriet Beecher Stowe's im-
mensely popular novel of the 1850s, *Uncle Tom's Cabin*, featured the
Simon Legree character who beat slaves regularly. Illustrations in
Harper's Weekly during and after the Civil War often spotlighted this
practice, while in the period of Reconstruction the cartoonist
Thomas Nast showed that blacks continued to be whipped as pun-
ishment for alleged crimes (Figs. 3–12, 3–13, and 3–14).[50]

More desperate and violent attempts against black people oc-
curred as blacks gained their legal freedom with the Emancipation
Proclamation. Slaves fleeing to the North were mercilessly hunted
down by Cuban bloodhounds (the same used in the West Indies to
pursue the *maroons* or *cimarrones*),[51] and blacks serving in the Union

Army who were caught by the Confederate side were often killed without quarter.[52] Lynching became a common sight in the South and, surprisingly, even in New York, where race riots broke out in the aftermath of the Emancipation Proclamation (Fig. 3–15).[53] During Reconstruction, blacks appeared even more threatening, as they had an opportunity to organize and seize political power. Nast painted the Massacre of New Orleans in 1866 when blacks, assembling for a political meeting, were systematically gunned down by professional thugs protected by local police (Fig. 3–16). Of course, the psychological cruelty inflicted on blacks in both the North and the South after the Civil War is incalculable, only hinted at in such images as Joseph Decker's *The Accused* (Fig. 3–17).

THE QUESTION OF BLACK COMPETENCY

Oller's *Rafael Cordero*, showing a scene of a famous Puerto Rican black teacher, exemplifies the second major theme pervading nineteenth-century discourse on the slave issue: the capacity of free black people to assimilate into the dominant society by entering trades and the learned professions (Fig. 4–1).[1] The argument for equal mental capacity became a standard theme in the antislavery repertoire. The black sculptor Edmonia Lewis so impressed Boston abolitionists with her native skills that they quickly paraded her as an example to put the lie to the racist "imputation of artistic incapacity."[2]

The first publicizer of the idea of black competence was Anthony Benezet, a Philadelphia Quaker whose prolific writings from about 1758 to 1784 were widely circulated among English and French abolitionists. To prove his point he opened an evening school for black children in his home in 1759 and was instrumental in organizing a free Quaker school for blacks in 1770. He manifested his concern for black education until his death in 1784, and many notable black leaders of the next generation received their first lessons under Benezet's tutelage.[3]

Cordero modeled his career after the example of Benezet but lacked his advantages. Nevertheless, he became one of the most celebrated pedagogues in the history of Puerto Rico. The child of freed slaves in San Juan, he almost single-handedly founded elementary education for slave children. He opened his first school in 1810 at

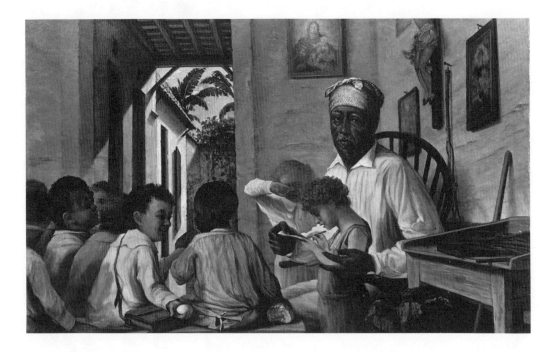

Fig. 4–1. Francisco Oller y Cestero, *The School of Rafael Cordero*, 1892.

San Germán for black and mulatto youths, and later, in San Juan, he maintained a free school for all poor children regardless of race until his death in 1868. Cordero taught without remuneration, earning his living as a cigar maker. He was idolized by Puerto Rican abolitionists like Baldorioty de Castro, who had studied with him as a child. They saw him as both a skilled artisan and a self-taught genius who worked in behalf of others. Oller's friend, the poet José Gualberto Padilla, points to this combination in his poem "El Maestro Rafael":

Sacerdote de la idea,	Priest of ideas,
De la ilustración obrero,	Enlightened worker,
Tuvo el noble tabaquero	Possessed the noble cigar maker
La fe que redime y crea:	The faith that redeems and creates:
En la fecunda tarea	Of the many tasks
A que dio su vida fiel,	To which he devoted his faithful life,
Conquistó como laurel	He earned the honor
De la tumba que lo abriga	Of the tomb that shelters him

Que hoy el nombre se	That today the name be
bendiga	blessed
Del maestro Rafael.[4]	Of the teacher Rafael.

The black artisan was an important figure in abolitionist literature. Acosta's edition of Friar Abbad's *Historia* furnishes statistics of freed black artisans working in the island.[5] Acosta and his fellow reformists contradict the slaver's claim that blacks are inherently lazy and incapable of learning; they show that in Puerto Rico and Cuba "almost all of the mechanical and domestic labors of the land" were performed by free black and mulatto artisans. They further observe that the stereotype resulted from the very practice of slavery, which degrades all labor and renders the oppressed idle and recalcitrant.[6]

Cordero overcame every hurdle, thanks to his abundant energy and high motivation. Schools in his day did not admit black children, but he was a voracious reader and on his own acquired the knowledge that made it possible for him to follow his chosen profession of teaching. Oller's *Cordero* is thus a rare nineteenth-century image of black competence and a testament to the differences between the Spanish and American approaches to slavery.

While on a day-to-day basis the slave enjoyed a life qualitatively no better on a sugar plantation in Puerto Rico than on a cotton plantation in Virginia, slaves in the Spanish colonies enjoyed certain privileges (no matter how limited, as Schoelcher shows) not available to their American counterparts. These privileges were based on the needs of local landowners, merchants, and speculators for skilled workers above the level of manual labor. They included manumission—the right of slaves to purchase their freedom—the right to appeal to the courts if masters got out of line, and the right to own property whose income belonged entirely to them.[7] Blacks and mulattoes in Puerto Rico and Cuba also had access to culture and a role in social life—they were permitted to commingle with freed blacks, for instance—unknown to slaves in the United States. The former were allowed—in some cases, encouraged—to openly celebrate their native culture in music, religion, and storytelling. Slaves in the South, on the other hand, were guarded against preserving their cultural practices, and while of course not disappearing outright, these practices had to take more furtive, underground routes. For example, the Southern slaveholders were sufficiently fearful of drumbeats inciting slave rebellions as to outlaw the slaves' use of drums, and they prohibited the syncretism of African and Christian religions enjoyed by slaves in the Spanish colonies under the more tolerant Catholic Church. The Catholic Church in fact often tried to protect slaves from abuse, officially sanctioned interracial

marriages, and supported the cause of the slave family. Although in
its confrontation with the landowners the Church was often stale-
mated when it came to enforcing the laws, the Iberian tradition al-
lowed slaves a larger road to freedom, and once freed they could
find a niche in the national culture.[8]

In the Southern United States, however, slaves were chattel—
the object of rights rather than the subject of them. Again, these dif-
ferences had very little bearing on the daily life of slaves in either
area: in both cases they were dehumanized, brutally tortured, and
driven to the point of utter exhaustion. But after working hours,
Puerto Rican and Cuban slaves could exercise some choice and free-
dom of action, and while not always enforced, their legal status rep-
resented a notch above that of slaves in the United States, where the
law disallowed any challenge to the master's full property rights. The
killing of a slave by an American master was not generally consid-
ered a felony, for it could not be presumed that malice aforethought
(which makes murder a felony) could induce persons to destroy their
own property.[9] In some cases social pressures and paternalism ("the
mildest form of slavery," as the apologists put it) mitigated the sever-
ity of the slave codes in the South, and even the most hardened
slave owner could never deny the slave's ultimate humanity and that
he or she possessed a soul. In addition, the Southern slaves' free
time was their own—not always the case in the Spanish colonies,
where slaves often had to supply their own food by working on a
special plot during their off hours. But if Southern slaves enjoyed
better material treatment than their colonial counterparts, they had
less independence and less chance for personal development. De-
spite overwhelming evidence of African-Americans' adaptability and
competence, black people there were denied the moral capacity to
become whole persons. All legal obstacles were placed in the way of
manumission; if an American master wanted to free a slave out of
gratitude, the law placed several constraints on the action. If free
blacks were unable to prove they were free, they were presumed to
be runaways. The formula boiled down to "Negro = slave": the mere
fact of being black was presumptive of slave status. This pertained to
all children born of slave mothers, no matter how much "white
blood" they had.

While in Puerto Rico freed quadroons, octoroons, and
quinteros were grouped with whites in nineteenth-century records,
in North America there was an impassable line of demarcation be-
tween "every man who has one drop of African blood in his veins,
and every other class in the community."[10] Even those who wished to
see blacks liberated from slavery by transferring them to an African
colony justified their outlook by assigning them to permanent inferi-
ority in the United States: "The African in this country belongs by

birth to the lowest station in society; and from that station he can never rise, be his talent, his enterprise, his virtues what they may."[11]

As W. D. Jordan suggests, racially mixed offspring undermined the logic of the division of the races on which the institution of slavery rested:

> For the separation of slaves from free men depended on a clear demarcation of the race, and the presence of mulattoes blurred this essential distinction. Accordingly [the colonist] made every effort to nullify the effects of racial intermixture. By classifying the mulatto as a Negro he was in effect denying that intermixture had occurred at all.[12]

Thus the color separation based on the anagogical and allegorical interpretations of "blackness" and "whiteness" began to bleed out through sexual intimacy, and the only solution for nineteenth-century America was to pretend to be color blind to hues other than black and white.

This attitude is romanticized in both the literature and the visual productions of whites at this time. The "tragic octoroon" became a stereotyped heroine especially in pre–Civil War fiction. Although the plots change, invariably the beautiful octoroon is a daughter of a

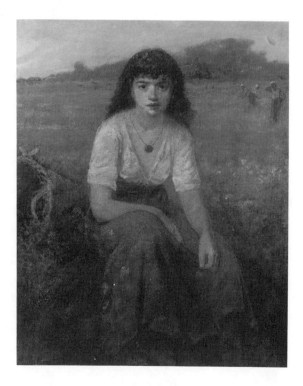

Fig. 4–2. George Fuller, *The Quadroon*, 1880. The Metropolitan Museum of Art, gift of George A. Hearn, 1910. (10. 64. 3)

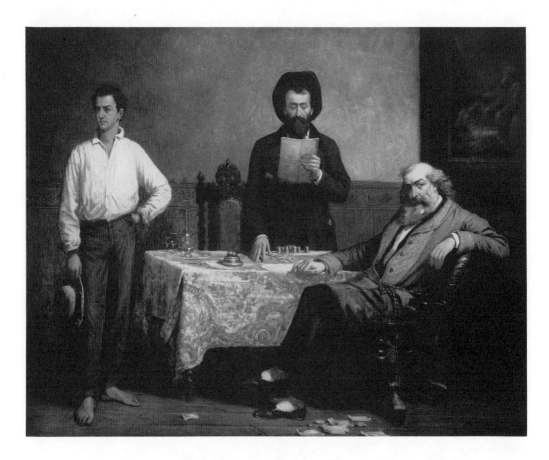

Fig. 4–3. Thomas
Satterwhite Noble, *The
Price of Blood*, 1868.
Morris Museum of Art,
Augusta.

well-established Southern plantation owner and his mulatto mistress
and is raised and educated as white. Through negligence or indiffer-
ence in obtaining proper papers, she is sold into slavery after the
death of her father. Her degradation reaches a dramatic culmination
at the slave auction.[13]

A similar perception of multiracial offspring as at home in nei-
ther world is manifested in imagery focusing on the children of
slaves and masters: George Fuller, a Northern painter who visited
the deep South in the 1850s to paint portraits of wealthy planters,
depicted a quadroon based on his recollection of the sale of a
woman at a slave auction.[14] In *The Quadroon*, a young woman broods
alone while her coworkers toil in the cotton field behind her (Fig.
4–2). Her sense of utter hopelessness could only have been painted
by an American, since in the Spanish colonies the quadroon would
not have been an outcast or a victim. Another example of the treat-
ment of such children is by Thomas Noble, a painter from Kentucky
(Fig. 4–3).[15] *The Price of Blood* is one of a series of pictures based on
themes connected with slavery in the post–Civil War period that we

will study in depth in the next chapter. It deals with the sale of a mulatto male by his father-master, who has just completed negotiations with the slave agent. The fragment of the picture on the wall at the right depicts the Sacrifice of Isaac, thus underscoring the curious expression and gestures of the seated father and the standing son. Despite their relationship, the youth has been sold into slavery for the pile of gold on the table. Here again is a subject that could only have been painted by a North American artist. Both the Fuller and the Noble demonstrate the general sense in America of that time of the permanently inferior status of African-Americans and their descendants.

Unlike the slave system in the Spanish colonies, then, the Southern slaveholding community had, by law and custom, by belief and practice, developed a static institutional ideal that it invested with a high ethical basis. It seemed to Southerners that they had achieved the best possible society—one that by divine sanction would remain forever intact. The abolition of slavery in the United States was thus cataclysmic and violent because the institution had seemed to the Southerners to be so eternal. Their denial of change on "moral" principle was the basic difference between the two slave systems, which Oller caught in his image of Cordero.

Not that Oller's picture is totally free of bourgeois attitudes and condescension: it shows the able pedagogue looking wistfully at the spectator—seemingly overwhelmed by boisterous and mischievous children. Cordero is not shown as the austere teacher, but as a kind of comical, touching creature unable to control his pupils. The walls of the school interior bear images of the Holy Family and the Crucifixion, thus reassuring the spectator that all of this is taking place under the watchful guidance of the Church. A devout Catholic, Rafael Cordero did in fact socialize his pupils into religious ideals. His role as pioneer of instruction for black children constituted no threat to the basic colonial economy and even suggested an extension of Church control. Seen in this context, the sight of the rowdy pupils has an ironic twist and could be enjoyed as a good joke by Oller's privileged audience.[16]

Nevertheless, Oller essentially advances the case of the learned artisan who also happens to be black. Cordero wears a turban, the familiar headdress worn by slaves and black artisans. His progressive position is also suggested by the presence of the whip fastened to the wall directly behind him.[17] It hangs among the pictures and next to the Crucifixion. The whip symbolizes martyrdom for both slave and Christian, while at the same time pointing to their emancipation and ascension. Finally, it is a reminder of Cordero's ancestral state and points up the distance that he, a descendant of freed slaves, has traversed.

Thus Oller's liberated sense of the black man's capacity for social and professional progress achieved rare expression in nineteenth-century painting. Yet even in the United States we may trace a progressive projection of black people in terms of pre– and post–Civil War imagery. The typical prewar racist defined African-Americans as inherently savage brutes who became domesticated under slavery. Docility was not natural to them but an artificial outcome of the institution of slavery. The "lovable slave" stood poised against the "monstrous freedman." Slaves were deliberately kept from education; laws in most Southern states forbade the education of slave children. (Blacks nevertheless studied on their own, received some instruction from their masters, learned hymns and Bible passages at church, and were educated in small, clandestine private schools.) Slavers then set up the adult black person as analogous to a dependent, carefree child who would only suffer from advancement and lose the natural state of innocence. This racist philosophy was riddled with contradictions, asserting at one and the same time that black people were subhuman and dependent children—both attitudes, however, bound by the idea of permanent inferiority.

This was also the attitude of the average Northerner, who was more antislavery than pro-Negro, and who preferred segregated education in public institutions. In James Fenimore Cooper's *The Pioneers* (1823), one of the characters is a free black named Abraham Freeborn, or "Brom," who runs a Christmas shooting contest for profit. Participants paid him for a chance to shoot a turkey tied to a string; if they killed the turkey they could take it home for dinner. He naturally was delighted when players missed so that he could increase his margin of profit. When a sharpshooter failed to strike the target

> Then . . . the shout of the Negro rung through the bushes, and sounded among the trees of the neighboring forest like the outcries of a tribe of Indians. He laughed, rolling his head, first on one side, then on another, until nature seemed exhausted with mirth. He danced, until his legs wearied with motion . . . in short, he exhibited all that violence of joy that characterizes the mirth of a thoughtless Negro.[18]

This image was cast into stereotyped form in the next decade with the advent of the minstrel show. By the 1840s blackface minstrelsy was one of the most popular forms of entertainment in North America. Its founders—entertainers like Stephen Foster and Dan Emmett—were Northern members of the Democratic Party who used it as an outlet of expression for pro-Southern support of slavery.[19] The minstrel show created a form of popular entertainment based on the notion of the "happy, carefree" slave permanently assigned to a state of childhood.[20] Regardless of sectional differences and the various ap-

plications of this notion, it was almost universally believed by white people in the nineteenth century and explains the pervasive images of black musicians and dancers. These images often show a smiling face with much of the dentifrice exposed. The face tends toward caricature—the smile was actually painted on in the popular minstrel shows. The frozen smile suggested that outward decorum had to be maintained no matter how aggravated the individual's actual circumstances. The minstrel grin was the visual complement of the "cheerful" slave who was nevertheless brutalized in the fields and oppressed every waking hour. Both the character in the minstrel show and his or her real-life counterpart were perceived as mindless automatons who would react like puppets on a string and wear a perpetual smile even when struck on the head or reduced to backbreaking servitude. The grinning countenance was the parallel of the face expressing absolute exhaustion, for in both cases the person seemed emptied of all life. Naturally, it was in the interest of Southern propaganda that the slave spent his time off in laughter and dance and that "after his toil, he sings, he dances, he gives no sign of an exhausted frame or gloomy spirit."[21] Frederick Douglass claimed that "slaves sing more to *make* themselves happy, than to express their happiness," and in his autobiography he notes: "Slaves sing most when they are most unhappy. . . . The singing of a man cast away upon a desolate island might be as appropriately considered as evidence of contentment and happiness, as the singing of a slave; the songs of the one and of the other are prompted by the same emotion."[22] But the outward subservience concealed subversive intentions, part of the process through which the slave dealt with the master. The black poet Paul Laurence Dunbar, in the later era of minstrelsy around the turn of the century, expressed this in "We Wear the Mask":

> We wear the mask that grins and lies,
> It hides our cheeks and shades our eyes,
> This debt we pay to human guile;
> With torn and bleeding hearts we smile,
> And mouth with myriad subtleties.[23]

Above all, the smile reflected racist anxieties belying real fears of disguised intentions such as plans for collective action. In 1831 an American traveler to Puerto Rico noted that slaves played banjos and large gourd shells with strings: "On these instruments they were encouraged to play, singing and dancing at the same time to keep up their spirits. The vendors of these Negroes told me it was absolutely necessary to keep them in a good-natured mood, otherwise they

Fig. 4–4. William Sidney
Mount, *The Bone Player*,
1856. Courtesy, Museum of
Fine Arts, Boston. M. and
M. Karolik Collection.

would get the sulks, refuse all kind of food, and die with starva-
tion."[24] Here in a nutshell is the critical nature of the stereotype: the
singing, dancing, and smiling slaves showed an outward acceptance
of their role and gave solace to the planter, but at the same time the
routine could be exploited to conceal rebellious intentions. Thus the
"Yes, massa" and the accompanying leer were both a source of com-
fort and disturbance to the Southern slavers.

The American genre painter from Long Island, William Sidney
Mount, revealed a particular fascination for toothy grins in his de-
piction of black people.[25] Perhaps no other artist of the pre–Civil
War era painted as many works of black people as did Mount, who
established himself—as one of his contemporaries put it—as a
painter of "Ethiopians." Mount had been born into a prosperous
farm family in Setauket, Long Island, that owned slaves (slavery was
abolished in New York State only in 1827), and throughout his life
he assumed a paternalistic attitude toward blacks.[26] He belonged,
like the founders of minstrelsy, to the Northern wing of the Demo-
cratic Party and espoused its principles of white supremacy.[27] One of
his earliest works was *Rustic Dance after a Sleigh Ride* (1830), show-
ing an African-American playing a fiddle for a group of white danc-
ers. While he physically occupies the same interior as the others, he

is relegated to a special place in the foreground and at the extreme left. This isolation is reinforced by the singularity of his broad smile. What was an unconscious attitude then could be more precisely articulated thirty-four years later: "We had a carnival on the Setauket Mill Pond Saturday in the way of skating. It was a gay scene, Negros [*sic*] on one pond and whites on the other—that was right and proper."[28]

Mount's blacks are characteristically shown grinning, such as in his series of portraits of African-American musicians engraved and widely distributed by the French-based firm of Goupil et Cie. They include *Right and Left* (a fiddler), *The Banjo Player*, and *The Bone Player* (Fig. 4–4). These paintings must be understood in the context of the general view that black people possessed limited intellects, and as such enjoyed a "carefree" state. As a writer for the Northern journal, *Putnam's Monthly*, observed in 1855: "A true Southern melody is seldom sentimental, and never melancholy. And this results directly from the character and habits of the colored race. No hardship or troubles can destroy or even check their happiness and levity."[29]

Mount painted a work entitled *The Lucky Throw* (now lost) for a lithographic reproduction conceived by William Schaus, Goupil's New York agent, as a companion piece to the series of single black

Fig. 4–5. Jean-Baptiste Adolphe LaFosse (after William Sidney Mount), *The Lucky Throw or Raffling for a Goose*, 1851. The Museums at Stony Brook, gift of Richard M. Gipson, 1951.

musicians. Mount referred to it in his journal entry of 15 September 1850: "One picture—Negro—African—head life size—laughing and showing his white teeth and holding something funny in his hand—Goose, a Duck, or a squirrel xc. 25 x 30."[30] It is clear that for Mount the subject was important mainly as a pretext to depict an African head grinning from "ear-to-ear."

The lithograph that bore the altered title of *Raffling for a Goose* was destined primarily for an urban European audience desperate for images evoking a nostalgia associated with a disappearing way of life (Fig. 4–5). Mount could exploit this taste because he identified with the frozen world of the past and packaged it for the delectation of New York buyers. The reception of the painted version by both Northern and Southern critics bears this out. The supposedly liberal *Harper's Monthly Magazine* observed:

> W. S. Mount, the only artist among us who can delineate God's image carved in ebony; or mahogany, has just finished a picture in his happiest style. It represents a genuine sable Long Islander, whom a "lucky throw" of the coppers has made the owner of a fat goose. . . . The details of the picture—the rough coat, the gay worsted comforter and cap, disposed with the native tendency to dandyism, which forms so conspicuous an element of the negro character, are admirably painted. The effect, like that of every true work of art, and unlike that of the vulgar and brutal caricatures of the negro which abound, is genial and humanizing.[31]

Against the backdrop of evolving attitudes and actions concerning blacks and slavery in the pre–Civil War period, this writer demonstrates the degree to which stereotyping still affected Northern attitudes toward African-Americans. While he is critical of dehumanizing caricatures, he himself has a fixed social place for blacks and a rigid set of qualifiers that smack of caricature.

Indeed, nothing in the work spelled trouble for the slaveholders and their sympathizers. When the painting was exhibited in Mobile, Alabama, one journalist wrote:

> Strolling into Strickland's a few days since I was stopped at the entrance by a sprightly, grinning, happy colored boy, who greeted me with such a characteristic display of irony and pouting lips, that I at once gave myself up to his demands. He had a goose in his arms—a plucked goose. It was evident to my mind he had not stolen the goose, or he would not have looked so fearless: It was equally evident he had not bought the goose, he told me, in his mute but unmistakable language, that he had cast his dimes on him in a raffle and had won him—fairly won him. . . . Our friend Strickland's enterprise has brought this gem here to grace his next Annual Prize list, and he has doubtless paid

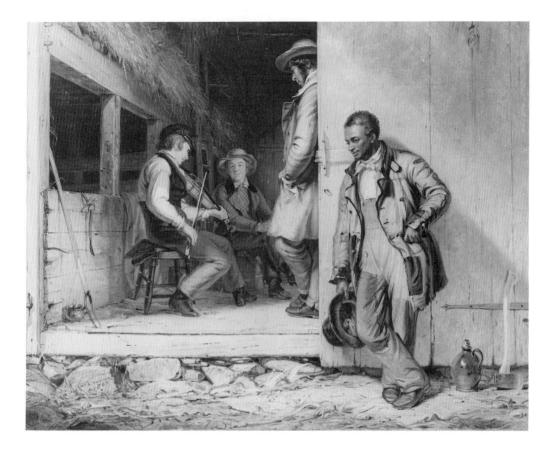

Fig. 4–6. William Sidney Mount, *Music Hath Charms* or *The Power of Music*, 1847.

for the boy—for, be it known, a nigger of his value can only be bought, even in New York![32]

Both the Northern and the Southern critics—despite the former's more euphemistic labels—shared a common perception of the protagonist and could confidently read his behavior on the basis of the signs indicated by Mount. It might be argued that Mount's approach was typical of genre painting with its stock themes and characters, but what is crucial here is his capacity to depict black people as signifiers of white America's pastoral fantasies. Mount's own statements confirm the reception; in September 1852, he responded to Schaus's request for works for the series of musicians:

I will undertake those large heads for you—although I have been urged not to paint any more such subjects. I had as leave paint the character of some negroes as to paint the characters of some *whites* as far as the morality is concerned. "A Negro is as good as a white man as long as he behaves himself."[33]

Hence, for Mount the appropriate outlook for blacks is to know their place at all times. He may not have been a slaveholder, but he similarly assigned blacks to a permanent position of inferiority.

Mount's *Music Hath Charms* or *The Power of Music*—a title inviting the idea of the "savage beast" who may be soothed—is a more complex and interesting statement about Northern attitudes toward black people in the pre–Civil War period. It depicts an African-American male standing outside a country barn listening attentively but unseen to a fiddler who plays for two listeners gathered around him inside, all of whom are white (Fig. 4–6). Next to him on the ground are a jug of cider and an axe leaning against the side of the barn, clues to his natural disposition, which has been momentarily suspended as a result of the captivating music. He evidently has a disinterest in work and a taste for hard cider, but the music possesses the potential to temporarily "civilize" him. The painting is part of the standard racist ideology attributing to blacks a relaxed and casual sensibility and a love of pleasure that rationalized the actual treatment of them as beasts of burden.

The black laborer leans his head and upper body in the direction of the music, forming the right-hand slope of a triangle that ascends to embrace the standing auditor inside on the elevated platform of the barn and then descends to enclose the other two figures. Once again, a conventional visual system representing social hierarchy has consigned the black person to its lowest plane. Mount locates him in a distant and exclusive relationship to the white world, entranced and enhanced by it, but at the same time very definitely keeping to a fixed place within that world. One writer quoted in Mount's journal constructed the following interpretation of *The Power of Music*:

> An old man is listening seated also, with his hands on his knees. Another listener is a young man in the prime of life also absorbed in the music. The third auditor is a humble negro man, who stands, hat in hand, outside the barn completely entranced in the dulcet sounds of the violin. The old man is looking back into the past, the young man is dreaming of the future, the negro thinks of the present.[34]

Thus in this interpretation black people have no past and no future but are hopelessly condemned to their "innate," ever-present disposition.

Mount, however, manages to bring this off in a highly natural and logical construction. The whites appear "higher" not because of any inherent superiority they might possess as whites, but because they rest on a raised floor. The black neither sits nor kneels, but stands nonchalantly as if his position derived wholly from his own free will. Mount gives him a dignified air devoid of all taint of cari-

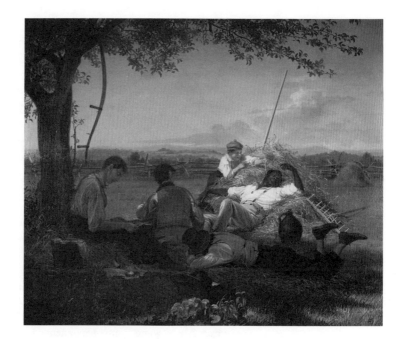

Fig. 4–7. William Sidney Mount, *Farmers Nooning*, 1836.

cature, and his closer proximity to the frontal plane establishes him in a key compositional role. While in the "textual" script he stands outside the white man's realm, in the visual scenario the angle of his posture and the disposition of his limbs relate him unmistakably to the figure standing just inside the opening. Mount clearly tried to reconcile the status of blacks within an egalitarian vision and deal with the issue of their inherent qualifications for participation in the white man's community. But his solution—vividly shown by the barn wall—was physical separation.

More typical is Mount's *Farmers Nooning* of 1836, which draws a striking contrast between the indolent black napping on a stack of hay—again sporting the inevitable grin and pearly teeth—and the industrious white Yankee seated at the left honing his scythe sharpener (Fig. 4–7). In fact, while all the characters are shown taking a noonday break, the whites alone are alert and active. Mount's early biographer (1851) describes the picture thusly: "How lazily lolls the sleeping negro on the hay. . . . The white laborers are naturally disposed about with their farming implements."[35] Like Copley's servant in the boat, the black man alone in Mount's picture is passive. Above all, he is the butt of a joke, as a youth tickles him with a straw. Black people were common victims of practical jokes in early nineteenth-century imagery, emphasizing their humiliating social position and powerlessness.

Mount's penchant for deploying black males for comic relief is seen in his notes for projects and diary entries. For one painting planned in 1863 he summarized: "One horse drawing four workman [*sic*], they seated on a plank of a small waggon. It would add to the humor of the scene by introducing a negro driver or as one of the workman."[36] On a visit to Washington on 23 May 1865 Mount watched a review of the Union Army file past President Johnson and his cabinet. He isolated as the "comic element" the *contrabands*—the runaway slaves who served in the Union Army—and their mules:

> Amusing was the appearance in the rear of the First Pennsylvania cavalry of a solitary negro, *black as a coal*, mounted upon a mule. He was recognized as the original cause of the rebellion, although he rode along apparently unconscious of *his importance*.

One transportation brigade known as the "Bummers Corps" especially provoked Mount's mirth as it passed up Pennsylvania Avenue:

> The lean and lank mules, heavily loaded with blankets and articles of subsistance [*sic*] and camp, were attended by their colored drivers and headed by two whitish colored mules of a diminutive size, ridden by two diminutive contrabands, was novel and unique and caused shouts of laughter and rounds of applause from the lookers on.

Blacks were always there, from earliest childhood on, to provide Mount with amusement, and they made appropriate subjects with which to amuse his own audience.[37]

Farmers Nooning was painted for the New York businessman Jonathan Sturges, who spent a good part of a fortune earned from the wholesale grocery trade on contemporary American painting. In addition to this work, he also owned two other Mount pictures, *Ringing the Pig* (1842) and *Who'll Turn the Grindstone* (1851), both themes having to do with the moralizing implications of rural work. Sturges's relationship to these themes was clearly based on his personal perception of work and workers and a condescending attitude to the rural laborer who more or less knew his place, akin to the rural blacks of Long Island. Mount made a speech in 1851 at the annual supper of the National Academy of Design in which he singled out Sturges for particular praise:

> Since the death of Luman Reed, no man in this city holds a more prominent place in the affections of artists and the public than our esteemed President of the New York Gallery, Jonathan Sturges. He has apartments richly decorated with paintings and busts by native artists, and I believe has but one mirror, which reflects well his taste. He reminds me of some of our good old farmers. I know him to be one by the fact that I have *sanded his rifle, rung his hogs,* and *turned his grindstone.*[38]

Mount's reference to "rifle" is not to an actual gun but to the scythe sharpener in the hands of the resting laborer at the left of *Farmers Nooning*, so that his last statement refers to his own "work" for the patron. By this allusion to three of his paintings, Mount hints at the importance of the employer-employee relationship to the subjects of his art, and to Sturges's ability to command labor of all sorts on his own terms. While the sleeping black figure bears a contrasting pictorial relationship to the white farmer who hones his scythe, it is clear that he is not Sturges's "ideal" laborer, but the "comic element" in the picture.

Mount's most memorable painting, *Eel Spearing at Setauket*, also projects the most positive image of a black person in his production (Fig. 4–8). This majestic portrayal of a black country woman dominating the landscape by her narrative role and visual presence is unique in nineteenth-century American art. Karen Adams describes her as a "figure of unmitigated dignity" and locates her at the center of the archetypal American theme as defined by Leslie Fiedler: the pairing off of a white and a black (or other person of color), their isolation in a panoramic view of the landscape, and their pursuit of a thrilling adventure (e.g., Huck Finn and Nigger Jim, Ishmael and Queequeg).[39]

Furthermore, the monumentalizing of the woman has been facilitated by the sharply defined triangular configuration that we have heretofore associated with the visual equivalent of the exclusive social hierarchy. Poised on the front rim of the boat with her tilted spear in readiness, her powerful figure follows along the most compelling and energetic trajectory of the design. The youth, seated at the opposite end of the boat with his navigating oar held at the opposite angle of the spear, barely holds his place next to her. Falling between Copley's *Watson and the Shark* and Homer's *Gulf Stream*, this work represents another striking exception to the norm.

What conditions could have made this possible when Mount painted it in 1845? Mount gives us a clue in his notes where he refers to the picture as "Recollections of early days. Fishing along shore—with a view of the Hon Selah B. Strong's residence in the distance during a drought at Setauket, Long Island." Mount's picture, although commissioned by the patron whose manor house is glimpsed in the background, derives from his own personal memories of childhood. Two years after he painted the picture, he set down in a letter the specific details of these recollections to his friend and patron Charles Lanman:

> An old Negro by the name of Hector gave me the first lesson in spearing flat-fish and eels. Early one morning we were along shore according to appointment, it was calm, and the water was as clear as a mirror,

every object perfectly distinct to the depth from one to twelve feet, now and then could be seen an eel darting through the seaweed or a flat-fish shifting his place and throwing the sand over his body for safety. "Steady there at the stern," said Hector, as he stood at the bow (with his spear held ready) looking into the element with all the philosophy of a crane, while I would watch his motions, and move the boat according to the direction of his spear. "Slow now, we are coming on the ground," on sandy and gravelly bottoms are found the best fish— "look out for the eyes" observes Hector, as he hauls in a flat-fish, out of his bed of gravel, "he will grease the pan, my boy," as the fish makes the water fly about in the boat. The old negro mutters to himself with a great deal of satisfaction "fine day—not a cloud—we will make old mistress laugh—now creep—in fishing you must learn to creep," as he kept hauling in the flat-fish and eels, right and left, with his quick and unerring hand—"Stop the boat," shouts Hector, "shove a little back, more to the left, the sun bothers me, that will do—now young Master step this way. I will learn you to see and catch flat-fish—There," pointing with his spear, "don't you see those eyes, how they shine like diamonds."—"very good now," says he, "I will strike it in the head," and away went his iron and the clear bottom was nothing but a cloud of moving sand, caused by the death struggle—The old negro gave a grunt and sang out "I am a little negro but oh! Lord," as he threw his whole weight upon his spear. . . . The fish proved to be a large flounder and the way old Hector shouted was a caution to all wind instruments.[40]

In this rich and complex relation of childhood memories we see Mount's mature stereotyping restructuring the image of Hector; he has become the butt of a comical anecdote, handling the situation with "the philosophy of a crane" and throwing all rationality to the wind when he catches his precious flounder. Mount intersperses enough of the social relations to let his reader know that he was the "master" and Hector the "old negro," the domestic. But one thing that Mount cannot alter is the profound impression of this childhood experience on his entire life. He recalls all the little intricacies and topographical incidents of the moment—the precise dialogue, or monologue, so it seems. Above all, no matter how he belittles Hector in his mature retelling of the story, it is easy to see that Hector had total control of both the situation and his youthful protégé.

Hector's mastery and decisiveness comes through every statement, as he conveys his orders with the assurance and clarity of a veteran naval officer. He condenses years of experience into pithy phrases that Mount could never forget. Hector was one of his most memorable teachers—the word "learn" appears twice in the narrative. In fact, it is Hector who teaches Mount "to see" as well as "to creep." Mount emphasizes Hector's dominance in his recollection of the black's self-deprecation at the moment of his triumph—"I am a

little negro but oh! Lord"—but demonstrates that in fact, for young Mount, Hector was something like a god who initiated him into the mysteries of life.

The powerful image of Hector that emerges from the anecdote despite the comical trappings helps clarify the fundamental transformation of its visual encoding: Hector becomes a majestic woman. This curious displacement suggests that the mature Mount could not have permitted himself the freedom to portray a black male with the force and commanding presence of the type he recalled from his childhood, but he could show a maternal black female who would have been less threatening and less paradoxical for him in 1845. At the same time, however, the memory of the incident occurred before he became conscious of the racial stereotype, and he could not repress the powerful memory of Hector's presence in the final working out of the theme.

Yet the image of the powerful, protective woman possesses its own energy and assertive confidence that is not sufficiently explained by an act of simple substitution. Such unforgettable details as the straw hat and the bandana that partially envelops her face, the muscular arms and the columnar gravity of her clothing, have their own intrinsic character that points to another layer of signification. Mount's father died when he was yet a child, and thereafter the youth was cared for by the females of the extended family, his mother and maternal grandmother. With four sons, his mother had her hands full, and Mount, the youngest, recalls that he "was not always under the government or training of my Mother but alternately under the care of my Grandmother and herself until I was eight years old."[41] What Mount omits to mention is the care he received from the blacks in the household, although in several instances he links them with specific incidents, as in the case where he recalls sitting on the knee of one of the favorite family servants. It is more than likely that African-American women nurtured Mount in his childhood, and this is the source of the picture's vitality in spite of the displacement.

The role of the protective "mammy" makes sense in still another way. Mount's intimate recollections of the black servants usually involve males, and there seems to be a strong erotic undercurrent in these associations. This eroticizing of the black male comes through most vividly in the "dandified" musicians, but it is also strikingly revealed in the hedonistic pose of the sleeping protagonist in *Farmers Nooning*. Mount's homoerotic attraction, therefore, may have mitigated against portraying a heroic black male, and instead he unconsciously displaced these feelings onto a symbol more appropriate for the "feminized sensibilities" of the stereotype and one more consistent with heterosexual preferences. Both blacks and women were ultimately

subservient to white males, for whom the mammy image collapsed the
two categories into an idealized projection of race and sex relation.
The supposed total devotion of the mammy to white children and
her benign sexuality pacified guilty fears of miscegenation and of
women's emasculating sexual powers.[42] Mount's mammy attains tran-
scendent status as symbol while black women were actually at the
very bottom of the social scale.

Finally, however, Mount's *Eel Spearing at Setauket* is about
human dominance over natural contingencies. The artist's recollec-
tions include a reference to drought in Long Island, and the aridity
of the landscape is scrupulously depicted in his picture. The tension
of the picture must inhere partly in its associations with a period of
deprivation, and the action of the woman is therefore tied to
survival. The work was commissioned by George Washington Strong,
one of the heirs of the vast landed property that extended the width
of the island, shown in the painting. The picture in fact belongs to
the category of estate portraits that constituted a staple living for
landscapists since the eighteenth century. The estate's manor house,
occupied by his nephew, Selah B. Strong,[43] is located almost in the
center of the triangular shape formed by the spear and the oar. A
New York lawyer and pro–Southern Democrat like Mount, George
W. Strong was well known in New York circles and was immediately
associated with the painting. The connection between the drought
and the picture is clear enough, but the patronage circumstances
give the convention a unique narrative twist by implying that the
Strong family property—erected into a lordship in the late seven-
teenth century—will survive the momentary catastrophe through the
family's command not only of its resources but also of the bodies of
those who work there. The black woman, in her identification with
the ebb and flow of nature's cyclical and therefore ultimately
changeless time, is portrayed as the key to the white man's survival.

Mount's mature views on blacks were expressed through his af-
filiation with the Democratic Party, the party of slavery. He opposed
both abolition and the left-wing populism generated by Jackson. As
the crisis over the Union neared, Mount's proslavery views became
even more strident. As early as 1859, he recorded in his journal in
connection with the abolitionist work Hinton Helper's *Impending
Crisis of the South*, which had just been endorsed by the Republican
Party, that "The Republican ticket is the Negro ticket. Mr. Greeley, I
can't vote on your ticket because there is a negro in the fence."
After the Civil War, Mount strenuously opposed Radical Republi-
canism. He displayed a sign in his studio that read: "THE DEMO-
CRATS CALL UPON ALL UNION MEN, TO SUSTAIN ANDREW
JOHNSON AGAINST THE RADICALS." In 1867, he and a few allies
gathered to celebrate recent Democratic victories that stemmed the

Fig. 4–9. William Sidney Mount, *Dawn of Day*, ca. 1867. The Museums at Stony Brook; gift of Mr. and Mrs. Ward Melville, 1958.

tide of Reconstruction. Mount drew the picture representing *A Rooster Standing upon a Dead Negro*, or *The Break of Day*. One of the members of the committee wrote that its function was "to see that the cock shall crow from time to time, protected; and taken to Port Jefferson & Stony Brook, and exhibited in Setauket on his return."[44] Mount evidently explained the meaning of the picture to the editor of a Republican paper who had commented upon it:

> The design of the picture is also misrepresented as the rooster is not intended to represent the Democratic party, but such gifted politicians as the Editor of the staff who are trying to galvanize some life into the defunct nigger. He is politically dead; radical crowing will not awake him. It is the Radical Republican Rooster trying to make more capital out of the negro who is about used up for their purpose; which is glorious news for the country. The African needs rest.[45]

Mount had painted a smaller version of this work that was exhibited at the National Academy in 1868–69 as *Dawn of Day (Politically Dead)* (Fig. 4–9). The critic of the *New York Herald* of 10 April 1871 wrote that it conveyed "a truthful representation of a young negro, one of those genuine Long Islanders of whom it has been asserted that 'love of ease is their chief characteristic.' The day of his prosperity is about to dawn, but not even the shrill crowing of Chanti-

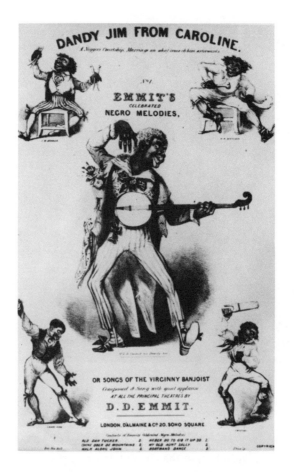

Fig. 4–10. Anonymous,
Dandy Jim from Caroline,
ca. 1844.

cleer can awaken him to a consciousness of the fact."[46] Hence as
blacks began to move out of their assigned niche and demonstrate
that no law of nature justified their previous position of subordina-
tion, Mount and his Northern allies felt the structure of their illu-
sions collapsing all around them.

Mount's visual stereotypes came to him by way of his slavehold-
ing ancestors. His uncle, Micah Hawkins, was one of the originators
of the minstrel theatrical style. He wrote a popular patriotic song
about Washington and Lafayette that was meant to be sung in black-
face and in the Negro dialect.[47] The casting of the stereotype of the
singing and dancing slaves on Southern plantations in the form of
minstrelsy was pioneered by Thomas Dartmouth Rice, whose Jim
Crow song and dance was first performed in 1828. In the 1840s,
Dan Emmett (author of "Dixie"), the founder of the genre as it came
down in popular American theater, fixed the definitive image with a
beaming smile, a tattered hat, worn gloves, a fiddle, a tambourine,
bones, and the cakewalk—a routine that had astonishing durability
until around the middle of the present century.

Emmett's standard gesture was displayed on the front covers of
his published repertoire. He is typically depicted strumming his
banjo while enacting popular minstrel gestures and facial expression
that border on freakishness (Fig. 4–10). The banjo-picking Jim Crow
character with the apelike features and wide grin became the stereo-
typical ideal of white racism in the nineteenth century, and it is no
coincidence that the performers were whites disguised in blackface.
Minstrelsy was of course a white fantasy projected upon black
people—no wonder the safe, familiar vision of the grinning black
who could "hoof it off" through thick and thin had a powerful and
lasting appeal for American whites.

As mentioned previously, minstrelsy was in fact linked to Jack-
sonian Democracy as a form of mass entertainment that fostered pro-
Southern sympathies. Its inventors belonged to the Northern wing of
the Democratic Party, the party of Mount and his patrons. The Dem-
ocratic control of the federal government, which lasted until the
Civil War, required the support of the Southern Democrats, who ex-
tracted in return for unity the guarantee that the national party
would defend the institution of slavery. The basic themes of Mount's
representations of blacks—the grinning musicians, the black as sym-
bol of eternal nature rather than a figure in history, the love of the
master—come straight out of the minstrel tradition, with all of its
political implications.

Closer to actuality is Henry O. Tanner's *The Banjo Lesson*,
which shows an unsentimental affection and tenderness between an
African-American grandfather and his grandson, whom he teaches to
play the banjo (Fig. 4–11). Both are totally self-absorbed and con-
centrated on the lesson, seemingly unaware of the spectator. The
theme is the impartation of experience to a younger generation that
is interested and capable. This is not idle amusement or play, but an
opportunity for the transmission of knowledge. The intimacy of this
scene is far removed from the "acting out" so typical of the scenes of
blacks with banjos; here the object of the lesson counts for less than
the depth of the pedagogical exchange. Here the banjo is no prop or
stereotyped accessory but the means for passing on instruction. The
older figure frets the instrument at the top of the neck, indicating to
the younger the proper strings to press against the frets. He points
out to him the rudiments of finger-picking as the boy plucks the
strings of the bridge. The lesson is neither authoritarian nor face-to-
face, but consists in shared intimacy between a nurturing parent and
a developing young mind bent on mastering a musical skill. Not sur-
prisingly, Tanner was a black artist born in Pittsburgh, and his fa-
ther was a bishop in the African Methodist Episcopal Church. His
viewpoint moderates for us the ideological slant of white painters
depicting black subjects.[48]

Tanner had been a student of Thomas Eakins, whose own *Negro Boy Dancing* of 1878 conveyed a convincing representation of a black family drawn together by their musical interests (Fig. 4–12). While Eakins's parents were Northern Democrats like Mount and opposed the Union cause, his own commitment to factual representation encouraged his individualized treatment of the people he portrayed.[49] Sidney Kaplan credits Eakins with challenging in this scene "the slavophile iconography of banjo, grin, and jig" by showing the intense absorption of the family in the expression of the motor skills of its youngest member.[50] At the moment they do not perform on the white man's stage, and they form their own triangular enclosure in this rare glimpse of the private side of black life in the nineteenth century. The sitting banjo player, who plays with concentration and assurance, studiously eyes the efforts of the child, while an older man, standing and leaning on a chair, keeps time to the music by tapping his foot. A top hat and a cane on the seat of the chair suggest preparation for the stage, but for the present this family is "oblivious to the vaudeville public." The scene reminds us that entertainment was one of the few avenues of expression open to black people, although they were systematically excluded—both as spectator and as participant—from the main public showcases of talent that were the traditional training ground for white performers.

Mount's image of African-Americans derived from the perspective of a conservative Northerner; in Richard Caton Woodville (whose work we discussed briefly in Chapter 2), we find the standpoint of a well-to-do Southerner born in the slaveholding state of Maryland. There are similarities, but the differences are crucial, as is exemplified in the artist's *War News from Mexico* of 1848 (Fig. 2–1). Woodville's group of townspeople on the front porch of the local post office have just had their idle chit-chat interrupted by the central figure, who has received the "extra" edition of a California newspaper and now reads the lead article. The surprise he registers and the absorption of the others strongly suggests that the headlines recount the treaty that terminated the Mexican War, which was signed at Guadalupe Hidalgo on 2 February 1848. The treaty was opposed in America both by those who wanted more territory from Mexico than the treaty secured and those who wanted no territory at all. The variety of expressions on the faces of those who read and hear the news suggests diverse opinions on the terms of the treaty.

The overwhelming victory of the Americans culminated with their acquisition of the entire Southwest, including the extension of Texas, California, and all the territory between them. American nationalist and jingoist aspirations—which pacified Southern sectionalists but sharply divided Northerners—now saw the United States becoming a transcontinental republic and a power in two oceans. All

this, of course, was at the expense of a Mexico now reduced to one-half its original size. Woodville's hint at rampant patriotism is seen in the image of the U.S. eagle and shield on the sign reading "American Hotel" that is affixed to the pediment of the Greek Revival portico.

As in the case of Mount, Woodville's African-American characters—in this case an adult male and a young girl—are not integrated with the main group enclosed within the geometric arrangement but are located outside the frame of the portico and below. It is as if there were a sign on the American Hotel that read "No Blacks Allowed." In this context, moreover, the presence of the Greek Revival architecture—the style of the plantation manor as well—reeks with ironic allusion to exclusionary Athenian "democracy." In addition to this visual and social exclusion, blacks are contrasted intellectually and materially with the whites on the porch: the latter respond with immediate comprehension at the announcement, whereas the former turn slowly and their bodies remain hunched over in immobility, the face of the seated man showing apathy and miscomprehension. The townspeople are further distinguished by their fashionable clothes, unlike the blacks, who wear tatters and rumpled castoffs. They are more brutalized than the figures in Mount's pictures and barely relate to the main composition. While in the Mount blacks relate thematically and compositionally to the main action, in the Woodville they are visual as well as social adjuncts. They are literally there to add "local color," despite the fact that the war news from Mexico deeply affected the slave issue and therefore exacerbated the sectional crisis of North and South. But the newspaper reveals new information only for the literate white men at the top of the pyramid.

In the aftermath of the Civil War, Northern artists reflected the change in attitude toward the capacity of the black to integrate into a white world. Now there was a need to educate and employ the recently emancipated, rootless people. Often the freed slaves were sent away empty-handed, without money, and without friends to contact. To cope with this situation, Congress set up the Freedmen's Bureau under the Army in March 1865. It built or aided in the creation of the first widespread free public school system in the South, the most important accomplishment of Reconstruction. Only one black person in ten among the newly freed could read and write, but they were eager to make every sacrifice for an education. There was literally a crash program to train the ex-slaves and their children. Little of this was altruistic; most whites felt antipathy toward black and white equality and experienced forebodings that blacks would emerge from slavery with benumbed moral faculties and vengeful attitudes. The diehards in the South opposed all education for blacks, whereas the

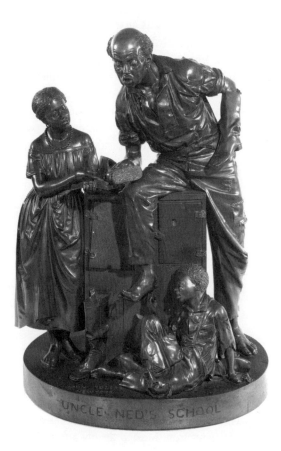

Fig. 4–13. John Rogers,
Uncle Ned's School, 1866.
Courtesy of the New-York
Historical Society, New
York City.

moderates perceived it as a way of socializing blacks and keeping
them from roaming Southern roads in a period of desolation and
starvation.[51]

Blacks themselves seized the initiative in bringing schools to
their children, thus forcing both moderates and conservatives to ac-
knowledge the African-American community's desire to improve their
status. Although white historians of American (especially Southern)
education have duly recorded the efforts of Northern white school-
teachers in the new curricula of the postbellum South, in actual fact
the former slaves played the major role in financing, building, and
running the new schools. Representatives of the Freedmen's Bureau
affirmed the number of schools operated by African-Americans,
whose pupils ranged from kindergarten age to senior citizens. Often
these were no more than improvised classrooms in cellars, old sheds,
or abandoned schoolhouses, but many were brand-new structures
raised through the labors of the ex-slaves.[52]

Several images by Northern artists in the postwar era show
young black children and adults together learning to read. One of

the most popular was John Rogers's bronze and plaster casts of
Uncle Ned's School dated 1866 (Fig. 4–13).[53] Uncle Ned (the title is
ironic) is actually a bootblack, momentarily pausing in his labors to
take reading lessons from a young black girl. A Farmville, Virginia,
teacher noticed black shoemakers who took advantage of their em-
ployer's absence to "indulge in stolen readings."[54] The man's fur-
rowed brow and puckered lips show him struggling with the pro-
nunciation of the text. Meanwhile, a young boy seated on the floor
beneath Uncle Ned has cast aside his book and is tickling the bot-
tom of Ned's right foot and interrupting his concentration. The
comic element here submerges the more serious theme of the quest
for learning, and viewers could be consoled by the implication that
the education process would take such a long time that it would not
immediately threaten the institutional control of blacks.

Although during the war Rogers wholeheartedly supported the
Northern cause, afterward he advocated a conciliatory policy toward
the South in opposition to the Radical Republicans.[55] No doubt this
reflected his increasing popularity in the South, where his group
Taking the Oath enjoyed almost as much popularity as in the North.
Modeled in 1865, it portrayed an incident that actually occurred, in
which a proud, aristocratic Southern woman desultorily takes an
oath to uphold the Union in exchange for rations from the occupy-
ing Union armies. Rogers's position on Reconstruction was tamer
than had been his position on slavery, as is evident in his two
groups of the period 1865–66.

But compared to "moderate" Southerners, Rogers must have ap-
peared as a progressive. For example, Joel Chandler Harris, whose
Uncle Remus stories were widely acclaimed as friendly to Southern
blacks and as the most authentic expression of the New South, put
these words into the mouth of his eponymous hero:

> Hit's [education is] de ruinashun er dis country. . . . Put a spellin'-
> book in a nigger's han's, en right den en dar' you loozes a plow-hand.
> . . . What's a nigger gwineter 'larn outen books? I kin take a bar'l stave
> an' fling mo' sense inter a nigger in one minnit dan all de schoolhouses
> betwixt dis en de State er Midgigin.[56]

The enthusiastic reception of the *Uncle Remus* attitude up North
suggested that moderates on both sides of the Mason-Dixon Line
took a similar position on the question of education for blacks. W.
E. B. Du Bois expressed surprise at the hostility of some Northerners
to the education of blacks, especially those in the Freedmen's Aid
Societies. While they were willing to provide food and clothing to
prevent suffering and starvation, they would not cooperate in any
movement looking to the education of blacks.[57]

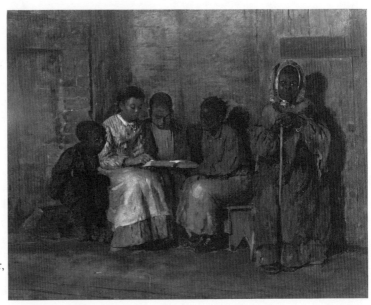

Fig. 4–14. Winslow Homer, *Sunday Morning in Virginia*, 1877.

More insightful and accurate is Winslow Homer's *Sunday Morning in Virginia*, in which children are being taught to read the Bible by a young black woman in the quiet niche of a ramshackle cabin (Fig. 4–14).[58] The crude fireplace and the plank door underscore the hostility of Virginians to the education of its citizens, black and white, and the ingenuity of the former slaves in overcoming this obstacle. The first schools built under the public school system opened as late as 1870. As one author on the subject described the situation generally in the South:

> The per-capita expenditure for public education remained pitifully low throughout the period 1875–1900 and provided only the most meagre elementary educational facilities. . . . The schoolhouses were often log or dilapidated buildings without windows, desks, tables, maps, charts, or blackboards.[59]

Schools were left to themselves, receiving no attention from school or county officials. In Virginia, teachers and pupils in black schools were abused and threatened, and schoolhouses often burned to the ground. Despite this hostile climate for education, blacks in Virginia opened the largest number of day and evening schools in the South (192) and demonstrated an enthusiasm for learning that stunned white observers.

In Homer's painting, which takes place in Virginia, the teacher makes do with her limited facilities: she and her pupil are profoundly absorbed in their lesson, while two others, eyeing each

other with curiosity, presumably wait their turn. Nearby, an old "mammy" peers off wistfully, both perplexed and discomfited by the lesson. Many young black female teachers from the North came south to teach. Their classes included both young and old: one agent of the Freedmen's Bureau described a scene he witnessed in North Carolina in 1866: "A child six years old, her mother, grandmother and great-grandmother, the latter over 75 years of age . . . commenced their alphabet together and each one can read the Bible fluently."[60] Already by 1867 every county in the South had at least one school for blacks, attended simultaneously by both old and young. Popular imagery of the period captured the flavor of these "extension" schools where all ages were thrown together (Figs. 4–15 and 4–16).[61] Homer's painting presents a more "private" kind of lesson, where the volunteer teacher is making the rounds. Sunday schools of every type were formed by African-Americans soon after emancipation, but the principal book studied in the Sunday school was the spelling book.[62] Here Homer's figures work to overcome handicaps, facing the future more optimistically than the lonely hero of his later *Gulf Stream*.

EASTMAN JOHNSON

The gradual transformation of the public image of black people as a result of the Civil War may be traced in the work of the New England painter Eastman Johnson (1824–1906).[63] Johnson is especially interesting as a case study because his career shows several parallels with Oller's. Although nine years older than the Puerto Rican artist, Johnson similarly followed the progress of abolition in his own country. Like Oller, he descended from the solid middle class (his father was a lawyer and worked in state government) and he studied with Couture—just three years before Oller entered the studio. Both painters worked in landscape and genre and painted a number of images of black people.

Henry T. Tuckerman, writing just after the Civil War, put Johnson's particular contribution into perspective:

> No one of our painters has more truly caught and perfectly delineated the American rustic and negro, or with such pathetic and natural emphasis put upon canvas bits of household or childish life, or given such bright and real glimpses of primitive human nature.[64]

Clearly identifying blacks, children, and rustics in the same category, Tuckerman saw reflected in Johnson's imagery his own Northern elitist outlook. While naturally assuming himself to be most enlightened

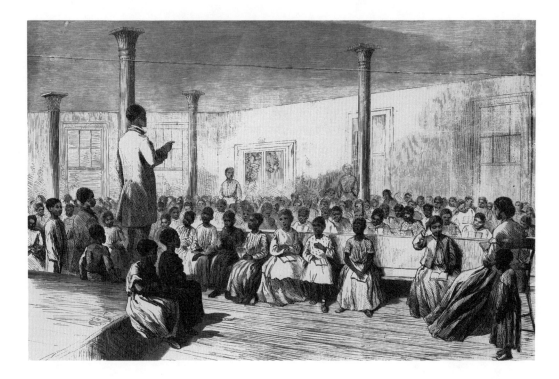

Fig. 4–15. *"Zion" School for Colored Children, Charleston, South Carolina, 1866.*

in these matters, Tuckerman's "liberalism" takes the form of a sympathy for social groups unable to fend for themselves—a paternalistic position. As he writes later:

> In his delineation of the negro, Eastman Johnson has achieved a peculiar fame. One may find in his best pictures of this class a better insight into the normal character of that unfortunate race than ethnological discussion often yields. The affection, the humor, the patience and serenity which redeem from brutality and ferocity the civilized though subjugated African, are made to appear in the creations of this artist with singular authenticity.

Now that blacks have been emancipated their ability to maintain the race is questioned, and Tuckerman sees the need to record them as if they faced imminent extinction:

> It is characteristic of American civilization to be perpetually in a transition state; and as Audubon has depicted and described species of birds that have since disappeared from this continent, so the novelist, historian, and artist do no inadequate service when they conserve the aspect and traits of life and manners soon to become things of tradition. And in view of the subject, we cannot but hope that Eastman Johnson will do for the aborigines what he has partially but effectually done for the negroes.[65]

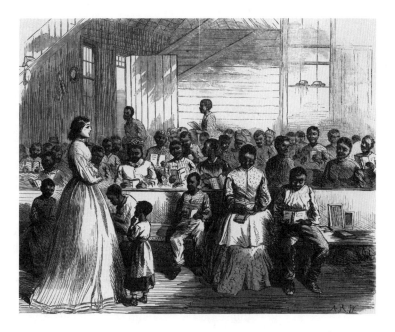

Fig. 4–16. *Primary School for Freedmen, in Charge of Mrs. Green, at Vicksburg, Mississippi, 1866.*

Blacks, for Tuckerman, like birds and Native Americans, are a species apart and should be treated like vanishing breeds, the stuff of anthropological folklore and nostalgic album books.

So much for the reception of Johnson's work by a Northern writer who supported the Union cause. Tuckerman's view of the painter, however, seems to have been determined by Johnson's pre–Civil War picture—his first major effort to depict black people—*Negro Life at the South*, later dubbed *Old Kentucky Home* after the nostalgic song by Stephen Foster that reeks of antebellum sentiment (Fig. 4–17). Tuckerman thought it as "valuable as a memorial as it is interesting as an art study." Exhibited at the National Academy of Design in 1859, it enjoyed enormous popularity and secured for the painter membership in that institution.

Negro Life at the South depicts plantation slaves in a leisurely moment—actually the servants of Johnson's own father shown in the backyard of the family house in Washington, D.C. Although the family originally came from Maine, Johnson's father had moved there in 1846 when he was appointed chief clerk in the bureau of construction of the Navy Department. The family seems to have slipped easily into the Southern lifestyle. Indeed, Johnson's painting appears to make a bid for the easy, benign view of slave existence promulgated by Southern apologists who assured the North that all the old abuses had by then been eliminated from the system.

In the center of the picture an elderly slave plays the banjo, and a kneeling mother encourages her young son to dance. At the

left, a male youth flirts with a young woman, while at the far right the well-dressed white daughters of the master's house sneak through the fence to join in the festivities. The ramshackle setting is dramatized by the deteriorating wooden overhang, whose rotten beams seem on the verge of collapse. Missing chunks of plaster, loose clapboards, and broken windows complete the picture of miserable living conditions. Thus the scene suggests not only that slaves remain cheerful and merry in impoverished surroundings, but that they actually have more fun than white people. The work comes close to the notion of many Southerners that the Negro can find happiness and fulfillment only when in the service of a white master. As William A. Smith, whose *Lectures on the Philosophy and Practice of Slavery* of 1856 enjoyed a wide reading in the South, put it: Negro slaves are "the most cheerful and merry people we have among us."[66]

Even in the North, however, the response to Johnson's work was predicated on a similar set of conclusions. The critic for the *Crayon* analyzed the painting as an example of the ability of "Art" to transform the ugly into something worthy of enjoyment:

> One of the best pictures in respect to Art and the most popular, because presenting familiar aspects of life, is E. Johnson's "Negro Life at the South." Here are several groups of negroes, who are assembled in the rear of a dilapidated house. . . . Although a very humble subject, this picture is a very instructive one in relation to Art. It is conscientiously studied and painted, and full of ideas. Notwithstanding the general ugliness of the forms and objects, we recognize that its sentiment is one of beauty, for imitation and expression are vitalized by conveying to our mind the enjoyment of human beings in new and vivid aspects.[67]

In short, for this reviewer the encoding of the ugly in aesthetic form is analogous to the actual circumstances of poor blacks who do not allow their degradation and impoverishment to interfere with their happiness. By thus disguising the ugliness in conventional aesthetic trappings, the spectator in turn may derive delight from their circumstances.

Another critic, quoted by Tuckerman, received the same message from the picture but also recognized it as a form of propaganda for the South. Yet by its inadvertent presentation of the environment of slavery, *Negro Life at the South* also projected the institution's demise:

> How fitly do the dilapidated and decaying negro quarters typify the approaching destruction of the "system" that they serve to illustrate! And, in the picture before us we have an illustration also of the "rose-water" side of the institution. Here all is fun and freedom. We behold the very reality that the enthusiastic devotees of slavery have so often

painted with high-sounding words. And yet this dilapidation, un-
heeded and unchecked, tells us that the end is near.[68]

In promulgating the stereotype of the happy and contented bonds-
man, Southerners were doing more than simply putting out propa-
ganda to counter the abolitionist image of the wretched slave. As
mentioned earlier, they were also seeking to put to rest their own
nagging fears of slave rebellion. In moments of candor, Southerners
admitted their suspicion that duplicity, opportunism, and potential
rebelliousness lurked behind the mask of Negro affability. This dual-
ism of contentment and duplicity runs through the writings of anti-
slavery proponents as well. William Ellery Channing, a leading Uni-
tarian minister in New England, noted the cliché of the happy slave
and its use to repudiate arguments for the rights of slaves. But the
slave's cheerful disposition is the result of a degraded existence and
is one beat away from bitterness:

> It is not possible to contemplate the occasional gayety of the slave
> without some mixture of painful thought. He is gay, because he has not
> learned to think; because he is too fallen to feel his wrongs; because he
> wants just self-respect. We are grieved by the gayety of the insane.
> There is a sadness in the gayety of him whose lightness of heart would
> be turned to bitterness and indignation, were one ray of light to
> awaken in him the spirit of a man.[69]

Channing, however, accepts that even in the "darkest abode" there
is a possibility of "a cheering beam." Thus the slaves' hut

> occasionally rings with thoughtless mirth. . . . God is no respecter of
> persons; and in some slaves there is a happy nature which no condi-
> tion can destroy, just as among children we find some whom the worst
> education cannot spoil. The African is so affectionate, imitative, and
> docile, that in favorable circumstances he catches much that is good,
> and accordingly the influence of a wise and kind master will be seen in
> the very countenance and bearing of his slaves.

Here we see that even the moderate antislavery writer exemplifies the
use of the stereotype formulated by proslavery advocates. Johnson's
Negro Life at the South was certainly informed by Channing's writ-
ings, which were well known in Johnson's New England circles.

That the work stood so close to the cutting edge between pro-
and antislavery views explained its immense popularity among the
privileged elite. There seemed to be something for everyone in the
picture: Southerners and their partisans claimed to see a confirma-
tion of what they had been saying all along about slave conditions,
whereas abolitionists perceived in the crumbling and decaying archi-
tecture a sign of the "impending crisis" spelled out by Hinton Helper

in a popular book first published two years before Johnson painted
his picture.[70] A Southerner, Helper cited statistics to demonstrate
that the South lagged far behind the North in industrial and agricul-
tural growth. He blamed this condition on "slavocracy" and warned
that the South was headed for "utter ruin" unless it immediately
abolished slavery.[71] But considering the moment when Johnson
painted the picture, it does indeed come off as an apology for slav-
ery, especially when compared with Harriet Beecher Stowe's *Uncle
Tom's Cabin*.

Like *Negro Life at the South*, this work had an astonishing suc-
cess in the 1850s. The immensely popular novel did more than any
other published work to crystallize antislavery feeling in the North
in the 1850s. *Uncle Tom's Cabin* began to appear serially in a moder-
ate antislavery journal, the *National Era*. Of course, Stowe begins
with the assumption that blacks were "confessedly more simple, doc-
ile, childlike and affectionate, than other races." Not fortuitously,
her second antislavery novel, *Dred*, published in 1856, deals with a
different kind of African-American, a rebel modeled after Nat Turner.
It exemplified her basic revulsion to the idea of black retaliation
against the whites. To Stowe a black rebel was clearly a warped and
deviant personality.

Her ideal or "normal" black was Uncle Tom, and the novel no
doubt inspired Johnson's work. The story unfolds in Kentucky (a lo-
cation later added to the title of the painting), and two of Stowe's
central characters have some white ancestry that allows the author to
define them in terms of nineteenth-century heroic ideals. The mulatto
George Harris, for example, "inherited a set of fine European fea-
tures and a high, indomitable spirit."[72] Indeed all the mulatto
characters—George, his wife Eliza, and Simon Legree's female
victims—refuse to adhere to the stoic philosophy of Uncle Tom and
actively resist their state. The flirting light-skinned pair at the left of
Johnson's picture may have been suggested by Stowe's George and
Eliza Harris. Uncle Tom is himself discussed in such saintly terms
that he seems unreal amid the brutalities and the crimes; the same is
true of the sympathetic Southern whites. In the end, the unreality of
these characters gives a fantastic aspect to the novel and explains
why in 1853 Stowe felt obligated to publish a "key" to it document-
ing the horrors described therein. It seemed that Johnson, a kind of
inveterate compromiser, tried to give a more "balanced" account of
the system from his own perspective, pretending to straightforward
documentary and removing the abhorrent elements of slavery by de-
picting slaves on their day off.

Johnson modeled his backdrop after the typical slave quarters
of house servants attached to the "Great House" or "Big House."
Known as "the Kitchen," house servants lodged and prepared meals

*old kent
Home*

there for those in the mansion. The house servants inevitably fared better than field slaves, and Johnson's quest for ideological "balance" predisposed him to focus on that portion of the slave population that enjoyed the most material advantages. Children of house servants played with the white children, sharing each other's joys and problems, neither group yet fully aware of their class and social differences. But it was a tragic moment—barely hinted at in Johnson's picture—in the life of a young slave when she or he realized that their white comrades "were of a superior," and they "of a subject, race."[73]

Perhaps the literary work that had the most influence on Johnson's conception is Frederick Law Olmsted's *A Journey in the Seaboard Slave States*, published in 1856 and starkly revealing of the sympathies and prejudices of a wealthy Northerner.[74] Olmsted, who was later renowned for planning and constructing major urban recreation areas, claims here that his journey was based on his desire to personally witness for himself "the causes and extenuating circumstances . . . of those phenomena which are commonly reported to the prejudice of the slave-holding community."[75] Olmsted actually started out from Washington, D.C., the original site of Johnson's picture. He notes that right in the heart of the capital a slave could be flogged. As he moves to Richmond, Virginia, he observes a good many "substantial old plantation mansions, most of them constructed of wood, of two stories, painted white, and have, perhaps, a dozen rude-looking little log-cabins scattered around them with fireplaces in the center, for the slaves."[76] He writes that porches and galleries in front of the plantations are "almost always in sad need of repairs," and he is struck by the "co-habitation and association of black and white"—children playing together, for instance—that would probably have been frowned upon in the North.[77] Later, he lauds the good-natured and "jocose" temperament of the slaves, and how their musical gifts offered them moments of respite from drudgery.[78]

Olmsted's "innocent eye" viewed the situation through the prejudiced lenses of his social group. He rarely interviews blacks about their own conditions, relying for the most part on the testimony of the white planters. His few conversations with blacks are patronizing and lack candor; he avoids direct questions in deference to what he reads as their level of comprehension. On one occasion, Olmsted's remarks on the "cruel savages" of Africa led his black interviewee to inquire whether slaves in America were better off than in Africa; taken by surprise, Olmsted replied in the affirmative, pointing to "the heathenish barbarism of the people of Africa."[79]

Olmsted winds up his journey agreeing with the abolitionists about the effects of slavery on individuals but evaluates it primarily on the basis of material benefits. It develops that his real motivation

in writing the book has more to do with his fears of an urban prole-
tariat and growing trade unionism. He uses his observations on slav-
ery to show that the industrial laborer, the wage-slave, is far better
off than the plantation slave no matter how miserable the working
conditions of the former. He addresses his concluding remarks on
the one hand to those who commend the advantages of slavery over
wage-labor, and on the other to those who decry the capitalist sys-
tem for its inequities. Olmsted employs statistics to demonstrate that
workers are ordinarily better fed and clothed than slaves, a fact also
evident from laborers' demands and expectations even "when they
are deemed to be suffering."[80] At the same time, he sees genuine
hardship on the part of the working class as mainly "a consequence
and a punishment of their own carelessness and improvidence." Fi-
nally, Olmsted asserts that the "competitive system . . . is far prefera-
ble to the slave system."[81] His reasoning is clear and addressed to the
laboring classes in general: Stop complaining, avoid socialist views,
and thank the owners of production for not being down South.

Johnson belonged to the same privileged class as Olmsted. He
became the favorite painter and portraitist of the self-made men in
America—presidents, financiers, industrialists, merchants, and
wealthy professionals. Like Olmsted, Johnson bent over backwards
in the pre–Civil War phase to give the Southern slave owners the
benefit of the doubt. On the eve of the Civil War, Johnson still per-
ceives slaves as part of the general laboring class and takes the side
of the employer. It may be noted that major Northern textile interests
maintained strong ties with Southern cotton planters and tended to
vote with the party of slavery. Johnson's New England ties may have
disposed him to ingratiate this faction as well. His later studies of
country life in the North depict field workers delighting in their
labor. They show village people "hoofing it off" in the same way ear-
lier artists showed slaves enjoying a musical interlude. The "happy
worker" now supersedes the "cheerful slave." Johnson therefore sus-
tained the philosophy of paternalism that dominated the thought of
the privileged classes on both sides of the Mason-Dixon Line.

While shifting his interest to cranberry pickers as symbols of
joy-through-work, events made him more responsive to the condi-
tions of black people. Eight months after the exhibition of *Negro Life
at the South*, John Brown was hanged for his raid on the arsenal at
Harper's Ferry. Now the overwhelming issue was the saving of the
Union, and those in the North who relied on Southern products
quickly discerned which side had the best chances of winning. The
textile industrialists and the merchants of the North now made
money from government contracts, and emancipation could be seen
in wholly different terms. The enlightened Northern elite needed
blacks to serve in the army and also anticipated former slaves swell-

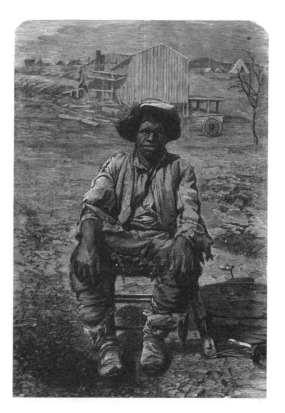

Fig. 4–18. *The Escaped Slave*, 1864.

ing the ranks of the wage workers. This transformation is seen in the many "before-and-after" pictures of ex-slaves, first as a worn-out plantation worker and then as a dynamic, uniformed member of Uncle Sam's army (Figs. 4–18 and 4–19).[82] Now the North needed a justification for their economic, military, and political aggressiveness, and they made the slave issue the basis of the sectional conflict. Black people were suddenly regarded in a different light—as the same as Caucasians, whose own progress depended on release from serfdom and feudal oppression. By the time of the Emancipation Proclamation the North, desperate for recruits, encouraged young black males to make their way north and join the Union Army.[83] Naturally, the image of the black in both art and literature now assumed a different visual emphasis in response to the social transformation.

Johnson's *A Ride for Liberty: The Fugitive Slaves* (ca. 1862–63), showing a black family escaping across the border on horseback, conveys an impression totally at variance with *Negro Life at the South* and other American examples (Fig. 4–20). The painter now represents black people as being energetic and forceful and, above all, as determining their own fate. The theme of the runaway slave was a popular one in this period, contradicting the Southern propaganda

Fig. 4–19. *The Escaped
Slave in the Union Army*,
1864.

that slaves were satisfied with their lot and attached to their masters.
An illustration in *Harper's Weekly* of 7 May 1864 shows several ex-
amples of escaping slave couples mounted on a single horse (Fig.
4–21).[84] The Preliminary Emancipation Proclamation, issued 22 Sep-
tember 1862, promised that, on the first day of the new year, the
United States government would "recognize and maintain the free-
dom" of people held in bondage by rebels and would "do no acts or
act to repress such persons, or any of them, in any efforts they may
make for their actual freedom."

The encouragement of runaways and, later, of freed slaves, to
go north is also reflected in Johnson's *Fiddling His Way* of 1866
(Fig. 4–22). The painter shows a young black man earning his way
door-to-door by his wit and talent. He is no longer a servant or a
local court jester, but an enterprising youth bent on entering the
Northern work force. The stereotypical grin is gone, and he is the
narrative focus as the family gathers around him to enjoy his music.
They do so with a serious air, with the children rapt in attention or
the elders momentarily halting their activity to listen. The black is
now not only an integral member of this little society but capable of
inspiring its members with warm sentiments.

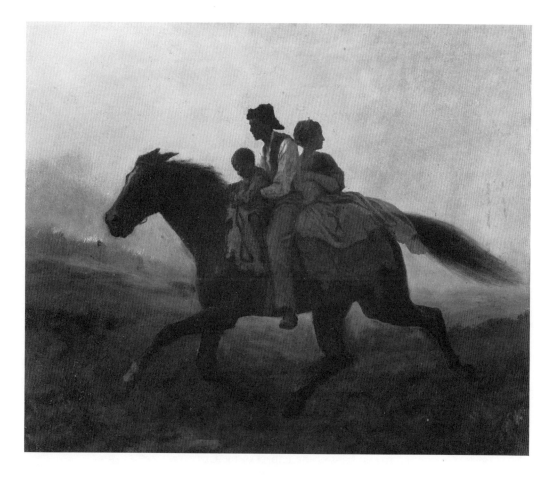

Fig. 4–20. Eastman Johnson, *A Ride for Liberty: The Fugitive Slaves*, ca. 1862–63. The Brooklyn Museum. Gift of Gwendolyn O. L. Conkling.

Johnson's *The Chimney Corner*, done in 1863, returns us to the theme of the educability of black people: here in the shelter of the warm hearth a black man concentrates on his reading (Fig. 4–23). This isolation and quiet recall the settings of older images of philosophers now transposed to a humble log cabin. The figure's dull expression, awkward way of grasping the book, and uncomfortable-looking position suggest some difficulty with the reading but at the same time project an intense commitment on his part to meeting the obstacles in the way of his education. We may compare this work with Johnson's *Boyhood of Lincoln*, which similarly shows a youth reading a book by the fireplace (Fig. 4–24). He is alert and holds the book nimbly, as if ready to turn the page at an instant. Unlike *The Chimney Corner*, where the head lies in shadow, this work uses the light of the fire to illuminate the head of young Lincoln. Thus Johnson makes the act of reading an enlightening experience through the literal manipulation of the light. The fire of the hearth not only illuminates the page but enkindles Lincoln's youthful imagi-

Fig. 4–21. Anonymous, *Negroes Escaping Out of Slavery*, 1864.

nation. Despite these differences, however, *The Chimney Corner* does trace Johnson's progressive reinterpretation of black people's social role in light of the impact of the Civil War.

Johnson's evolution in the depiction of black people was stimulated by the Civil War, as was Oller's. It may be recalled that the American Civil War was a decisive factor in Puerto Rico's drive toward emancipation. Except for Portugal, Spain now found itself isolated as a slaveholding nation, and abolitionists in Cuba and Puerto Rico warned of the need for the home country to make concessions in this regard. Even conservatives in these colonies recognized the need for some amelioration of slave conditions to ward off a potential American invasion and to preserve the basic colonial relationship.[85] Puerto Rican abolitionists proclaimed that slavery could not exist after the collapse of the South's rebellion and warned of possible United States intervention in the event of an insurrection in the colonies.

The great Puerto Rican abolitionist, Julio L. de Vizcarrondo Coronado, founded the Sociedad Abolicionista Española in 1864 and became secretary of the organization.[86] Puerto Rican reformists elected to the Spanish Cortes (parliament) joined this society and pressed for immediate abolition in the colonies. That Lincoln was a

Fig. 4–22. Eastman Johnson, *Fiddling His Way*, 1866. Chrysler Museum, Norfolk.

model for these reformists is seen in the address delivered by prominent abolitionist José Julián de Acosta y Calbo before the Sociedad Abolicionista in 1872, in which he paraphrases "the great abolitionist": "Este país no puede vivir mitad esclavo y mitad libre: *tiene que ser o todo esclavo o todo libre*. ("I believe this government cannot endure permanently half-slave and half-free: It will become all one thing or all the other.")[87]

On 29 November 1865, a decree calling delegates to Madrid from Puerto Rico and Cuba to report to the government on the special reforms promised the islands in 1837 was submitted to Queen Isabel II for her signature. Public hearings opened on 30 October 1866, with Puerto Rico represented by four delegates including Acosta, Ruiz Belvis, and Quiñones, all from the Committee of Information (Junta de Informacción). Claiming that the abolition of slavery must furnish the basis for insular reform, they issued a written statement rejecting the whole procedure because the crown accepted as given the existence of slavery. They refused to participate in such a mockery, adding that they wanted the immediate abolition of slavery in Puerto Rico, with or without indemnity. The public hearings were closed, and the delegates returned home in 1867.[88]

But their economic and humanitarian arguments had a significant effect, and on 23 December 1872 the Spanish overseas minister

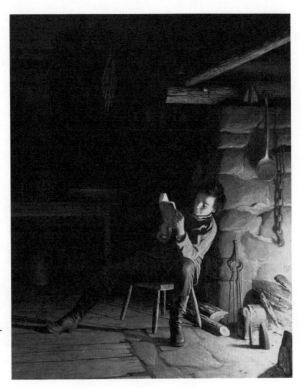

Fig. 4–24. Eastman Johnson, *Boyhood of Lincoln*, 1868. Oil on canvas. 46 x 37 in. Signed and dated, l.l.: E. Johnson. 1868. The University of Michigan Museum of Art, bequest of Henry C. Lewis. Acc. No. 1895.90.

authorized a bill abolishing black slavery in Puerto Rico. On 22 March 1873, the abolition of slavery in the island was approved by the indigenous abolitionist movement supported by liberal elements in Spain. Now came the task of rehabilitation and absorption of the freed slaves into the larger Puerto Rican society.

OLLER'S *EL VELORIO* AND THE QUESTION OF SPIRITUAL GRACE

Oller's masterpiece, *El Velorio* (The Wake), addresses itself to this question (Fig. 4–25). It does so by calling attention to the black man's capacity for spiritual renewal.[89] We may recall that Oller's earliest image in his series was *The Flogged Negro*, pointing to the inhumane and unjust nature of the slave system. As elsewhere, Puerto Rican abolitionists first called attention to the cruelties of slavery, dealing less with the personality and the individuality of black people than with their mistreatment. Oller's *Rafael Cordero* takes up the issue of competency of black people, and *El Velorio* brings us to the third and final theme stressed by the abolitionists, the capacity of black people for religious salvation. This theme was central to abolitionist literature from the start but reaches its peak just prior to the

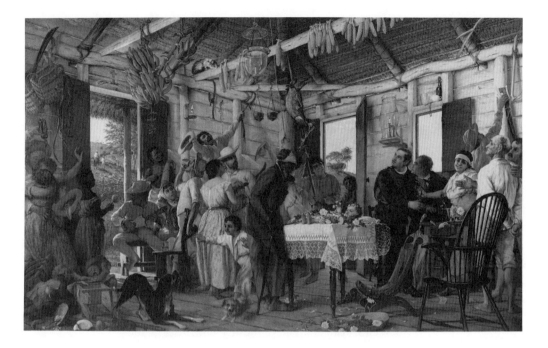

Fig. 4–25. Francisco Oller y Cestero, *El Velorio (The Wake)*, 1893.

Civil War. For example, Alexander Kinmont saw in black servitude a religious advantage over white mastery, since willingness to serve is preferable to desire for dominion. Hence blacks, not whites, would be the first to receive millennial perfection.[90]

The question of black mental capacity was intimately connected to the question of spiritual grace; indeed, the issue of black people's mental ability arose historically out of reservations about their ability to undergo conversion. So long as people thought of themselves primarily as spiritual creatures, any discussion of an innately inferior intelligence would have sounded absurd. Later, however, under the steadily growing influence of scientific thinking, the separation of mental from spiritual abilities became a commonplace assumption.

Early objections to black subordination derived not from ideas about earthly qualities but from the concept of equality before God. Central to religious egalitarianism was the idea that blacks were ultimately the equals of whites because they possessed immortal souls, and although skin color showed otherwise, "black" souls were "white." The first antislavery stirrings sprang from the application of the religious idea to social practice, an application made possible by the gradual weakening of old ideas about inherent and inevitable social hierarchy. It is a striking fact that early antislavery agitation developed among the Society of Friends, which itself evolved out of the social and religious turmoil of the English Civil War in the late seventeenth century.[91]

Almost by definition, new religious movements, revivalism, and evangelical fervor were inclusive: new organizations and individual itinerant or self-appointed preachers used every tactic possible to gather lost sheep, black as well as white, to build up a congregation. The revivals especially tended to break down traditional racial, social, and class barriers by emphasizing the universal priesthood of true believers. Religious enthusiasm was elevated over religious sophistication as the basis of authentic piety, thus opening the way for the untaught to participate. Out of this tradition—primarily Baptist and Methodist—developed the opportunity for black preachers to assume primary leadership responsibilities in their community.

The black as a natural Christian received its fullest treatment and its most influential expression in Harriet Beecher Stowe's *Uncle Tom's Cabin*. The long-suffering Tom, in his attempt to convert the educated, sophisticated, and jaded Augustine St. Clare, got this response from the master: "Thou has hid from the wise and prudent, and revealed unto babes." This idea of the black man as martyr is also elaborated upon in the final passage of a pamphlet written by several Cuban and Puerto Rican abolitionists in 1865:

> The modern world will not abandon the noble work which the Savior committed to the future generations from the Cross. It will prove that the noble Martyr of Love, Justice and Liberty did not shed his blood in vain on the Golgotha.[92]

Thus the fall of slavery emanates from martyrdom, the capacity for self-sacrifice and self-abasement that humbles the mighty and shames the proud tyrant.

The role of the Church in the colonies was ambiguous: while it had to uphold principles of equality, humanitarianism, and paternalism, it found itself in a weak position against the royal administration and the local groups of planters and merchants. Its moral position was at a nadir in the nineteenth century; anticlericalism in Spain and throughout Europe hardly helped the local priests, who often had a reputation for "unclerical" behavior, corruption, and indifference. The appeal of the abolitionists in the name of religion was not channeled through the Church but pitched to an evangelical sensibility consistent with the position of the abolitionists in England and North America.

Significantly, popular illustrations of the nineteenth century depicting black experience seized on the subject of evangelical church meetings as an example of the quaint mixture of Christianity and lingering "primitivism." Most high art examples of black spiritual participation focused on funeral rites, as in the case of George Fuller's *Negro Funeral* of 1881.[93] The unusual long-distance viewpoint, twi-

light gloom, cloud-swept sky, and stark, barren landscape add a su-
pernatural mood to this scene of mourning. Fuller locates the
preacher declaiming with upraised arms in the center of the group,
where he is echoed by those responding to his charisma.

Oller's contribution belongs to this category of subject matter
but consciously attacks the lingering syncretism as an outmoded relic
of the new Puerto Rican society. *El Velorio* actually indicts the nega-
tive role of the Catholic Church in this and other issues touching on
black emancipation. Oller testifies to this in his own description of
the work:

> Extraordinary criticism of a custom that still exists in Puerto Rico among
> country people and which has been propagated by the priests. On this
> day the family and friends have kept vigil all night over the dead child,
> extended on a table with flowers and laces. The mother is holding back
> her grief, on her head she wears a white bandana; she does not weep
> for fear her tears might wet the wings of this little angel on his flight to
> heaven. She laughs and offers a drink to the priest, who with eager
> eyes gazes up at the roast pig whose entry is awaited with enthusiasm.
> Inside this room of indigenous architecture, children play, dogs romp,
> lovers embrace and musicians get drunk. This is an orgy of brutish ap-
> petites under the guise of a gross superstition.[94]

The custom of celebrating the wake was known in the Caribbean
area by the names *baquiné, baquiní,* or *florón*. The first two terms
were of African origin, and it is certain that the custom was prac-
ticed by black slaves. Although the wake (as in *Finnegan's Wake*)
had precedents in Catholic Europe, in Puerto Rico its peculiar char-
acter presented itself as a synthesis of African and Catholic rites.[95] In
the passage above, "country people" (*campesinos*) refers to a marriage
of two cultures brought about by the actual intermarriage of run-
away and freed slaves with the rural segment of the island's popula-
tion. From the time of the introduction of African slavery up to its
abolition in 1873, many runaway slaves found refuge among sympa-
thetic farmers in the sparsely settled mountainous districts and inter-
bred with them there. They became the *jíbaros*, Puerto Rico's native
term for *campesinos*.[96]

Oller's attack on the "gross superstition" reflects his reaction to
the assimilation of black people in the aftermath of emancipation. He
sympathized with the progress of modern science and hoped to erad-
icate what he considered retrogressive ideals. One of these was the
influence of African rites on colonial culture among the underclasses.
Oller's ideal was total assimilation into the dominant class and elimi-
nation of "superstition." Local priests often tolerated these rituals for
personal gain or encouraged conversion by allowing a syncretism of
Catholicism with African folk religions. *El Velorio* is in fact a testa-

ment to Oller's creole sensibility adjusting to the exigencies of abolition and the accompanying social change.

His microcosmic view of Puerto Rican society not only includes stereotypical depictions of music-loving peasants (of all shades) but also reserves a special role for a black field hand, who alone contemplates the dead child with the gravity and compassion commensurate with high religious ideals. Clad in crude but severe clothing, he stands in striking contrast to the orgiastic revelers. Symbolizing restraint and piety, he embodies Oller's explicit criticism of the "barbarous" custom. Rays of light pierce through chinks in the logs, falling over the child and the black man. This hint at the divine presence is also suggested by the uncovered, lit candle on an upright at the left. Oller singles out a black person to point up the genuine religious spirit in the midst of a saticlike ritual.

Oller succeeded in constructing a creole iconography manifesting his social and political position. He derided the priesthood as exploiting the people's credulity for its own gain and ridiculed with equal intensity the superstitious customs of rural areas affected by African ritual. Above all, Oller takes the black man as the symbol of innocence and genuine faith in a corrupt and irreligious world. His black man (wearing an earring—exemplifying his former status as African slave), however, is no obedient follower of Church orthodoxy; his faith is that of the simple believer. In an age when traditional religious and moral values seemed to be losing their hold on the bourgeoisie, many could be consoled by contemplating a people supposedly free of lust for material pleasures and power and therefore immune to desires that led others to exploit and enslave them. In this sense, Oller sees the black man more as a symbol than as a person, more as a vehicle for social criticism than as a human being with the normal range of virtues and vices. Like Uncle Tom, Oller's character is not simply a black but a spokesperson for the evangelical "religion of the heart," which abolitionists recommended as the only path to salvation for those whose cultivation and intellectualism led them to doubt the redeeming power of Christ. The picture comes close to suggesting that salvation for blacks is obtainable only on the next plane of existence, thus making the ex-slave teeter dangerously between Copley's invisible man and Homer's condemned man.[97] Oller, however, an anticlerical bourgeois, attains his ideological solution by locating his metaphorical black man in the center of a familiar setting of Puerto Rican life and advancing the idea of salvation through understanding.

BURGOO AND BOURGEOIS
The Images of a Border-State
Consciousness

Thomas Satterwhite No-
ble's series of pictures
based on slave-related
themes and painted in
the post–Civil War period provides a dramatic case study for the is-
sues we have discussed thus far. They reveal the strengths as well as
the ambivalences of a human being born in a border state in the sec-
ond quarter of the nineteenth century. Noble was born in Lexing-
ton, Kentucky, on 29 May 1835;[1] Lexington at that time was the
center of the state's slave trade. He was twenty-six when the Civil
War broke out, and from his youth he had been exposed to the in-
stitution of slavery and to the abolitionist debate. Kentucky played
an unusual role in the debate because of its divided loyalties; hemp
and tobacco farmers who used the Ohio and Mississippi Rivers to
ship their produce and needed unlimited access to both waterways
and the international port of New Orleans identified their interests
with the North, whereas the large plantation owners and states-
rights advocates sided with the lower South and formed a secession-
ist party. The issue of slavery, however, cut across political and eco-
nomic lines as a binding social force based on criteria of kinship and
social status.[2]

Kentucky still clung to the institution even after the Thirteenth
Amendment (which it refused to ratify) abolished slavery in Decem-
ber 1865. Yet from the inception of statehood some Kentuckians had
opposed slavery as a contradiction to the Declaration of Indepen-
dence. While the opponents of slavery in Kentucky never achieved

its elimination through state action, they kept the issue alive and under discussion until slavery was finally terminated by constitutional amendment. Kentucky, in fact, formed a battleground on which every side of the political spectrum on slavery fought out their case. Significantly, Noble did not begin his series until the period of Reconstruction, when the issues became clearer and much more sharply defined in his thought—as well as safer to treat. Nevertheless, it would seem that Noble, who had to overcome his father's objections to his becoming an artist and repudiating the family business, was a citizen lost to Kentucky because of his loathing of its slave environment.

Thus we need to know something about the influence of Kentucky's environment on Noble's life and art. He was the son of a prosperous hemp rope and cotton bagging (the coarse cloth used for wrapping bales) manufacturer who employed slaves and black wage-labor on his hemp farm. Hemp was one of Kentucky's principal crops in this period, but it required heavy manuring and exhausted the soil, and it is not surprising that hemp farmers either diversified their interests or often got into the business to "make a killing" and move on to other things.[3] Hemp flourished in Lexington for a time, and factories processing it were largely staffed by rented or purchased slaves. The elder Noble subsequently opened a rope and bagging factory in St. Louis, but he continued his contacts with slave traders in Lexington, using their slaves as "hired" hands. While the slave population more or less stabilized itself in Kentucky just prior to the Civil War, the need for slaves declined, and many Kentucky slaveholders hired them out for wages.[4] A letter from Noble's father to the slaveholder John Hunt Morgan in Lexington requests "some Negroe men to hire" for the purpose of spinning hemp, "and who will be under my control, and situated on my property at my place of residence about three miles out from the Court House."[5]

Noble spent much of his time in the cabins of the blacks at his father's rope walk, sitting around their fires and listening to their stories and probably their complaints.[6] He recalls listening to their tales "until night had settled over the cabins and the way back to the house seemed long and dark. Then one of the negroes would say, 'Mars Tom, I'll take you back home, if you'll give me some of the biscuits from the white folks' table'. The price was a small one to pay for the escort along the lonely path, after the ghost stories I had heard down in the cabin." Such reminiscences are commonplace in the autobiographical commentaries of privileged white children growing up in the South in the last century, and they naturally elide the harsh deprivations of the blacks implied in the request for "biscuits." (Noble for example also recalled "enjoying their crude fare"—

but clearly the slaves did not. They ate what they were given, not what they wanted.) Similarly, Noble's representations of black people do not deal with the cruelties of their everyday life but rather project them in epic moments focusing on the dissolution of families. In this he was a child of his time and class, idealizing the poor by universalizing their plight.

Certainly, growing up in Lexington, Noble would have been exposed to the most horrible cases of black persecution. When he was two years old, Caroline A. Turner of Lexington crippled a black child by throwing him out of a second-story window. Her husband, the ex-judge Fielding L. Turner, acknowledged that she had already killed six slaves by giving out severe beatings. When the judge died in 1843 he deliberately left all his slaves to his children, but Mrs. Turner contested the will and secured several of them. In August 1844, while she was whipping a young slave named Richard, he tore loose from his chains and strangled her. Despite her record, Richard was hanged on 19 November—when Noble was nine years old.[7]

The most important antislavery organization in Kentucky during Noble's youth was the Kentucky Colonization Society, established in 1829 as a state auxiliary of the national American Colonization Society for the Free People of Color. Its aim was to facilitate the transfer of free blacks to the African colony of Liberia. While the colonization movement had the support of well-intentioned people, it also had the backing of slaveholders, who saw it as a wedge to place between the abolitionists and slavery reforms. (Kentucky slaveholders vaunted their ability to carry out reforms on their own, pointing to the law of 1833 prohibiting all importation of slaves even for personal use. But it was clear that slaveholders supported this law only because of the threat of the increasing population of blacks relative to the population as a whole.)[8] Henry Clay was active in this movement, mainly out of negative motives: he felt that free blacks were generally corrupt and that their presence threatened the stability of the slavery institution and therefore the social order. He hoped for long-term emancipation, but had no intention of interfering in the short run with the existing system. Only extremists perceived colonization as a disguised abolitionist agency, and a high percentage of free blacks, born in North America, indicated their reluctance to move to Liberia.

The colonization concept, however, appealed to the majority of moderate Kentuckians, and by 1832 the state had at least thirty-one branches, one of the highest numbers in the slave states. These societies repudiated William Lloyd Garrison's call for immediate emancipation, but they condemned slavery as a moral and political evil that had to be phased out gradually. Indeed, the process was so gradual

that during the period 1829–59 the state society sent only 658 emi-
grants to Liberia, a number that barely dented the institution of slav-
ery in Kentucky.

More progressive Kentuckians looked to reformers like James
Birney of Danville, who resigned in disgust from the Colonization
Society, and Cassius Marcellus Clay, who followed the lead of Garri-
son. Clay in some ways anticipated the intellectual development of
Noble: his father was one of the state's wealthiest slaveholders, and
he had to overcome his deeply ingrained socialization process to join
the emancipationists. As a youth he condemned the "horde of fanati-
cal incendiaries in the north" and favored gradual abolition, but by
1840 he became a determined advocate of emancipation. Clay argued
less from a moral and religious standpoint than from an economic
one, using statistics to demonstrate that Kentucky's commercial devel-
opment lagged far behind that of such free-state neighbors as Ohio.
Clay also tried to reach working-class whites by showing that slav-
ery depressed the economy and held down wages, but he failed to
prevent them from supporting the wealthy planters against their own
interests. He denied that he was an abolitionist, although his politi-
cal opponents consistently attacked him on these grounds. In Lex-
ington in January 1845 Clay founded the *True American*, which was
devoted to the cause of gradual and constitutional emancipation.
The proslavers felt threatened by the journal and denounced him as
the tool of abolitionists; they threatened to lynch him with the very
material fabricated in the Noble manufactory ("The hemp is ready for
your neck."), and in August his press was seized and shipped to
Cincinnati. This ruthless suppression of Clay's paper had the sup-
port of most Kentuckians. Free blacks were now openly attacked in
the streets of Lexington, and the *Christian Intelligencer*, a small Meth-
odist paper printed in Georgetown, was forced to close down after
the editor condemned this chain of events.

The Frankfort antislavery convention met on 25 April 1849
with more than 150 delegates representing twenty-four counties.
Cassius Clay was one of its most prominent members, but according
to one calculation over half of the delegates were major slaveholders.
Henry Clay presided, but even his eloquence could not produce an
acceptable plan of emancipation, although the majority leaned in that
direction and favored colonization. The delegates did agree to set up
an election of convention delegates who would oppose further im-
portation of slaves, and the consequent campaign was hotly con-
tested. Duels were not infrequent, and Clay himself participated in a
bloody melee. When the results came in, the proslavers controlled
most of the regular party machinery and the state's press, and they
selected moderates from both the Whig and the Democratic Parties.
Although the Emancipation Party ran candidates in twenty-nine

counties, it did not elect a single delegate to the state convention. This decisive defeat in 1849 took the wind out of the sails of the antislavery group in Kentucky. Many who would not accept a life in a permanent slave environment left the state, while a handful of more determined opponents of unpaid servitude continued the struggle until the outbreak of the Civil War.

The inability of the various antislavery groups to forge a unified front weakened their cause in the 1850s. The great abolitionist heroes of the decade were those who helped slaves escape via the underground railroad, such as Calvin Fairbank and Delia Webster. Webster purchased a large farm in Trimble County on the Ohio River during the winter of 1853–54, and so many slaves from the area disappeared that a group of slaveholders demanded that she be expelled from the state. She eventually fled to Indiana to avoid arrest. Another courageous abolitionist of the period was John G. Fee, also the son of a slaveholder. His popular *Anti-Slavery Manual* of 1851 demolished the slaveholder's arguments based on scriptural authority and exercised a notable influence in Kentucky. Fee rejected the concept of the Colonization Society and set up a community on the present site of Berea College to counteract the pernicious influences of slavery and caste, rum and tobacco. His support of John Brown, however, was exploited by the proslavery supporters to breakup the Berean community, which had to relocate in Cincinnati until after the war. The following year, 1860, when the presidential election was held, Kentucky's blacks were still solidly in bondage, and Lincoln polled just 1,364 votes in the state of his birth.

Noble's childhood in Lexington, and later in Louisville, could not have eluded the impact of such formidable influences on both sides of the fence. Although his family was Episcopalian, and Episcopalians figured less prominently than Baptists, Presbyterians, and Methodists in Kentucky's slave agitation,[9] Noble's special circumstances brought the issue directly to his doorstep. His immediate contact with his father's plantation and rope walk and the slaves that operated them gave him an insight that few painters of the period possessed. Surrounded by the spun hemp and the homespun rough cotton shirts and heavy underwear worn by the slaves, Noble developed a love of coarse textures, both fabricated and natural, that he associated with his childhood and which became a hallmark of his pictorial style. His compassion for persecuted people, unemployed workers, and family traumas is expressed visibly on his painted surfaces through the textural manipulation of his paint, used both to capture a coarse environment and to "touch" the victims he depicts through the directness and buildup of his technique.

In his adolescence he studied art under Samuel Price (1828–1918) in Louisville, himself a former disciple of Kentucky's

famous portrait painter Oliver Frazer (1808–64). Frazer, who settled in Lexington in 1838, had studied with Baron Gros in Paris in 1834, where he got to know George Healy and Thomas Couture. Healy, who was originally from Boston, hit it off with Frazer, and they became intimate friends. When Healy was commissioned by the French king Louis-Philippe to paint Henry Clay's portrait at Ashland, Kentucky, in 1845, Frazer enjoined him to share his home and studio. Later, when Healy moved to Chicago in 1855, he regularly visited his friends in Kentucky. In this way Noble probably got to know Healy and to choose Couture, who reinforced his fascination with surface texture and painterly handling, as his French master.

Noble went abroad to study under Couture in 1856 and remained under his tutelage for three years. During this period, the master began making a transition from a historical to a more popular genre style, which had a wide appeal to the American art market. Noble assimilated this primary position in his art although on occasion working himself in the grand manner. Couture was highly political, although he had lost some of his energy when the 1848 Republic was usurped by Louis-Napoleon's coup d'état in December 1851. Dependent on official commissions, he had to make his peace with the new regime and paint pictures, like the *Baptism of the Imperial Prince*, that were flattering to the Second Empire. Yet Couture had a basic concern for the fate of the underdog that shows up in such works as the *Pifferari* (itinerant Italian musicians), the *Bird-Catcher*, and *La Noblesse* (an allegory of the corruption of the nobility). It is no coincidence that his pupils show a preoccupation with black people: Eastman Johnson, Francisco Oller y Cesteros, and Thomas Noble all treated themes central to black emancipation, and the list should also include Edouard Manet, whose image of the black maid in *Olympia* we discussed in the first chapter. (The racist Edward V. Valentine also studied with him, but he was a die-hard Southerner.) How Couture's social concerns got transmitted to his pupils has yet to be explored, but it would seem that he attracted highly gifted and intelligent students with definite political and social convictions.

The main body of Noble's pictorial activity deals with his direct experience and social ideals. He returned to the United States in 1859 and settled in St. Louis, where his work was soon interrupted by the Civil War. As in the case of Kentucky, Missouri was a border state, and the metropolitan center of St. Louis was bitterly divided throughout the Civil War. Both Kentucky and Missouri had a curious status during the war; they were slave states that did not secede. Noble himself would not have supported the cause of slavery, but he sided at last with Confederate sympathizers in Missouri and with the conservative element of his native Kentucky in behalf of the princi-

ple of states' rights.[10] He enlisted at St. Louis for three years and was
assigned to the cavalry. In late October he was detached for service
in the ordnance department at Camden, Arkansas, where he worked
as a gun designer. From Camden he transferred to New Orleans as a
captain to the staff of Governor Henry Watkins Allen of Louisiana.
Here his experience with his father served him well: he operated a
rope walk to help supply the needs of the Confederate Army and
Navy and helped construct an early pontoon bridge.

After the war he returned once again to St. Louis, where he em-
barked with burning enthusiasm on a series of canvases exposing the
injustice of slavery and the plight of black people in North America.
Clearly the war and its aftermath influenced the production of these
works, perhaps not without an underlying sense of guilt for his par-
ticipation in the conflict and in remembrance of his childhood exper-
iences on the rope plantation of his father, who made extensive use
of slaves. At the same time, a major market in the North now opened
for pictures with slave subjects; Eastman Johnson, also a student of
Couture, had exhibited his ambiguous but highly popular *Negro Life
at the South* (later changed to *Old Kentucky Home*) at the National
Academy in 1859 and during and after the war began selling pic-
tures of black people in a more positive light. Noble's early works
sold quickly to patrons in New York and Chicago, suggesting that
he too tapped into this market. Northern businessmen and merchants
may have sought out such images to display their liberal sympathies
and support of Reconstruction, which benefited them economically.

Noble's earliest project in this category was a series of three
paintings, now lost, representing the history of black people in
North America, entitled the *Past, Present & Future Conditions of the
Negro*. The *Present Condition of the Negro*, painted immediately after
the war, brought the artist a great deal of notoriety. It depicted an
elderly black woman who, having just returned from the market, sits
before the fireplace and enjoys her pipe while calculating her ex-
penditures. On the wall over the fireplace hangs a picture of Abra-
ham Lincoln. The image of Lincoln was naturally a pervasive liberal
icon in this period, but for progressive Kentuckians he merited a
special place: Lincoln was born near Hodgenville, Kentucky, and his
wife, Mary Todd, came from Lexington. Lincoln's firsthand knowl-
edge of unpaid servitude derived from visits to his inlaws in Noble's
hometown.[11] Until the originals or a description of them turns up,
we will not be able to analyze the series with much precision. But
the central theme is reminiscent of the propagandistic imagery of the
period showing blacks in a before-and-after sequence linked to
Lincoln's Emancipation Proclamation and the need to recruit blacks
for the war effort, which we have previously linked to Eastman

Johnson's work. Usually they are first depicted as worn-out planta-
tion workers and then in their new state as self-reliant and energetic
blacks in uniform. Noble's series also serves to glorify the Republi-
can version of the post–Civil War period and hints at its production
for a Northern audience.

It may be recalled that throughout the decade of the 1850s
Harriet Beecher Stowe's *Uncle Tom's Cabin* kept Northern audiences
spellbound. The Stowes lived in Cincinnati, and it was her observa-
tions of conditions just across the Ohio River that stimulated her to
write the novel. The story itself is set in Kentucky, and thus its texts
and subtexts on slavery and those who oppose it are based on the
conflicts within Noble's home state. (Noble would undoubtedly have
been intrigued by the mulatto hero of the novel, George Harris, who
had been hired out to a bagging factory and invented a machine for
cleaning hemp—the very business of his father.[12]) Runaway slaves
from Kentucky often made their way to Ohio across the frozen river,
as in the case of the novel's heroine, Eliza, and her child. The huge
success of the novel demonstrated even before the Civil War the

Fig. 5–1. Thomas
Satterwhite Noble, *The
Last Sale of Slaves in St.
Louis*, 1870. Replica of
1865 painting.

commercial possibilities of slave subjects for Northern audiences. Stowe's statement in her preface might easily have been applied to Noble's pictures a decade later: "The object of these sketches is to awaken sympathy and feeling for the African race, as they exist among us; to show their wrongs and sorrows, under a system so necessarily cruel and unjust as to defeat and do away the good effects of all that can be attempted for them, by their best friends, under it."[13] Stowe noted that "the poet, the painter, and the artist" were engaged in the same humane enterprise as she, spreading "a humanizing and subduing influence, favorable to the development of the great principles of Christian brotherhood."[14]

Noble's next significant work on the theme of slavery was *The Last Sale of Slaves in St. Louis*, one of his most prominent paintings (Fig. 5–1). The title alludes to the (alleged) last sale of slaves in 1865 on the east front steps of the St. Louis courthouse on Fourth Street (where the Dred Scott case was argued). Noble organized the crowd in a pyramidal arrangement, with the auctioneer and a light-skinned slave next to him located at the apex. Most of the slaves are seated below the platform or are relegated to a marginal position at the far left or behind the platform. Race, class, and social distinctions are scrupulously guarded and, as we shall see, transmitted clear signals to the audience.

Noble executed the work in St. Louis in 1865 and exhibited it in 1866 at Pettes & Leathe's Gallery at 101 North Fourth Street in August. In October Noble moved to New York and exhibited the work at the Seventh Annual Artists' Fund Society Exhibition, held at the National Academy the following month. Next he exhibited it at Child's & Company in Boston, and in February and March of 1867 it was displayed in the rotunda of the U.S. Capitol in Washington. In August it was shown again at Pettes & Leathe's in St. Louis, and at the end of November it was at the Opera House Gallery in Chicago. Eventually the work was purchased by William B. Howard, who donated it to the Chicago Public Library. It was destroyed in a Chicago fire, but the work is known through the replica of 1870 in the Missouri Historical Society. The replica was painted when Noble lived in Cincinnati and includes himself, members of his family, and friends. This indicates the personal importance of the work for him. Nevertheless, if we track the exhibition record of the original we find that Noble had in mind Northern audiences and clients. The work reached Washington during the year Congress approved the Reconstruction Act, motivated by the refusal of most Southern states, including Kentucky, to ratify the Fourteenth Amendment protecting black citizenship, and its exhibition coincided with the emergence of the Black Codes of slavery days and by growing violence against

black people. When the liberal *St. Louis Guardian* learned that Noble's picture would be displayed in the Capitol rotunda, it enthusiastically noted:

> Congress will now have an opportunity to compare a really admirable picture with some of the weak and indifferent apologies for art which now hang in the building. Mr. Noble's picture, besides its excellence of execution, is the graphic, truthful record of a salient incident of the most important historical fact in the life of the nation. The rotunda of the Capitol is the proper destination of this significant picture.[15]

The work depicting "the last sale" of slaves was actually painted with the knowledge that Reconstruction had now enfranchised blacks as citizens, with the right to vote and entitlement to equal protection of the country's laws. Since 18 December 1865 slavery was no longer legal anywhere in North America. Thus the sentiment of the picture had a belated impact, treated internally as if the event were a thing of the past. As one reviewer described it:

> About seventy-five figures are grouped around a parti-colored slave girl standing upon the auction block, at the foot of the Court House steps. Her hands are clasped, her head bent forward, and her eyes upon the ground, with a finely brought out expression of sadness in her features. . . . Immediately in front of the block are a number of negro women and children, in bright dresses, waiting their turn to be disposed of. On the extreme left an aged negro—one of the best figures in the picture—is bidding goodbye to his wife. Both have been sold, and to different masters, and the parting scene is well wrought up. . . . In the immediate central foreground, a fashionably-dressed lady and gentleman, with a greyhound, are idly gazing at the scene. . . . There is an old gentleman who has purchased a donkey. There is a newsboy crying his papers in vain. There is an Italian image-vendor, and from the tray on his head the effigy of the dying Christ seems to look down upon the scene in sorrow. The architectural features of the picture are also suggestive. In the distance a church spire is towering heavenward. Upon the abutments are a statue of Justice skilfully thrown half in shadow by the painter, and a statue of Liberty, with head averted.[16]

According to the critic, there was hardly a figure in the picture not stereotyped or laden with local color. The reviewer's own kind of lazy, descriptive reading here accepts all the clichés rehearsed in Stowe's novel as a given and barely speaks to the tragic consequences of the event. The reviewer was far more interested in the coloring and "general effect" than in the painter's compassion for the victims. But Noble himself had fallen prey to the stereotypes and had to assume responsibility for the various critical readings in that period.

The critic of the *St. Louis Guardian* clearly responded to Noble's presentation as if it had the "correct" editorial viewpoint:

> In the center, on a raised platform, is portrayed a young girl, an octo-roon, we should say, who is made to look so innocent and modest, with such beautiful eyes, so meekly cast down, as to call forth sympathy for her fate. In striking contrast with this, is the countenance, hard and unrelenting, of the auctioneer, who has evidently run up the "chattel" to a high figure, and is about saying "third and last time," when an eager bidder in the distance catches his eye, and competition is renewed. The expression of countenance depicted in the face of each slave introduced into the picture is very telling. One, an aged man, who has just been sold, is bidding farewell to his wife, while grief and resignation combined are painfully depicted in the countenances of himself and his partner; behind appears the purchaser apparently hur-rying him off to his new home.[17]

On the other hand, the conservative *St. Louis Times* published a blurb alongside its lengthy full-column review that stated: "We must—without expressing any opinion as to the merits of the work—question the propriety of the subject. Art has no limits, it is true, but art has no right to distort history." In this case, the editor seems to have dissociated himself from the subject while paying lip service to the aesthetic claims of art. Yet a close reading of the review indi-cates that the work was indeed read ideologically from the perspec-tive of an audience sympathetic to an antebellum world. The critic, Alfred Jingle, perceived many of the characters of the work similarly to the reviewer of the *Guardian*:

> The centre of the picture is occupied by a beautiful octoroon girl, who stands for sale on a platform, with her hands clasped meekly before her, and her small head bowed down, it would almost seem, by the weight of her large downcast eyes.

But he saw this as a deliberate attempt to gain the sympathy of the audience: "I doubt not, but that some enthusiast of the *new race* of freed people, would pronounce her—the intelligent equal, sensible of her degraded position amongst the whites." In other words, the degree of her self-consciousness is in direct proportion to the degree of "whiteness" in her color. Jingle's racism pervades his entire inter-pretation of Noble's work: the work, however, must assume some re-sponsibility for the reviewer's reading:

> Grouped around the base of the platform are slaves of all ages, loung-ing and squatting in all the easy indifference of their nature. One, she must surely have been the cook, overburthened with flesh and laziness,

has just fallen off into the arms of Somnus. It will be well for the god, if his arms be stout enough to hold her. . . .

She sits, as she might have been sitting any day, in the old kitchen, after the labor of cooking dinner had been satisfactorily gone through.

Behind this drowsy load of flesh, stands leaning on her staff "old aunty" keen and sharp, like all old ladies who have raised numerous grand-children. She was the ruling spirit "on the place." Both the white and the black children had to "look smart thar" when "aunty" hobbled about. . . .

One negro's head in this group finely expresses that stolid resignation so frequently met with among the race.

Jingle's racist reading is pitched to Noble's stereotypes, although the painter was far more liberal than his critic. This comes through in his interpretation of a group of three whites on the right (actually on the left in the replica) of the picture arguing politics:

They may be set down as portraitures of the three shades of our political ethics—old fogyism, conservatism and radicalism. The radical (a young man) is earnestly advancing some one of the theories his party was built upon—perhaps the "equality of the races"—with a good deal of warmth. His argument is listened to by the Conservative (a middle-aged man) with attention. The grand "old timer" has said his say on the subject, and looks surprised, with a slight touch of contempt that any young man could gainsay it.

No group in this picture more intelligently carries out my interpretation than does this. In expression of countenance and action of body: each figure is carefully studied. Grand "old timer" possesses a good old head. And I doubt not is the owner of as big and good a heart.

If I misinterpret the artist in any part of this composition, I hope it will be in this group. For to my thinking, there is too much thought expressed in the countenance of the practical Conservative—to be produced by anything as theoretical [as a] Radical would say.

The right of the picture is terminated by a sad parting between a slave who has just been purchased and his wife who was in attendance to see him sold. His expression, as he quietly stands there, supporting her head, as she sobs on his breast is very fine.

Directly in front of the sale are a lady and her gallant. They are merely passers by and stand a moment to look on. Their halt is taken advantage of by a pretty little orange girl who takes a fruit out of her basket and modestly offers it for sale.

The beautiful little face is entirely in shadow, whilst the sun shines gloriously on the back of the favored lady—just in the picture, as in life![18]

Jingle leaves no doubt as to his social sympathies and his political biases. Nevertheless, he thought Noble's picture "the most masterly

work of any Western artist." His review unmistakably coincides with the editorial viewpoint of the paper, but his unexpected enthusiasm for the subject relates to his interpretive conclusion that after all the smoke of social and political battle clears, the ruling elite will still be in place. The radical will be ignored, the conservative will retain his good sense, and the "old fogy's" "big and good heart" will ensure that the Beautiful People will retain control.

These critical readings must now be analyzed in the context of Noble's experience with actual slave auctions and the responses of his peers to those events. Slave auctions in front of courthouses were familiar sights to the crowds that gathered on the public square of many Kentucky towns on county court day. Court day in Kentucky was an institution peculiar to the state. On a set Monday in each month, while the justices of the peace, who made up the county court, assembled in the courthouse to transact the people's business, rural folk for miles around took the day off and poured into town for the court-day sales and for gatherings on the public square. Like some grotesque version of a modern flea market, every imaginable item was offered for sale—including human beings.

The most common slave sales were those made in the settlement of estates. The majority of the local sales were disposed of by administrators and executors of estates, rather than by their owners. After an announcement in the press, the sale was usually conducted on the public square, near the door of the courthouse. The sellers cared little for the fate of the slaves or the division of families. A typical ad in the *Louisville Weekly Journal* of 2 May 1849 ran: "I wish to sell a negro woman and four children. . . . I will sell them together or separately to suit purchaser."

As a child in his native Lexington, Noble lived at 539 West Third Street, just minutes away from the courthouse. He would have frequently witnessed court-day sales on Cheapside, the public square of the town just across the road from the courthouse. Here assembled a motley crowd, including some of the wealthiest and most cultured of the bluegrass—fashionable men and women from Cincinnati, Louisville, Frankfort, and even from as far south as New Orleans. Frequently, the cruel indignities heaped on the men and women for sale disgusted the crowds and reinforced the case of the local abolitionists. Scenes of grief-stricken parents separated from their offspring were commonplace in the antebellum days in Lexington.[19]

It was a Kentucky auction sale on court day that became a pivotal scene in *Uncle Tom's Cabin* and probably informed Noble's picture. The sale of slaves took place "before the Court-house door, in the town of Washington, Kentucky," reminding us that slave auctions at courthouses had to do with executors' sales for the benefit

of creditors and heirs. (In St. Louis, for example, the typical slave
auction took place at Lynch's private slave market at 104 Locust in
the downtown area.) A mixed crowd gathered around the court-
house steps, with those held in bondage sitting in a group apart.
The central figure in this episode was an older slave woman, anxious
over the possibility that her only remaining son would be separated
from her. Every other member of her family had been sold, and she
trembled every time a slave agent approached to examine him. After-
ward, two characters discuss the black family breakup, and one at-
tests to its customary occurrence in Kentucky and Virginia. Still later
in the novel, at another location in Kentucky, a young black woman
named Lucy, expecting to be hired out to the tavern where her hus-
band works, finds herself sold to a ruthless slaver and separated
from her ten-month-old infant. The tragedy of the separation of the
families had been a basic argument of abolitionists since the eigh-
teenth century, and it is the theme of Noble's *Last Sale of Slaves* as
well. While he made major changes in the later replica, he retained
the drama of separation. Noble kept the black couple at the left ex-
changing farewells, and, in addition, he substituted for the central
woman clasping her hands a mother cradling a child in her arms. In
her concluding remarks to *Uncle Tom's Cabin*, Stowe admonished the
"mothers of America" to "pity those mothers that are constantly made
childless by the American slave-trade!"[20]

Noble thus manipulated the historical event to focus on the
plight of the broken families, a key abolitionist argument capable of
pricking the conscience of the moderates and of outraging the pro-
slavery advocates. In fact, the actual circumstances of the last slave
sales in St. Louis were quite different from the way Noble depicted
them. One notable example was the slave auction in front of the St.
Louis courthouse on New Year's Day of January 1861, which devel-
oped into a boisterous and turbulent affair when opponents of slav-
ery hooted and jeered at the proceedings. As a result, the auction
had to be disbanded before a single slave was sold. The slaves were
returned to their "warehouse" (actually the St. Louis County jail-
house) and ultimately disposed of through private sales. Slavery re-
mained legal in Missouri until abolished by the ordinance attached
to the state constitution of 4 July 1865, and the court records indi-
cate that slave sales continued to be held at the courthouse until the
end.[21] These sales, carried out during the Civil War, continued to be
controversial and rowdy events. Noble, who knew the facts, trans-
formed the incident into a type of "real allegory" of man's inhumanity
to man. His audience, however, is sedate and passive, and they sim-
ply gaze at the event without registering a protest. Noble painted
himself and his wife as fashionable spectators in the replica and in-
cluded many of his professional friends from Cincinnati. This pre-

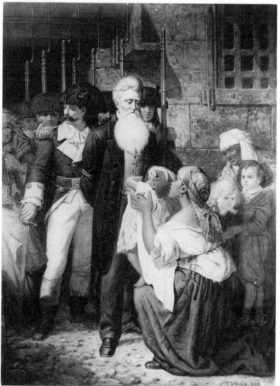

Fig. 5–2. Thomas
Satterwhite Noble, *John
Brown Led to Execution*,
1867. Courtesy of the New-
York Historical Society,
New York City.

dominantly middle-class milieu tells us a good deal about the actual
public for Noble's picture, Northern and liberal and moderate on the
issue of slavery.

Noble's next painting, *John Brown Led to Execution*, also focuses
on a black mother and her child (Fig. 5–2). Noble's John Brown
stands like an Old Testament patriarch before a black woman who
has raised her child for his blessing; together they form a powerful
pyramidal grouping. While in this case the black is again shown
kneeling, forming the base of the triangle, she moves energetically
within it and elevates her child as if in symbolic anticipation of its
future rise in the social structure. Brown places his hand affection-
ately on the head of the infant, who plays with his vest in acknowl-
edgment of this symbolic action. Brown is shown as tough and reso-
lute, but with the goal of his efforts ever present in his mind.

This presentation contradicted the conservative responses in
Kentucky to the original raid on Harper's Ferry in 1859. Accounts
of the raid were carried in almost all the Kentucky newspapers, but
these were mainly unsympathetic. The *Western Citizen*, for example,
declared it the result of "a handful of crazed fanatics," while the
Kentucky Statesman described Brown's white associates as "broken-

down Yankee school-masters, debauched and unfrocked preachers, and others of that class of vermin to be found at the North, too lazy to work, and generally too cowardly to steal, and therefore, who turn to abolition lectures, &c."[22] These irrational comments corresponded to the uneasiness that spread throughout the border slave-state with the news of the outbreak. Clashes and demonstrations that took place soon afterward in Kentucky between abolitionists and slaveholders were traced to Brown's raid. Thirty-six advocates of emancipation were stripped of their property and driven from their homes in Berea in late 1859 by local slaveholders, and William S. Bailey, editor of the weekly *Free South*, an abolitionist paper in Newport, was openly attacked for his sympathetic view on Brown's raid. His office was set on fire, his presses smashed, and the type thrown into the Ohio River by angry slaveholders and their hired thugs.

Thus Noble's sympathetic portrayal of Brown—tough but humane—ran counter to the view of Kentucky conservatives. Although by 1867 Brown had become one of the martyrs in the cause of abolition, Noble's picture upheld the original motivation of Brown, which the insurrectionist himself stated in his last speech at the trial: "If it is deemed necessary that I should forfeit my life for the furtherance of the ends of justice and mingle my blood further with the blood of my children and with the blood of millions in this slave country whose rights are disregarded by wicked, cruel, and unjust enactments—I say, let it be done." When Noble's picture exhibited in Boston in December 1867, the *Commonwealth* wrote that it had cost him "friends and position at home by representing so unwelcome a matter to the South.[23]

The picture may also have owed something to Noble's knowledge of the abolitionist movement in St. Louis. The founder of this movement, Elijah Parish Lovejoy, came from Albion, Maine, to St. Louis in 1827 to teach school, believing that education would work against slave oppression in the West. He started the newspaper the *St. Louis Observer*, which took a progressive position on emancipation, in November 1833. Lovejoy antagonized not only the proslavery people in the city, but also the moderate opponents of the system who warned him to tone down his harsh denunciations. Eventually his press and furnishings were vandalized by proslavery thugs, and he moved the press to the free territory of Illinois. There, in Alton, he established the *Alton Observer*, which advocated immediate freedom for the slaves and no compensation for the owners—the straight Garrison line. But in Alton, as in St. Louis, Lovejoy faced a concerted hostility, as his presses were destroyed one after another. In November 1837 Lovejoy himself was shot by antiabolitionists, and the abolitionists now had a martyr. Shortly after the event, young

John Brown and his father attended a special prayer meeting for
Lovejoy in Hudson, Ohio. Brown was deeply moved by the services,
and just before the meeting ended he pledged that he would devote
his life to the overthrow of slavery. Thereafter Lovejoy became one
of Brown's heroes, a white who made personal sacrifices for blacks.
Noble, in turn, may have linked Brown in his mind with the chief
founder of abolitionism in St. Louis.

Noble's composition proved effective enough to persuade peo-
ple that the poet Whittier rewrote his famous poem, "Brown of
Ossawatomie," to include the incident in the picture. This is one of
the myths associated with Noble's painting. Whittier wrote his poem
in 1859 shortly after Brown's execution, and his revisions were all
in place before the end of the year. In fact, there is no doubt that
Noble based *his* picture on the poem.

> John Brown of Ossawatomie spake
> on his dying day:
> "I will not have to shrive my soul a
> priest in Slavery's pay.
> But let some poor slave-mother whom I
> have striven to free,
> With her children, from the gallows-
> stair put up a prayer for me."
>
> John Brown of Ossawatomie, they led
> him out to die;
> And lo a poor slave-mother with her
> little child pressed nigh.
> Then the bold, blue eye grew tender,
> and the old harsh face grew mild,
> As he stooped between the jeering ranks
> and kissed the negro's child.[24]

The poem goes on to make explicit the distinction between the fa-
natical John Brown who raided Harper's Ferry and the generous
thought that motivated him: "Not the raid of midnight terror, but the
thought which underlies / Not the borderer's pride of daring, but
the Christian's sacrifice." Whittier's original poem was printed in the
New York *Independent* on 22 December and was widely circulated. It
emphasized Brown's irrationality ("the rash and bloody hand," "the
folly that seeks through evil good") and drew sharp criticism from

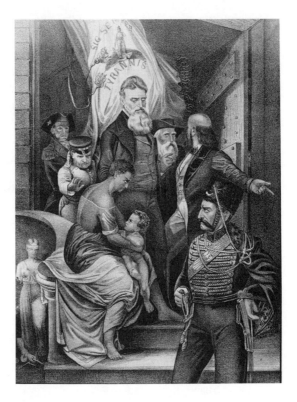

Fig. 5–3. Louis Ransom,
*John Brown on His Way
to Execution*, 1863.

William Lloyd Garrison in his *Liberator*, where the new version was
printed on 13 January 1860.[25] Whittier's revision softened the lan-
guage, but it added no new incident to the initial poem.

Noble was not the only one inspired by the poem; already
Louis Ransom did his version in 1860, *John Brown on His Way to Ex-
ecution*, a work that had gained such notoriety that P. T. Barnum ex-
hibited the painting in his museum in New York in 1863.[26] The print
of the work by Currier and Ives sold well, especially to newly eman-
cipated blacks (Fig. 5–3). Noble's work was also designed for mass
appeal, and the artist took his cue from Ransom's composition. The
basic designs of both are structurally similar, except that in the Ran-
som the mother and child are located on the left side of the work,
and Brown does not touch the baby. The Virginia militia, wearing
the Continental uniform of the American Revolution, is conspicuous
in both pictures, reminding the audience of the disparity between
the national promise and its unfulfillment. Noble's picture is less
stagey and allegorical than Ransom's, gaining in visual power
through greater naturalism. But Noble planned his work as well to
attract the crowds, and he exhibited it in Boston in December 1867
and in New York the following January. He also issued a large folio
lithograph of the painting in this period to sell to a popular market.

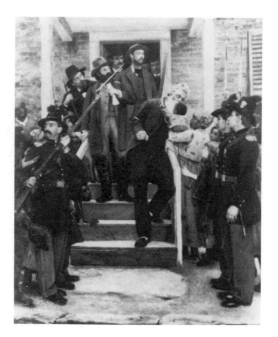

Fig. 5–4. Thomas
Hovenden, *Last Moments
of John Brown*, ca. 1884.

Noble's work in turn inspired a later version by the painter Thomas
Hovenden, whose *Last Moments of John Brown* is the only one that
actually shows the abolitionist leader kissing the child (Fig. 5–4).
Brown bends over to kiss the child, and the main group is set
deeper into the picture. Hovenden's version is both more realistic
and more ideologically conservative than Noble's; the representation
is more naturalistic, almost photographic, but the content has been
subverted to make Brown a benign father figure rather than a pow-
erful leader and prophet.

All the versions, however, err in the historical sense. The baby-
kissing episode that appeared in the *New York Tribune* of 5 Decem-
ber 1859, with a Harper's Ferry dateline of 3 December,[27] was a
complete fabrication. On the day of the execution rumors spread of
an impending rescue, and no chances were taken. Soldiers were
lined up on both sides of the road leading to the scaffold, and the
public was excluded from any direct contact with the prisoner. Just
before Brown left the jail the streets were cleared of all except those
assigned to official duties. Thus Brown could not have kissed a
black baby, since women and children were prohibited from the
grounds. But if the story was the brainchild of a reporter, its accept-
ance as fact had to do with Brown himself. Three days before his ex-
ecution he had expressed the wish that at the time of his execution
his "religious attendants" be confined to "poor *little, dirty, ragged
bare headed, & barefooted Slave boys; & Girls*; led by some old *grey*

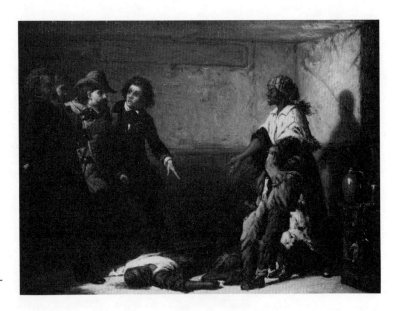

Fig. 5–5. Thomas Satterwhite Noble, *Margaret Garner*, 1867.

headed Slave Mother."[28] It would have been in character then for Brown to kiss a black child, and the story was symbolically true if not historically accurate. But the image of the white patriarch blessing and kissing a black child had a powerful appeal for liberals who very much longed to see a paternalistic system sustained. Brown's image in Ransom, Noble, and Hovenden projected a symbolic view of society in the post–Civil War era that asserted the ongoing dependence of blacks on reform-minded whites.[29]

Noble used the same model for the mother in his John Brown for perhaps his most memorable image in the series, *Margaret Garner* (Fig. 5–5). Commissioned by a New York City leather broker named Harlow Roys, it was shown in the 1867 exhibition of the National Academy of Design and then went to Boston to accompany *John Brown Led to Execution* at the exhibition of DeVries, Ibarra & Co. The work was photographed by Mathew Brady and reproduced in the form of a wood engraving in *Harper's Weekly*, the primary Republican voice in New York (Fig. 5–6). Noble also painted a smaller version that exhibited in Cincinnati in 1868.

Margaret Garner addresses the issue of the Fugitive Slave Act, passed by Congress in the Missouri Compromise of 1850, which allowed slave owners to enter free territory and claim their runaway slaves. This law was severely abused. Seizures of persons across the Ohio River, even of people who had escaped from bondage years before and had established families, took place daily. The threat to the slavocracy of slaves repudiating the regime and choosing freedom at the highest risk went beyond the mere capital loss, but touched

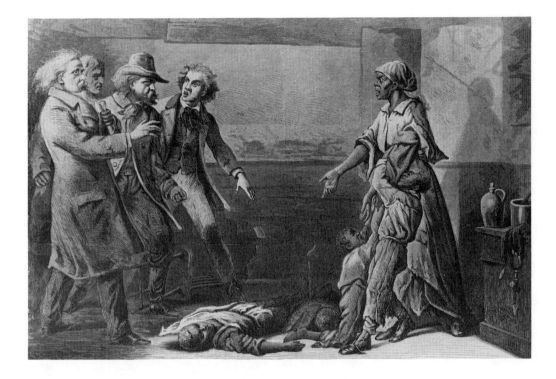

Fig. 5–6. Anonymous, *The Modern Medea—The Story of Margaret Garner*, 1867.

more fundamentally upon the demonstration of an alternative to the condition of slavery.[30] Kentucky's northern border bounded on several free states, and its slaveholders were especially vulnerable to escapees, whom they pursued with a vengeance.

The case of Margaret Garner was one of the most tragic and most widely publicized. Similar to Eliza's break for freedom in *Uncle Tom's Cabin*, Simeon Garner and his wife Margaret and their four children fled from Boone County across the frozen Ohio River in January 1856 and made their way to the home of a freed black in Cincinnati. Their armed pursuers traced the fugitive family to their hideout in Cincinnati, broke down the door, and entered the house. There they found Margaret who, preferring death to slavery for her children, had attempted to take their lives, with one of the children, her favorite, already dead on the floor. The case was tried and rendition ordered. On their return to slavery, Margaret, in despair, attempted to drown herself and one of her children by jumping into the river, but even emancipation by suicide eluded her, for she was recovered and subsequently sold to a trader who took her to the cotton fields of the deep South. The incident electrified the country, including future president Rutherford B. Hayes, then practicing law in Cincinnati and living on a proslavery street. He told James Monroe, a professor at Oberlin College, that the tragedy converted the

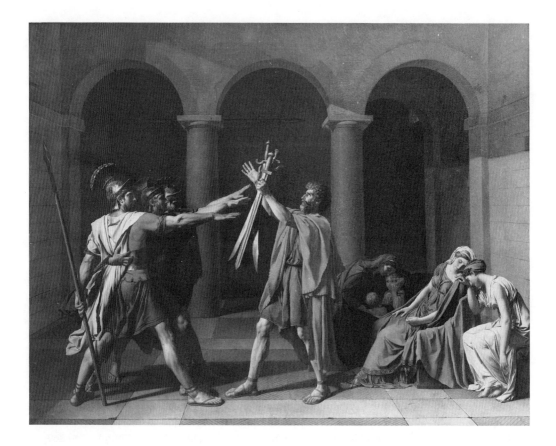

Fig. 5–7. Jacques-Louis David, *Oath of the Horatii*, 1784.

whole street, and that a day after the murder "a leader among his proslavery neighbors" called at his house and claimed to enlist in both the Republican Party and the abolitionist cause.[31]

Noble's unusual representation of this event is organized along the frontal plane, with Margaret Garner and her children on one side and her pursuers on the other. Separating them like a no-man's land is a space filled by two dead children. (Noble either erred here or deliberately heightened the tragic consequences of the event; a preliminary drawing even shows three of the children dead.) Garner's figure and her two surviving children form a powerful pyramidal configuration—reinforced by the indexical gesture of her hand toward the dead children—whose energy dominates the pictorial field and arrests the forward motion of her pursuers. The four males are aligned in a row analogous to the figures in Jacques-Louis David's famous picture, *Oath of the Horatii*, and the mother confronts them like the elder Horatius (Fig. 5–7). While in David's picture the men are heroes and the women simpering subordinates, here the woman heroically dominates (*Harper's* called her "the modern

Medea"), and the males are reduced to poltroons. The women in the David are incapable of making the self-sacrifices taken on by the males, but Noble's female protagonist makes the greatest self-sacrifice imaginable in the name of "liberty." The work has a sense of liberation in a double sense: Garner not only rebels against her subjection as a female and a black but exercises her only freedom as a mother to extinguish the lives of her offspring. The violation of her space sets her into motion to defeat the system of slavery by denying the slavers more black bodies to oppress. This astonishing act and its exploding of the institutional limits could not be shown in the traditional forms used by David and stimulated Noble to make novel use of the conventional triangular design. While black bodies lie dead at the base, the immediate controlling, decisive factor in these tragic circumstances occupies the apex. Here the whites are brusquely excluded from the structure. Garner's act essentially demonstrated the incredible inequity of the Fugitive Slave Act and pointed out not simply the barbarity of the Slave Code, but held up for all to see the obvious ruthlessness of the slavers. Once slavers could cross the threshold of a freed person's home, the sanctity of even the white household could no longer be guaranteed. The horror of the household drama of Margaret Garner was literally too close to home for even the most calloused whites.

While Noble's picture was based on an actual event, it is noteworthy that a similar incident is found in *Uncle Tom's Cabin*. In the chapter entitled "The Quadroon's Story," Cassy, whose children from a previous relationship had been snatched from her, gives her two-week-old baby laudanum and holds him close "while he slept to death." Determined not to allow another of her children to grow up in slavery, she tearfully concludes, "What better than death could I give him, poor child."[32]

It is possible that the same chapter influenced Noble's theme of a different kind of parental self-sacrifice, *The Price of Blood*, which was shown in New York, Boston, Philadelphia, Cincinnati, and Chicago before its sale to a Scottish collector (Fig. 4–3).[33] When Cassy's white master, with whom she has cohabited, sells their children and shows her the money, she notes with disgust "the price of their blood."[34] The theme of the picture is the sale of a mulatto male by his father-master, who has just closed negotiations with the slave agent. A glimpse of a picture on the wall reveals it to represent the Sacrifice of Isaac, thus underscoring the curious expressions and gestures of the seated father and the standing son. The youth has been sold into slavery for the pile of gold shown on the table. Here is a subject that could only have been painted by a North American artist, and it attests to the general sense of the permanently inferior status of African-Americans and their descendants. Indeed, it may have

Fig. 5–8. Anonymous,
*"What Day ob de Month
id Dis, Massa?"* 1863.

been fueled by the recent debate over "amalgamation" sparked by the
pamphlet *Miscegenation*, published at the end of 1863. Written anon-
ymously by two Democratic journalists but purported to be the view-
point of a radical abolitionist, it argued for interracial unions. The
book created a sensation throughout 1864, revealing in the cited
pros and cons abolitionist reservations about how far to push racial
equality, Republican denials of sympathy for such a program, and
Northern insistence that the actual source of mulattoism in the
United States had been the institution of slavery.[35]

The debate further disclosed the extent to which Northern lib-
erals were about to enter Reconstruction with their own entrenched
set of racial prejudices. They could appreciate blacks as gentle crea-
tures with some fine virtues, whose basic docility had served—and
could continue to serve—Northern purposes. But at the same time
blacks were expected to know their place and not act "uppity," to
remain in the South remote from the northern workplace and avoid
the unholy sexual crossover that would contaminate the white race
with African blood. For Republicans, such a horrifying prospect had
been opened up by the ungovernable appetites of slave masters such
as Noble's aristocratic planter.

One popular source for Noble's composition is a cartoon that
appeared in *Harper's Weekly* on 10 January 1863 (Fig. 5–8).[36] Ex-
cept for the absence of the slave agent, the two designs are remark-
ably similar in layout and protagonists. A dialogue ensues between a
standing, dandified black and his disgruntled master, seated at a
table laden with a wine bottle and glasses. Their gestures are strik-
ingly close to Noble's characters: the black at the left poses non-

chalantly with his feet forming a right angle, while the master sits
crosslegged, one arm slung over the back of his chair, the other rest-
ing on the table. The dialogue hints at the slave's new-found status
and imminent rupture with his master. The servant "Pompey," crudely
caricatured, inquires about the date, and when the master asks why,
Pompey replies: "Oh! cause you knows Massa LINKUM he gib us
our Papers on de First January, God bless um; and now I wants to
say as how you allus was a good Massa, and so I'll gib you a Mont's
Notice to git anudder Boy. Niggers is powerful cheap now, Massa!"
This blatantly racist cartoon in the North's favorite newspaper con-
veys a sense of the anxiety over "uppity" blacks on the threshold of
freedom, and its formal and thematic connection with Noble's paint-
ing is unmistakable.

Noble's youth, although depicted in a more dignified manner
than Pompey, nevertheless assumes the elegant pose of Gainsbor-
ough's *Blue Boy*—a pretentious gesture that would have been re-
garded as ironic by nineteenth-century spectators. It gives ambigu-
ous stature to the youth, recalling one of Stowe's ambivalently
motivated characters in the section of *Uncle Tom's Cabin* titled "The
Slave Warehouse." Here could have been seen "numberless sleeping
forms of every shade of complexion, from the purest ebony to white,"
including Adolph, whose light complexion made him the target of
taunts about his "airs and graces."[37]

Miscegenation, a common phenomenon among the slaveholders,
resulted in some of the most heartrending tales of separation. Such a
case moved the population of Noble's hometown, Lexington, in the
mid-1850s. A wealthy, respected white man was the father of two
nearly white girls whose mother was a quadroon slave. The girls
were educated at Oberlin College (where many interracial offspring
attended school), passing easily for whites. Financial difficulties
plagued the father, and when the daughters came to Lexington to at-
tend his funeral they were seized and ordered sold for the benefit of
creditors of the estate. Despite a public outcry, they were subjected
to the humiliation of the auction block in front of the county court-
house and sold.

The sale of children of slave mothers and their white masters
had always been problematic for the moderates in Noble's hometown.
In May 1843 a slaver's young daughter named Eliza was put up for
sale in the public square of Lexington. She could have easily passed
for white and had been raised a family servant in an old bluegrass
home. Now, to satisfy the master's creditors, she was subjected to
every imaginable abuse. The unrestrained treatment of Eliza by the
auctioneer won the crowd to her side, and when a Methodist
preacher—who had bid tensely against a slaver—bought her to free
her the crowd cheered.

Fig. 5–9. Thomas Couture, *The Love of Gold*, 1844.

Slaveholders in Kentucky had their allegiance to the institution severely shaken by the sale of Eliza. Abolitionists held it up as a prime example of the barbarity of the slave system, and it was widely believed that the incident converted many moderates to their ranks. In 1852 another young woman, also the daughter of her master, was offered for sale and forced to submit to every indignity. She was sold to a Southern slave trader while her weeping mother stood by, sadly acknowledging their definitive separation. Indeed, the most vividly remembered and longest talked about were sales of quadroon and octoroon girls, whose "whiteness" made the scene all the more repulsive for the crowd. Noble's work also exploits the resemblance, cleverly done through the facial expressions—especially the raised eyebrows—between "aristocratic" father and "slave" son, and by this linkage plugs into the sympathetic associations harbored by moderates and Northern liberals. Even Stowe's slave heroes have some white ancestry that allows her to define them in terms of nineteenth-century heroic ideals. The mulatto George Harris, for example, "inherited a set of fine European features and a high, indomitable

spirit." Indeed, all the mulatto characters—George, his wife Eliza, and Simon Legree's female victims—refuse to adhere to the stoic philosophy of Uncle Tom and actively resist their state of bondage.

The irascible look on the face of Noble's youth and his defiant stance are contrasted to the venal gesture of the slave agent who reads the terms of the contract and rests his fingers on the table next to the piles of gold coins like the vulturine miser in Couture's *Love of Gold* (Fig. 5–9).

The seated culprit looks at the spectator with a half-guilty, half-challenging expression, as if to complete the terms of a rebus that needs to be deciphered. But the fragment of the picture of Abraham and Isaac framing his head mocks his somewhat quizzical look, because except to other slave owners he suffers no moral quandary and has a clear ethical choice. Abraham would sacrifice his beloved son only because he loved God completely, thus suspending his paternal feelings for a higher sense of obligation, whereas the father in Noble's picture "sacrifices" his offspring for cash. Perhaps this master had some scruples, but the price was high enough to help him overcome them.

For every such incident in actuality, thousands of slaves were sold without arousing a public protest. The definition of Southern society required the exclusion of the black Other, and the Other aroused sympathy only to the degree that he or she resembled the color of the dominant group. Like some fantastic Dr. Seuss story, the supporters of slavery rested their case on a trivial mark of identity and imposed their definition on an accepting society. Although the dissolution of families was a painful component of the institution of slavery, most Kentuckians accepted it as inevitable. It was especially during the aftermath of the Civil War that it became clear, by the pervasive sense of loss and the bitter reaction accompanying emancipation, that slavery had been indispensable to the self-identification and the social status of slave owners. This realization would have made the psychological environment intolerable for progressives like Noble.[38]

Noble's later work, beyond the scope of this essay but deserving of a special study, shows his ongoing commitment to social and political justice. His series of themes on the treatment of black people prepared him to engage with the economic discrimination he observed in the North. Indeed, it may be claimed that the antislavery movement's glorification of Northern society helped support those who would uphold the inequalities within its economic order. Critics like Frederick Law Olmsted asserted that competitive capitalism was preferable to the slave system and urged Northern workers to stop complaining, to avoid socialist and trade union views, and to thank the owners of production for not being down South. Ironi-

cally, as Noble enlarged his understanding of past and present eth-
nic persecution and economic injustice in the country generally, the
popularity of his work began to decline in the North as well.

His depictions of *The Salem Martyr* or *Witch Hill* (1869), *The
Tramp* (1876), *Forgiven* (1872), *The Anarchist, Idle Capital, The Polish
Exile* (ca. 1882), and *Out of Work* (ca. 1870–75) dealt for the most
part with the broader issues of poverty and social and economic ex-
ploitation in the United States. His late work often relates to the
problems of unemployment or the circumstances of immigrants re-
cruited to work in the factories of the North in the last quarter of
the century. Their attempts at organized protest against the harsh
conditions of industrial life brought on systematic repression. Move-
ments in this period such as anarchism and trade unionism that
gained the allegience of disaffiliated workers represented a response
to stifling working conditions and were ruthlessly suppressed. The
very year the Statue of Liberty was unveiled to great fanfare in New
York, the Haymarket Riot revealed the true condition of the recep-
tion of the "huddled masses yearning to breathe free." The aesthetic
response in this period followed the lead of the new industrial elite,
who now preferred the new French styles and their American imita-
tions, which could be interpreted first of all for their formal qualities
and then for their subject matter. Noble's work fared rather poorly
in this taste shift, as a Cincinnati critic summed up in 1896: "Noble
has been condemned because his subjects have not chanced to
please the multitude. They are considered morbid, and, as the sub-
ject does not attract, the qualities of painting and science of compo-
sition and treatment are ignored."[39] No statement could more dramati-
cally demonstrate the inevitable politics of aesthetics lurking behind
the so-called "fine arts." The acclaim or disapprobation of Noble's
work at any given time was directly related to the political priorities
of his audiences.

CHAPTER **6**

EMANCIPATION AND THE FREED

I n 1916 a black writer named Freeman Henry Morris Murray published one of the most remarkable and idiosyncratic texts of art criticism in the modern epoch. The outgrowth of several years' research, *Emancipation and the Freed in American Sculpture* is a work full of passion, informed by a rare intelligence that took images seriously. The text is indispensable to an understanding of how black people (keeping in mind that Murray belonged to the educated class) personally experienced the pictorial matter described in the previous chapters. I have quoted him extensively, not only because his authorial voice deserves a "hearing," but because he probingly dissects the central theoretical issues involved in the politics of visual experience—the relationship of part to whole, the opposition between appearance and reality, the dialectic of content and form, and the interaction between subject and object.

Writing in a period when the cultural elite had reified its hegemonic concept of "art for art's sake," Murray insisted on standing with those who held "that the most important feature of art is *what* is portrayed." Indeed, the subtitle of his text, "A Study in Interpretation," already hints at his aim to reawaken numbed perception to the immediacy of art's effects in the real world. As Murray declares:

> Hence, when we look at a work of art, especially when "we" look at one in which Black Folk appear—or do not appear when they should,— we should ask: What does it mean? What does it suggest? What im-

153

pression is it likely to make on those who view it? What will be the ef-
fect on present-day problems, of its obvious and also of its insidious
teachings? In short, we should endeavor to "interpret" it; and should
try to interpret it from our own peculiar standpoint.[1]

Murray was clearly a foucauldian critical theorist *avant la lettre*; he
states his intentions and biases at the outset, leaving no doubt as to
his particular perspective. He promises an ideological critique bear-
ing on the visual language of modern art and an attempt to break
down the mechanics of this language through phenomenological
analysis. He uses deconstructive methods for political ends, concern-
ing himself not only with what is *present* but also with what is *absent*
from the visual fields he chooses to study. He then proceeds to ex-
plain why his emphasis on what is omitted from a work is especially
pertinent to sculpture, the most public of art forms:

> This matter of interpretation, as also regard for the contents of, as
> well as for the omissions from, art works, is especially important as to
> sculpture, because sculpture more frequently than painting serves
> higher purposes than that of mere ornament or of the mere picturing of
> something. Often it is designed to commemorate some individual or some
> event, or, particularly in the group form, its main purpose is to "say
> something." The fact is, nearly all sculptural groups, and a considerable
> number of individual statues, are based on some purpose beyond mere
> portraiture or illustration. Moreover, these commemorative and "speak-
> ing" groups generally stand in the open, at the intersections of the
> highways and in the most conspicuous places. We cannot be too con-
> cerned as to what they say or suggest, or what they leave unsaid.[2]

Murray's grasp of the "politics of sculpture" played out in commemo-
rative and public contexts testifies to his heightened awareness of
the ideological functions of art that call for deconstructive readings
of the works. He goes on to assert that art generally has been mobi-
lized in the service of racist ideology, and that black people espe-
cially should understand how art impinges upon their lives:

> We can hardly press too strongly the importance of careful, perspica-
> cious interpretation. I am convinced that, for Black Folk—in America,
> at least—this is of paramount importance. Under the anomalous condi-
> tions prevailing in this country, any recognition of black folk in art
> works which are intended for public view, is apt to be pleasing to us.
> But it does not follow that every such recognition is creditable and
> helpful; some of them, indeed, are just the opposite. It is my purpose
> herein, to indicate, as well as I can, what I think are the criteria for the
> formation of judgments in these matters. It is not expected that the
> views herein stated will meet with unanimous approval. That is not im-
> portant. If, however, the discussions and attempted analyses herein,
> tend to encourage or to initiate, in other persons, candid statement and

critical analysis in the matters now under consideration, one of my main purposes will be accomplished.[3]

Murray's tone of urgency corresponds to the didactic character of his text: he is bent on informing black people of the uses and abuses of art in defining their social position and thus in reinforcing or modifying their actual position in society. With populist fervor he takes on the professional critics and the art historians, challenging their elitist assumptions with the studied sobriety of someone coming to the sudden realization of the links between cultural practice and political power. He seeks to establish the criteria for reading sculptural "texts" and in the process demonstrates that nineteenth-century cultural practice embraced a system of coding that was—and is—of crucial importance to the self-image of black people.

Thus Murray's art criticism is not that of the dilettante or the critic-seer writing for the initiated, but that of someone whose reading of art is analogous to pedestrians reading traffic signals—their lives depend upon it. But Murray is never dogmatic, nor is he overly zealous: he argues his case probingly, lucidly, imaginatively, and rigorously. He references his sources, provides alternative arguments, and wherever possible consults the artists themselves. This is not to say that he is free of prejudice: one blindspot is his Victorian attitude about the "manliness" of certain types of behavior; another is his bizarre idea that black soldiers prefer to strip naked to the waist in combat, while whites seldom get warm enough to wish to discard their uniform. But he constantly probes the depths of his preferences and exposes them; for example, a remarkable sensitivity to the subtleties of race and gender bias emerges in his discussion of Anne Whitney's *Ethiopia*, which he claims is the best thing she ever did, although later "she did some excellent and notable things." He then catches himself and states: "I will not say 'excellent for a woman'; for that sort of praise, be it directed toward a particular sex, or class, or race, is irritating to me."[4] He clearly understood that such an evaluation presupposed the racial or gender stereotype and repudiated the individuality of the subject. This is typical of Murray's narrative, which he interrupts repeatedly to bring the reader (and himself) back to everyday life.

What is important for my study is the fact that Murray provides a sustained critique of the work of mainly white artists depicting images that vitally concerned him as a black citizen living in a racist environment. Thus in this chapter I will be investigating an art critic investigating works of art, trying to recover the perspective of a black person grappling with the ideological instruments of the dominant majority, and at the same time providing my own perspective on the works under scrutiny. While I differ in many of my conclusions

about the objects of his inquiry, Murray establishes the categories that enable me to proceed beyond him as a beneficiary of the literature arising out of the Civil Rights Movement and from the New Left.

Who was Freeman Henry Morris Murray? Regrettably, there is scant documentation; we know that he earned his living as a typesetter and that he also wrote and lectured extensively on art history, illustrating his public papers with lantern slides. His book is a compilation of his lectures given at the Summer School and Chautauqua of the National Religious Training School at Durham, North Carolina, in 1913. We learn from John Cromwell, the well-known African-American historian and former professor at Howard University, that Murray began to broaden his field of inquiry when he was studying the inaccurate portrayals "of the darker races" in the paintings of the Adoration of the Magi. They "excited his protest," as he wrote in his articles and lectures, and he planned to write a more general study to include the whole range of images of black people in the history of art.

Murray begins by observing that sculpture in America did not secure a prominent place in world art prior to the Civil War, with the lone exception of Hiram Powers's *Greek Slave*. Exhibited in London at the time of the Great Exhibition of 1851, it excited much public attention. But Murray asserts that its popularity has never been properly evaluated, and that the discussion of its nudity masked the more important issue of the subject. Here he ties the reception of the work to the antislavery agitation of the period, "but then, as now, a 'white' slave would attract more attention and excite far more commiseration than a black one or one less white than 'white'."[5] While recent scholarship has made the same point,[6] Murray's observation in 1916 was new and insightful and based on the historical circumstances of the time. In support of his contention that Powers's *Greek Slave* was America's first antislavery commentary in high art, he quotes the last lines of Elizabeth Browning's poem inspired by the statue:

> Appeal, fair stone,
> From God's pure heights of beauty against man's wrong!
> Catch up in thy divine face, not along
> East's griefs, but West's,—and strike and
> shame the strong,
> By thunders of white silence overthrown.[7]

Murray concludes that Powers's work, which he considers the nation's first internationally acclaimed sculpture, is "America's first anti-

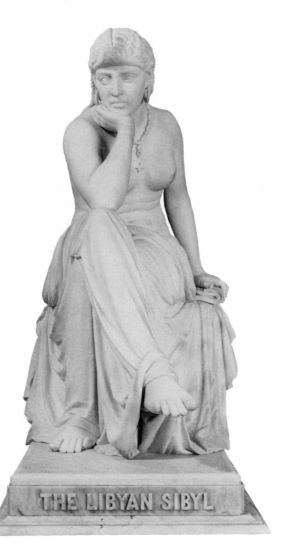

Fig. 6–1. William Wetmore
Story, *Libyan Sibyl*, 1868,
after original of ca. 1861.
National Museum of Ameri-
can Art, Smithsonian Insti-
tution. Gift of the estate of
Henry Cabot Lodge.

slavery document in marble." Related to this observation is Murray's
subtext, which runs throughout his study, that America's outstand-
ing sculpture has derived its energy and attention from its relation-
ship to the history and abolition of slavery. Slavery was the one sig-
nificant national issue that could command the talents and thoughts
of its most gifted practitioners.

The tension of the pending Civil War allowed opportunities for
artists to deal with this subject more frankly and expediently, and
for Murray the first American sculptor who directly addressed the
issue of slavery was William Wetmore Story, a New Englander who
exhibited his landmark *Libyan Sibyl* at the London Exhibition of

1862 (Fig. 6–1). Story's intentions were stated in a letter to his friend Charles Eliot Norton on 15 August 1861, where he claims the figure to be his best work:

> I have taken the pure Coptic head and figure, the great massive Sphinx-face, full-lipped, long-eyes, low-browed and lowering, and largely-developed limbs of the African. She sits on a rock, her legs crossed, leaning forward, her elbow on her knee, and her chin pressed down upon her hand. The upper-part of the figure is nude, and a rich simple mantle clothes her legs. . . . It is a very massive figure, big-shouldered, large bosomed, with nothing on the Venus in it, but, as far as I could make it, luxuriant and heroic. She is looking out of her black eyes into futurity and sees the terrible fate of her race. This is the theme of the figure—Slavery on the horizon, and I made her head as melancholy and severe as possible, not at all shirking the real African type. On the contrary, it is thoroughly African—Libyan Africa of course, not Congo.[8]

Murray is quick to spot the stereotypical comments in Story's description, and he warns his readers that they will find his "African type" less "African" than the account would lead them to expect. This is because

> the popular American conception of the African is the type exemplified by the more outlandish of the captives brought here from the Congo and Niger regions. Seldom does any American geography or illustrated dictionary or cyclopedia indicate that Africa yields any other ethnological fruit, and the specimens shown are almost always as outré and repulsive as possible.[9]

But given this reservation, Murray sees the work itself as a rare example of an American representation of black people that does them justice. Indeed, the idea for the sculpture was suggested by Story's knowledge of the life of Sojourner Truth, as provided by Harriet Beecher Stowe. Shortly after Stowe related her history to Story, he conceived of the idea for the *Libyan Sibyl*. He then requested that Stowe repeat what she had told him, and a day or two later he showed her his clay model of the figure.[10] The direct connection between the allegorical work and actual historical events predisposed Murray to view it as a precious contribution to the African-American image:

> Its purpose, its history, its frankness and truth, its "personality" one might say, should strongly appeal to us. . . . Here would seem to be a fitting work for one or more of our Colored Women's Clubs; for, so far as I am aware, not in all art, ancient or modern, American or foreign, is there a masterpiece nobler in conception and more unreservedly complimentary to our race, and to our women especially.[11]

Murray next focuses his attention on John Quincy Adams Ward's

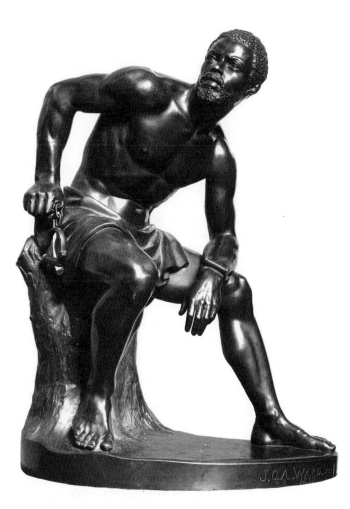

Fig. 6–2. John Quincy
Adams Ward, *Freedman*,
1863.

popular statuette called the *Freedman*, which was exhibited in New
York in 1863 shortly after the publication of the Emancipation Proc-
lamation (Fig. 6–2). Murray compiled the various critical references
to the work, carefully documenting the opposing viewpoints. An
early critic, James Jackson Jarves, writes in 1864: "A naked slave has
burst his shackles, and with uplifted face thanks God for freedom.
We have seen nothing in our sculpture more soul-lifting or more
comprehensively eloquent. It tells in one word the whole sad story
of slavery and the bright story of emancipation."[12] Later writers, on
the other hand, were less enthusiastic and missed the profundity
elucidated by Murray, including an unnamed critic quoted by
Tuckerman in his *Book of the Artists*: "Here is the simple figure of a
semi-nude negro sitting, it may be on the steps of the Capitol, a fugi-
tive, resting his arms on his knees, his head turned eagerly piercing

into the distance for his ever-vigilant enemy, his hand grasping his broken manacles with an energy that bodes no good to his pursuers. A simple story, simply and most plainly told."[13] In the same vein Lorado Taft, in his pioneering history of American sculpture in 1903, sums up the statuette in these words: "[It] is as notable for its containment as for its more technical excellence."[14] Finally, here is Charles Caffin's dismissive appraisal in his *American Masters of Sculpture* appearing in 1913, three years before Murray's work: "It shows simply a Negro, in an entirely natural pose, who has put forth his strength and is looking very quietly at the broken fetters. The whole gist of the matter is thus embodied in the most terse and direct fashion, without rodomontade or sentimentality but solely as an objective fact into which there is no intrusion of the sculptor's personal feeling."[15] Murray notes in answer that Caffin failed to take into account the stirring emotional climate under which the work was made, and that even the artist himself—judging from previous subjects he treated—had been impacted by events.

But for Murray none of the writers catch the important features of the work: the freedman's shackles are broken, but he remains partially fettered and is almost totally nude, "still un-clothed with the rights and prerogatives which freedom is supposed to connote." He is a "Freedman but not a Free-man." Murray proposes that the remaining links of his chain allude to the black's "separation—in schools, in public places, in social life, exclusion from political life; a curtailed school curriculum purportedly adapted to his special needs and limited capacities." The representation of a lone figure also suggests to Murray that the subject himself broke free from his fetters, an idea that conflicts with the indoctrination of most of his contemporaries, who believed that the slaves were "set free by Mr. Lincoln." Murray goes on to elaborate:

> But the "Freedman" was conceived and modeled in a time of "stress and struggle," while the burial parties were gathering the dead black soldiers from a half-dozen bloody battle grounds, including Port Hudson and Fort Wagner, and two-hundred thousand more black men were rallying beneath the flag whose triumph they hoped and believed would insure their freedom. Mr. Ward and many others then living had been witnesses of, and participants in, the agitations and struggles, the sacrifices and martyrdoms, which had culminated in the war then raging and which had prepared the way for the Emancipation Proclamation. These men knew well that in the struggles and even in the martyrdoms, black men had borne conspicuous and noble part.[16]

Indeed, for witnesses like Ward it would have been dishonest and mocking to have spoken of merely "bestowing" freedom on the quarter-million blacks who at that very moment were sacrificing their

lives so that "a government of the people, for the people, and by the people should not perish from the earth." It was only later, during the post-Reconstruction period, when economic competition and neo-imperialism became government policy, that sculptors could interpret the Emancipation Proclamation as an act of "charity" and "benevolence" where Lincoln had clearly stated, "An act of justice, and upon military necessity."

Murray further observes that Ward made numerous replicas of the statuette, stimulating a whole industry that turned them out by the dozens. He finds it hard to believe that so unostentatious a figure—"which portrayed but did not caricature the Negro—should have made such a powerful appeal to the parents of the present generation."[17] In fact, and here I take leave of Murray's argument, Ward created an ambivalent figure that is neither sitting nor standing. Although the physical characterization corresponds to the idealized nudes of mainstream nineteenth-century sculpture, the indeterminate action leaves the narrative unresolved and thus proved unoffensive even to prejudiced whites. The critics generally perceived the figure

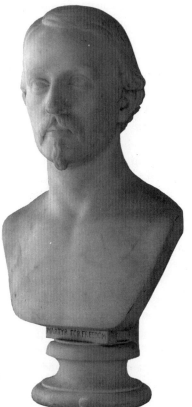

Fig. 6–3. Edmonia Lewis,
*Bust of Robert Gould
Shaw*, 1865.

as immobile and quiet—in a sort of transitional state that would have placated the fears of Northern liberals in the wake of the Emancipation Proclamation and Reconstruction. Murray interprets this in-between state as prognostic but his interpretation squares with the critics while at the same time supplying a different emphasis and approaching it from the opposite perspective. Although the work strikes him as positive, it is essentially a conservative statement meant to reassure the "parents of the present generation." Caffin further verifies the conservative signification in his claim that the wide popularity of the group demonstrates "how keen and true was Ward's instinct for the sculpturesque qualities of sculpture and for the limit to which it is safe to go in the interpretation of sentiment."[18]

Murray next takes up the marble group carved by Edmonia Lewis, the daughter of a black father and a Chippewan mother. Lewis attended Oberlin College—a liberal school that admitted racially mixed students—just prior to the outbreak of the Civil War. Oberlin's admission policies, however, had been haunted from the first by controversy, and the tension between black and white, always intensified by the town-and-gown conflict, created a hostile environment for the strong-willed Lewis. She was plagued by accusations of theft and attempted murder, and although acquitted she was never permitted to graduate. This outcome prompted one hostile classmate to comment that it would "humble her some"—evidence that it was her independent personality that aroused the enmity of her peers.[19]

Lewis then moved to Boston, where abolitionists subsidized gifted African-Americans and paraded their achievements to counter the racist arguments of the proslavery party. She met William Lloyd Garrison, who in turn introduced her to a local sculptor named Brackett. Brackett lent her studio fragments to copy, including a bust he did of the martyred John Brown. From this she sculpted her own medallion of Brown, copies of which were sold to abolitionists and advertised in Garrison's *Liberator*. She also executed busts of Garrison, Charles Sumner, and Wendell Phillips, attesting to the social milieu in which she now moved. By her own statement, her first major work was the portrait bust of Col. Robert Gould Shaw, the widely lamented leader of the 54th Massachusetts Volunteer regiment of black troops, who lost his life in the assault on Fort Wagner (Fig. 6–3)[20]. She claimed that she made the bust "out of grateful feeling, 'for what he has done for her race'." Shaw's family considered it an excellent likeness and organized a group to purchase a hundred copies at fifteen dollars each. Indeed, the bust is a remarkable translation of Lewis's apparent photographic source (Fig. 6–4).

The publicity generated by the Shaw bust and the sale of its replicas helped finance her trip to Italy the following year (1865),

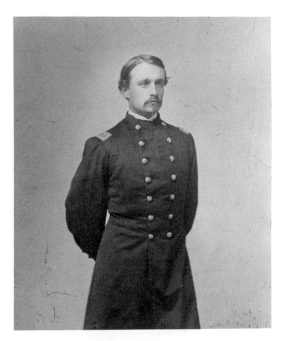

Fig. 6–4. Robert Gould
Shaw, ca. 1863.

and eventually she established a studio in Rome. There she partici-
pated in the American community of expatriates and immediately took
up the theme of the emancipated slave. Her first sculpture done in
Rome depicts a woman wearing the chains of a slave, kneeling in
gratitude as she learns of her emancipation while her son embraces
her. Lewis claimed that it owed its inspiration to her desire to do
something "for my poor father's people." She used the same theme in
1867 for her most well-known work, *Forever Free*, originally called
The Morning of Liberty, both titles having been inspired by the rheto-
ric that had ultimately found its way into the Emancipation Procla-
mation (Fig. 6–5). This time the kneeling woman is paired with a
standing male: she clasps her hands in grateful thanks, while he
holds up the broken chain in his left hand and with his left leg
steps onto the discarded ball and chain.

The theme of "forever free" had become a major source of hope
and propaganda for black people and their abolitionist supporters in
their drive to gain maximum political recognition during the Civil
War. It became a formula adapted to popular poetry:

God's law of compensation worketh sure,

So we may know the right shall age endure!

'*forever free!*' God! how the pulse doth bound

At the high, glorious, Heaven-prompted sound

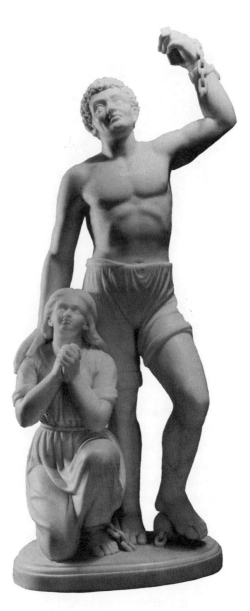

Fig. 6–5. Edmonia Lewis,
Forever Free, 1867.

That greets our ears from Carolina's shore!
'forever free!' and slavery is no more!

This motif was launched by the proclamations of Maj. Gen. John C. Frémont, then in command of the Union Armies in the West. Frémont, who was subsequently dismissed by Lincoln, had taken it upon himself to free a number of slaves as early as September 1861. In one case, he manumitted the slave of a city and county official of St. Louis who supported the Confederacy, declaring "Hiram Reed,

heretofore held to service of labor by Thomas L. Snead, to be FREE, and forever discharged from the bonds of servitude."[21]

Lincoln actually annulled this proclamation, but its logic took on a kind of momentum within the ranks of his commanding officers. Maj. Gen. Hunter, whose action inspired the poem above, issued an even bolder statement from his headquarters at Hilton Head, South Carolina, on 9 May 1862: "Slavery and martial law in a free country are altogether incompatible. The persons in these three states, Georgia, Florida, and South Carolina, heretofore held as slaves, are therefore declared forever free."

Lincoln hastened to annul this order as well, claiming the responsibility for declaring slaves free was reserved to himself alone. These actions were praised by the proslavery press of the North as well as of the South, but before this message reached South Carolina, Maj. Gen. Hunter was furnishing slaves with free papers that declared the bearer "free, and forever absolved from all claims to his services." Two months later the Second Confiscation Act and the Militia Act formally adopted emancipation and the employment of fugitive-slave labor as military weapons. These acts declared "forever free" all captured and fugitive slaves of rebels and authorized the recruitment of blacks "in any military or naval service for which they may be found competent." Eventually these actions gave Lincoln no other choice than to assimilate the formula in both the Preliminary Emancipation Proclamation of September 1862 and the final version of 1 January 1863. While the Emancipation Proclamation freed no more slaves than had the Second Confiscation Act, it captured the imagination of the Northern public and elevated the prestige of the Union in the eyes of the entire Western world.

The swelling chorus of those broadcasting the theme of "forever free" reached a crescendo in Washington, D.C., on the last night of December 1862. A major demonstration gathered at what was called the "contraband camp," a temporary habitation for runaway slaves received by the Union Armies and defined as "contraband of war." They waited for the coming day, when, as stipulated in the Preliminary Emancipation Proclamation, they should become free. The demonstrators spent the night singing songs and prayers, and, just after midnight, they sang an ode written especially for the occasion, whose chorus ended "Free forever! Forever free!"

> Ring, ring! O Bell of Freedom, ring!
> And to the ears of bondmen bring
> The sweet and freeman-thrilling tone.
> On Autumn's blast, from zone to zone,

The joyful tidings go proclaim,
In Liberty's hallowed name:
Emancipation to the slave,
The rights which his Creator gave,
To live with chains asunder riven,
To live free as the birds of heaven,
To live free as the air he breathes,
Entirely free from galling greaves;
The right to act, to know, to feel,
That bands of iron and links of steel
Were never wrought to chain the mind,
Nor human flesh in bondage bind;
That Heaven, in its generous plan,
Gave like and equal rights to man.
Go send thy notes from shore to shore,
Above the deep-voiced cannon's roar;
Go send Emancipation's peal
Where clashes North with Southern steel,
And nerve the Southern bondmen now
To rise and strike the final blow,
To lay Oppression's minions low.
Oh! rouse the mind and nerve the arm
To brave the blast and face the storm;
And ere the war-cloud passes by,
We'll have a land of liberty.[22]

After singing the final refrain, "Free Forever! Forever Free!," the demonstrators "seemed to leap for joy: some were singing, some praying, some weeping, some dancing, husbands embracing wives, friends shaking hands,—a sister broke out in the following strain, heartily joined in by the vast assembly:

Go down, Abraham, away down in Dixie's land,
Tell Jeff Davis to let my people go.[23]

Here in a nutshell is an account of the pressures on Lincoln moving him inexorably to take a step he was reluctant to take until the last moment. As the ode suggests, those involved in this movement were not passive recipients of the Emancipation Proclamation but active

militants—many of whom were blacks who were soon to put their
lives on the line in the volunteer regiments.

The author of this reportage is William Wells Brown, the first
major black novelist and essayist in North America. It was published
in 1867, the year Edmonia Lewis sculpted her group known as *For-
ever Free*, which attempted to embody the sense of exhilaration expe-
rienced that early morning of 1 January 1863. That Lewis acknowl-
edged this connection is seen in the ceremony in which she
presented her group to the Rev. L. A. Grimes at Tremont Temple,
Boston, on 18 October 1869. Among those giving addresses in
honor of the occasion were William Lloyd Garrison and William
Wells Brown.[24]

It is this sculpture that Murray discusses in his book, taking off
on a critic's remark (which he actually misread, since the critic had
in mind an earlier work she did in Rome) that the kneeling woman
"was represented as overcome by a conflict of emotions on receiving
tidings of her liberation." Murray's response to this observation
again attests to his historistic approach:

> Those who know the conditions affecting the Freed people which were
> prevailing in 1867 . . . will not find it difficult to imagine what would
> be the nature of the conflicting emotions which this sculptress would
> herself feel and would therefore, consciously or unconsciously, embody
> in this figure.[25]

Murray declares that by American custom Lewis was "identified
wholly with the Negro." Thus she had to experience her *Freed-
woman* (his title for *Forever Free*, which he had not yet seen) differ-
ently from the way Ward had experienced his *Freedman*. Not only
the racial differences, he claims, but the different moments—although
relatively close in time—in which they worked gave rise to different
conceptions. When Lewis modeled her group in 1867,

> Reaction—re-enslavement, I had almost said—had set in. If, perchance,
> Mr. Ward and other sincere and absorbed souls had not observed it,
> Miss Lewis and "her people" had felt it. The Sun of Emancipation
> which had risen in 1863, had seemingly reached its zenith in 1865
> with the passage of the 13th Amendment prohibiting slavery. But al-
> ready it was being obscured by the clouds. Already the sheriff's hand-
> cuffs were taking the place of the former master's chains; already the
> chaingang stockade was supplanting the old slave pen. . . . The freed-
> woman was being told that it would be better for her children, even in
> the North, to go to "separate" schools; and that it would better, "for a
> while, anyway," for her people not to "thrust" themselves forward too
> much but to accept "separation" on public conveyances and in public
> places. She was being gravely assured that there was no degradation
> nor detriment in all of this. "Of course," she was being told with a ca-

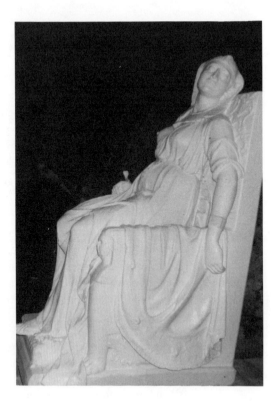

Fig. 6–6. Edmonia Lewis,
Death of Cleopatra, 1876.

joling smile, "your people will be more 'comfortable' to have churches
and a social circle all your own: public sentiment, you see, is not yet
ripe enough—: you know you've got to begin at the bottom" etc., etc.[26]

In the course of setting up the type for the book (he did the type-
setting himself on his brother's presses), Murray succeeded in locat-
ing the group, which at that time belonged to George Glover, an
African-American living in Boston. The sight of the original did not
substantially affect Murray's interpretation, but he did send a photo-
graph of it to another black female sculptor, Meta Vaux Fuller, who
gave it the following reading: "The man accepts it [freedom] as a glo-
rious victory, while the woman looks upon it as a precious gift."[27]
Her distinction between the attitudes of the male and female added
considerable insight to Murray's complex reading, hinging on the
presumed identification of the sculptor with her female subject.

 While Murray still shows an exceptional trace of inflexibility in
view of his mistaken preconception, his appreciation of the historical
influences on Lewis's work is borne out by the sculptor's subse-
quent career: she returned to her native land only during summers
or for business, and her late years are a blank, with the date and the
place of her death unknown. Her last notable public appearance

came with the exhibition of the bizarre *Death of Cleopatra*,[28] which
she sent to the Philadelphia Centennial of 1876. This is an angry
and conflicted image of Cleopatra writhing in agony, her face dis-
torted into a pained grimace (Fig. 6–6). That such an embodiment of
feminist power should be subjected to this unprecedented treatment
suggests Lewis's alienation from the neoclassical circle in Rome and
gives evidence of antifeminist feelings turned against herself. A
shrewd businesswoman, however, Lewis often took her show on the
road, participating in western fairs to avoid the competition in New
York and setting up booths in the form of wigwams, emphasizing the
links between the West and her Native American heritage. It is clear
that she devoted much of her time to her financial affairs to subsi-
dize her permanent exile.[29]

Lewis tried to find her way into the cosmopolitan society of the
American colony in Rome, and she evidently encountered a layer of
prejudice even in the tough-minded feminist circle of the sculptor
Harriet Hosmer and the actress Charlotte Cushman. As at Oberlin,
she refused to act out the assigned role of the passive black and dis-
regarded the proprieties of upper-class society that still marked the
lifestyles of her more advantaged white counterparts. She wore man-
nish costumes and acted out the role of the eccentric, transforming
herself into an exotic attraction for her visiting American compatri-
ots.[30] Her early conversion to Catholicism around 1868, however,
evinces her need to overcome her sense of isolation and also raises
interesting questions about the pressures of race and class in her
new surroundings. It is possible that her masochistic female images,
more consistent with male fears of emasculating women, provided a
psychological compensation for her unconventional lifestyle and mas-
culine identity. In this context, the sculptures could be seen as em-
bodiments of her frustration at the very real powerlessness that she
tried to overcome and which she despised in her sex.

Lewis's *Forever Free* is carved, ironically, from white marble.
Like Manet and Melville, she went out of her way to break the ster-
eotype, in this case using the beloved medium of the neoclassical
idealists to render the physiognomies and the costumes of an op-
pressed ethnic group. Whereas Hiram Powers exploited white marble
for his discreet Caucasian slave, Lewis appropriated the medium for
her metaphorical black sister and brother. This action may be read
on two levels: either she "liberated" the white marble from its exclu-
sive function in perpetuating the hegemony of white mythology and
history—thereby liberating blacks from their stereotyped role in art—
or she used the color "white" in this instance as the desired goal of
emancipation and the "ideal" state of all peoples. In this connection,
Murray was disturbed to find that the physiognomy of Lewis's kneel-
ing female more closely resembled a white person than that of the

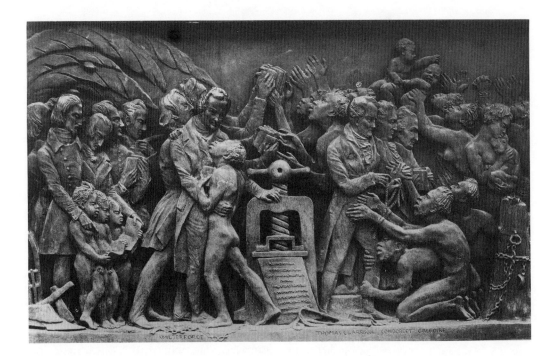

Fig. 6–7. David d'Angers, *Emancipation Relief for Gutenberg Monument,* 1840.

standing male. This phenomenon he compares with what he called "toning," the attempt on the part of some blacks to lighten their complexion in identification with their oppressors, or the predominant social group. He does admit "that there may have been some justification for such a procedure at that time, before fifty years of unexampled accomplishment had proven that what Black Folk really need, and should strive for, is not the Caucasian's physical features but the Caucasian's opportunity."[31]

Both Murray and Fuller rightfully see the kneeling figure as more problematic than the male. The formula for sculpture in the nineteenth century generally positioned subordinate, accessory, or complementary figures in kneeling positions. Such figures pay homage in the peripheries of a public monument to the "great ones" depicted on the pedestal, or, when occupying the same space as the protagonists, do so in acknowledgment of their "deliverance" from oppression, plague, or natural calamity. (We have already seen black kings reduced to this status in the presence of the Christ child, despite the seeming naturalness of this position as a condition of prayer.) Given the tradition, Lewis's female figure has to be seen as subordinate and dependent in the double sense of gender and race; she accepts her freedom not as something earned but as something bestowed by a benevolent power, and it is a male power who actively destroys the chains that bind her. As the victim of both racism

and sexism, "freedom" is more ironic for the woman than for the man.
The male places his hand condescendingly on her shoulder as he
lifts the manacles up to heaven. In his case, "God helped him who
helped himself," but in her case she had to rely on external supports
for her deliverance. One variation in the formula is that the genu-
flecting female does not gaze at her standing black benefactor, but
away from him to some unseen force, presumably a transcendent vi-
sion of Lincoln. Lewis's group manifests her personal indebtedness
to the predominantly (white) male social reformers and abolitionists
who guided her early career and who show up most frequently in
her portrait busts.

The idealization of the emancipation moment manifested itself in
all the visual media that showed exulting seminude blacks holding
up broken manacles and kneeling in gratitude to formally clad
whites. David Brion Davis provides one example of this iconography,
a bronze relief by the French sculptor David d'Angers for his Guten-
berg monument in Strasbourg (Fig. 6–7).[32] Commemorating the his-
tory of printing and the power of the printed word, this relief cen-
ters on a printing press from which a large printed sheet has just
been run off. At the left, the figure of William Wilberforce rests one
hand on the press while his other clasps the back of a naked black
male who embraces his "liberator" with a look of impassioned grati-
tude. Though a small man in actuality, Wilberforce towers over the
diminutive black, whose face registers the outsized lips and the ex-
aggerated prognathism of popular caricature. At the right, three
naked black men kneel at the feet of Thomas Clarkson; Condorcet,
the French thinker and radical theorist who supported abolition;
and the abbé Grégoire, the only *ami des noirs* to survive the French
Revolution. Clarkson unties the ropes that bind the wrists of the
first kneeling figure, who replicates the posture of the kneeling slave
in Wedgwood's famous abolitionist icon entitled *Am I Not a Man and
a Brother?* The second black embraces Clarkson's leg, and the third
clasps Condorcet's hand. Grégoire is in the process of handing over
a Bible, while in the background Europeans are seen distributing
books to eagerly raised hands and well-dressed whites teach three
naked children to read.

Images of emancipation, like the actual emancipation rituals and
ceremonies, were designed to emphasize the dependence of the
emancipated slaves upon their benefactors as well as their ongoing
need for the culture and the guidance of their liberators. Thus eman-
cipation is shown to have occurred under controlled conditions that
muted the idea of self-sufficiency and independence. Emancipation-
ists masked their fears of slave revolts, or their own need for black
support, by maintaining the fiction of black people's ongoing
dependence on the white power structure that abolitionists also ex-

ploited in their debates with the proslavery groups. Murray identi-
fies this phenomenon in his astute analysis of the representations of
black people, mainly by foreign artists, at the Centennial Exposition
in 1876. He stated that the attitude to emancipation derives basically
from conditions of exploitation. Such conditions are so pervasive
and so ancient that most people, including the victims, come to re-
gard them as natural and inevitable. And he elaborates:

> So Emancipation—even under the circumstances through which it came
> about in this country—is conceived and expressed nearly always as a
> bestowal; seldom or never as a restitution. Hence American art—and
> foreign art, too, it seems—usually puts it: objectively, "See what's been
> done for you"; or, subjectively, "Look what's been done for me."[33]

The iconographic embodiment of this conservative ideological con-
viction was the image of what I call the *abased slave* and the *exalted
liberator*. Although Lewis subverts this formula somewhat by substi-
tuting the half-clad black slave for the well-dressed white, she essen-
tially sustains the traditional model by suggesting an unseen "libera-
tor" acknowledged by the upturned head of her kneeling female.
Murray's problematic response to Lewis's work and his analysis of
other groups in which this stereotype appears demonstrate that he
clearly grasped its political implications.

 This is most evident in his examination of Thomas Ball's *Emanci-
pation Group*, the original of which was unveiled in Washington,
D.C., in 1875. In Murray's time this group had become a popular icon
itself as the exemplification of the moment of emancipation. For him
this constitutes "conclusive evidence of the need of an 'enlarged vi-
sion,' and of greater circumspection and care in analysis and inter-
pretation."[34] He quotes Taft, whose glowing praise he ultimately chal-
lenges: "His [Ball's] conception of Lincoln is a lofty one. . . . One of
the inspired works of American sculpture; a great theme expressed
with emotion by an artist of intelligence and sympathy, who felt
what he was doing."[35] Murray, however, considers this group "as far
less adequate than it has been popularly regarded." On the whole,
he asserts, it degrades the theme of emancipation to the level of con-
ventional religious representations of Jesus and the Magdalene. In
fact, Ball comes perilously close to making Lincoln appear to be say-
ing: "Go, and sin no more," or, "Thy sins be forgiven thee,"[36]

 Murray is anxious to point out its contradictions and negative
projection, because the work had been held in high regard by many
of his "fellow-citizens and fellow-sufferers" who not only had con-
tributed to the fund for its erection but also felt that any type of im-
aging of black people was "a step forward."[37] Above all, as he points
out, the concept of Lincoln functioning as a bestower of liberation

as if in blessing or benediction is so contrary to historical fact that it
seriously distorts the gains made by black people through their own
efforts and sacrifices:

> As for the kneeling—or is it crouching?—figure, his attitude and ex-
> pression indicate no elevated emotion, or any apparent appreciation of
> the duties and responsibilities of his new position and little if any con-
> ception of the dignity and power of his own personality and manhood,
> now first recognized and respected by others. He seems to have a hazy
> idea that he is, more or less, or maybe is about to be made, free, but it
> appears probable that introspectively, he is yet a "kneeling slave." In
> his attitude he more exemplifies a man who perhaps has escaped ex-
> treme punishment by commutation of sentence, than a man who feels
> that he is one of those who, as the Declaration of Independence ex-
> presses it, "are, and of right ought to be free"! If he should speak, he
> would probably murmur, dubiously and querously, "O Mr. Lincoln! am
> I—?" Whereas, Ward's "Freedman" plainly and somewhat resolutely
> says: "Well Sir; you see I am."[38]

Murray remarks in a footnote that the presence of the large iron ball,
with attached chain and ankle fetters "such as convicts frequently
carry, but which slaves in America seldom or never did, gives added
color to the convict idea."[39] Murray claims that Ball's group was orig-
inally called *Lincoln and a Kneeling Slave* (the sculptor referred to it
in his autobiography as *Lincoln and a Liberated Slave*), but the sculp-
tor consented to its use as a representation of the emancipation
theme. Murray further notes that the pamphlet put out for the inau-
guration ceremonies of the Boston replica in 1877 erred in its inter-
pretation, which follows:

> The work was conceived and executed by Mr. Ball, under the first in-
> fluence of the news of Mr. Lincoln's assassination. The original group
> was in Italian marble, and differs in some respect from the bronze
> group. In the original the kneeling slave is represented as perfectly pas-
> sive, receiving the boon of freedom from the hand of the great liberator.
> But the artist has justly changed all this, to bring the presentation
> nearer to the historical fact, by making the emancipated slave an agent
> in his own deliverance. He is represented as exerting his own strength,
> with strained muscles, in breaking the chain which had bound him. A
> greater degree of dignity and vigor, as well as of historical accuracy is
> thus imparted.[40]

Murray cites this quote to show that a segment of the public has
recognized the work's initial inadequacy as a monument to emancipa-
tion, and he concludes that it would have been vastly improved if
the naked slave had been eliminated altogether. It would take a great
stretch of the imagination to see the slave "exerting his own strength

with strained muscles"—a perception that the contemporary specta-
tor can verify.

To add to the realism of his group, the sculptor modeled the
head of the black man after a photograph of Archer Alexander, the
last slave taken up in Missouri under the Fugitive Slave Act, who
was rescued from his captors under orders of the provost-marshal of
St. Louis. Alexander's condition of bondage legally continued until
Lincoln proclaimed emancipation, and those who commissioned Ball's
work considered him the appropriate model for the kneeling slave.
The inaugural pamphlet declares: "The ideal group is thus converted
into the literal truth of history without losing anything of its artistic
conception of effect."[41] Murray hastily repudiates this suggestion as
self-serving, concluding that the only changes were the facial fea-
tures and that what we see in this group "is probably no more the
literal truth of history than is usual in such cases; perhaps less than

Fig. 6–8. George E. Bissell,
Emancipation Group,
1893.

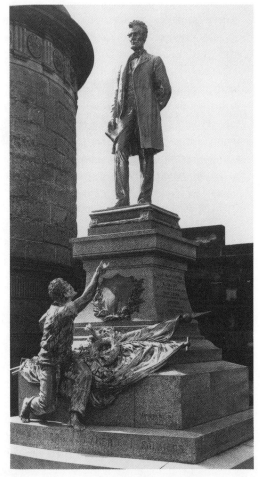

is usual."[42] This is confirmed by Ball's own autobiographical recollections, where he claims that he used himself as the model for the position of the slave. He had difficulty finding an appropriate model, so he hit upon the idea of lowering his clay to the floor to enable him to work on it in kneeling fashion with the help of mirrors.[43]

Murray seems to have overlooked a reference to an incident in Ball's youth that throws light on his ambiguous presentation of the kneeling black man. Ball worked for a private museum in Boston whose proprietor maintained a separate policy for blacks: they were not admitted on special occasions like the Fourth of July celebration. On such holidays the museum was mobbed, and crowd control was the owner's special concern. As Ball recalls: "And if his good eye happened to fall upon a negro coming up the stairs, he would call out in his big, jolly voice, 'Here you darkey! You'd better turn back; we don't want any huckleberries here tonight.' That witticism invariably put the crowd in good humor."[44] Ball wrote these recollections at the end of his life, and it is clear he still found the "joke" amusing and the attitude perfectly acceptable—although he then may have been under the influence of the climate of prejudice in the United States that marked the last few years of the century.

Murray finds much more congenial George E. Bissell's *Emancipation Group*, commissioned for the old Calton burying ground in Edinburgh, Scotland, and dedicated to Scottish-American soldiers who served on the side of the North during the Civil War (Fig. 6–8). Lincoln occupies the pedestal; below, a black man serving as an allegorical personification is shown partly kneeling and partly rising to greet the emancipator with an upraised right arm. In this instance, Lincoln is a "recipient" and not a "bestower," and his arm is not extended as if in blessing or benediction—a gesture that Murray particularly resented. Yet even here he allows for the difference in historical epochs: Bissell's work was unveiled in 1893—thirty years after Ball's group—when conditions were favorable for a broader and more sober perspective. At mention of Lincoln's name, the thoughts that sprang to mind "were no longer of a deliverer and martyr but rather of a level-headed, far-sighted, and supremely patriotic statesman: an accomplisher of great things rather than a bestower of large benevolences."[45] In 1893, Murray continues, one could recognize that emancipation was not the personal work of a single individual, and that in the end it had to be seen as an act of supreme duty and as overwhelmingly important "as an aid in securing a justifiable end."[46] Murray sees emancipation not so much as "an immediate and unmitigated blessing as a gradually unfolding opportunity."[47] Here he shows a basic contradiction in nineteenth-century American liberal thought, which, as David Brion Davis put it, "honored the abolition of slavery as a glorious moment of national rebirth

Fig. 6–9. Thomas Nast,
Patience on a Monument,
1868.

and in the next breath . . . acknowledged that emancipation was in
many ways a failure, and that its main significance lay in establishing
a national commitment that had yet to be fulfilled."[48] Murray's atti-
tude toward the various emancipation groups is rooted in his frus-
tration over the contradiction between his glorious historical memory
and the world as he encounters it in everyday life.

Hence he overlooks the subordinate position of the black man
in Bissell's sculptural group, corresponding to the standard conven-
tions of heroic monuments that located allegorical complements and
"ordinary" mortals on a lower register. So deeply ingrained was this
convention that Thomas Nast could parody it with an imaginary
monument to the African-American *victim*, enabling him to reverse
the pattern and locate his black protagonist, a Civil War veteran,
atop an elevated pedestal (Fig. 6–9). At the base of the pedestal in-
scribed with a long list of atrocities against blacks and quotations
from contemporary hate literature lie his dead wife and children. In
this triangular plan the victims occupy both the apex and the base,
but the monument becomes a gravestone.

Comparing the image of the black man with that of Ball's group,
Murray can claim that he is "neither dazed nor exultant. He is,

nevertheless, appreciative and thankful." Murray queried the sculptor on his intention, and Bissell replied that the black man's "impulsive gesture" calls the world's attention "to the man who was the author of the freedom of his race, and is an exemplar for all rulers and law-makers that may follow."[49] Murray sees this as an improvement on the Ball concept, for in this case the freedman functions dynamically for all his fellow citizens and projects his appreciation and their acclaim forward to future generations. Nevertheless, from the contemporary perspective Bissell's advance on Ball is minimal, cleverly concealing his preference within the conventions of official sculpture. But his black man remains marked by "an impulsive gesture" that acknowledges Lincoln as his savior, thus precluding rational self-government and understanding of the process by which he gained his freedom. Like an interval in an animated sequence, the black man is shown rising up slightly from the prostrate position of the Ball; this in-between stage corresponds to the type of compromise that Booker T. Washington encouraged and which Murray in frustration seems to have settled for in his constructions. Analogously, he could commend Ward's Henry Ward Beecher Monument, unveiled two years earlier than the Bissell, because the young African-American woman flanking the abolitionist displayed "no suggestion of abjection nor appearance of bewilderment."[50] Yet the figure

Fig. 6–10. John Quincy Adams Ward, *Henry Ward Beecher Monument*, 1891. Brooklyn Historical Society.

occupies a lower level of the monument exactly as in the emancipationist formulas and looks on the godlike effigy adoringly like a true believer (Fig. 6–10).

Murray likewise responds enthusiastically to Levi T. Scofield's *Emancipation Panel* in the Soldier and Sailor Monument in Cleveland, Ohio, which was dedicated on 4 July 1894 (Fig. 6–11). Again, Lincoln occupies the central position and is flanked by the four Ohio statesmen who advised him to publish the Emancipation Proclamation: Salmon P. Chase, John Sherman, Benjamin Wade, and Joshua R. Giddings. Lincoln is portrayed holding aloft shackles with his right hand, while his left hand grasps a musket and accessories. The musket is also grasped by a freedman in military costume who, with his right hand upraised, takes the soldier's oath. Murray imagines the trooper repeating the words of the oath and making his own contribution akin to that of the black color-sergeant at Port Hudson: "I'll bring back these colors in honor, Sir, or report to God the reason why."[51]

Murray perceives this memorial as giving "double recognition" to black people for their contribution to the cause of freedom, a rare portrayal that he attributes to the liberal tradition of Ohio's Western Reserve and the city of Cleveland. It is even more remarkable

Fig. 6–11. Levi T. Scofield, *Emancipation Panel*, 1894.

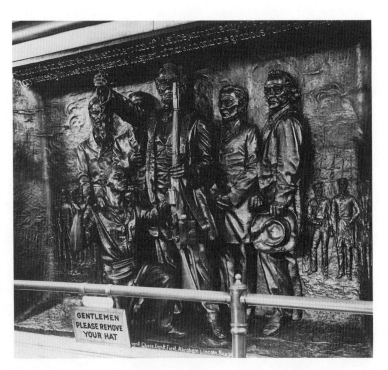

when we remember that, of the numerous productions of American art—
including sculpture, painting, and especially illustration—in which
Black Folk are depicted, far the greater number are insidious belittle-
ment or plain caricature or worse, this panel by Scofield must grow in
our regard; for it takes of none of these: nor is it one of that other
class of productions which, while not exactly offensive or irritating,
yet, when we view them, incline us to say to ourselves: "Well, yes;
that's correct, I suppose, but—."[52]

Here Murray provides us with a rare insight into what it means for
an ethnic minority to live under a constant bombardment of images
defining their social and political role in behalf of the dominant ide-
ology. In this context, he could overlook the fact that the black man
in the Scofield relief rests on one knee, thus maintaining—albeit in
modified form—the visual convention for depicting the abasement of
the subordinate social groups.

Nevertheless, Murray expresses general dissatisfaction with the
emancipation groups he has studied, essentially criticizing the cul-
ture for not having produced a representative worthy of the event—
including its authentic causes and the role of its principal beneficiar-
ies. Murray next cites the well-known critic of his time, Kenyon
Cox, who, in his *Classic Point of View*, gives the theme of emancipa-
tion as an example of the kind of conception that lends itself easily
to verbal exposition but defies visual embodiment. Murray disagrees,
hinting that Cox falls back on convenient aesthetic formulations to
rationalize the failure of American culture to produce a representa-
tion of an event of such "great and far-reaching importance" on a
par with the great history painting of the past.[53]

The nearest any single work came to his concept, despite its
failure to embody the complete chain of ideas connected with the
theme, was the sculptural group entitled *Emancipation Group* (or
Emancipation Proclamation) by Meta Vaux Warrick Fuller and exhib-
ited at the Emancipation Exposition held in New York City in Octo-
ber 1913 to commemorate the fiftieth anniversary of the Emancipa-
tion Proclamation (Fig. 6–12).[54] Murray notes that, independent of
its content and technique, the work especially interests him because
it was conceived and executed by "one of the race of the 'emanci-
pated'." The group centers on a newly emancipated couple standing
under a gnarled, stunted tree that takes the form of a human hand
stretched threateningly above them, while a weeping woman tries to
urge them forward. Fuller sketched her intention in a letter to Mur-
ray, claiming that the black "has been emancipated from slavery but
not from the curse of race hatred and prejudice."[55] Thus the funda-
mental idea of the group represents "Humanity weeping over her
suddenly freed children, who [stand] beneath the gnarled fingers of

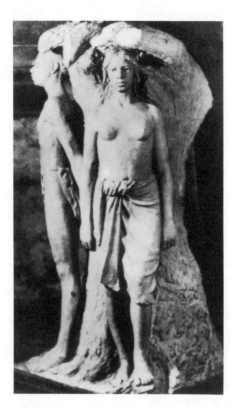

Fig. 6–12. Meta Vaux
Warrick Fuller, *Emancipa-
tion Group*, 1913.

fate grasping at them to draw them back into the fateful clutches of
hatred, etc."[56] Thus they are unable to fully exercise their new-found
freedom and stand nude, empty-handed, and vulnerable; the man
and the woman are conflicted on the one hand by their eagerness to
test out their freedom, and on the other by their timidity and uncer-
tainty in the face of danger. While they try to realize all that free-
dom implies but hesitate to take the plunge, the menacing branches
begin to envelop them.

Murray praises not only the conception, but also the formal
means through which it expresses itself. The figures are almost
motionless—appropriate for a sculptural group—while the execution
constitutes a repudiation of the smooth contours, the graceful forms,
and the conventional ideal of "beauty" of the academic school in
which most American artists were indoctrinated. This outmoded style
is of course unrealistic, and for Murray the more independent efforts
of the Americans Barnard, the Borglums, and Konti, and in Europe
of Rodin, get closer to reality, to "deep seriousness of purpose and
virility in expression." These workers are indifferent to "finish" and
risk seeming "incompleteness" to express character with utmost di-
rectness and simplicity.[57]

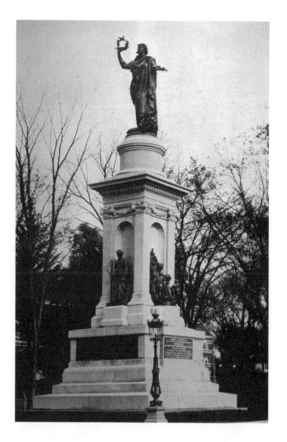

Fig. 6–13. George E. Bissell, *Soldiers and Sailors Memorial*, 1884.

Noting that Fuller leans in the direction of this movement, he also praises her absence of affection and display:

> The portrayal is emptied of the usual accessories as well as of the frequent claptrap—no broken shackles, no obvious parchments, no discarded whips, no crouching slave with uncertain face; no, not even a kindly, benignant Liberator appears; in short, she essays to set forth and to represent, not a person, not a recipient—not the Emancipator nor one of the Emancipated—not even the Emancipation itself, as a mere formal act, but far higher, the Emancipation as an embracing theme.[58]

In short, Murray sees in Fuller's sculpture the first modern representation of the theme so central to his life's work. Here the artist provided a screen onto which he could project his deepest aspirations as well as his anxieties for the future of black people in North America.

Similarly, Murray reserves some of his highest praise for Bissell's *Soldiers and Sailors Memorial* in Waterbury, Connecticut, which had been inaugurated in 1884 (Fig. 6–13).[59] One face of this monument,

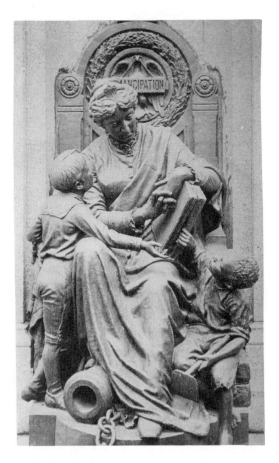

Fig. 6–14. Detail of Bissell's monument, showing *Emancipation Group*.

entitled *Emancipation Group*, depicts a seated maternal figure in an attitude of listening, having seemingly interrupted her reading to listen to a well-dressed white child at her right knee (Fig. 6–14). The woman's right foot rests on a cannon, beside which is a broken shackle. The fillet binding her hair is ornamented with a shield of stars and stripes—she is Mother Country as well. While she leans forward to hear the words of the schoolboy, she simultaneously gazes at "a ragged little Negro" seated on a cotton bale at her left foot. He holds a hoe in one hand, while with the other he attempts to pry open the book on her knee. The white child makes an appeal on behalf of the young black child to extend to African-Americans the same educational advantages enjoyed by whites, and the black child "illustrates by his position and action the eager desire of his race to secure the education which they know to be necessary to success in a free republic."[60]

Murray comments on this group: "If indeed this Negro boy represents his race mentally—as he plainly does physically—it would

be difficult to express, concerning the race, anything more compli-
mentary and reassuring."[61] The motif of the child taking his own ini-
tiative to gain an education profoundly moved him, prompting this
effusive response: "I know of nothing in American art that is more
frankly and generously complimentary to Black Folk."[62] This in turn
led to his praise for the town of Waterbury itself, for "only a gener-
ous and noble community, would have sanctioned such a representa-
tion."[63] Henceforth he would carry a photo of this work with him to
counter the tiresome claim that there existed a natural and instinctive
aversion of one race for another—a weak argument to buttress culti-
vated prejudice and "calculated meanness."[64]

In his enthusiasm for the monument Murray overlooks the
French-trained Bissell's exploitation of sculptural conventions to
maintain the ranking of the dominant majority. A hierarchical ar-
rangement is achieved through the central position of the maternal
personification of the state—based on standard allegories of the Re-
public and Liberty—and moves in descending order to the white
schoolboy standing at her side and thence to the black child seated
on the cotton bale. While incorporated into the main action, the
black child literally occupies a position at the lowest point of the
composition, analogous to the black's marginalization in earlier genre
painting. The child is further discriminated against by his allegorical
attributes, which are notably absent in the case of the schoolboy.

Fig. 6–15. Levi T. Scofield,
Mortar Practice, 1894.

The incongruous cotton bale serves the function of justifying a seated—that is, lower—position in the social order. The fact that the black child is associated with the accessories of slave life as late as 1884 suggests that white society remained reluctant to yield up the image—as well as the actual control. Murray's applause for this work signifies the extent of the impoverishment of American cultural practice and entrenched racism in the late nineteenth century.

The narrow options for sculptors under these conditions show up most strikingly in the numerous military monuments of the post–Civil War epoch. Murray tabulated that only three of these monuments, which could be found in nearly every major town in the United States, included a black representative. The earliest of the three, Scofield's *Mortar Practice* in Cleveland, dated from as late as 1894 (Fig. 6–15). Scofield depicts a mortar platoon in which a black soldier is conspicuously placed. He is strikingly posed as if prepared to meet a present danger, whereas the others in the group appear absorbed in their duties. Murray catches himself expressing a certain machismo but sees it as consistent with the ideal motivating public monuments:

> Whether indifference to danger or contempt of it is an actual military asset, is nowadays being seriously questioned. But such has long been held up as the ideal. Hence Scofield's portrayal was intended to be— and it actually is—highly complimentary to Black Folk; and the courage displayed by the artist in executing this group was of a character at least as praiseworthy and as effective for ultimate good as the courage which he ascribed to this stalwart black man.[65]

Murray attributes Scofield's unusual portrayal of the black soldier to the fact that the sculptor had served in the Civil War and had thus seen black men in action on the battlefield. He further emphasizes that Scofield did not fall prey to the typical tendency of white artists who depict black people in crisis to show "squeamishness" and "equivocation," nor did he indulge in "covert caricature." The black man is portrayed "doing a noble work—a man's work, in a manly way. We could ask no more and I trust that we shall never, without protest, accept anything less."[66]

Similarly, he applauds Frederick MacMonnies's *Navy* group for the Soldiers' and Sailors' Memorial at the entrance to Prospect Park, Brooklyn, which depicts a black sailor conspicuously among a group of frontally posed heroes. The work was totally unexpected from the sculptor, who gained his reputation for his "rollicking Bacchante" and "lissom Diana," but he rose to the occasion in a spectacular fashion. Murray wonders how it could be possible that as late as 1900, "long after the Nation had grown cold, if not callous, toward its black defenders," MacMonnies could have produced such a

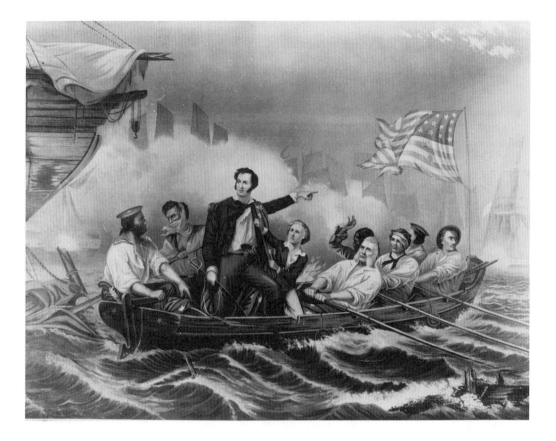

Fig. 6–16. William Henry Powell, *Battle of Lake Erie*, 1868.

work.[67] Again he sought a historical explanation, ascribing its conception to the temporary sense of fraternal feeling that followed the Spanish-American War. As in the Scofield, the combatant readies himself for instant action: "There is no indication of apprehension, much less of fright; no, not even where one might not be surprised to find it depicted: in the facial expression or the attitude of the one Negro in the group."[68]

Murray willfully overlooks the fact that in the MacMonnies monument the black figure is shown kneeling, in contrast to his standing buddies, thus maintaining the old separation. But beside similar depictions in painting and sculpture, it did appear progressive. Murray had in mind such grotesque portrayals as the squeamish sailor in Powell's painting, *The Battle of Lake Erie*, a copy of which hangs at the head of the main staircase in the Senate wing of the Capitol building (Fig. 6–16).[69] At the time Murray wrote, it was the only work of art commissioned by the federal government that displayed a black defender. But the black man in the boat with Perry expresses exaggerated fright at the splash of a cannonball that has

fallen nearby, while all of his (white) companions are shown wholly unconcerned with or oblivious to the danger. Murray marvels that such "an injustifiable and inexcusable falsification" should have been approved and installed in its official setting in 1871, less than ten years after blacks had sacrificed their lives at Fort Wagner, Port Hudson, Mobile Bay, and Fort Fisher, and while social reformers like Charles Sumner sat in the Senate. He concludes: "Their eyes must have been strangely holden."[70]

Murray's outspoken denunciation of the figure has to be placed alongside white responses to the work's initial appearance in 1865. One Ohio politician (the original was commissioned for the rotunda of the Ohio Capitol) voiced outrage over the presence of a black at Perry's side, thus giving the black a "prominent place" in the state-house. He fumed over Powell's demand for an increase of ten thousand dollars above the original asking price and remarked, "Well ten thousand dollars for a nigger."[71] Aside from wanting to rewrite history (Perry's black servant Hannibal was indeed in the boat), the politician was surprised to see a black break the color barrier of the visual sign system dominated by hegemonic white culture. Thus in the "free" state of Ohio, whence many blacks came who volunteered for the all-black regiments, mere inclusion in the visual hierarchy was sufficient to make newspaper editorials.

While for Murray exclusion is intolerable, inclusion alone is not enough. This is brought home dramatically in Murray's condemnation of the *War Group* by Bruno Schmitz on the Soldiers' and Sailors' Monument in Indianapolis for its omission of a black representative. In a battlefield scene of the Civil War with a wide array of American types and allegorical personifications of War and Columbia, this absence was particularly regrettable and dishonest. Conversely, on the opposite face of this shaft, the relief entitled *Peace* does depict a black man, but he shows up as a kind of afterthought or supernumerary. The scene represents the homecoming of the soldiers at war's end, and the reunion of families is presided over by an allegory of Peace and her emblematic accessories. At her feet the black man lifts up his broken chains, reminiscent of the "grabbag-like 'grand finale' of our old country tableau-exhibitions in which every character in preceding 'pictures' turns up," from "'Mother Goose' to the 'Angel of the Resurrection', and from 'Columbus' to 'Uncle Tom and Eve'—adding, of course, 'Uncle Sam' and 'Columbia' with the flag, and as many other characters as we were able to costume and could crowd on the stage."[72] In other words, the freed black in this instance is insultingly stagey, and according to Murray the figure's glaring inappropriateness resulted from its last-minute addition owing to civic pressure. But Murray refused to be taken in by such a fraudulent inclusion:

I cannot see that it serves any worthwhile purpose so far as "we" are concerned. And when I look at the relief I think of what Ruskin said concerning a certain statue which he much admired, except for one thing. His objection lay against an obtrusive buckle, or some such appurtenance, which he said he could scarcely refrain from knocking off with his walking-stick. So like-wise, I feel an impulse to seize this "super" by his dangling foot and slide him gently off into oblivion—or else say to him, as sternly as I can: "Awake, awake, put on thy strength . . . shake thyself from the dust; arise." You deserve a place at Liberty's side, not at her feet. Assist her soberly to uphold the Flag, while others rejoice; for, but for your strong right arm the Flag would even now perhaps be trailing in the dust![73]

Here is art criticism torn from the spleen, alive and impassioned— leaving the professionals "trailing in the dust."

Murray's wide-ranging perspective could even embrace Southern sculptors and their depictions of black people, despite his understanding that the region produced few practitioners because of the "lack of the environment, and the freedom, which fosters art of

Fig. 6–17. Edward Virginius Valentine, *Knowledge Is Power*, 1868.

the higher, which means the nobler, class." But his curiosity drives
him to ask if Southerners "ever depicted any Black Folk, and if so,
after what manner were they portrayed?" Murray's research un-
earthed "astonishingly few" examples, especially given the fact that
Southerners were surrounded by blacks on every hand and also
must have been aware that those "picturesque and pathetic folk"
were profoundly attractive to Northern and foreign artists.[74]

His sole illustration in this category is Edward Virginius Valen-
tine of Richmond, Virginia, whose work he first came across in read-
ing Lorado Taft's *History of American Sculpture*. Taft mentions Valen-
tine's *Knowledge Is Power*, showing a black child asleep with a
dog-eared book dropping from his hand, and he compares it to the
satirical genre groups of John Rogers (Fig. 6–17). Murray, without
having seen the sculpture, went to work on the title, which he con-
sidered highly ambiguous. While seemingly sarcastic, it contains a
sinister connotation, reminding him of a discussion he once heard of
the possible meanings of the Indian name "Afraid-of-Nothing." Some
held that it should be taken literally as signifying a person without
fear, whereas others claimed that it meant precisely the opposite; that
is, that the person is so excessively frightened of life that she is even
afraid of things less than imaginary—nothing at all. Murray applies
this double reading to Valentine's ragged black youth, whose de-
jected state could be interpreted as either an indictment or a takeoff.
He places it on the level of an "end-man's joke," the banter between
the performer in a minstrel show who sits at the end of the company
and the interlocutor.

Murray's analysis was right on target. Valentine, who in fact
did a series of takeoffs on black citizens of Richmond, meant this
work to be an indictment of Northern liberalism. In the biography of
her granduncle, *Dawn to Twilight*, E. G. Valentine draws upon his
personal reminiscences as well as his manuscripts to describe his
work. After a brief training under Thomas Couture, Valentine moved
to Berlin to study with the sculptor August Kiss. Valentine's grand-
niece records in her biography that it was while he was working in
Germany that the Civil War broke out, and at this point she inter-
rupts the narrative to venture her opinion on the subject, which she
no doubt shared with her granduncle: "We all know the result, and
appreciate the South's attitude in choosing war rather than submit to
what she believed wrong."[75] Clearly, she assumed a Southern reader-
ship for her biography and their sympathy for an antebellum world.
Valentine did a statuette of Lee from photographs received in Berlin
and sold it in Liverpool for the benefit of the Southern cause. De-
spite his advantageous situation in Germany "he returned to Rich-
mond in 1865 to face reconstruction days in the South."[76]

A hint of bitterness pervades these reflections on Valentine,

Fig. 6–18. Edward
Virginius Valentine, *The
Nation's Ward*, 1868.

who sorely missed the camaraderie of his Parisian days and regretted
leaving Kiss's studio, which had been offered to him by the sculp-
tor's widow. His confrontation with the day-to-day exigencies of Re-
construction and lack of commissions could only have sharpened his
resentment over lost opportunities. His former semiaristocratic life-
style had to be exchanged for the professional life of the artist, with
the need to advertise himself and to find clients, who were exceed-
ingly scarce in that depressed period. The accumulated resentment
found an outlet in 1868 with the first of his genre portrayals of
black people. According to his grandniece's account, Valentine en-
countered "a little darky" who sparked his interest, and he asked
him to sit for a bust that he subsequently entitled *The Nation's Ward*
(Fig. 6–18). This is her description of the work:

> The darky's head is thrown back with a smile on his carefree face none
> can resist, eyes half closed in merriment and the typical flat, broad nose
> of his race in prominence. On his kinky, cocoanut shaped head is an
> old army cap with visor turned up at a rakish angle. His low, square
> neck shirt is kept on by the single strap of his overalls which are knot-
> ted together. He is charming and characteristic of "the pickaninny."[77]

One look at Valentine's bust leaves no doubt as to the "accuracy" of
his grandniece's interpretation; its close-up, spiteful emphasis on the
physical defects of the upturned face (gaps between the teeth, swol-

len eyelids) and the dishevelled clothing were meant to project this "ward" of the nation in the worst possible light. Valentine's nasty formulation exploits a vulnerable child as the pretext for discrediting Reconstruction, as if the child—and by extension the entire newly enfranchised black population—is not only below political awareness but also oblivious to his own exploitation as the pawn of unscrupulous Yankees. Just as Murray suspected, Valentine's titles are deliberately ambiguous and cruelly mock their subjects from inside Southern culture. On 13 May 1868 two women from the North visiting Richmond saw a copy of the bust and thought the title and the sentiment had positive connotations, "but on conversing with a Southern gentlemen found it was meant as satire."[78]

Valentine had used the same model for his *Knowledge Is Power*, executed the same year. The description unequivocally verifies Murray's reading:

> On an old kitchen chair with torn rug thrown over the seat, sleeps the kinky-haired, broad-nosed, thick-lipped darky of the days "before the war." With his head falling on one side, his mouth open, and the whites of his eyeballs almost visible, one can nearly say, "I hear him snore." His scanty clothes consist of tattered shirt open from neck to waist, short coat minus elbows, and patched trousers. A book unread and unreadable, lies open on his right hand, which is all but slipping off his knee. His left arm hangs limp by his side, his feet, which are partly covered in "old men's comforts" are stretched forward, while five toes peep out.[79]

Murray rightfully concludes that this concept attempted to contravene that which he most cherished: the infinite capacity and the determination of black people to educate themselves. Thus Valentine's statuette bitterly derides the most important accomplishment of the Freedmen's Bureau—the establishment of the free school concept among blacks, and the idea of free elementary education for all classes in the South. As Du Bois noted, the opposition to black education during Reconstruction mobilized the worst traits of the old South, which "believed an educated Negro to be a dangerous Negro."[80]

Under the guise of realism, Valentine tried to produce an image that would repel the viewer. The figure's slack jaw, the exaggerated thrust of the slumbering body, the limp limbs, and the sculptor's obsessive preoccupation with the shabby clothing demonstrate that he mobilized all the horrid details at his disposal to express his personal disgust. His realism casts the subject in a negative light by its concentration on physical deformities and a deteriorating costume. The result is an ad hominem attack on the body and the soul of an exposed human being, a kind of overkill of his subject that attests to the irrationality of Valentine's response to historical change.

A third example in the series is Uncle Henry, a bust of the family coachman of "ebony hue" who drove his "white folks" to the races to watch their thoroughbred run. As the grandniece recalls: "Many years later his 'young master' modelled a bust of him which is typical in its interpretation of the old time darky with a broad grin and half-closed merry eyes which express his adoration. He wears his coachman livery, soft stock with flowing bow, over a ruffled front shirt."[81] Here the nostalgia for the Old South clearly manifests itself, further emphasized by the fact that Valentine inscribed on the plinth of the work just beneath the title, "Ancien Régime." The sculptor recorded in his diary entry of 4 April 1896, when he was at work on a monument to Jefferson Davis, that he had a visit from two Northerners and a Southern black who had been a juror at Davis's trial. They had inquired about local antiques, and Valentine noted with bitter irony: "How strange the darky juror and the Northern man both looking for the 'old things of the south'."[82]

Valentine's grandniece refers to a fourth study of a black person entitled The Old Negro, which she claims shows off the sculptor's "keen sense of humor."[83] Thus every one of his images of blacks reduces them to caricature or makes them the target of cruel jests. This use of sculpture for "end-man" burlesque is almost without precedent in the history of nineteenth-century sculpture (even Daumier's Ratapoil takes on the tyrant Louis-Napoleon, thus guarding a "high art" referent in its attack on authority at the highest level), especially for a sculptor indoctrinated in the neoclassical ideal of August Kiss. Valentine's grandniece insists upon his wholehearted devotion to "idealism" and depicts him as a gentleman of the old school who refused to "sacrifice his ideals to uncultured demands" and preserved "at all cost the worthiest traditions of the best art," cherishing and protecting them "against the encroachments of inferiority born of quick sales."[84] Hence, she confesses, he was doomed to obscurity. No doubt she eliminated the series of images of blacks from contention, just as she segregated them in her text under the category of "negro subjects."[85] If she had not overlooked this inconsistency, she may have uncovered a more historical explanation for Valentine's sense of failure and lack of recognition.

My claim that satire and jest are incompatible with the "noble" genre of sculpture needs qualification in the context of American sculpture. The lone exception to the general rule are the popular groups of John Rogers, one of Murray's favorite sculptors. Murray's enthusiastic admiration for Rogers runs so deep that he occasionally excuses the type of lapses and formal conventions he is quick to condemn in Rogers's contemporaries. He characterizes Rogers as a populist sculptor, whose work appeals chiefly to the common people "of whom I am pleased and proud to regard myself as one."[86] Rogers's

gentle sense of humor, akin to that of "Mr. Rogers" of the Public Broadcasting System, engaged with proverbial and anecdotal statements to forge a consensus of progressive, middle-class Northerners. He rarely makes a joke—especially a racially motivated one—at someone else's expense, and he presumes an audience of Northern moderates like himself.

Rogers, moreover, stood apart from his contemporaries. He was an isolated phenomenon, most visible from around 1860 to 1890, who considered himself as much an artisan and a businessman as a creative artist. His achievement required wholesale rejection of neoclassical doctrine, which stipulated an ideal subject with the frozen look of "eternity" and celebrated rarified thought accessible only to a cultured elite. During the years 1858 to 1859, which he spent abroad, he fell in with the American colony at Rome that practiced this system, and it immediately repelled him. He notes that neoclassicists wished to eliminate accessories in favor of an abstract concept, but for him these "little odds and ends" were the mainstays of his sculptural narratives: "You see when you leave all those out it is difficult to make any particular action or position tell the story."[87] He cites the example of Hiram Powers's *Greek Slave*, whose popularity he attributes to the presence of the emblematic chain that "told the story."

Rogers knew his audience well—an understanding rooted in his artisanal background. Although he was descended from proper Bostonians on both sides of his family, his father so poorly managed his inheritance that Rogers was raised in conditions far below the level of the family's class status. Young Rogers trained as a tool-and-dye mechanic and spent most of his youth in machine shops in New England and the Midwest, working on sculpture groups in his spare time. Following his return from Europe in 1859, he sold his first group, *Checkers Players*, at a fund-raising fair in Chicago, and the response of the crowds to his work prompted him to conceive of a mass-produced art form for a broad spectrum of the middle class.

His second group, *The Slave Auction*, executed on the eve of the Civil War in 1859, launched his long and successful career (Fig. 6–19). It depicted a miniature environment about a foot high, with an auctioneer at the rostrum hammering away at the bids and a male slave on one side of the box confronting the offstage bidders with folded arms and a defiant gaze, while on the other side his tearful octoroon wife presses a naked baby to her bowed face and a toddler hides in the folds of her skirt. A sign on the front of the rostrum bears these words: "Great Sale of Horses, Cattle, Negroes & Other Farm Stock—This day at Public Auction." Rogers targeted his audience and calculated well: abolitionists attempted to enlist the sympathy of Northern whites by appealing to their Victorian pride in the extended family, and they did so by calling attention to the slaver's

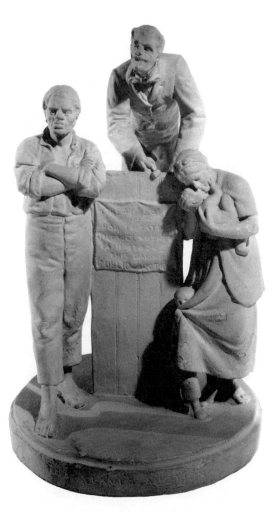

Fig. 6–19. John Rogers, *The Slave Auction*, 1859. Courtesy of the New-York Historical Society, New York City.

disdain for family ties and their inhumane separation of husbands and wives, parents and children, to get "fair-market value." The sculptor established the idea of separation metaphorically through the division caused by the auctioneer's box, and by the distinctive body gestures of the black protagonists. Rogers, who frequently sent his groups to prominent individuals for promotional purposes, sent a replica of *Slave Auction* to Henry Ward Beecher, who wrote that the sculptor ingeniously translated the thought of the abolitionists into visual form.[88]

Settling in New York because of the availability there of technical facilities and a responsive clientele, Rogers proceeded to produce replicas of this group to meet the large demand. When he discovered that enough sympathy for the South in the Empire State prevented retailers from offering his products for sale, he opened his own outlet and hired a black man to sell them on the street. He planned

from the start "to employ a good looking Negro to carry them round on a sort of tray, with an appropriate notice printed in the front. . . . The black man will be a distinguishing feature from the italien [sic] & it will bring them more into notice than any other way I think."[89] As a result of such marketing techniques and with patents on all of his groups, by the end of the decade he was distributing them to major art dealers and retail stores and maintaining a staff of twenty artisans to reproduce the pieces. The plaster copies were generally from eight to thirteen inches high and sold for anywhere between six and fifteen dollars. Murray observes that Rogers put out eighty thousand copies of more than fifty different groups, and one could find them in shop windows, parlors, schools, raffles, and fairs.

Murray was well aware of the objection of the culture gurus to classifying Rogers's groups as "art." He prefers to define his work as "sculptural story-telling" and even compares him to Jesus of Nazareth, of whom it could be said "that the common people heard him gladly."[90] Murray notes that Rogers produced at least six Civil War groups (including *The Slave Auction*) that depict black people. While he acknowledges that they were all done for "Northern consumption," he commends Rogers for such sympathetic and touching portrayals, which work a positive effect and deserve the gratitude of his "emancipated fellow-countrymen."[91]

Rogers's *The Wounded Scout or a Friend in the Swamp* shows a black fugitive rescuing a severely wounded Union soldier in a Southern marshland, and Murray quotes Taft's description: "A soldier torn and bleeding and far gone is rescued and raised up by a faithful and kind-souled negro."[92] Murray agrees that the main theme of the work is the black's compassion for "One of his fellow-men," but he has reservations about Taft's interpretation of the black man as a kind of loyal servitor of a deserving master. He further declares that the group would have been equally appealing "and just as true as to fact, if the uniform on the rescued soldier had been Confederate instead of Union."[93] Murray implies here that the black man is unfairly imputed to be meting out preferential treatment or demonstrating dogged loyalty to an ex-master, rather than simply responding to someone in need of help.

Murray also singles out *The Fugitive's Story* (1869) as "touching and eloquent in its appeal" (Fig. 6–20).[94] The fugitive—a young black woman holding an infant in her arms, with a bundle containing all her possessions at her feet—stands before a writing desk at which sits William Lloyd Garrison, the abolitionist editor of the *Liberator*. Standing near him are two other noted social reformers, the preacher Henry Ward Beecher and the poet John Greenleaf Whittier. They listen with grave dignity and sympathy to the story told them by the escapee, and each, in his own particular way of combat-

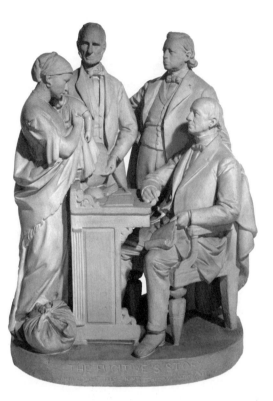

Fig. 6–20. John Rogers,
The Fugitive's Story, 1869.
Courtesy of the New-York
Historical Society, New
York City.

ting slavery, will publish the account in some form. Murray points
out that they were representative, respectively, of the entire spec-
trum of the Friends for Freedom, epitomizing as they did the three
main divisions: the militant, the political, and the conscience-stricken.

Yet in all this there is a striking contradiction: the white social
reformers dominate the composition, forming a semicircle that sur-
rounds the eponymous hero in a protective, patriarchal embrace. The
woman appears lackluster and slumped under her burden (despite
the energy and determination that would have been required to find
her way into such a situation), in contrast to the men who stand or
sit erect with august bearing and elegant attire. They receive her
with condescension, standing far enough apart from her to maintain
an air of detachment. Murray himself, as much as he admired the
work, had to admit that, "as one looks at this group, it is difficult
not to pay more attention to the listening 'audience' than to the
speaking 'actor,' the fugitive hero who is telling the story."[95] While
far in advance of David d'Angers, Rogers nevertheless maintains in
visual form the analogous constraints imposed on black freedom by a
society eager to define the limits of that freedom and to maintain
black people in a state of dependence.

Murray gained further insight into the wellsprings of Rogers's

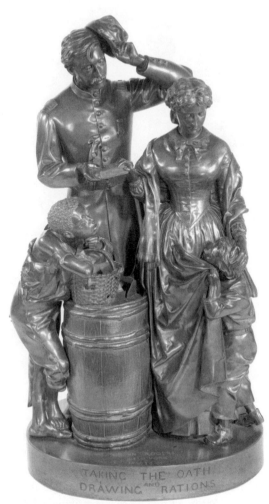

Fig. 6–21. John Rogers,
*Taking the Oath and
Drawing Rations*, 1865.
Courtesy of the New-York
Historical Society, New
York City.

outlook in his analysis of *Taking the Oath and Drawing Rations* (Fig.
6–21). This scene takes place in the occupied South; a Confederate
woman has to pledge an oath of allegiance to the Union before
being allowed to draw rations from the federal commissariat. She
clearly has been driven to this expedient as a last resource, con-
cerned for the health of her child, at whom she gazes while perform-
ing the oath perfunctorily. A young black servant leans his chin
nonchalantly on the basket soon to be filled with food, scanning the
face of the woman with curiosity and wonderment. The black's ca-
sual attitude is a token of his new status and guaranteed by the
Union environment, but he still functions as servitor and is relegated
to sly commentary on the central motif. Murray admits that he sees
nothing here that could give offense to Southerners and concludes
that the group makes "an equal appeal to South and North."[96] Here

again he intuited correctly: Rogers favored the conciliatory policy to the South and opposed the Radical Republicans.

Murray devotes the second longest section of his book to a discussion of the group I have already analyzed, *Uncle Ned's School* (Fig. 4–13). Rogers's widow brought it to the attention of Murray, who saw it for the first time in the course of writing his book. He considers it unique because "all the persons in it are Black Folk" and claims it demonstrates that Rogers had more "depth and insight" than he had previously suspected.[97] Yet in his description of the subject we recognize many of the features of Valentine's biting satire. The use of the word *school* is misplaced, since there is no school here and Uncle Ned is not a teacher but a student of a much younger person. His breeches are patched in a crude fashion, and he looks intently at the book "with a perplexed and troubled countenance."[98] Meanwhile, a mischievous urchin seated on the floor has put aside his book and tickles the bare foot of Ned that dangles over the cupboard.

Murray bends over backward to give Rogers the benefit of the doubt, particularly since the subject concerns the educational issue that Murray sees as central to black progress. Ned grew to maturity before the war and had no opportunity for learning, "hence the dull, un-responsive mind, disclosing itself in the be-fogged, discomfited look." But despite his age, "the marvel of mankind—he desires to learn; nay more, he strives to begin learning, and *book*-learning at that." Rogers shows him pausing in his work to make another stab at the text, while his young teacher waits patiently for "the slow working of the unpracticed brain." The young woman has been attending a public school founded by some Yankee "enthusiast," but now it is supported more efficiently by public taxation. Under the new state constitution and the laws of the Reconstruction era, people have begun the building of the New South with the support of "the labor and the votes of a million 'Uncle Ned's'."[99]

Murray encountered some difficulty with the "mischief-loving urchin," which he ascribed to Rogers's irrepressible sense of humor and satirical disposition. This impish type

> inhabits every land and infests every temple of worship and of learning, and cabin's sunny side. He is black here, of course. But he, too, has a book. Its condition indicates that it has been used, although he has put it aside for the moment. I am glad that it is a book, even if it is not in use just at the present. I am glad that he has not been merely "training" with a hoe or a handsaw.[100]

Murray's problematic reading of this motif reveals tortuous repetitions in his effort to convince himself that Rogers's motives are con-

sonant with his own. What he would not accept in the Valentine, he willingly excuses in the Rogers.

I argued in Chapter 4 that *Uncle Ned's School* is a put-down of Reconstruction efforts to educate the enfranchised blacks, one of the most successful programs of the era. Rogers's caricatured males, either too dull-witted or too "mischief-loving" to learn, while externally more benign than Valentine's vicious slurs, are inherently related to the same fears and anxieties shared by the ruling white elite. The "young miss with smiling face" exhibits intelligence and learning capacity, but this is allowable in her case since Victorian sexism consigned women to the domestic interior far removed from the competitive world of males. It is the fear of competition at the workplace that discomfited Northern interests, especially the artisanal class with whom Rogers identified.

Murray, however, steadfastly supports his hero and in the process betrays his own Victorian blindspot. Continuing his defense of the group, he struggles with the contradictory signals it communicates to him:

Fig. 6–22. Augustus Saint-Gaudens, final version for *Shaw Memorial*, 1901.

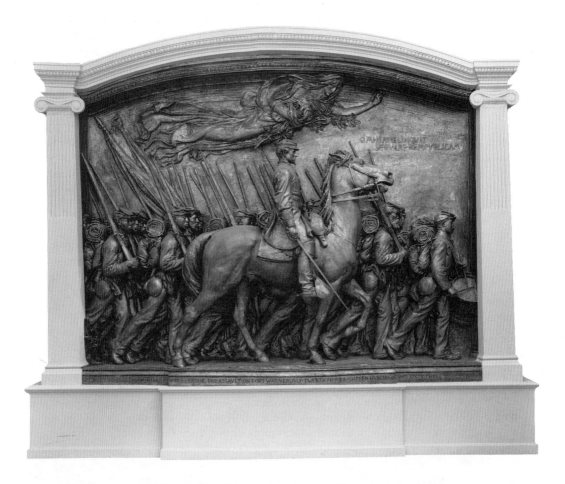

I am very glad that the early "enthusiasts" started us right—with books. It will not be their fault, and not wholly ours, if we are pushed off, or inveighed off, the right track now. These people knew, and I believe that Rogers knew also, that advancement is easy and sure—to act with the hoe and the hands and the thimble—from the book foundation, but extremely difficult, slow, and precarious the other way. Look at the group again. "Uncle Ned" strains his muscles, his nerves are in tension, his forehead wrinkles, his thick lips pucker; but he just can't—. Notwithstanding the evident thickness of the integument, it is possible that the tickling of his foot disconcerts him a little. What bearing, if any, that has on his perplexity, I shall leave for others to argue over. There is, however, no mistaking the placid, smiling assurance of the girl who has been attending school—the Public's school, and therefore "Uncle Ned's School."[101]

SAINT-GAUDENS'S SHAW MEMORIAL

Murray's only other judgmental lapse—an understandable one once the autobiographical facts are known—involves his even lengthier evaluation of Augustus Saint-Gaudens's *Memorial to Robert Gould Shaw*, with which he terminates his book. He had claimed at the outset of his investigation: "For artistic reasons, for racial reasons, and *for personal reasons*, I desire to direct special attention to a certain sculptural work, with the consideration of which we may properly close" (emphasis mine).[102]

Saint-Gaudens was a celebrated sculptor whose memorial to Col. Robert Gould Shaw on Boston Common was generally considered his masterpiece. Shaw led the country's first black volunteer regiment, the 54th Massachusetts Volunteer Infantry, and fell in its assault on Fort Wagner in 1863.[103] Saint-Gaudens's bronze relief depicts Shaw and his troops marching in profile, with the officer elevated in the center and leading on horseback (Fig. 6–22). Murray lauds the work as "a memorial to a man, a race, and a cause." He recollects that Rodin "reverently took off his hat before this monument," adding that it seemed "strangely providential that the greatest of American military memorials should have been inspired primarily by the valor and devotion of Negro-American soldiery."[104]

The history of this event and the evolution of the commission make fascinating chapters in themselves, as both are intimately bound up with the aims of various black constituencies and the aspirations of the abolitionists. In February 1863 Robert Gould Shaw, a young Bostonian of patrician parents who actively participated in the worldwide abolitionist movement, was named by the governor of Massachusetts to lead the country's first black volunteer regiment. The absorption of black soldiers into Union ranks provided a vast

source of manpower that enhanced the antislavery character of the war. Black enlistment and emancipation advanced together and became inseparable, thus demonstrating the positive, practical role of blacks in bringing about their own freedom.

Prominent among the advocates of enlisting freemen for the North was John A. Andrew, governor of Massachusetts and a determined opponent of slavery.[105] Andrew figured prominently in the abolitionist movement and wanted to make his mark in this critical period. Black leaders and abolitionists had proposed the formation of black volunteer units from the outset of the war, and under Andrew the idea took concrete shape. He carefully screened white officers (following Secretary of War Stanton's stipulations) whose high social standing could counter anticipated opposition to black fighting outfits and eliminate the stigma that might plague officers joining such a group. Andrew's letter of 30 January 1863 to Shaw's father, the Massachusetts abolitionist Francis Shaw, spoke of his organization of a "colored regiment" that he hoped could serve as a "model for all future colored regiments."[106] For this reason he wanted its officers

> to be young men of military experience, of firm anti-slavery principles, ambitious, superior to vulgar contempt for color, and having faith in the capacity of colored men for military service. Such officers must necessarily be gentlemen of the highest tone and honors; and I shall look for them in those circles of educated anti-slavery society, which next to the colored race itself have the greatest interest in the success of this experiment. Reviewing the young men of this character I have described, now in the Massachusetts service, it occurs to me to offer the colonelcy of such a regiment to your son, Captain Shaw of the 2nd Massachusetts Infantry. . . . With my deep conviction of the importance of this undertaking in view of the fact that it will be the first colored regiment to be raised in the free states, and that its success or its failure will go far to elevate or to depress the estimation in which the character of the colored American will be held throughout the world, the command of such a regiment seems to me to be a high object of ambition for any officer. My mind is drawn towards Captain Shaw by many considerations. I am sure that he would attract the support, sympathy and active cooperation of many besides his immediate family and relatives. The more ardent, faithful and true Republicans and friends of liberty would recognize in him a scion from a tree whose fruit and leaves have always contributed to the strength and healing of our generation.[107]

It might seem odd that Andrew did not make his pitch directly to Robert Gould Shaw but to his father, using every type of inducement and flattery to persuade the elder Shaw of the need for his son to take on a symbolic role as head of the regiment. Andrew's intimations of his own personal stake in forming the "model" regiment and

the high price he attached to its potential performance in the eye of world opinion would indicate a certain callousness toward Shaw, his immediate family, and the troops themselves. His offer of the "colonelcy" to a captain represented in itself an extraordinary military promotion, suggesting that Andrew hoped to tap the ambition for glory that the younger Shaw—who left Harvard after his junior year to join the Union Army—actually craved.

Andrew had to surmount opposition to the concept of black soldiers from Northerners and members of his own constituency and factor in the Confederate Congress's resolution condemning the command of white officers over black troops and declaring that any such Union officer captured would be subject to execution or otherwise harsh punishment. But Andrew shrewdly enlisted the aid of Northern allies and gained the support of Ohio governor David Tod, who urged Ohio freemen to join the Massachusetts regiment, assuring them—erroneously as it turned out—that the terms of their enlistment would be the same as those of white soldiers. By the end of March 1863 recruiters had more than filled the 54th Massachusetts Volunteer Regiment and began forming a second black Massachusetts regiment.

Andrew presented the colors to the regiment with great fanfare on Boston Common, 28 May 1863. Black groups with their ensign and banners, special flags, and various civic organizations crowded to pay their homage to the regiment on the day of its departure for the front in South Carolina. The governor's presentation speech stressed the exceptional nature and historical importance of the event, marking "an era in the history of the war, of the Commonwealth, of the country, and of humanity:"

> I need not dwell upon the fact that the enlisted men constituting the rank and file of the fifty-fourth Regiment of Massachusetts Volunteers are drawn from a race not hitherto connected with the fortunes of the war. And yet I cannot forbear to allude to the circumstance, because I can but contemplate it for a brief moment, since it is uppermost in your thoughts, and since this regiment, which for many months has been the desire of my own heart, is present now before the vast assembly of friendly citizens of Massachusetts, prepared to vindicate by its future, as it has already begun to do by its brief history of camp-life here, to vindicate in its own person and in the presence, I trust, of all who belong to it, the character, the manly character, the zeal, the manly zeal, of the colored citizens of Massachusetts and those other States which have cast their lot with ours.[108]

Andrew went out of his way to arrange events to emphasize his personal role; he knew, and his audience knew, that the "race" in question was profoundly "connected with the fortunes of war." His rhe-

torical repetition of traits like "character" and "zeal" with the qualifier "manly" implies that he still felt the pressure to persuade his audience of the desirability of his action. He certainly does not conceal his stake in the hoped-for success of the regiment, reminding all that his reputation rides on it:

> My own personal honor, if I have any, is identified with yours. I stand or fall, as a man and a magistrate, with the rise or fall in the history of the Fifty-fourth Massachusetts Regiment. I pledge not only in behalf of myself, but of all those whom I have the honor to represent to-day, the utmost generosity, the utmost kindness, the utmost devotion of hearty love, not only for the cause, but for you that represent it. We will follow your fortunes in the camp and in the field with the anxious eyes of brethren and the proud hearts of citizens.[109]

Andrew then shifts to the abolitionist-inspired idea of the regiment as a symbolic and actual force in the liberation of slaves in the South; with the arms provided by the state of Massachusetts,

> they have found breathed into their hearts an inspiration of devoted patriotism, and regard for their brethren of their own color, which has inspired them with a purpose to nerve that arm, that it may strike a blow which, while it shall help to raise aloft their country's flag—*their* country's flag now, as well as ours—by striking down the foes which oppose it, strikes also the last blow, I trust, needful to rend the last shackle which binds the limb of the bondman in the rebel States.[110]

Did Andrew understand the implications of the color symbolism he used when presenting the flag to Shaw? "The white stripes of its field will be red with their blood before it shall be surrendered to the foe." Shaw's response to Andrew as he accepted the colors demonstrated that the significance of the governor's agenda was not lost on him. Thanking him for the flags, he spoke in behalf of the troops: "May we have an opportunity to show that you have not made a mistake in intrusting the honor of the state to a colored regiment!— the first State that has sent one to the war."[111]

At the conclusion of Shaw's remarks, the regiment marched out of Boston Common toward Boston Harbor with the cheers of a vast crowd urging them on. But not everyone in Boston shared this enthusiasm. As they marched past certain clubs and mansions, some Bostonians pulled down their window shades to protest what they considered an offense to New England propriety. From the perspective of a nineteenth-century black author, however, who noted that the regimental banner of the 54th bore a golden cross on a golden star, the black troops carried the first Christian banner into battle. Thus by a "strange, and yet not strange, providence, God has made

this despised race the bearers of his standard. They are thus the real leaders of the nation."[112]

The subsequent history of the regiment on the field is a story of heroism, tragedy, and ruthlessness on the part of both North and South. On 16 July the Confederate Army attacked the 54th on James Island but, although outnumbered, the regiment routed the rebels. Twelve days later they were ordered to lead the assault on the well-defended Fort Wagner and met a murderous volley of fire as they neared the walls. Col. Shaw was one of the first to fall as he mounted the parapet and shouted the order to advance. Despite the loss of their commanding officer, the regiment pushed forward, and more than one-half succeeded in reaching the inside of the fort. Sgt. Carney managed to plant their banner on the ramparts before being driven off by the rebels. Even Confederate accounts emphasized the "courage and determination" manifested on both sides at Fort Wagner.[113] But the losses to the 54th were heavy and compounded by the summary execution of captives and the desultory medical relief provided the wounded.

Several facts in the case also indicate gross negligence on the part of Union headquarters. The forward drive of the 54th Regiment was not supported by rearguard troops nor aided by the guns of the fleet, who quietly watched as the soldiers retreated or fell into the hands of the rebels. It was believed that if the fleet had moved up at the same time and raked the fort with their artillery, the 54th would have succeeded in overrunning their target. The naval captain said in his defense that he knew nothing of the maneuver and would have gladly assisted in the attack had he been notified. (There had been a noticeable lack of cooperation between land and naval forces operating in the Charleston area, based on their jealous rivalry.) While it was tempting for the land officers to blame the naval officers, however, it was widely suspected that the 54th was used maliciously in the attack on Fort Wagner. The testimony of the special correspondent of the *New York Tribune* before the American's Freedmen's Inquiry Commission in 1864 claimed that the black regiment was deliberately put in advance of the other troops, partly as a "decoy," and partly to "dispose of the idea that the negroes could fight; Major Smith advised Gen. Gilmore [sic] to put the negroes at the head of the assaulting party and get rid of them."[114] (Smith was assistant adjutant general to Gen. Quincy A. Gillmore, commander of the armies in the Department of the South, who had little confidence in black troops.[115])

Murray, in recalling the tragic fate of the regiment, was well aware of the conflicted feelings of white society toward the troops who had lost their lives at Fort Wagner, Olustee, and Honey Hill.

He tries to imagine the hopes and fears of the regiment as they marched for Boston Harbor en route to Port Royal, South Carolina. But "the misgivings and yet the faith—bound up in this departure are perhaps beyond the realization of us of this generation. But in the hearts of those who were responsible for the sending forth of these men, there was seemingly unmixed and sublime faith. The misgivings dwelt not with those who had issued the call which these stout-hearted blacks had so eagerly answered."[116]

Murray rightfully believed that the sculptor of the monument, Saint-Gaudens, knew the history of the 54th with all of its heroic and tragic associations. Doubtless he also realized that the men of this regiment were representative and typical of the "quarter-million black men—some formerly free, some slave—who wore 'the blue' bravely, creditably, and effectively." Murray goes out of his way to praise Saint-Gaudens for his profound inspiration, his combination of "instinct with taste and technical mastery, yet sublime in its expressiveness and mighty in its moving power."[117]

Here Murray's opinion coincided with the professional art critics of the period. Taft considered it "one of the most impressive monuments of modern times—one of the masterpieces of the nineteenth century" and singles it out for being "distinctively American": "It would be difficult to trace its ancestry outside of our country. There is nothing like it or even suggestive of it, in the annals of art."[118] He continues:

> A very large relief in bronze, perhaps fifteen by eleven feet in dimensions, containing many figures of soldiers who march across the narrow stage, the foreground occupied largely by a young officer on horseback; above and vague, like a cloud, a floating female form which points onward—this is what appears at first glance, this and an impression of many shouldered muskets cutting sharp and inexorable athwart the metal sky; a feature almost as striking as the forest of lances in Velasquez's picture, the "Surrender at Breda." Nearer view reveals new beauties. The scene is evidently the departure of the colored troops; the leader a young man of noble mien who recognizes the significance of the fateful day. With head square set upon the broad shoulders and sad eyes unflinching, he rides steadily to his fate. The fiery horse is a splendid sculptural achievement, clean cut and magnificently wrought, but, conspicuous as he is, easily dominated by the presence of the silent rider. Then, behind and across the entire background, march with swinging tread the black men, their muskets over shoulders which bend under the burdensome knapsacks. They are equipped for a long journey from which not many will return. The movement of this great composition is extraordinary. We almost hear the roll of the drums and the shuffle of the heavy shoes. It makes the day of that brave departure very real again.[119]

Taft then asks rhetorically:

> What is it that gives this power to a bronze panel? Why should it
> bring dimness to the eyes and a grip to the heart? On what ground do
> men call it the highest expression of American art? Certainly it is not
> because of the workmanship alone; muskets and trousers and varied Af-
> rican types, however perfectly modelled, could not thrill us thus; nei-
> ther could the splendid steed nor even the physical presence of the
> hero who rides. After all, it is the largeness of the man behind the
> work, of the artist-mind which saw more in that scene than uniforms
> and accoutrements, or types of human kind, who felt the greater import
> of it; who bore it for twelve years upon his mind and heart, studying,
> dreaming, living with its qualifying phrases, and finally rose spiritua-
> lized and perfected above the earth, the fit and adequate expression of
> America's new-born patriotism.[120]

It was this last phrase that Murray seized upon to suggest that that
"new-born patriotism" represented a beginning, still in the process of
unfolding, and when developed to its "full stature, [it] will tower
above the odious 'color line'."[121]

Murray's reference to the color-line alludes to an antiblack for-
mulation that originated when he was growing up in Ohio. It signi-
fied a new, subtle form of discrimination in both North and South
that euphemistically conjured up a seemingly abstract threshold that
white society drew between its world and the chromatic gradations
it associated with ethnic diversity. The color-line, realized materially
in the Jim Crow laws, assumed ever-increasing reality in the North in
response to profound fears—grounded in both reality and
imagination—of miscegenation.

Ironically, Saint-Gaudens consistently manifested racist—both
anti-Semitic and Negrophobic—views in his writings and memoirs,
and especially regarding the evolution of the Shaw Monument. In-
deed, the visual working out of the troops gave him a good deal of
trouble, but not simply because he had difficulty—as one recent bi-
ographer put it—"finding blacks who were willing to serve as mod-
els."[122] The depth of Saint-Gaudens's prejudice reveals itself in a
story he told his child about his uncle, a slaveowner in Pensacola,
Florida:

> He was a very good man, and he had a lot of niggers who had little
> nigger children that they called Pickaninnies, and they used to play
> with oranges and alligators. But when the little Pickaninnies didn't take
> care, the alligators swallowed the Pickaninnies and oranges and all to-
> gether.[123]

Doubtless his uncle was a "good man," but for whom?

Of course, Saint-Gaudens related this tale during a period in

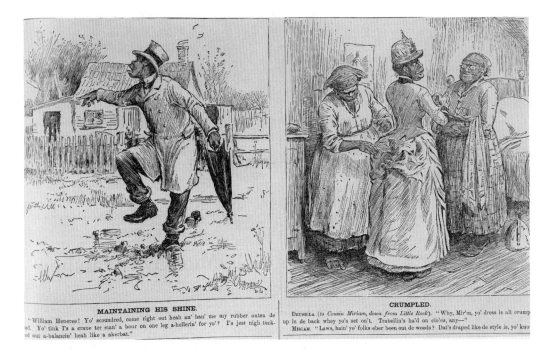

MAINTAINING HIS SHINE.

"William Heneree! Yo' scoundred, come right out heah an' han' me my rubber outen de
ud. Yo' tink I's a crane ter sian' a hour on one leg a-hollerin' for yo'? I's jest nigh tuck-
ed out a-balancin' heah like a akerbat."

CRUMPLED.

DRUSILLA (to Cousin Miriam, down from Little Rock). "Why, Mir'm, yo' dress is all crump
up in de back whey yo's set on't. Trabellin's ha'd on clo'es, any—"
MIRIAM. "Laws, hain' yo' folks eber been out de woods? Dat's draped like de style is, yo' kno'

Fig. 6–23. *Maintaining His Shine* and *Crumpled.* 1886.

the nation's history when all ethnic groups were subject to attack, especially by stalwarts of the genteel tradition who felt menaced by the hordes of immigrants and the challenge of domestic change. During a trip to San Francisco in 1883, Saint-Gaudens describes one area as "a dirty Jew place."[124] Jews, next to blacks, were the target of the most harmful stereotypes: these groups were not attacked for certain "inherent" traits as in the case of the "tight-fisted Scot" or the "dumb Swede," but for their presumed threat to the body politic. The black was not only deemed "uppity," but "lazy, improvident, child-like, irrepressible, chicken-stealing, crap-shooting, policy-playing, razor-toting, immoral and criminal" (Fig. 6–23).[125] Although the derogatory term "pickaninny" was not used in news articles, it pervaded popular anecdotes, jokes, cartoons, and narrative stories in the popular press. Such stereotypes abounded in periodicals like *Harper's New Monthly Magazine* and *Scribner's* (*Century Illustrated Monthly Magazine* after 1881), whose editor was one of Saint-Gaudens's closest friends and patrons, Richard Watson Gilder. Their lampoons and caricatures unmistakably informed Saint-Gaudens's "children's" story.

In his behind-the-scene descriptions of his work on the Shaw Monument, Saint-Gaudens similarly demeans blacks and associates them with animals:

> The models I used for my task, a horse and countless negroes, all fur-
> nished me with the greatest amusement. The horse was a gray animal,
> which I bought especially for this relief. I used to keep him in an ad-
> joining stable and, at the end of the day, ride him in the park for exer-
> cise, thereby accomplishing a double purpose.[126]

And he continues:

> The darkeys were more exciting in the entertainment they furnished. In
> the beginning, when I met a colored man of whom I thought well, I
> would approach him politely, with evident signs of embarrassment, and,
> after hemming and hawing, I would explain that I was a picture-maker
> who wanted to take his picture and that if he would come along with
> me I would do it for nothing. Any one who knows the negro of that
> class can readily understand what followed. They would look at me
> suspiciously. Some would accompany me part of the way and suddenly
> go off. Others would refuse altogether. A few would follow me as far as
> the door and then leave. One I remember saying as we reached my
> threshold: "You don't kotch me in dat place!" while those that I did
> succeed in trapping, trembled and perspired in utter terror as I stood
> them up with guns over their shoulders and caps on their heads.[127]

Finally, a friend suggested to Saint-Gaudens that there probably was
some kind of misunderstanding, and that the people he approached
may have feared that he "was a physician trying to lure them to their
death and to cut them up for anatomical purposes, and that their
terror was augmented by seeing plaster heads, painted a brown
color, lying about."[128] Following his advice, Saint-Gaudens now di-
rectly asked, "Do you want a job?" But this still failed to produce
the desired results, until he "found a colored man to whom I prom-
ised twenty-five cents for every negro he would bring me that I
could use: the following day the place was packed with them and I
had not only a great choice, but endless trouble in getting rid of
them and stopping their besieging the studio."[129]

 Saint-Gaudens treated blacks generically rather than individu-
ally in a stereotypical way. He "traps" them, they "pack" his studio,
and a certain "class" of them can be expected to behave in a predict-
able manner. Even more astonishing is his naive and insensitive man-
ner in enlisting their help. Considering the persecution of black
people in this period, and their economic hardship, there must have
been both temptation and fear commingled in their response. But he
approaches blacks like a species apart, as if they existed for his bid-
ding and amusement. His descriptions of his models all betray the
comical stereotype of the popular and vulgar literature:

There were some amusing liars among them. Several, born since the war, who did not know how to hold a gun, described to me in detail the battle of Fort Wagner and their part in it. They ranged in character from a gentle Bahama Islander to a drummer-boy who, while posing for the figure in the foreground, told me how he had just been released from prison, where he had gone for cutting his brother with a razor. On the whole, however, they are very likable, with their soft voices and imaginative, though simple, minds.[130]

At the same time, Saint-Gaudens regards blacks as fascinating creatures, and a trace of homoeroticism filters through some of his accounts. For example, once one of his models persisted in gaining entrance despite Saint-Gaudens's wish not to be disturbed at that moment (he actually did not know who was at the door) and his repeated request to his studio assistant not to let anyone in. Finally, the model's tenacity won out and Saint-Gaudens saw "a magnificent big black negro" who entered "grinning from ear to ear." In his "soft negro accent" he apologized: "You told me, sah, when I cam here, if anybody wanted to put me out, to just stick and say, sah, that you wanted to see me, no matter what happened, sah."[131] Saint-Gaudens responds to the physical traits of the man while putting him down for his affective nature, as if he were a feminized being in the Victorian mode. This attitude is seen again in a letter to his brother-in-law in 1893, where he refers to some possible models in Boston:

> At Young's Cafe, in your great City of Boston, there are two gorgeous darkeys, so gorgeous that I wish to put them in the Shaw Monument. . . . When they are here I shall select the one that best suits my purpose, send the other back, and the one that I keep will have from two weeks to a month's work with me at three dollars a day. Their names are John Lee and Riley Lee. In order that I may have them, permission must be obtained from E. McDuffie, the darkey headwaiter at that establishment, a most intelligent man, who does not imagine that I wish them in order to cut their livers out as the average darkey suspects. I've already spoken to him. He knows all, and if you will step in there and get him to ship me these two beauties at once you will be eternally blessed. Don't let him ship me any others. I've lots of others here, lots, but none such busters. . . . It is possible that when I have them here in the cold light of my studio, and without the enthusiasm of L'Athène moderne always throws me in, I may find that it was all in my eye that they are no better than hundreds of Seventh Avenue darkeys, and I may send 'em both back. That should be understood.[132]

Is Saint-Gaudens talking about people or roses? He speaks of the models as if they were specimens at a slave sale. Even making allowance for Victorian linguistic patterns, Saint-Gaudens's language implies a strange fascination for the models and an especial pleasure in

being able to buy and sell them at will. Is it any wonder that he excited fear in those whom he approached? Indeed, we know that the "darkey" who tended the stoves in his studio was treated roughly if the temperature varied from the preferred norm.[133]

Thus Saint-Gaudens, contrary to what Murray and the professionals imagined, did not share their optimistic faith in the progress of the black man in America, nor did he see them as patriotic emblems of the future utopia. His treatment of them in his letters is more akin to that of Gen. Gillmore, who ordered the 54th to lead the charge on Fort Wagner. Does this attitude reveal itself in the visual configuration of the relief? One clue may be the response of the critic Charles Caffin, writing at the same time as Taft:

> He portrays the humble soldiers with varying characteristics of pathetic devotion, and from the halting uniformity of their movement, even from the uncouthness of their ill-fitting uniforms, from such details as the water-bottles and rifles, secures an impressiveness of decorative composition, distinguished by virile contrasts and repetitions of line and by vigorous handsomeness of light and shade. Mingled with our enjoyment of these qualities is the emotion aroused by the intent and steadfast onward movement of the troops, whose doglike trustfulness is contrasted with the serene elevation of their white leader.[134]

Caffin's interpretation of the relief suggests that Saint-Gaudens modeled the black soldiers on his conception of their character as well as their physique, as we have seen from his remarks on their animal-like devotion, associating them with his horse and other generic stereotypes. When we study the relief in the context of standard sculptural conventions, we see that Saint-Gaudens has used them in an original way to illustrate caste. The white officer is centered in the composition elevated on horseback, thus sharing the upper zone with the allegorical Angel of Death who bears Victory and Sleep. The noble, erect bearing of Shaw and his look of determination are contrasted with the listless and somewhat rumpled-looking troops. Their expressions, hand gestures, and postures are less certain and less energetic than Shaw's, and their forward movement coincides visually with the hind legs of the horse, with the hooves and human feet practically confounded. The horse's head—rearing, majestic— complements the regal bearing of Shaw's torso, while the body screens out a large number of soldiers who are recognizable only by their boots. The net result of this motif is to visually promote the identification of troops and animal, who move in obedience to Shaw's command, further reinforced by his diagonally thrusting riding cropper. Frederick Douglass always opposes horses to slaves when recollecting the relationship of slave and master: "Colonel Lloyd's horses and dogs fared better than his men. Their beds must

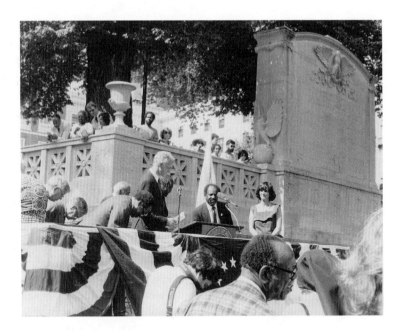

Fig. 6–24. Rededication ceremonies of the Shaw Monument, 1982.

Fig. 6–25. Rear of the Shaw Monument with the sixty-two names of the black troops killed at Fort Wagner. 1982.

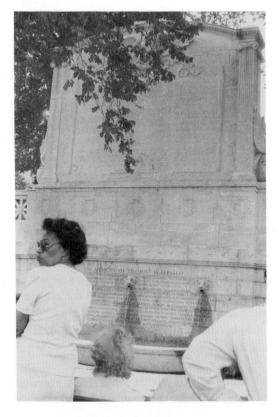

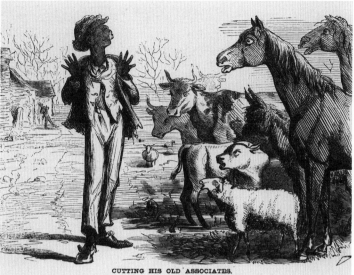

CUTTING HIS OLD ASSOCIATES.
MAN OF COLOR. "Ugh! Get out. I ain't one ob you no more. *I'se a Man, I is!*"

Fig. 6–26. *Cutting His Old Associates*. 1863.

be softer and cleaner than those of his human cattle." The slaves of an estate were valued together "with horses, sheep, and swine. There were horses and men, cattle and women, pigs and children, all holding the same rank in the scale of being, and were all subjected to the same narrow examination."[135] Finally, only Shaw was specifically identified in this memorial. The rest are anonymous figures chosen at random to satisfy the pictorial conception. It was not until 1982 that this omission was rectified, when the monument was re-dedicated [Figs. 6–24 and 6–25].[136] Saint-Gaudens thus succeeded in establishing a visual "color-line" that guarded white supremacy.

The identification of the African-American male with animal life unconsciously maintained the old "chattel" category that could now be buttressed more overtly with anthropologically validated racial hierarchies. A cartoon that appeared in *Harper's Weekly* shortly after emancipation cruelly caricatures a black proudly announcing to a herd of astonished quadrupeds, "I ain't one ob you no more. *I'se a Man, I is!* [Fig. 6–26].[137] It indicates that even in the supposedly liberal North, whites desired to prevent blacks from participating in "civilized" culture. We see this again in the monumental decorations at the World's Columbian Exposition at Chicago in 1893, organized in large measure by Saint-Gaudens. His collaborators, Daniel Chester French and Edward C. Potter, designed the pair of great horses on the Manufactures side of the Great Basin, one accompanied by a black teamster and the other by a white farmer [Figs. 6–27 and 6–28]. At first glance, the standing, robust African-American seems to break with the stereotype and usher in a new era, but a compari-

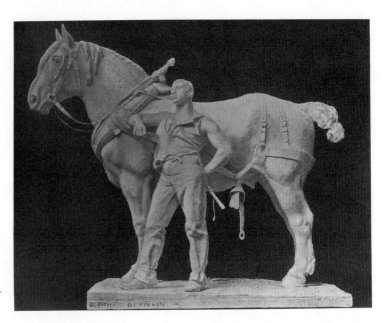

Fig. 6–27. Daniel Chester
French and Edward C. Pot-
ter, *The Teamster*, 1893.

son of this group with its pendant contradicts this first impression.
The two are deliberately contrasted and each treated differently in
relationship to their animal: the teamster leans for support against
the horse and looks dreamy-eyed and fatigued, while the farmer
stands tautly astride his shovel, vigilantly gazes outward, and grabs
the reins of his horse. The black faces in the direction parallel with
the horse's profile and is swallowed up by its voluminous mass,
whereas the white faces frontally in opposition to the horse's profile
and overpowers it by his energy. The two groups are subtly con-
trasted to express active and passive states, domination and subordi-
nation. It is not surprising to learn that the model for the farmer was
Daniel Burnham, the industrious director of works at the fair—the
living embodiment of the ideology of the World's Columbian Exposi-
tion, which fostered the hierarchical perception of races to legitimize
racial exploitation at home and the creation of empire abroad.

Saint-Gaudens shared this chauvinist outlook and in this re-
spect behaved much less liberally than Shaw's parents. His initial
plan for the monument to their son called for a conventional eques-
trian figure that he wanted to do "by hook or by crook." But Shaw's
family objected on the grounds that their son's youth and relative in-
experience hardly merited that exalted honor and that it would ap-
pear pretentious. At the same time, an isolated equestrian group
would have downgraded the role of his troops, who carried on
without his leadership for some time afterward. Thus they encour-

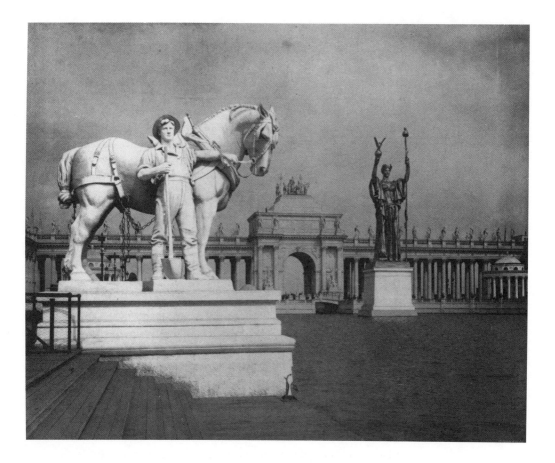

Fig. 6–28. Daniel Chester French and Edward C. Potter, *The Farmer*, 1893.

aged him to come up with an alternative project that would associate Shaw directly with his troops.

This modesty squares with another Shaw incident involving a critical family decision. When Shaw fell at Fort Wagner, his body was stripped of its uniform and thrown into a common grave with a number of his black troops. The Confederates deliberately set out to disgrace him by this action, conveying the information that Shaw was buried "with his niggers!" George Henry Boker used this phrase as the leitmotif of a poem he wrote to honor Shaw:

"They buried him with his niggers!"

But the glorious souls set free

Are leading the van of the army

That fights for liberty.

Brothers in death, in glory

The same palm branches bear;

And the crown is as bright o'er the sable brows

As over the golden hair.[138]

By this reasoning the burial in the common ditch became a metaphor for the unity of black and white. When Gen. Gillmore proposed to recover the body of Shaw and give him a special burial, the family rejected the idea and requested that the present grave not be desecrated: "We hold that a soldier's most appropriate burial-place is on the field where he is fallen." And the elder Shaw added that Gillmore should "prevent the disturbance of his remains or those buried with him."[139] Thus the family sustained the sense of unity symbolized by this common grave and rejected preferential treatment.[140]

Young Shaw was more inclined to follow his troops than lead them. For example, he sided with his troops over the issue of their pay. Black soldiers were outraged by the fact that they received less pay than their white counterparts, a difference that worked a hardship on the families they left behind. Shaw shared their view that the discriminatory pay policy was yet another vestige of second-class citizenship, and he was determined to eradicate it. Rather than submit to inferior treatment, some troops went over a year without pay. The 54th and the 55th Massachusetts Regiments even rejected Gov. Andrew's offer to use state funds to increase their compensation to the amount white privates received. They were offended by his refusal to insist on the principle of equality. In the meantime, the troops fought and died, dug trenches and fell ill, and worried about the progressive impoverishment of their families. Only in June 1864 did Congress finally pass an act equalizing the pay of black and white soldiers.[141]

Many of the soldiers of the 54th distinguished themselves as heroes after Shaw met his untimely death. The noncommissioned officer who bore the colors up to the parapet of Fort Wagner while severely wounded, Sgt. William H. Carney, won a Congressional Medal of Honor for his action. Carney was widely celebrated in the North, and his heroism inspired one Boston sculptor to project a special statuette that resembled the groups of John Rogers. On 13 December 1865 Truman H. Bartlett wrote to the adjutant general of Massachusetts requesting the name of one of the officers of the 54th Regiment to obtain information on the assault on Fort Wagner: "I wish to learn the facts relating to the wounded color-bearer, who, though wounded severely, bore the flag heroically while crawling from the parapet to his retreating or repulsed regiment. It would make a splendid subject for a statuette."[142]

Thus there were other subject options for Saint-Gaudens, but he chose to glorify one man of the 54th—the white officer and regi-

mental leader. The inscription on the relief reads: "He forsook all to preserve the public weal," the motto of the Society of the Order of the Cincinnati, of which Shaw had been a hereditary member. While this came at the suggestion of Shaw's father, it suited the conception of Saint-Gaudens, which focused on the lone figure of the leader whose actual participation in the 54th was briefer than those who served under him.

Saint-Gaudens might have followed the suggestion of a black veteran who wrote a history of black soldiery in the Civil War. Even earlier than Murray (1888), George R. Williams lamented that the national craze for monuments to Civil War heroes did not extend to the black participants. While the deeds of the white soldiers have been commemorated,

> nowhere in all this free land is there a monument to brave Negro soldiers, 36,847 of whom gave up their lives in the struggle for national existence. Even the appearance of the Negro soldier in the hundreds of histories of the war has always been incidental. These brave men have had no champion, no one to chronicle their record, teeming with interest and instinct with patriotism.[143]

Williams himself proposed a monument for Washington, D.C., to be dedicated to its "brave black soldiers." He recommended the site in front of Howard University (the Government Park) as an appropriate location. Significantly, his project provided a unique content at variance with the conventional prototypes that the Saint-Gaudens, with all its originality, could not substantially alter:

> A commanding monument made of Southern granite, surmounted by a private soldier in great-coat, equipments, fixed bayonet, gun at parade rest, looking south towards the Capitol, would be most impressive. At the four corners the three arms of the field-service and the navy would be represented. *First figure*, a Negro artilleryman in full-dress uniform, with folded arms, standing by a field-piece. *Second figure*, a cavalryman in full-dress uniform, with spurs and gloves, and sabre unhooked at his left side. *Third figure*, an infantry man in full-dress uniform, accoutrements, and musket at in-place rest. *Fourth figure*, a Negro sailor in uniform standing by an anchor or mortar.[144]

If the formal character was not new, Williams posited a new content in which all the figures would stand erect and have equal emphasis.

Williams proposes that the park wherein the monument would stand be named for Col. Robert Gould Shaw and praises him as the most commanding individual associated with black troops: "He came of a noble race of men, and his broad views of humanity were an inheritance; he was pure as he was just, beautiful as he was good, patriotic as he was brave."[145] Williams emphasizes that despite his

wealth and position, Shaw responded to his country's call for help:

> When other officers not only despised the Negro, but had no faith in
> his manhood or courage, Colonel Shaw chose to lead the first Massa-
> chusetts Colored Troops to the battle-field. And so he resigned his
> commission in one of the best veteran white regiments of Massachusetts
> and became the colonel of the Fifty-fourth Massachusetts (Negro) Regi-
> ment. His influence over his regiment, his gentle kindness, and yet his
> firmness as a disciplinarian, his rectitude in camp and his courage in
> battle, are remembered by all whose good fortune it was to come within
> the sphere of his military activity.[146]

The tragic fall of Shaw at the head of his regiment is "known by
heart throughout the land, and in the humble huts of the unlettered
blacks of the South his name is a household word." Thus to name
the park for Shaw would be most appropriate and would stand as a
proper tribute to him.

> Many Spartans fell at Thermopylae, but in the battle-picture of that he-
> roic defence the student of history sees alone the commanding form of
> Leonidas. Many brave men fell at the storming of Battery Wagner, yet
> nevertheless but one figure will be conspicuous in the eye of history
> for all time, Colonel Robert Gould Shaw, crying, *"Forward! my brave
> boys!"*[147]

Williams even predicts that one day a great painter will commemorate
the battle of Fort Wagner with an immortal representation in which
Shaw would be the central figure, "and America will only remember
one name in this conflict for all time to come—Colonel Robert Gould
Shaw!"[148]

 While he considered this just and worthwhile, his own project
was based on a different scenario. Shaw's apotheosis as the hero of
myth and legend should not lead people to forget the black soldiers
who also fought and died and had as yet to be accorded a proper
memorial in "marble or brass" for their patient sufferings and degra-
dation:

> But a monument such as here proposed would surely and safely elevate
> the Negro to a proud place in the history of the nation. There are hun-
> dreds of thousands of ignorant people in the streets of Paris, but the
> great French nation can never lack patriotic defenders so long as its
> multitudinous monuments teach the unerring and inspiring lessons of
> its history. No people can be dangerously ignorant if their government
> build monuments.[149]

Williams accepts the notion that the masses of black people were ig-
norant like the masses in France, but America could command their
respect and foster a race of patriots

so long as a monument records the magnificent military achievements of
the Negro soldier. Under such an object lesson, held by the sacred
spell, touched by such an immutable influence, centuries might pass,
treasures corrode, cities disappear, tribes perish, and even empires
whose boast was duration might crumble, but a republic that remembers
to defend its defenders in tracing their noble conduct in monumental
marble and brass can never decay. Heaven and earth may pass away,
but God's word endures forever. Truth only is immortal.[150]

Williams reveals in these poignant passages how important images
were to African-Americans to testify to the "truth" of their participa-
tion not only in the Civil War but also in the entire history of their
nation. As in the case of Murray, images for the black man served no
merely decorative or status-seeking function. It was a question of
black survival in a world growing increasingly indifferent to the fate
of those thousands of individuals who sacrificed their lives in behalf
of the union. For Saint-Gaudens it was a question of creating a
work that reinforced the hegemony of the reigning elite, whereas for
Williams and Murray the problem went straight to the heart of their
existence.

Williams and Murray represented a black intellectual elite that
would galvanize the African-American community to action. This elite
succeeded in erecting the one monument dedicated to a black hero
in the nineteenth century. The project began its history as a com-
memorative marker for fallen black soldiers of the Civil War, but
when Rochester's prominent black citizen, Frederick Douglass, died
in 1895 the organizers opened a subscription for ten thousand dol-
lars for a statue of him. The work, executed by Sidney W. Edwards
and unveiled in 1899, portrays the distinguished orator as he ad-
dressed a large crowd in Cincinnati shortly after the ratification of
the Fifteenth Amendment and uttered these words: "Fellow citizens: I
appear before you to-night for the first time in the more elevated po-
sition of an American citizen" (Fig. 6–29).[151]

John W. Thompson, a black citizen of Rochester who headed
the organizing committee for the statue, was clearly aware of the
sculptural tradition that degraded blacks to subsidiary positions and
played on the double sense of "elevation" by commissioning a nine-
foot-high pedestal of granite. Most whites in Rochester never re-
garded Douglass as a social equal, so Thompson's stress on the "ele-
vated" theme as both social and physical fact was a direct riposte to
the visual tradition and to local bigotry. In this sense, the rather
conventional representation assumed a highly charged political signi-
fication.[152]

Thompson also seized the occasion provided by the statue to
promote black unity. Black masonic lodges (Douglass was not a

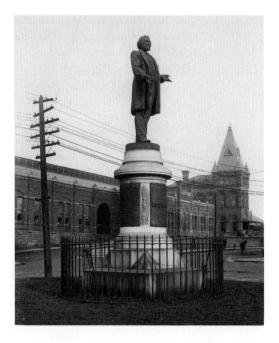

Fig. 6–29. Sidney W.
Edwards, *Frederick
Douglass Monument*,
1899.

mason but Thompson was) arranged the ceremonial laying of the
monument's cornerstone, and Thompson, with a number of his black
colleagues, hoped to use the opportunity of the unveiling to rally
American blacks for a National Afro-American League, with state and
local branches.[153] Blacks, however, contributed less than five hun-
dred dollars for the statue (not counting the government of Haiti,
which donated one thousand dollars in memory of Douglass's service
there as United States minister), and Thompson and his friends were
disillusioned.[154] Judging from Murray's own commentary on the
statue, it is possible to conclude that his writings were motivated in
part by the failure of the statue to spark the black community to
greater participation.[155]

 Murray's almost desperate need to validate Saint-Gaudens's
monument grows out of his sense of frustration with the entrenched
tradition and his wish to arouse black people to its residual dangers.
Murray, of course, could not have known all the facts, and we have
seen previously that the paucity of positive images celebrating black
participation in American history often prompted him to lean over
backward to give artists the benefit of the doubt. Yet in the case of
the Shaw monument, a highly personal attachment predisposed him
to see it as the ideal memorial, an excellent work of art with the
"correct" ideological message. We recall that he even asked the read-
er's indulgence for his closing "with a personal reference." Many of
the soldiers who hailed from Ohio and served under the flag of Mas-

sachusetts had been his friends, neighbors, and relatives while he was growing up. He recalled one summer evening in Boston, as he stood before this monument, that a particular memory cherished since childhood had pushed itself to the forefront of his reflections. He had been told as a child that when the recruits left his town one of them pulled aside a young woman and whispered to her: "Now Katie, don't forget; you are to wait; and if I get back—you know."[156] This particular trooper sustained severe wounds at Fort Wagner and Honey Hill, and then spent many miserable months in the dreadful prison of Andersonville. But he managed to survive his ordeal, and when he returned he found that Katie had waited. And Murray ended his narrative, one of the most insightful pieces of art criticism ever written, with this revealing confession: "And I am gratified to tell you that he still lives, and Katie, too; and often do I see my own little daughter put her arms lovingly around this old veteran's neck and call him, 'Grandpa'."

NOTES

CHAPTER 1

1. B. S. Groseclose, *Emanuel Leutze, 1816–1868: Freedom Is the Only King* (Washington, D.C., 1975), 31–32.

2. M. Sérullaz, *Musée du Louvre. Cabinet des dessins: Inventaire général des dessins. Ecole française. Dessins d'Eugène Delacroix, 1798–1863*, vol. 2, no. 1755 (Paris, 1984), 367–68.

3. F. Portal, *Des couleurs symboliques dans l'antiquité, le moyen age, et les temps modernes* (Paris, 1837), 33, 167. See also W. B. Cohen, *The French Encounter with Africans: White Response to Blacks, 1530–1880* (Bloomington, Ind., 1980, 221–22).

4. J. M. Paillot de Montabert, "Du caractère symbolique des principales couleurs employées dans les peintures chrétiennes: Question empruntée au savant ouvrage de M. Frédéric Portal, et simplifiée et disposée à l'usage des artistes," *Mémoires de la société d'agriculture, science, arts et belles lettres du département de l'Aube* 17 (1838): 19.

5. See S. L. Gilman, "Black Bodies, White Bodies: Toward an Iconography of Female Sexuality in Late Nineteenth-Century Art, Medicine, and Literature," *Critical Inquiry* 12 (Autumn 1985): 213–19.

6. Cohen, 107.

7. H. Melville, *Moby-Dick or, The Whale*, ed. C. Feidelson, Jr. (Indianapolis, 1964), ch. 42, 253.

8. Ibid., ch. 40, 237.

9. Ibid., ch. 13, 94.

10. Ibid., ch. 93, 526.

11. K. M. Adams, "Black Images in Nineteenth-Century American Painting and Literature: An Iconological Study of Mount, Melville, Homer and Mark Twain," unpublished Ph.D. dissertation (Emory University, 1977), 64–66, 82.

12. A. Frankenstein, *William Sidney Mount* (New York, 1975), 245.

13. L. Bugner, ed., *The Image of the Black in Western Art*, 3 vols. (New York, 1976–79), vol. 1: *From the Pharoahs to the Fall of the Roman Empire*, 9–32; vol. 2: *From the Early Christian Era to the "Age of Discovery,"* 9–139.

14. *The Narrative of Lansford Lane, Formerly of Raleigh, N.C.* (Boston, 1842), 36–37.

15. W. W. Brown, *The Negro in the American Rebellion*, new edition (New York, 1971), 361–74.

16. D. B. Davis, review of Bugner, *Image of the Black*, in *From Homicide to Slavery: Studies in American Culture* (New York, 1986), 224–26.

17. Bugner, *Image of the Black*, vol. 1, 29–30; P. Mark, "Africans in European Eyes: The Portrayal of Black Africans in Fourteenth and Fifteenth Century Europe," unpublished M.A. thesis (Syracuse University, 1974), 44–53, 76–91.

18. P. H. D. Kaplan, *The Rise of the Black Magus in Western Art* (Ann Arbor, 1985), 23–25.

19. For an excellent account of the project see M. H. Bogart, *Public Sculpture and the Civic Ideal in New York City, 1890–1930* (Chicago, 1989), 111–34.

20. F. H. Norton, ed., *Frank Leslie's Illustrated Historical Register of the Centennial Exposition 1876* (New York, 1876). The special issue was issued in ten parts, all with the same cover.

21. R. W. Rydell, *All the World's a Fair: Visions of Empire at American International Expositions, 1876–1916* (Chicago, 1984), 27–29.

22. J. H. Franklin, ed., *Color and Race* (Boston, 1968), ix–xii. For other examples of blacks privileging whiteness over blackness in early slave narratives, with all the conventional associations, see H. L. Gates, Jr., *The Signifying Monkey: A Theory of Afro-American Literary Criticism* (New York, 1988), 134.

CHAPTER 2

1. For Oller's depiction of black people see A. Boime, "Francisco Oller and the Image of Black People in the 19th Century," *Horizontes, Revista de la Universidad Católica de Puerto Rico* 28 (April 1985): 35–78.

2. P. Hills, *The Painters' America: Rural and Urban Life, 1810–1910* (New York, 1974), 52; B. Wolfe, "All the World's a Code: Art and Ideology in Nineteenth-Century American Painting," *Art Journal* 44 (Winter 1984): 330–33.

3. For the main literature on this picture see J. D. Prown, *John Singleton Copley* (Cambridge, Mass., 1966), vol. 2, 267ff.; I. B. Jaffe, "John Singleton Copley's *Watson and the Shark*," *American Art Journal* 9 (1977): 15ff; R. Stein, "Copley's *Watson and the Shark* and Aesthetics in the 1770s," *Discoveries and Considerations: Essays on Early American Literature and Aesthetics Presented to Harold Jantz*, ed. C. Israel (Albany, N.Y., 1976), 85–130; A. U. Abrams, "Politics, Prints, and John Singleton Copley's *Watson and the Shark*," *Art Bulletin* 61 (March 1979): 265–76.

4. Stein, "Copley's *Watson and the Shark*," 121–23.

5. I. B. Jaffe, *John Trumbull, Patriot-Artist of the American Revolution* (Boston, 1975), 316.

6. J. T. Wilson, *The Black Phalanx*, new edition (New York, 1968), 38.

7. Prown, *John Singleton Copley*, vol. 1, 267–68 (n. 17).

8. Cited in H. Honour, *The Image of the Black in Western Art*, vol. 4, pt. 1, "Slaves and Liberators" (Cambridge, Mass., 1989), 38.

9. England's monopoly on the slave trade had been made possible by the system of licenses, or *asientos*, issued by the Spanish to English firms in return for an obligation to carry a specified number of slaves to particular destinations. See P. D. Curtin, *The Atlantic Slave Trade: A Census* (Madison, Wisc., 1969), 21.

10. T. Clarkson, *The History of the Rise, Progress & Accomplishment of the Abolition of the African Slave-Trade*, by the British Parliament (London, 1808), vol. 1, 71.

11. S. Isham, *The History of American Painting* (New York, 1927), 26; J. C. Webster, *Sir Brook Watson, Friend of the Loyalists* (Sackville, N.B., 1924), 24.

12. For New England slave trading see W. E. B. Du Bois, *The Suppression of the African Slave-Trade to the United States 1638–1870* (New York, 1965), 27ff.; D. Mannix and M. Cowley, *Black Cargoes: A History of the Atlantic Slave Trade 1518–1865* (New York, 1962), 61, 67–68, 156–57, 159ff.; J. H. Franklin, *From Slavery to Freedom* (New York, 1980), 63.

13. J. W. Tyler, *Smugglers & Patriots: Boston Merchants and the Advent of the American Revolution* (Boston, 1986), 8–9.

14. R. Pares, *Yankees and Creoles: The Trade between North America and the West Indies before the American Revolution* (London, 1968), 46, 53–57; R. B. Sheridan, *Sugar and Slavery: An Economic History of the British West Indies 1623–1775* (Baltimore, 1973), 343–44.

15. J. C. Webster, *The Journal of Joshua Winslow* (Saint John, N.B., 1936), 11, 18.

16. Abrams, "Politics, Prints, and *Watson and the Shark*," 267–68.

17. *Criticisms on the Rolliad*, 2d ed. (London, 1785), 134. This has come down slightly askew in the Copley literature: see M. B. Amory, *The Domestic and Artistic Life of John Singleton Copley, R. A.* (Boston, 1882), 71–72.

18. For the references to Wilkes's relationship to the Bostonians see G. M. Elsey, ed., "John Wilkes and William Palfrey," *The Colonial Society of Massachusetts. Transactions 1937–1942* 34 (1941): 411–28; also, W. C. Ford, "John Wilkes and Boston," *Massachusetts Historical Society Proceedings* 47 (January 1914): 190–215.

19. Abrams, "Politics, Prints, and *Watson and the Shark*," 269–71.

20. The connection had been established by Hogarth's best-selling print of 1763, which attacked the popular champion of British liberties, and soon the motif was adorning pottery, glassware, and medals. See N. McKendrick, J. Brewer, and J. H. Plumb, *The Birth of a Consumer Society: The Commercialization of Eighteenth-Century England* (Bloomington, 1982), 244. For the American association of Wilkes and the staff surmounted by a Liberty Cap see D. H. Cresswell, *The American Revolution in Drawings and Prints*, Library of Congress exhibition catalog (Washington, D.C., 1975), 257, no. 644; Y. Korshak, "The Liberty Cap as a Revolutionary Symbol in America and France," *Smithsonian Studies in American Art 1* (Fall 1987): 54–57.

21. Quoted in R. Furneaux, *William Wilberforce* (London, 1974), 67. Wilkes had long joined the terms *liberty* and *slavery* in his rhetoric, thus providing a model for the colonists. See *The Correspondence of the Late John Wilkes*, J. Almon, ed. (New York, 1970), vol. 4, 19.

22. S. Hopkins, *A Dialogue Concerning the Slavery of the Africans* (Norwich, Conn., 1776), iii. Hopkins was the pastor of the First Congregational Church of Newport, Rhode Island.

23. B. Quarles, *The Negro in the American Revolution* (Chapel Hill, N.C., 1961), 43–44.

24. L. F. Litwack, *North of Slavery: The Negro in the Free States* (Chicago, 1961), 7.

25. Ibid.

26. Ibid., 9.

27. Ibid., 9–10.

28. Ibid., 11; W. D. Jordan, *White over Black: American Attitudes toward the Negro, 1550–1812* (Baltimore, 1969), 289–92.

29. Quarles, *Negro in the American Revolution*, 16.

30. Cited in D. B. Davis, *The Problem of Slavery in the Age of Revolution, 1770–1823* (Ithaca, N.Y., 1975), 275–76.

31. Wilson, *Black Phalanx*, 43–46; Quarles, *Negro in the American Revolution*, 19–32.

32. Honour, *Image of the Black in Western Art*, 38.

33. Clarkson, *Abolition of the African Slave-Trade*, vol. 2, 72–73, 76ff., 81–82, 253–54, 262, 364.

34. W. Dunlap, *A History of the Rise and Progress of the Arts of Design in the United States* (New York, 1969), vol. 1, 117–18. Tuckerman based his account on Dunlap: see H. T. Tuckerman, *Book of the Artists* (New York, 1966), 78–79.

35. Jaffe, "*Watson and the Shark*," 18, 20.

36. Hopkins, *Dialogue Concerning Slavery*, 5.

37. Jordan, *White over Black*, 299.

38. Abrams, "Politics, Prints, and *Watson and the Shark*," 268, 274.

39. P. H. Wood, "Waiting in Limbo: A Reconsideration of Winslow Homer's *The Gulf Stream, The Southern Enigma: Essays in Race, Class, and Folk Culture*, ed. W. J. Fraser, Jr., and W. B. Moore, Jr. (Westport, Conn., 1983), 85–87. See also Franklin, *From Slavery to Freedom*, 41.

40. Ironically, like Watson, blacks served as British spies, guides, and informers: see Quarles, *Negro in the American Revolution*, 142–46.

41. Blacks served the British mainly *behind* the lines to reserve white manpower for actual combat: ibid., 119.

42. A. Locke, *Negro Art: Past and Present* (Washington, D.C., 1936), 45–46.

43. For Homer's family background see G. Hendricks, *The Life and Work of Winslow Homer* (New York, 1979), 10; L. Goodrich, *Winslow Homer* (New York, 1944), 1–2.

44. For Homer's imagery of blacks see Adams, "Black Images," 111–53; M. Quick, "Homer in Virginia," *Los Angeles County Museum of Art Bulletin* 24 (1978): 61–81; M. A. Calo, "Winslow Homer's Visits to Virginia during Reconstruction," *American Art Journal* 12 (Winter 1980): 4–27; Wood, "Waiting in Limbo," 76–94.

45. G. M. Frederickson, *The Black Image in the White Mind* (New York, 1971), 246–54.

46. We can catch a glimpse of the widespread bias against blacks at the respectable northern publishing house of Charles Scribner's Sons in the 1880s. Pretending to be scientifically objective, the authors of its popular *Atlas* wrote:

> Statistics show little regarding the relative increase of the colored race before and after emancipation, but it is fair to assume, from all the circumstances of the case, that the increase is less now than formerly, a presumption borne out by such statistics as are at hand. When slaves were property, every consideration of self-interest on the part of the slaveholder prompted him to watch over their

health, to encourage child-bearing and to protect and preserve the children. It is not to be supposed for a moment that a careless, improvident race, thrown suddenly upon their own resources, could at once, or within a generation, learn to exercise such care over either their own health or that of their own children, as they had received when slaves. Wherever mortality statistics are available, there is shown a death rate of the colored population far in excess of that of the whites, a death rate so large throughout the country generally as to overbalance the greater birthrate, as appears by the fact that the increase from 1860 to 1880 was, for the colored, but 48 per cent, while for the whites it was 61 per cent. The conclusion is unavoidable that the colored race cannot hold its own numerically against the white, but must fall farther and farther behind, unless, under conditions of freedom, the race shall develop physical and moral qualities which it has not yet shown. (Fletcher W. Hewes and Harry Gannett, *Scribner's Statistical Atlas of the United States Showing by Graphic Methods Their Political, Social and Industrial Development* [New York, 1883], xlii.)

47. Frederickson, *Black Image*, 249ff.

48. R. W. Logan, *The Betrayal of the Negro from Rutherford B. Hayes to Woodrow Wilson* (New York, 1965), 70–71.

49. C. M. Pepper, "Cuba in Suspension," *Harper's New Monthly Magazine* 99 (November 1899): 969–70. Henry Cabot Lodge, representative of Homer's native state, Massachusetts, stated unequivocally that Cuba's condition was largely owing to "the sinister influence of slavery," which had led "the United States to hold Cuba under the yoke of Spain, because free negroes were not to be permitted to exist upon an island so near their Atlantic Seaboard." See H. C. Lodge, "The Spanish American War: I: The Unsettled Question," *Harper's New Monthly Magazine* 98 (February 1899): 450–52.

50. Logan, *Betrayal of the Negro*, 99.

51. The entire text of the speech may be found in H. A. Ploski and R. C. Brown, eds., *The Negro Almanac* (New York, 1967), 100–102.

52. *The Official Catalogue of the Cotton States and International Exposition* (Atlanta, 1895), no. 311: "Homer, Winslow, *Upland Cotton* (oil)," 251.

53. Calo, "Homer's Visits to Virginia," 21–22, 23, 24–25. Calo notes that reviews of the work often emphasized the cotton plant itself.

54. J. W. Thompson, *An Authentic History of the Douglass Monument* (Rochester, N.Y., 1903), 97.

55. F. Douglass, "The Claims of the Negro Ethnologically Considered," *Negro Social and Political Thought 1450–1920*, ed. H. Brotz (New York, 1966), 243.

56. F. Douglass and I. B. Wells, *The Reason Why the Colored American Is Not in the World's Columbian Exposition* (Chicago, 1893); E. M. Rudwick and A. Meier, "Black Man in the 'White City': Negroes and the Columbia Exposition," *Phylon* 26 (1965): 356.

57. Douglass and Wells, *Reason Why*, 9; Rudwick and Meier, "Black Man," 359.

58. Douglass and Wells, *Reason Why*, 2–4.

59. Ibid., 10.

60. M. Craton, *A History of the Bahamas* (London, 1962), 254ff.

61. W. C. Church, "A Midwinter Resort. With Engravings of Winslow

Homer's Water-Color Studies in Nassau," *Century Magazine* 23 (February 1887): 499–506. For Homer's trips to Key West, Cuba, and the Bahamas see P. Hannaway, *Winslow Homer in the Tropics* (Richmond, 1973).

62. Church, "A Midwinter Resort," 506.

63. Wood, "Waiting in Limbo," 84–85.

64. W. C. Ford, "Trade Policy with the Colonies," *Harper's New Monthly Magazine* 99 (July 1899): 294–301; Pepper, "Cuba in Suspension," 966–67.

65. Goodrich, *Winslow Homer*, 162.

66. At the time Homer conceived his picture, liberal white critics used such phrases as "arbitrarily restrained," "abridgement of opportunity," "the development . . . checked," "obstruction," "exclusion," and "all doors closed" to describe the conditions of labor for black workers. See J. S. Durham, "The Labor Unions and the Negro," *Atlantic Monthly* 81 (February 1898): 222–31.

CHAPTER 3

1. L. M. Díaz Soler, *Historia de la esclavitud negra en Puerto Rico (1493–1890)* (Madrid, 1953), 183; O. Delgado Mercado, *Francisco Oller y Cestero (1833–1917)* (San Juan, 1983), 48–49.

2. This form of torture was familiar to the abolitionists; it was mentioned in the reminiscences of an ex-slave published in 1843 where it is called *boca abajo* (mouth downward). See "Narrative of James Thompson, a British Subject, Twenty-Years a Cuban Slave," *British and Foreign Anti-Slavery Reporter* 4 (3 May 1843): 72.

3. D. V. Erdman, "Blake's Vision of Slavery," *Journal of the Warburg and Courtauld Institutes* 15 (1952): 242–52; Erdman, *Blake, Prophet against Empire* (Princeton, N.J., 1977), 230ff.; A. Boime, *Art in an Age of Revolution* (Chicago, 1987), 335–42.

4. This method of torture was known in the French colonies as *trois piquets* and was the reverse of the *boca abajo*. The victim was tied faceup to three stakes, thus resembling a crucifixion. See "Slavery in the French Colonies: M. Duclary and the *Trois Picquets*," *British and Foreign Anti-Slavery Reporter* 3 (12 January 1842): 3.

5. A concise account is given in E. Chevalier, *Histoire de la marine française* (Paris, 1900), 4–7. See also L. E. A. Eitner, *Géricault's "Raft of the Medusa"* (London, 1972); *Géricault, His Life and Work* (London, 1983), 158–201. The first report of the shipwreck was that given by J. B. H. Savigny to the ministry of marine, of which an unauthorized version was leaked to the *Journal des débats* on 13 September 1816. *The London Times* carried a full translation of this report on 17 September. Savigny and A. Corréard, two of the survivors, subsequently produced a book-length account with the title *Naufrage de la frégate La Méduse faisant partie de l'expédition du Sénégal en 1816*, which appeared in November 1817. A second revised edition was published the following year and used for the English version, *Narrative of a Voyage to Senegal in 1816*, which came out in London the same year.

6. See the article "Méduse (Le Radeau de la)," in P. Larousse, *Grand dictionnaire universel du XIXe siècle* (Paris, 1866–79), vol. 10, pt. 2, 1438.

7. S. Daget, "L'abolition de la traite des noirs en France de 1814 à 1831," *Cahiers d'études africaines* 11 (1971): 31, 34.

8. Savigny and Corréard, *Voyage to Senegal*, 317.

9. Ibid., 318.

10. E. E. Williams, *Capitalism & Slavery* (Chapel Hill, N.C., 1944), 188–89; J. Walvin, "The Rise of British Popular Sentiment for Abolition, 1787–1832," *Anti-Slavery, Religion, and Reform*, ed. C. Bolt and S. Drescher (Folkestone, 1980), 156–57. Walvin has been among the critics of Williams's thesis, suggesting that slavery was an expanding economic force of increasing importance to the British economy. For a summation of the pros and cons see S. L. Engerman, "Some Implications of the Abolition of the Slave Trade," and H. Temperley, "The Ideology of Antislavery," both in *The Abolition of the Atlantic Slave Trade*, ed. D. Eltis and J. Walvin (Madison, Wisc., 1981), 3–18, 21–35; S. L. Engerman and D. Eltis, "Economic Aspects of the Abolition Debate," *Anti-Slavery, Religion, and Reform*, 272–93.

11. Serge Daget claims that Anglo-American historiography has erred in supposing that no French fleet was used to suppress the slave trade. But although he also spells out some of the positive results of the fleet, he in effect sustains the traditional conclusions. After the *Medusa* incident, the government reinstated experienced Napoleonic veterans; meanwhile, some of those who had been discharged had taken jobs as skippers aboard slave ships. When the newly reinstated naval officers encountered their old comrades on the high seas they turned the other way. See S. Daget, "France, Suppression of the Illegal Trade, and England, 1817–1850," *Abolition of the Slave Trade*, 193–217.

12. Daget, "Abolition de la traite des noirs," 36; Cohen, *French Encounter with Africans*, 187–89.

13. A. Midas, "Victor Schoelcher and Emancipation in the West Indies," *Caribbean Historical Review* 1 (December 1950): 112.

14. African Institution, *Adresse aux nations de l'Europe sur le commerce homicide appelé traite des noirs* (London, 1822), 5ff. The antislavery society African Institution also published accounts of the murderous results of the slave trade, emphasizing the indifference of the French minister of marine (Baron Portal) to the problem. French cruisers closed their eyes to the atrocities of the slavers and thus sanctioned them. The African Institution also pointed out that Senegal had become a major international entrepôt of slavery. See its pamphlet *De l'état actuel de la traite des noirs* (London, 1821), viiiff.

15. W. Wilberforce, *Lettre à l'empereur Alexandre sur la traite des noirs* (London, 1822), 56ff.

16. Ibid., 46ff.

17. *Discours prononcé par M. le duc de Broglie à la chambre des Pairs le 28 mars 1822 sur la traite des nègres* (Paris, 1822), 35ff., 59–60.

18. Clarkson, like Wilberforce, was deeply respected by the French abolitionists: see Daget, "A Model of the French Abolitionist Movement and its Variations," *Anti-Slavery, Religion, and Reform*, 65. See also the work of the female abolitionist S. Doin, *La famille noire, ou la traite et l'esclavage* (Paris, 1825), 141–42, 147.

19. Clarkson, *Le cri des africains, contre les européens, leurs oppresseurs, ou coup d'oeil sur le commerce homocide appelé traite des noirs* (London, 1822), 21ff.

20. K. Berger and D. Chalmers-Johnson, "Art as Confrontation: The Black Man in the Work of Géricault," *Massachusetts Review* 10 (Spring 1969): 301ff.

21. C. Clément, *Géricault, étude biographique et critique* (Paris, 1868), no. 159, 232–33, 261, 362–63; Eitner, *Géricault*, 275–76.

22. For this venture see L. Johnson, "*The Raft of the Medusa*, in Great Britain," *Burlington Magazine* 96 (August 1954): 249ff.; S. Lodge, "Géricault in England," *Burlington Magazine* 108 (December 1965): 616ff.

23. Clarkson, *Le cri des africains*, 21ff.

24. B. C. Matilsky, "François-Auguste Biard: Artist-Naturalist-Explorer," *Gazette des Beaux-Arts*, 6e pér., vol. 105 (February 1985): 75–88.

25. "Fine Arts," *Athenaeum*, no. 655 (16 May 1840), 401.

26. Ibid.

27. H. Honour, *The European Vision of America* (Cleveland, 1975), cat. nos. 316–17.

28. L. Delteil, *Le peintre-graveur illustré: Honoré Daumier* (Paris, 1926), vol. 3, no. 748. I am also grateful to Francine Farr for the translation (here slightly modified) of Daumier's caption and her discussion in "The Representation of Blacks in French Caricature and Illustration, 1830–1880," unpublished research paper (UCLA, 1979).

29. Cohen, *French Encounter with Africans*, 192–93.

30. Clarkson, *Abolition of the African Slave-Trade*, vol. 1, 79–82.

31. Furneaux, *William Wilberforce*, 68.

32. T. F. Buxton, *The African Slave Trade and Its Remedy* (London, 1839–40), vol. 1, 104ff.

33. A review of Buxton's book in the *Athenaeum* two months after the painting had been discussed reads remarkably alike: "Review," *Athenaeum*, no. 662 (4 July 1840), 523–25.

34. C. Buxton, ed., *Memoirs of Sir Thomas Powell Buxton* (London 1848), 436–37.

35. Ibid., 450.

36. Davis, *Problem of Slavery*, 236.

37. C. D. Rice, "Literary Sources and British Attitudes to Slavery," *Anti-Slavery, Religion, and Reform*, 322. The international Anti-Slavery Convention opened at the Freemasons' Hall on 12 June 1840, but the publicity surrounding it began way in advance and it seems certain that Turner's work was aimed at its supporters.

38. Clarkson, *Abolition of the African Slave-Trade*, vol. 1, 301.

39. Buxton, *Thomas Powell Buxton*, 522.

40. See the critical discussion of Davis, *Problem of Slavery*, 458–68. Not surprisingly, a parallel form of criticism of Northern factory conditions came from the proslavery ideologues of the Southern United States who actually took up points remarkably similar to those made by the leaders of the labor movement. See E. Foner, "Abolitionism and the Labor Movement in Antebellum America," *Anti-Slavery, Religion, and Reform*, 254–271.

41. Saint Marc de Giraudin, "France," *Journal des débats*, 8 December 1831.

42. See Díaz Soler, *Historia de la esclavitud negra*, 219–20; Morales Carrión, *Auge y decadencia de la trata negrera en Puerto Rico (1820–1860)* (Institute de Cultura Puertorriqueña, 1978), 163ff; G. A. Baralt, *Esclavos rebeldes:*

conspiraciones y sublevaciones de esclavos en Puerto Rico (1795–1873) (Rio Piedras, P.R.), 127ff.

43. V. Schoelcher, *Colonies étrangères et Haiti, résultats de l'émancipation anglaise* (Paris, 1843), vol. 1, 130, 376.

44. Ibid., vol. 1, 329ff., 335–36.

45. Ibid., vol. 2, 410.

46. I. Abbad y Lasierra, *Historia geográfica, civil y natural de la isla de San Juan Bautista de Puerto Rico*, with notes and commentary by J. Julián de Acosta y Calbo (Puerto Rico, 1866), 399.

47. Ibid., v (n. 1), 354–62.

48. Ibid., 357 (n. 1), 409; Julián de Acosta, *La esclavitud en Puerto Rico, discurso pronunciado en la conferencia del día 5 de Febrero de 1872* (Madrid, 1872), 9, 29. Acosta addressed one of the many antislavery conferences held in Madrid by the Abolitionist Society.

49. P. Valiente, *Réformes dans les îles de Cuba et de Porto-Rico* (Paris, 1869), 40, 178, 245–46; Several Planters of Cuba, *Project for the Extinction of Slavery in Cuba and Porto Rico* (New York, 1865), 3ff.; Several Cuban and Porto-Rican Abolitionists, *The Abolition of Slavery in Cuba and Porto Rico* (New York, 1865), 18ff. The last two pamphlets may be found in the New York Public Library (SEKO, p. v. 1 and *passim*).

50. "A Typical Negro," *Harper's Weekly*, 7 (4 July 1863): 429–30; *Harper's Weekly* (24 January 1863), 56–57; "The Escaped Slave and the Union Soldier," *Harper's Weekly* 8 (2 July 1864): 422, 428.

51. M. A. Hamm, *Porto Rico and the West Indies* (New York, 1899), 72–73.

52. H. Aptheker, *To Be Free: Studies in American Negro History* (New York, 1948), 95.

53. "Hanging a Negro in Clarkson Street," *Harper's Weekly* (1 August 1863): 484.

CHAPTER 4

1. See G. B. Nash, *Red, White, and Black: The Peoples of Early America* (Englewood Cliffs, N.J., 1974), 179, for the economic and demographic background of black artisans and their status. See also F. Ribes Tovar, *A Chronological History of Puerto Rico* (New York, 1973), 212–13; H. Venegas and M. Benítez, eds., *Francisco Oller: A Realist-Impressionist* (Museo de Arte de Ponce, 1983), 182–83, cat. no. 132. For a brilliant critique of the white demand that the black demonstrate capacity in order to enter the human community or to win the war against racism, see H. L. Gates, Jr., *Figures in Black: Words, Signs, and the Racial Self* (New York, 1987), xxiii–xxiv, 3–58.

2. Tuckerman, *Book of the Artists*, 603–4.

3. Jordan, *White over Black*, 357, 446; G. B. Nash, "'To Arise out of the Dust': Absalom Jones and the African Church of Philadelphia, 1785–95," *Race, Class and Politics* (Urbana, Ill., 1986), 327.

4. J. Gualberto Padilla, "El Maestro Rafael," *Rosas de pasión: Poesías completas* (Paris, n.d.), vol. 1, 192. My translation.

5. Abbad y Lasierra, *San Juan Bautista*, 220, 305.

6. Cuban and Porto-Rican Abolitionists, *Abolition of Slavery*, 4–5, 12–13.

7. A class of "free Negroes" existed in the United States (close to half a million in 1860), but their situation was precarious and generally they required white patronage or guardianship. See E. Genovese, *Roll, Jordan, Roll* (New York, 1973), 398–413.

8. E. D. Genovese, *In Red and Black* (New York, 1971), 25–26.

9. For the classic but idealized comparison, see F. Tannenbaum, *Slave and Citizen* (New York, 1947), 48, 106ff.

10. Frederickson, *Black Image in the White Mind*, 17.

11. Ibid., 17–18. See also Genovese, *Roll, Jordan, Roll*, 430–31.

12. Jordan, *White over Black*, 78.

13. J. Zanger, "The 'Tragic Octoroon' in Pre–Civil War Fiction," *American Quarterly* 18 (Spring 1966): 63–70.

14. S. Burns, "Images of Slavery: George Fuller's Depictions of the Antebellum South," *American Art Journal* 15 (Summer 1983): 36–37, 55–56. Fuller is a classic example of the Northern liberal artist who nevertheless moves south to paint the portraits of those profiting from slavery. The money he earned was gained at the expense of the very slaves whose plight he lamented. He hoped to make a fortune doing portraits of slave owners and even maintained "a good-looking yellow boy" to take care of his personal needs.

15. I am grateful to Peter S. Rohowsky for letting me read his unpublished manuscript, "*The Price of Blood*: Thomas Satterwhite Noble's View into the Abyss of Slavery and the Slave Trade."

16. A. Boime, "Oller and Nineteenth-Century Puerto Rican Nationalism," *Francisco Oller,* ed. Venegas and Benítez, 48.

17. I am grateful to Samuel B. Cherson for bringing this to my attention.

18. J. F. Cooper, *The Pioneers* (London, 1907), 1907. The other black character of the novel, Agamemnon ("Aggy"), does not fare much better and is evidently flogged regularly; at one point he is called "black dog" by his master.

19. A. Saxton, "Blackface Minstrelsy and Jacksonian Ideology," *American Quarterly* 27 (March 1975): 3–28.

20. See H. Nathan, *Dan Emmett and the Rise of Early Negro Minstrelsy* (Norman, Okla., 1962), 50ff.

21. W. E. Channing, "Slavery," in *Works* (Boston, 1903), vol. 2, 91.

22. See F. Douglass, *Narrative of the Life of Frederick Douglass, An American Slave. Written by Himself*, ed. B. Quarles (Cambridge, Mass., 1969), 38; *My Bondage and My Freedom* (New York, 1855), 100.

23. P. L. Dunbar, *Lyrics of Lowly Life; Complete Poems* (London, 1897), 112–13.

24. Díaz Soler, *Historia de la esclavitud negra*, 108. This was also true in the slave states of the South: see Tannenbaum, *Slave and Citizen*, 26; F. Douglass, "Why the Slaves Sang," in W. L. Katz, *Eyewitness: The Negro in American History* (New York, 1967), 114–15.

25. Adams, "Black Images," 10–60; "The Black Image in the Paintings of William Sidney Mount," *American Art Journal* 7 (November 1975): 42–59.

26. For a history of slavery on Long Island see P. Ross, *A History of Long Island* (New York, 1905), vol. 1, 119–33.

27. Frankenstein, *William Sidney Mount*, 10, 201–4, 358, 377, 423, 445, 446–47, 452.

28. Ibid., 394.

29. "Negro Minstrelsy,—Ancient and Modern," *Putnam's Railway Classics. Maga Social Papers* (New York, 1867), 285.

30. Frankenstein, *William Sidney Mount*, 162.

31. Adams, "Black Images," 48.

32. Ibid., 48–49.

33. Frankenstein, *William Sidney Mount*, 164.

34. Adams, "Black Images," 46–47.

35. M. B. Codrey and H. W. Williams, Jr., *William Sidney Mount, 1807–1868* (New York, 1944), 17, cat. no. 25.

36. Frankenstein, *William Sidney Mount*, 365.

37. Ibid., 385. The English traveler Harriet Martineau observed so many instances of blacks as the targets of jokes that she began "to suspect that one use of slaves is to furnish topics for the amusement of their owners." *Retrospect of Western Travel*, vol. 1 (New York, 1838), 198. For a broader view of this theme, see Marc Simpson, "The Bright Side: '*Humorously Conceived and Truthfully Executed*'," in *Winslow Homer Paintings of the Civil War* (San Francisco, 1988), 47–63.

38. Ibid., 100.

39. Adams, "Black Images," 52.

40. Frankenstein, *William Sidney Mount*, 120–22.

41. Ibid., 16.

42. See D. G. White, *Ar'n't I a Woman? Female Slaves in the Plantation South* (New York, 1985), 46–61.

43. B. F. Thompson, *History of Long Island* (New York, 1918), vol. 2, 392–93, 411; vol. 4, 234–35. George Washington Strong (1783–1855) was the son of Judge Selah Strong (1737–1815) and Anna Smith; his brother Thomas was the father of Selah B. Strong (b. 1792). See B. W. Dwight, *The History of the Descendants of Elder John Strong* (Albany, N.Y., 1871), vol. 1, 623–24, 633–34.

44. Codrey and Williams, *William Sidney Mount*, 31.

45. Ibid.

46. Ibid., 31, cat. nos. 138–39; Frankenstein, *William Sidney Mount*, 440–41.

47. Nathan, *Dan Emmett*, 35ff.

48. R. H. Coen, *The Black Man in Art* (Minneapolis, 1970), 58–59. For Tanner generally see D. C. Driskell, *Two Centuries of Black American Art* (New York, 1976), 49–58; Frederick Douglass Institute, *The Art of Henry O. Tanner (1859–1937)* (Washington, D.C., 1969); S. Lewis, *Art: African American* (New York, 1978), 43–51; L. R. Hartigan, *Sharing Traditions: Five Black Artists in Nineteenth-Century America* (Washington, D.C., 1985), 99–116.

49. F. Porter, *Thomas Eakins* (New York, 1959), 15–16; S. Schendler, *Eakins* (Boston, 1967), 13.

50. S. Kaplan, "The Black Soldier of the Civil War in Literature and Art," *The Chancellor's Lecture Series, 1799–1980* (Amherst, Mass., 1980), nonpaginated.

51. L. Hughes and M. Meltzer, *A Pictorial History of the Negro in America* (New York 1963), 188–91; Katz, *Eyewitness*, 240ff., 251.

52. See the chapter "Schools for Freedom: The Post-Emancipation Origins of Afro-American Education," in H. G. Gutman, *Power & Culture: Essays on the American Working Class*, ed. I. Berlin (New York, 1987), 260–97. I am grateful to Debra Bertram for bringing this work to my attention.

53. F. H. M. Murray, *Emancipation and the Freed in American Sculpture: A Study in Interpretation* (Washington, D.C., 1916), 153–63; E. Parry, *The Image of the Indian and the Black Man in American Art, 1590–1900* (New York, 1974), 102ff.

54. Gutman, "Schools for Freedom," 273.

55. D. H. Wallace, *John Rogers, the People's Sculptor* (Middletown, Conn., 1967), 104.

56. Logan, *Betrayal of the Negro*, 168. Harris's writings date from 1880, but the sentiment had not altered basically.

57. W. E. B. Du Bois, *Black Reconstruction in America* (New York, 1970), 646.

58. For Homer's Virginia sojourn see Quick, "Homer in Virginia," 61–81; Calo, "Homer's Visits to Virginia," 4–27.

59. E. W. Knight, *Public Education in the South* (Boston, 1922), 420–22.

60. Katz, *Eyewitness*, 242.

61. "Pictures of the South," *Harper's Weekly* 10 (23 June 1866): 398.

62. Du Bois, *Black Reconstruction in America*, 642.

63. See P. Hills, *Eastman Johnson* (New York, 1972); *The Genre Painting of Eastman Johnson* (New York, 1977).

64. Tuckerman, *Book of the Artists*, 467.

65. Ibid., 470.

66. W. A. Smith, *Lectures on the Philosophy and Practice of Slavery* (Nashville, 1856), 223–24.

67. "The National Academy of Design," *Crayon* 6 (June 1859): 189.

68. Tuckerman, *Book of the Artists*, 468.

69. Channing, "Slavery," 92.

70. H. R. Helper, *The Impending Crisis in the South: How to Meet It* (New York, 1857).

71. Ibid., 28 *et passim.*

72. H. B. Stowe, *Three Novels*, ed. K. K. Sklar (New York, 1982), 133.

73. *Lansford Lane*, 2, 50.

74. F. L. Olmsted, *A Journey in the Seaboard Slave States* (New York, 1856).

75. Ibid., x.

76. Ibid., 17.

77. Ibid.

78. Ibid., 551ff.

79. Ibid., 678–79.

80. Ibid., 707.

81. Ibid., 701ff.

82. See *Harper's Weekly* 8 (2 July 1864): 422, 428.

83. "Negro Emancipation," *Harper's Weekly* 7 (10 January 1863): 18.

84. "Negroes Escaping out of Slavery," *Harper's Weekly* 8 (7 May 1864): 294. This report of escaping slaves is even closer to Johnson's conception: "Sometimes three would mount upon one horse, and in one instance a father, mother, and two children rode one animal."

85. Planters of Cuba, *Extinction of Slavery*, 3, 12.

86. See Díaz Soler's introduction to S. Ruiz Belvis, J. Julián de Acosta, and F. Mariano Quiñones, *Proyecto para abolición de la esclavitud en Puerto Rico* (San Juan, 1870), 14–15.

87. Acosta, *Esclavitud en Puerto-Rico*, 19.

88. Belvis, de Acosta, Quiñones, *Proyecto para abolición*, 15ff.; Ribes Tovar, *History of Puerto Rico*, 297–98.

89. See Delgado Mercado, *Francisco Oller*, 91–92.

90. Frederickson, *Black Image in the White Mind*, 105.

91. Jordan, *White over Black*, 190–215.

92. Cuban and Porto-Rican Abolitionists, *Abolition of Slavery*, 23.

93. Coen, *Black Man in Art*, 60–61.

94. Venegas and Benítez, *Francisco Oller*, 193, cat. no. 43.

95. Slaves in the United States also held wakes, "which struck white observers as rivaling those famous Irish wakes in their raucousness." Their death watch, although African in origin, had in common with other preindustrial peoples the need to protect the dead from the exigencies of climate and wild animals. See Genovese, *Roll, Jordan, Roll*, 198.

96. Hamm, *Porto Rico and the West Indies*, 65; M. M. Tumin, *Social Class and Social Change in Puerto Rico* (Princeton, 1961), 18.

97. This is how Oller's friend, Zequeira, interpreted the figure in his pamphlet on *El Velorio*. See Delgado Mercado, 92.

CHAPTER 5

1. For the most comprehensive and documented information on Noble's career see J. D. Birchfield, A. Boime, and W. J. Hennessey, *Thomas Satterwhite Noble, 1837–1907* (Lexington, 1988). See also M. N. W. Garretson, "Thomas S. Noble and His Paintings," *New-York Historical Society Quarterly Bulletin* 24 (October 1940): 113–23; A. Boime, *Thomas Couture and the Eclectic Vision* (New Haven, 1980), 580–89.

2. For the complexities of the Kentucky slave system see I. E. McDougle, *Slavery in Kentucky 1792–1865* (Westport, Conn., 1970); E. M. Post, "Kentucky Law Concerning Emancipation or Freedom of Slaves," *Filson Club History Quarterly* 59, no. 3 (1985): 344–67; A. S. Martin, *The Anti-Slavery Movement in Kentucky prior to 1850* (Louisville, 1918); W. J. Coleman, *Slavery Times in Kentucky* (Chapel Hill, 1940); L. H. Harrison, *The Antislavery Movement in Kentucky* (Lexington, 1978).

3. For a discussion of a Kentucky hemp farm in this period see A. I. Ottesen, "A Reconstruction of the Activities and Outbuildings at Farmington, an Early Nineteenth Century Hemp Farm," *Filson Club History Quarterly* 59 (October 1985): 395–425.

4. For the hiring-out system see R. C. Wade, *Slavery in the Cities: The South 1820–1860* (London, 1975), 38–43.

5. The letter is dated "Louisville Ky December 24/57" and is located in the Hunt-Morgan papers at the University of Kentucky Library. I am grateful to Jim Birchfield and William Hennessey for bringing it to my attention. Hunt later commanded a "rebel" military company in Lexington that served the Confederacy, despite Kentucky's refusal to secede. See W. H. Townsend, *Lincoln and the Bluegrass: Slavery and Civil War in Kentucky* (Lexington, 1955), 281, 285, 328–29; N. S. Shaler, *Kentucky, a Pioneer Commonwealth* (Boston, 1885), 210, 258, 288–90, 326–30, 338–44.

6. For black folklore in Kentucky see A. A. Dunnigan, *The Fascinating Story of Black Kentuckians: Their Heritage and Traditions* (Washington, D.C., 1982), 7–10, 17–18. See also E. J. Gorn, "Black Spirits: The Ghostlore of Afro-American Slaves," *American Quarterly* 36 (Fall 1984): 549–65.

7. Harrison, *Antislavery Movement in Kentucky*, 10–11.

8. McDougle, *Slavery in Kentucky*, 46–47. The law was repealed in 1849, when the black population stabilized and the abolitionists carried out an intense campaign.

9. Coleman, *Slavery Times in Kentucky*, 292.

10. J. D. Birchfield, "Thomas S. Noble: 'Made for a Painter'," *Kentucky Review* 6 (Winter 1986): 42.

11. Townsend, *Lincoln and the Bluegrass*, 120–40.

12. Stowe, *Three Novels*, 22.

13. Ibid., 9.

14. Ibid.

15. "A St. Louis Artist," *St. Louis Guardian*, 16 March 1867.

16. Cited in Birchfield, "Thomas S. Noble," 44–45.

17. "Home Art. 'Slave Sale,' by Noble," *St. Louis Guardian*, 7 July 1866.

18. A. Jingle, "Fine Arts. Noble's 'Last Sale'," *St. Louis Times*, 12 August 1866.

19. Coleman, *Slavery Times in Kentucky*, 115–41.

20. Stowe, *Three Novels*, 515.

21. D. F. Dosch, *The Old Courthouse: Americans Build a Forum on the Frontier* (St. Louis, 1979), 102. There is some confusion on this score: some very dependable historians think that the disrupted auction on 1 January 1861 was the last slave sale in St. Louis. See G. Anderson, *The Story of a Border City during the Civil War* (Boston, 1908), 28–31; J. N. Primm, *Lion of the Valley, St. Louis, Missouri* (Boulder, 1981), 246. It is probably safe to say that the 1861 auction was the last sensationalized incident involving the sale of slaves. If so, then the *St. Louis Times* of 12 August 1866 was technically correct in criticizing Noble's picture for distorting history. For an outstanding study of black history in Missouri, see K. T. Corbett, "Missouri's Black History: From Colonial Times to 1970," *Gateway Heritage* 4 (Summer 1983): 16–25.

22. Coleman, *Slavery Times in Kentucky*, 110–12.

23. J. C. Malin, "The John Brown Legend in Pictures: Kissing the Negro Baby," *Kansas Historical Quarterly* 9 (November 1940): 341.

24. Lines 1–16.

25. See W. L. Garrison, "Whittier on John Brown," *Liberator*, 13 January 1860. The poem is published in the section titled "Poetry."

26. R. S. Fletcher, "Ransom's John Brown Painting," *Kansas Historical Quarterly* 9 (November 1940): 343–46.

27. This was picked up and inserted in the first major biography of Brown: see J. Redpath, *The Public Life of Capt. John Brown* (Boston, 1860), 397.

28. F. B. Sanborn, ed., *The Life and Letters of John Brown* (Concord, Mass., 1910), 610–11.

29. J. C. Malin, "The John Brown Legend in Pictures: Kissing the Negro Baby," *Kansas Historical Quarterly* 8 (November 1939): 339–41; B. Quarles, *Allies for Freedom: Blacks and John Brown* (New York, 1974), 120–24.

30. Genovese, *Roll, Jordan, Roll*, 657.

31. See "The Fugitive Slave Case before U.S. Commissioner Pendery," *Cincinnati Daily Enquirer*, 31 January 1856; W. H. Siebert, *The Underground Railroad from Slavery to Freedom* (New York, 1967), 302–3; Harrison, *Antislavery Movement in Kentucky*, 91. In Toni Morrison's novel *Beloved* (New York, 1987), a similar incident haunts the characters as part of their bitter past.

32. Stowe, *Three Novels*, 427.

33. Rohowsky, "*The Price of Blood.*"

34. Stowe, *Three Novels*, 425.

35. Frederickson, *Black Image in the White Mind*, 171–74.

36. *Harper's Weekly* 7 (10 January 1863): 32.

37. Stowe, *Three Novels*, 381.

38. See J. D. Smith, "The Old Arguments Anew: Proslavery and Antislavery Thought during Reconstruction," *Kentucky Review* 6 (Winter 1986): 3–23.

39. "Arts and Letters," *Cincinnati Tribune*, 24 November 1896, cited in Birchfield, "Thomas S. Noble," 62.

CHAPTER 6

1. Murray, *Emancipation and the Freed*, xix.

2. Ibid.

3. Ibid., xx.

4. Ibid., 139.

5. Ibid.

6. See V. M. Green, "Hiram Powers's *Greek Slave*: Emblem of Freedom," *American Art Journal* 14 (Autumn 1982): 31–39.

7. E. B. Browning, "Hiram Powers' 'Greek Slave'," *The Complete Works* (New York, 1900), vol. 3, p. 179, ll.10–15.

8. H. James, *William Wetmore Story and His Friends* (Boston, 1903), vol. 2, 69–70.

9. Murray, *Emancipation and the Freed*, 8.

10. H. B. Stowe, "Sojourner Truth, the Libyan Sibyl," *Atlantic Monthly* 11 (April 1863): 473–81.

11. Murray, *Emancipation and the Freed*, 6.

12. J. J. Jarves, *The Art Idea*, ed. B. Rowland, Jr. (Cambridge, Mass., 1960), 225. See also L. I. Sharp, *John Quincy Adams Ward, Dean of American Sculpture* (Newark, 1985), 41–43.

13. Tuckerman, *Book of the Artists*, 581.

14. L. Taft, *The History of American Sculpture* (New York, 1903), 220.

15. C. H. Caffin, *American Masters of Sculpture* (New York, 1913), 44–45.

16. Murray, *Emancipation and the Freed*, 18–19.

17. Ibid., 19.

18. Caffin, *American Masters of Sculpture*, 45.

19. For the main biographical studies of Lewis see W. Craven, *Sculpture in America* (New York, 1968), 333–35; D. C. Driskell, *Two Centuries of Black American Art* (New York, 1976), 48–49; S. Lewis, *Art: African-American* (New York, 1978), 39–43; M. W. Davis, ed., *Contributions of Black Women to America* (Columbia, S.C., 1982), 108–11; Hartigan, *Sharing Traditions*, 85–98.

20. "The National Sailors' Fair," *Boston Transcript*, 11 November 1864 (Merl M. Moore Archive, Washington, D.C.); see also "Edmonia Lewis: The Famous Colored Sculptress in San Francisco," *San Francisco Chronicle*, 26 August 1873.

21. Brown, *Negro in the American Rebellion*, 70.

22. Ibid., 69–73.

23. Ibid., 118.

24. "The Marble Group," *Daily Evening Transcript* (Boston), 18 October 1869 (Merl M. Moore Archive, Washington, D.C.).

25. Murray, *Emancipation and the Freed*, 21–22.

26. Ibid., 22–23.

27. Ibid., 225.

28. This work, lost for many years, has recently been discovered in a storeroom in the Forest Park Mall, Forest Park, Illinois. See R. Grossman, "2 Saviors Vie for 'Cleopatra'," *Chicago Tribune*, 20 June 1988.

29. "Santa Clara Valley Fair," *Daily Evening Bulletin* (San Francisco), 2 October 1873; "The Fair at San Jose," *Daily Morning Call* (San Francisco), 2 October 1873 (both in the Merl M. Moore Archive, Washington, D.C.).

30. While the reports vary, one account in 1873 described her thusly: "Miss Lewis, the colored American sculptress in Rome, is short, stout and rather fine looking. Her hair, which is slightly curly, is parted on the side and cut short. She dresses in a short black skirt and roundabout jacket, and wide rolling jacket. Her appearance is masculine and her voice hard and gruff."

31. Murray, *Emancipation and the Freed*, 226.

32. D. B. Davis, *The Emancipation Moment* (Gettysburg, Pa., 1983), 9–10.

33. Murray, *Emancipation and the Freed*, 135–36.

34. Ibid., 26–27.

35. Ibid., 27.

36. Ibid., 28.

37. Ibid., 32.

38. Ibid., 28.

39. Ibid., 28.

40. Ibid., 29–30.

41. Ibid., 199.

42. Ibid., 200.

43. T. Ball, *My Threescore Years and Ten. An Autobiography* (Boston, 1892), 252–53.

44. Ibid., 51.

45. Murray, *Emancipation and the Freed*, 33.

46. Ibid., 34.

47. Ibid.

48. Davis, *Emancipation Moment*, 7.

49. Murray, *Emancipation and the Freed*, 36.

50. Ibid., 70.

51. Ibid., 38.

52. Ibid., 39.

53. Ibid., 46–47.

54. For information on Meta Vaux Warrick Fuller see V. J. Hoover, "Meta Vaux Warrick Fuller: Her Life and Art," *Negro History Bulletin* (March–April 1977): 678–81; Davis, *Contributions of Black Women*, 111–14.

55. Murray, *Emancipation and the Freed*, 56.

56. Ibid., 57.

57. Ibid., 58.

58. Ibid., 65.

59. Ibid., 109–14. See also J. Anderson, *History of the Soldier's Monument in Waterbury, Conn.* (Waterbury, 1886), 48–50.

60. Murray, 110–11.

61. Ibid., 111.

62. Ibid.

63. Ibid.

64. Ibid., 112.

65. Ibid., 72–73.

66. Ibid., 73.

67. Ibid., 74.

68. Ibid., 76.

69. Ibid., 79.

70. Ibid., 80.

71. M. J. Devine, "The Historical Paintings of William Henry Powell," *Ohio History* 89 (Winter 1980): 65–77.

72. Ibid., 72–73.

73. Murray, *Emancipation and the Freed*, 127–28.

74. Ibid., 128–31.

75. E. G. Valentine, *Dawn to Twilight, Work of Edward V. Valentine* (Richmond, 1929), 67.

76. Ibid., 85.

77. Ibid., 94.

78. Ibid., 93–94.

79. Ibid., 94–95.

80. W. E. B. Du Bois, *The Souls of Black Folk* (New York, 1979), 24.

81. Valentine, *Dawn to Twilight*, 95.

82. Ibid., 139–40.

83. Ibid., 172.

84. Ibid., 176–77.

85. Ibid., 93.

86. Murray, *Emancipation and the Freed*, 163.

87. Wallace, *John Rogers*, 70.

88. Ibid., 83.

89. Ibid.

90. Murray, *Emancipation and the Freed*, 150.

91. Ibid., 152.

92. Ibid.

93. Ibid., 147.

94. Ibid., 148.

95. Ibid., 150.

96. Ibid., 154.

97. Ibid., 158.

98. Ibid., 160.

99. Ibid., 161.

100. Ibid., 162–63.

101. Ibid., 164.

102. Ibid.

103. See L. F. Emilio, *A Brave Black Regiment: History of the Fifty-fourth Regiment of Massachusetts Volunteer Infantry, 1863–1865* (Boston, 1894); Kaplan, "The Black Soldier of the Civil War."

104. Murray, *Emancipation and the Freed*, 172.

105. I. Berlin, ed., *Freedom. A Documentary History of Emancipation 1861–1867. Series II: The Black Military Experience* (Cambridge, Mass., 1982), 75–76.

106. Ibid., 86.

107. Ibid., 86–97.

108. Brown, *Negro in the American Rebellion*, 148–49.

109. Ibid., 150.

110. Ibid.

111. Ibid., 147–58.

112. Ibid., 156.

113. Wilson, *Black Phalanx*, 264.

114. Berlin, *Freedom*, 535.

115. For accounts of the inquiry, see G. W. Williams, *A History of the Negro Troops in the War of the Rebellion 1861–1865* (New York, 1969), 192–204; Wilson, *Black Phalanx*, 250; Berlin, *Freedom*, 535–36.

116. Murray, *Emancipation and the Freed*, 168.

117. Ibid.

118. Taft, *American Sculpture*, 302.

119. Ibid., 363.

120. Ibid., 303–4.

121. Murray, *Emancipation and the Freed*, 166.

122. K. Greenthal, *Augustus Saint-Gaudens, Master Sculptor* (New York, 1985), 143.

123. H. Saint-Gaudens, *The Reminiscences of Augustus Saint-Gaudens* (New York, 1913), vol. 1, 29.

124. Ibid., 304.

125. Logan, *Betrayal of the Negro*, 165–66.

126. Saint-Gaudens, *Reminiscences*, 333.

127. Ibid., 333–34.

128. Ibid., 334.

129. Ibid.

130. Ibid., 334–35.

131. Ibid., 337.

132. Ibid., 337–38.

133. Ibid., 338.

134. Caffin, *American Masters of Sculpture*, 11.

135. F. Douglass, *Narrative of the Life of Frederick Douglass, An American Slave. Written by Himself*, ed. B. Quarles (Cambridge, Mass., 1969), 23, 40–41, 74; F. Douglass, *My Bondage and My Freedom* (New York, 1855), 112.

136. For the rededication of the monument in 1982 the names of the sixty-two fallen of the Fifty-fourth Regiment were engraved in the rear of the monument.

137. *Harper's Weekly* 7 (17 January 1863): 118.

138. "Col. Robert G. Shaw," *Liberator*, 24 March 1865, "by a young lady in Florence, Italy."

139. Berlin, *Freedom*, 786–87.

140. Wilson, *Black Phalanx*, 203. Robert Lowell's famous poem on the monument, "For the Union Dead," seems to miss the point:

 Shaw's father wanted no monument
 except the ditch,

where his son's body was thrown
and lost with his "niggers."

(R. Lowell, *Life Studies, and For the Union Dead* [New York, 1964], 70–72.)
As Kaplan notes, Lowell uses the Shaw memorial as a springboard for an attack on contemporary life; "When I crouch to my television set, / the drained faces of Negro / school children rise like balloons" (Kaplan, "The Black Soldier of the Civil War," 39).

141. Brown, *Negro in the American Rebellion*, 248–54; Berlin, 21, 364–65.

142. Brown, *Negro in the American Rebellion*, 209.

143. Williams, *Negro Troops in the War of Rebellion*, 328.

144. Ibid., 328–29.

145. Ibid., 330.

146. Ibid.

147. Ibid., 331.

148. Ibid., 202.

149. Ibid., 332.

150. Ibid.

151. Thompson, *Douglass Monument*, inset between 34–35.

152. Ibid., 75, 89, 93.

153. Ibid., 53–55, 196–201.

154. Ibid., 114.

155. Murray, *Emancipation and the Freed*, 106–9.

156. Ibid., 173–74.

BIBLIOGRAPHY

Abrams, Ann U. "Politics, Prints and John Singleton Copley's *Watson and the Shark.*" *Art Bulletin* 61 (March 1979): 265–76.

Acosta, José Julián de. *La esclavitud en Puerto Rico, discurso pronunciado en la conferencia del día 5 de Febrero de 1872.* Madrid: Sec. de la Sociedad Abolicionista Española, 1872.

Adams, Karen M. "The Black Image in the Paintings of William Sidney Mount." *American Art Journal* 7 (November 1975): 42–59.

———. "Black Images in Nineteenth Century American Painting and Literature: An Iconological Study of Mount, Melville, Homer and Mark Twain." Unpublished Ph.D. dissertation. Atlanta: Emory University, 1977.

African Institution. *Addresse aux nations de l'Europe sur le commerce homicide appelé traite des noirs.* London, 1822.

Amory, Martha B. *The Domestic and Artistic Life of John Singleton Copley, R.A..* Boston: Houghton, Mifflin and Co., 1882.

Anderson, Galusha. *The Story of a Border City during the Civil War.* Boston: Little, Brown and Co., 1908.

Anderson, Joseph. *History of the Soldier's Monument in Waterbury, Conn.* Waterbury: Printed for the Monument Committee, 1886.

Aptheker, Herbert. *To be Free: Studies in American Negro History.* New York: International Publishers, 1948.

Ball, Thomas. *My Threescore Years and Ten. An Autobiography.* Boston: Roberts Bros., 1892.

Baralt, Guillermo A. *Esclavos rebeldes: conspiraciones y sublevaciones de esclavos en Puerto Rico (1795–1873).* Rio Piedras, P.R.: Ediciones Huracan, 1981.

Berger, Klaus, and Diane Chalmers-Johnson. "Art as Confrontation: The Black Man in the Work of Géricault." *Massachusetts Review* 10 (Spring 1969): 301–40.

Berlin, Ira. *Slaves Without Masters.* New York: Pantheon Books, 1974.

———, ed. *Freedom. A Documentary History of Emancipation 1861–1867. Series II: The Black Military Experience.* Cambridge, Mass.: Cambridge University Press, 1982.

Benítez, Marimar, and H. Venegas, eds. *Francisco Oller: A Realist-Impressionist.* Museo de Arte de Ponce, P.R., 1983.

Birchfield, James D. "Thomas S. Noble: 'Made for a Painter'." *Kentucky Review* 6 (Winter 1986): 35–60; (Summer 1986): 45–73.

Birchfield, James D., Albert Boime, and William J. Hennessey, *Thomas Satterwhite Noble, 1837–1907.* Lexington: University of Kentucky Art Museum, 1988.

Bogart, M. H. *Public Sculpture and the Civic Ideal in New York City, 1890–1930.* New York, 1989.

Boime, Albert. *Thomas Couture and the Eclectic Vision.* New Haven, 1980.

———. "Francisco Oller and the Image of Black People in the 19th Century." *Horizontes, Revista de la Universidad Católica de Puerto Rico* 28 (April 1985): 35–78.

———. *Art in an Age of Revolution*. Chicago: University of Chicago Press, 1987.

———. "Blacks in Shark-Infested Waters: Visual Encodings of Racism in Copley and Homer." *Smithsonian Studies in American Art* 3 (Winter 1989): 19–47.

———. "Invisible in the Foreground." Review of Honour's *The Image of the Black in Western Art*. *New York Times Book Review*, 2 April 1989.

Bolt, Christine, and Seymour Drescher, eds. *Anti-Slavery, Religion, and Reform*. Folkestone, Eng.: W. Dawson, 1980.

Brown, William W. *The Negro in the American Rebellion*. New ed. New York: Citadel Press, 1971.

Brotz, Howard, ed. *Negro Social & Political Thought, 1450–1920*. New York: Basic Books, 1966.

Browning, Elizabeth B. *The Complete Works*. 6 vols. New York: T. Y. Crowell & Co., 1900.

Bugner, Ladislas, ed. *The Image of the Black in Western Art*. 3 vols. New York: William Morrow and Co., 1976–79.

Burns, Sarah. "Images of Slavery: George Fuller's Depictions of the Antebellum South." *American Art Journal* 15 (Summer 1983): 35–60.

Buxton, Charles, ed. *Memoirs of Sir Thomas Powell Buxton*. London: J. Murray, 1848.

Buxton, Thomas F. *The African Slave Trade and Its Remedy*. 2 vols. London: J. Murray, 1839–40.

Caffin, Charles H. *American Masters of Sculpture*. New York: Doubleday, Page & Company, 1913.

Calo, Mary Ann. "Winslow Homer's Visits to Virginia during Reconstruction." *American Art Journal* 12 (Winter 1980): 4–27.

Carrión, Arturo Morales. *Auge y decadencia de la trata negrera en Puerto Rico (1820–60)*. San Juan, P.R.: Instituto de Cultura Puertorriqueña, 1978.

Channing, William E. *Works*. 6 vols. Boston: American Unitarian Association, 1903.

Chevalier, Edouard. *Histoire de la marine francaise*. Paris: Hachette, 1900.

Church, William C. "A Midwinter Resort. With Engravings of Winslow Homer's Water-color Studies in Nassau." *Century Magazine* 33 (February 1887): 499–506.

Clarkson, Thomas. *Le cri des africains, contre les européens, leurs oppresseurs, ou coup d'oeil sur le commerce homicide appelé traite des noirs*. London: Harvey and Darton, 1822.

———. *The History of the Rise, Progress & Accomplishment of the Abolition of the African Slave-Trade*. 2 vols. British Parliament. London: Cass, 1808.

Clément, Charles. *Géricault, étude biographique et critique*. Paris: Didier, 1868.

Codrey, Mary B., and Hermann W. Williams, Jr. *William Sidney Mount, 1807–1868*. New York: Columbia University Press for the Metropolitan Museum of Art, 1944.

Coen, Rena N. *The Black Man in Art*. Minneapolis, Minn.: Lerner Publications, 1970.

Cohen, William B. *The French Encounter with Africans: White Response to Blacks, 1530–1880*. Bloomington: Indiana University Press, 1980.

Coleman, Winston J. *Slavery Times in Kentucky*. Chapel Hill: The University of North Carolina Press, 1940.

Cooper, James Fenimore. *The Pioneers*. London: J. M. Dent & Co., 1907.

Corbett, Katharine T. "Missouri's Black History: From Colonial Times to 1970." *Gateway Heritage* 4 (Summer 1983): 16–25.

The Correspondence of the Late John Wilkes. Ed. John Almon. 5 vols. New York: B. Franklin, 1970.

Craton, Michael. *A History of the Bahamas*. London: Collins, 1962.

Craven, Wayne. *Sculpture in America*. New York: Crowell, 1968.

Cresswell, Donald H. *The American Revolution in Drawings and Prints*. Washington, D.C.: Library of Congress, Exhibition Catalog, 1975.

Criticisms on the Rolliad. 2d ed. London: printed for James Ridgway, 1785.

Curtin, Philip D. *The Atlantic Slave Trade: A Census*. Madison, Wisc.: University of Wisconsin Press, 1969.

Daget, Serge. "L'Abolition de la traite des noirs en France de 1814 à 1831." *Cahiers d'études africaines* 11 (1971): 14–58.

———. "A Model of the French Abolitionists Movement and Its Variations." *Anti-Slavery, Religion and Reform*. Ed. Christine Bolt and Seymour Drescher. Folkestone, Eng.: W. Dawson, 1980, 64–79.

———. "France, Suppression of the Illegal Trade, and England, 1817–50." *Abolition of the Slave Trade*. Ed. David Eltis and James Walvin. Madison, Wisc.: University of Wisconsin Press, 1981, 193–217.

Davis, David B. *The Problem of Slavery in Western Culture*. Ithaca: Cornell University Press, 1966.

———. *The Problem of Slavery in the Age of Revolution, 1770–1823*. Ithaca: Cornell University Press, 1975.

———. *The Emancipation Moment*. Gettysburg, Pa.: Gettysburg College, 1983.

———. *From Homicide to Slavery: Studies in American Culture*. New York: Oxford University Press, 1986.

Davis, Marianna W., ed. *Contributions of Black Women to America*. 2 vols. Columbia, S.C.: Kenday Press, 1982.

Delgado Mercado, Osiris. *Francisco Oller y Cestero (1833–1917)*. San Juan, P. R.: Centro de Estudios Superiores de Puerto Rico y El Caribe, 1983.

Delteil, Loys. *Le peintre-graveur illustré: Honoré Daumier*. Paris: Chez L'Auteur, 1926.

Devine, Michael J. "The Historical Paintings of William Henry Powell." *Ohio History* 89 (Winter 1980): 65–77.

Díaz Soler, Luis. *Historia de la esclavitud negra en Puerto Rico (1493–1890)*. Madrid: Editorial Universitaria, 1953.

Discours prononcé par M. le duc de Broglie à la chambre des Pairs le 28 mars 1822 sur la traite des Nègres. Paris: 1822.

Doin, Sophie. *La famille noire, ou la traite et l'esclavage*. Paris: Henry Servier, 1825.

Dosch, Donald F. *The Old Courthouse: Americans Build a Forum on the Frontier*. St. Louis, Mo.: Jefferson National Expansion Historical Association, 1979.

Douglass, Frederick. *My Bondage and My Freedom*. New York: Miller, Orton & Mulligan, 1855.

―――. *Narrative of the Life of Frederick Douglass, an American Slave. Written by Himself*. Ed. B. Quarles. Cambridge, Mass.: Harvard University Press, 1969.

Douglass, Frederick, and Ida B. Wells, *The Reason Why the Colored American is Not in the World's Columbian Exposition*. Chicago, 1893.

Driskell, David C. *Two Centuries of Black American Art*. New York: Alfred A. Knopf, 1976.

Du Bois, William E. B. *The Suppression of the African Slave-Trade to the United States 1638–1870*. New York: Russell & Russell, 1965.

―――. *Black Reconstruction in America*. New York: Atheneum, 1970.

―――. *The Souls of Black Folk*. New York: Dodd, Mead & Company, 1979.

Dunbar, Paul L. *Lyrics of Lowly Life; Complete Poems*. London: Chapman & Hall, 1897.

Dunlap, William. *A History of the Rise and Progress of the Arts of Design in the United States*. 2 vols. New York: Dover Publications, 1969.

Dunnigan, A. A. *The Fascinating Story of Black Kentuckians: Their Heritage and Traditions*. Washington, D.C., 1982.

Durham, John S. "The Labor Unions and the Negro." *Atlantic Monthly* 81 (February 1898): 222–31.

Dwight, Benjamin W. *The History of the Descendants of Elder John Strong*. 2 vols. Albany, N.Y.: J. Munsel, 1871.

Eitner, L. E. A. *Géricault's "Raft of the Medusa."* London, 1972.

―――. *Géricault, His Life and Work*. London, 1983.

Elsey, George M., ed. "John Wilkes and William Palfrey." *The Colonial Society of Massachusetts, Transactions 1937–1942* 34 (1941): 411–28.

Eltis, David, and James Walvin, eds. *The Abolition of the Atlantic Slave Trade*. Madison, Wisc.: University of Wisconsin Press, 1981.

Emilio, Luis F. *A Brave Black Regiment: History of the Fifty-fourth Regiment of Massachusetts Volunteer Infantry, 1863–1865*. Boston: The Boston Book Company, 1894.

Engerman, Stanley L. "Some Implications of the Abolition of the Slave Trade.." *The Abolition of the Slave Trade*. Ed. David Eltis and James Walvin. Madison, Wisc.: University of Wisconsin Press, 1981, 3–18.

Engerman, Stanley L., and David Eltis, "Economic Aspects of the Abolition Debate." *Anti-Slavery, Religion and Reform*. Ed. Christine Bolt and Seymour Drescher. Folkestone, Eng.: W. Dawson, 1980, 272–93.

Erdman, David V. "Blake's Vision of Slavery." *Journal of the Warburg and Courtauld Institutes* 15 (1952): 242–52.

―――. *Blake, Prophet against Empire*. Princeton, N. J.: Princeton University Press, 1977.

Farr, Francine. "The Representation of Blacks in French Caricature and Illustration, 1830–1880." Unpublished research paper. University of California, Los Angeles, 1979.

Fine, Elsa H. *The Afro-American Artist: A Search for Identity*. New York: Holt, Rinehart and Winston, 1973.

Fletcher, Robert S. "Ransom's John Brown Painting." *Kansas Historical Quarterly* 9 (November 1940): 343–46.

Foner, Eric. "Abolitionism and the Labor Movement in Antebellum America." *Anti-Slavery, Religion and Reform*. Ed. Christine Bolt and Seymour Drescher. Folkestone, Eng.: W. Dawson, 1980, 254–71.

Ford, Worthington C. "Trade Policy with the Colonies." *Harper's New Monthly Magazine* 99 (July 1899): 294–301.

———. "John Wilkes and Boston." *Massachusetts Historical Proceedings* 47 (January 1914): 190–215.

Frankenstein, Alfred. *William Sidney Mount*. New York: Abrams, 1975.

Franklin, John H. *The Emancipation Proclamation*. New York: Anchor Books, 1965.

———. *From Slavery to Freedom*. New York: Knopf, 1980.

———, ed. *Color and Race*. Boston: Houghton Mifflin, 1968.

Fraser, Walter J., Jr., and Winfred B. Moore, Jr., eds. *The Southern Enigma: Essays in Race, Class and Folk Culture*. Westport, Conn.: Greenwood Press, 1983.

Frederick Douglass Institute. *The Art of Henry O. Tanner (1859–1937)*. Washington, D.C., 1969.

Frederickson, George M. *The Black Image in the White Mind*. New York: Harper & Row, 1971.

Furneaux, Robin. *William Wilberforce*. London: Hamilton, 1974.

Garretson, Mary Noble W. "Thomas S. Noble and His Paintings," *New York Historical Society Quarterly Bulletin* 24 (October 1940): 113–23.

Gates, Henry L., Jr. *Figures in Black: Words, Signs, and the Racial Self*. New York: Oxford University Press, 1987.

———. *The Signifying Monkey: A Theory of Afro-American Literary Criticism*. New York: Oxford University Press, 1988.

Genovese, Eugene D. *In Red and Black*. New York: Pantheon Books, 1971.

———. *Roll, Jordan, Roll*. New York: Pantheon Books, 1973.

Gilman, Sander L. "Black Bodies, White Bodies: Toward an Iconography of Female Sexuality in Late Nineteenth-Century Art, Medicine, and Literature." *Critical Inquiry* 12 (Autumn 1985): 213–19.

Gleason, William J. *History of the Cuyahoga County Soldiers' and Sailors' Monument*. Cleveland: Cleveland Printing and Publishing Co., 1894.

Goodrich, Lloyd. *Winslow Homer*. New York: Published for the Whitney Museum of American Art by Macmillan Co., 1944.

Gorn, Elliot J. "Black Spirits: The Ghostlore of Afro-American Slaves." *American Quarterly* 36 (Fall 1984): 549–65.

Green, Vivien M. "Hiram Powers's *Greek Slave*: Emblem of Freedom," *American Art Journal* 14 (Autumn 1982): 31–39.

Greenthal, Kathryn. *Augustus Saint-Gaudens, Master Sculptor*. New York: Metropolitan Museum of Art, 1985.

Groseclose, Barbara S. *Emanuel Leutze, 1816–1868: Freedom Is the Only King.* Washington, D.C.: Smithsonian Institution Press, 1975.

Gutman, Herbert G. *Power & Culture: Essays on the American Working Class.* Ed. I. Berlin. New York: Pantheon Books, 1987.

Hamm, Margherita A. *Porto Rico and the West Indies.* New York: F. T. Neely, 1899.

Hannaway, P. *Winslow Homer in the Tropics.* Richmond, 1973.

Harrison, Lowell H. *The Antislavery Movement in Kentucky.* Lexington, Ky.: University Press of Kentucky, 1878.

Hartigan, Lynda R. *Sharing Traditions, Five Black Artists in Nineteenth Century America.* Washington, D.C.: published for the National Museum of American Art by the Smithsonian Institution Press, 1985.

Helper, Hinton R. *The Impending Crisis in the South: How to Meet It.* New York: Burdick Brothers, 1857.

Hendricks, Gordon. *The Life and Work of Winslow Homer.* New York: H. N. Abrams, 1979.

Hewes, Fletcher W., and Harry Gannett. *Scribner's Statistical Atlas of the United States Showing by Graphic Methods Their Political, Social and Industrial Development.* New York, 1883.

Hills, Patricia. *Eastman Johnson.* New York: C. N. Potter in association with the Whitney Museum of American Art, 1972.

———. *The Painter's America: Rural and Urban Life, 1810–1910.* New York: Praeger, 1974.

———. *The Genre Painting of Eastman Johnson.* New York: Garland Pub., 1977.

Honour, Hugh. *The European Vision of America.* Cleveland: Cleveland Museum of Art, 1975.

———. *The Image of the Black in Western Art.* Cambridge, Mass.: Harvard University Press, 1989.

Hoover, Velma J. "Meta Vaux Warrick Fuller: Her Life and Art." *Negro History Bulletin* (March–April 1977): 678–81.

Hopkins, Samuel. *A Dialogue Concerning the Slavery of the Africans.* Norwich, Conn.: printed and sold by Judah P. Spooner, 1776.

Hughes, Langston, and Milton Meltzer. *A Pictorial History of the Negro in America.* New York: Crown Publishers, 1963.

Isham, Samuel. *The History of American Painting.* New York: Macmillan Co., 1927.

Israel, Calvin, ed. *Discoveries and Considerations: Essays on Early American Literature and Aesthetics Presented to Harold Jantz.* Albany: State University of New York Press, 1976.

Jaffe, Irma B. *John Trumbull, Patriot-Artist of the American Revolution.* Boston: New York Graphic Society, 1975.

———. "John Singleton Copley's *Watson and the Shark.*" *American Art Journal* 9 (May 1977): 15–25.

James, Henry. *William Wetmore Story and His Friends.* 2 vols. Boston: Houghton Mifflin & Co., 1903.

Jarves, James J. *The Art Idea.* Ed. Benjamin Rowland, Jr. Cambridge, Mass.: Belknap Press, 1960.

Johnson, Lee. "The Raft of the Medusa, in Great Britain." *Burlington Magazine* 96 (August 1954): 249–54.

Jordan, Winthrop D. *White over Black: American Attitudes toward the Negro, 1550–1812*. Baltimore: Penguin Books, 1969.

Kaplan, Paul H. D. *The Rise of the Black Magus in Western Art*. Ann Arbor: U.M.I. Research Press, 1985.

Kaplan, Sidney. "The Black Soldier of the Civil War in Literature and Art 1799–1980." The Chancellor's Lecture Series. Amherst, Mass.: University of Massachusetts, 1980.

Katz, William L. *Eyewitness: The Negro in American History*. New York: Pitman Pub. Corp., 1967.

Knight, Edward W. *Public Education in the South*. Boston: Ginn and Company, 1922.

Korshak, Yvonne. "The Liberty Cap as a Revolutionary Symbol in America and France." *Smithsonian Studies in American Art* 1 (Fall 1987): 53–70.

Larousse, P. *Grand dictionnaire universel du XIXe siècle*. 26 vols. Paris, 1866–79.

Lassierra, Inigo Abbad y. *Historia geográfica, civil y natural de la isla de San Juan Bautista de Puerto Rico*. Notes and commentary by Jose Julián de Acosta y Calvo. Puerto Rico: Imp. y Libreria de Acosta, 1866.

Lewis, Samella. *Art: African American*. New York: Harcourt Brace Jovanovich, Inc., 1978.

Litwack, Leon F. *North of Slavery, The Negro in the Free States*. Chicago: University of Chicago Press, 1961.

Locke, Alain Le Roy. *Negro Art: Past and Present*. Washington, D.C.: Associates in Negro Folk Education, 1936.

Lodge, Henry Cabot. "The Spanish American War: I: The Unsettled Question." *Harper's New Monthly Magazine* 98 (February 1899).

Lodge, Susanne. "Géricault in England." *Burlington Magazine* 108 (December 1965): 616–27.

Logan, Rayford W. *The Betrayal of the Negro, from Rutherford B. Hayes to Woodrow Wilson*. New York: Collier Books, 1965.

Lowell, Robert. *Life Studies, and For the Union Dead*. New York: Farrar, Straus and Giroux, 1964.

Malin, James C. "The John Brown Legend in Pictures: Kissing the Negro Baby." *Kansas Historical Quarterly*, vols. 8 (November 1939) and 9 (November 1940).

Mannix, Daniel P., and Malcolm Cowley. *Black Cargoes: A History of the Atlantic Slave Trade 1518–1865*. New York: Penguin Books Ltd., 1962.

Mark, Peter. "African in European Eyes: The Portrayal of Black Africans in Fourteenth and Fifteenth Century Europe." Unpublished M.A. thesis, Syracuse University, 1974.

Martin, A. S. *The Anti-Slavery Movement in Kentucky Prior to 1850*. Louisville: The Standard Printing Company, 1918.

Martineau, Harriet. *Retrospect of Western Travel*. 2 vols. New York: Charles Loman, 1838.

Matilsky, Barbara C. "François-Auguste Biard: Artist Naturalist-Explorer." *Gazette des Beaux-Arts*, 6 per., vol. 105 (February 1985): 75–88.

McDougle, Ivan E. *Slavery in Kentucky 1792–1865*. Westport, Conn.: Negro Universities Press, 1970.

McKendrick, Neil, John Brewer, and J. H. Plumb. *The Birth of a Consumer Society: The Commercialization of Eighteenth Century England*. Bloomington: Indiana University Press, 1982.

Melville, Herman. *Moby Dick; or The Whale*. Ed. Charles Feidelson, Jr. Indianapolis: Bobbs Merril, 1964.

Midas, A. "Victor Schoelcher and Emancipation in the West Indies." *Caribbean Historical Review* 1 (December 1950): 112.

Morrison, Toni. *Beloved*. New York: Alfred A. Knopf, 1987.

Murray, Freeman H. M. *Emancipation and the Freed in American Sculpture: A Study in Interpretation*. Washington, D. C.: published by the author, 1916.

The Narrative at Lansford Lane, Formerly of Raleigh N. C. Boston: published by the author, 1842.

"Narrative of James Thompson, a British Subject, Twenty Years a Cuban Slave." *British and Foreign Anti-Slavery Reporter* 4 (3 May 1843), 72.

Nash, Gary B. *Red, White and Black: The Peoples of Early America*. Englewood Cliffs, N. J.: Prentice Hall, 1974.

———. *Race, Class and Politics*. Urbana, Ill.: University of Illinois Press, 1986.

Nathan, Hans. *Dan Emmett and the Rise of Early Negro Minstrelsy*. Norman, Okla.: University of Oklahoma Press, 1962.

"Negro Minstrelsy,—Ancient and Modern." *Putnam's Railway Classics, Maga Social Papers*. New York: G. P. Putnam & Sons, 1867.

Norton, Frank Henry, ed. *Frank Leslie's Illustrated Historical Register of the Centennial Exposition. 1876*. New York: Frank Leslie's Publishing House, 1876.

The Official Catalogue of the Cotton States and International Exposition. Atlanta, 1895.

Olmsted, Frederick L. *A Journey in the Seaboard Slave States*. New York: Dix & Edwards, 1856.

Ottesen, Ann I. "A Reconstruction of the Activities and Outbuildings at Farmington, an Early Nineteenth Century Hemp Farm." *Filson Club History Quarterly* 59 (October 1985): 395–425.

Padilla, Juan Gualberto. *Rosas de pasión: Poesías Completas*. 2 vols. Paris: P. Ollendorf, n.d.

Paillot de Montabert, Jacques Nicolas. "Du caractère symbolique des principales couleurs employées dans les peintures chrétiennes: Question empruntée au savant ouvrage de M. Frédéric Portal, et simplifiée et disposée à l'usage des artistes." *Mémoires de la societé d'agriculture, science, arts et belles lettres du département de l'Aube*. Vol. 17, 1838.

Pares, Richard. *Yankees and Creoles: The Trade between North America and the West Indies before the American Revolution*. London: 1968; Orion: Cambridge: Harvard University Press, 1956; NUC: Hamden, Conn.: Archon Books, 1968 reprint of 1956 ed.

Parry, Elwood. *The Image of the Indian and the Black Man in American Art, 1590–1900*. New York: G. Braziller, 1974.

Pepper, Charles M. "Cuba in Suspension." *Harper's New Monthly Magazine* 99 (November 1899): 969–70.

Ploski, Harry A., and Roscoe C. Brown, Jr., eds. *The Negro Almanac*. New York: Bellwether Publishing Company, 1967.

Portal, Frédéric, Baron de. *Des couleurs symboliques dans l'antiquité, le moyen age, et les temps modernes*. Paris, 1837.

Porter, Fairfield. *Thomas Eakins*. New York: G. Braziller, 1959.

Post, E. M. "Kentucky Law Concerning Emancipation or Freedom of Slaves." *Filson Club Quarterly* 59, no. 3 (1985).

Prager, Jeffrey. "American Racial Ideology as Collective Representation." *Ethnic and Racial Studies* 5 (January 1982): 99–119.

Primm, James N. *Lion of the Valley, St. Louis, Missouri*. Boulder, Co.: Pruett Publishing Company, 1981.

Prown, Jules David. *John Singleton Copley*. 2 vols. Cambridge, Mass.: Harvard University Press, 1966.

Quarles, Benjamin. *The Negro in the American Revolution*. Chapel Hill: University of North Carolina Press, 1961.

———. *Allies for Freedom; Blacks and John Brown*. New York: Oxford University Press, 1974.

Quick, Michael. "Homer in Virginia." *Los Angeles County Museum of Art Bulletin* 24 (1978): 61–81.

Redpath, James. *The Public Life of Capt. John Brown*. Boston: Thayer and Eldridge, 1860.

Ribes Tovar, Federico. *A Chronological History of Puerto Rico*. New York: Plus Ultra Educational Publishers, 1973.

Rice, Charles Duncan. "Literary Sources and British Attitudes to Slavery." *Anti-Slavery, Religion and Reform*. Ed. Christine Bolt and Seymour Drescher. Folkestone, Eng.: W. Dawson, 1980, 319–34.

Rohowsky, Peter S. "The Price of Blood: Thomas Satterwhite Noble's View into the Abyss of Slavery and Slave Trade." Unpublished manuscript.

Ross, Peter. *A History of Long Island*. 3 vols. New York: The Lewis Publishing Co., 1905.

Rudwick, Elliott M., and August Meier. "Black Man in the 'White City': Negroes and the Columbia Exposition." *Phylon* 26 (1965): 354–61.

Ruíz Belvis, Segundo, José Julian de Acosta, and Francisco Mariano Quiñones. *Proyecto para abolición de la esclavitud en Puerto Rico*. San Juan, P. R.: 1870.

Rydell, Robert W. *All the World's a Fair: Visions of Empire at American International Expositions, 1876–1916*. Chicago: University of Chicago Press, 1984.

Saint-Gaudens, Homer. *The Reminiscences of Augustus Saint-Gaudens*. 2 vols. New York: The Century Co., 1913

Sanborn, Franklin B., ed. *The Life and Letters of John Brown*. Concord, Mass.: F. B. Sanborn, publisher, 1910.

Savigny, J. B. Henri, and Alexandre Corréard. *Naufrage de la frégate la Méduse faisant partie de l'expédition du Sénégal en 1818*. Paris: Hocquet imprimeur, 1817.

Saxton, Alexander. "Blackface Minstrelsy and Jacksonian Ideology." *American Quarterly* 27 (March 1975): 3–28.

Schendler, Sylvan. *Eakins*. Boston: Little, Brown and Co., 1967.

Schoelcher, Victor. *Colonies étrangères et Haiti, résultats de l'émancipation anglaise*. 2 vols. Paris: Pagnerre, 1843.

Sérullaz, Maurice. *Musée du Louvre. Cabinet des Dessins: Inventaire général des dessins. Ecole Française. Dessins d'Eugène Delacroix, 1798–1863*. Paris: Musée du Louvre, 1984.

Several Cuban and Porto Rican Abolitionists. *The Abolition of Slavery in Cuba and Porto Rico*. New York: Bryant & Co., 1865.

Several Planters of Cuba. *Project for the Extinction of Slavery in Cuba and Porto Rico*. New York: S. Hallet, 1865.

Shaler, Nathaniel S. *Kentucky, a Pioneer Commonwealth*. Boston: Houghton & Mifflin, 1885.

Sharp, Lewis I. *John Quincy Adams Ward, Dean of American Sculpture*. Newark: University of Delaware Press, 1985.

Sheridan, Richard B. *Sugar and Slavery: An Economic History of the British West Indies 1623–1775*. Baltimore: Johns Hopkins Press, 1973.

Siebert, Wilbur H. *The Underground Railroad from Slavery to Freedom*. New York: Russell & Russell, 1967.

Simpson, Marc, ed. *Winslow Homer Paintings of the Civil War*. The Fine Arts Museums of San Francisco. San Francisco: Bedford Arts, 1988.

Smith, William A. *Lectures on the Philosophy and Practice of Slavery*. Nashville, Tenn.: Stevenson and Evans, 1856.

Stein, Roger. "Copley's *Watson and the Shark* and Aesthetics in the 1770s." *Discoveries and Considerations: Essays on Early American Literature and Aesthetics Presented to Harold Jantz*. Ed. Calvin Israel. Albany: State University of New York Press, 1976, 85–130.

Stowe, Harriet B. "Sojourner Truth, The Libyan Sibyl." *Atlantic Monthly* 11 (April 1863): 473–81.

———. *Three Novels*. Ed. Kathryn K. Sklar. New York: Library of America, 1982.

Taft, Lorado. *The History of American Sculpture*. New York: Macmillan, 1903.

Tannenbaum, Frank. *Slave and Citizen*. New York: A. A. Knopf, 1947.

Temperley, Howard. "The Ideology of Anti-Slavery." *The Abolition of the Atlantic Slave Trade*. Ed. David Eltis and James Walvin. Madison, Wisc.: University of Wisconsin Press, 1981, 21–36.

Thompson, Benjamin F. *History of Long Island*. 4 vols. New York: R. H. Dodd, 1918.

Thompson, John W. *An Authentic History of the Douglass Monument*. Rochester, N. Y.: Rochester Herald Press, 1903.

Townsend, William H. *Lincoln and the Bluegrass: Slavery and Civil War in Kentucky*. Lexington: University of Kentucky Press, 1955.

Tuckerman, Henry T. *Book of the Artists*. New edition. New York: G. P. Putnam, 1966.

Tumin, Melvin M. *Social Class and Social Change in Puerto Rico*. Princeton, N. J.: Princeton University Press, 1961.

Tyler, John W. *Smugglers & Patriots: Boston Merchants and the Advent of the American Revolution*. Boston: Northeastern University Press, 1986.

Tyler-McGraw, Marie, and Gregg D. Kimball. *In Bondage and Freedom: Antebellum Black Life in Richmond, Virginia*. Richmond: W. M. Brown & Son, Inc., 1988.

Valentine, E. G. *Dawn to Twilight, Work of Edward V. Valentine*. Richmond, 1929.

Valiente, Porfirio. *Reformes dans les îles de Cuba et de Porto-Rico*. Paris: A. Chaix et cie., 1869.

Venegas, Haydée, and Marimar Benítez, eds. *Francisco Oller: A Realist-Impressionist*. Museo de Arte de Ponce, P. R., 1983.

Wade, Richard C. *Slavery in the Cities: The South 1820–1860*. London: Oxford University Press, 1975.

Wallace, David H. *John Rogers, the People's Sculptor*. Middletown, Conn.: Wesleyan University Press, 1967.

Walvin, James. "The Rise of British Popular Sentiment for Abolition, 1787–1832." *Anti-Slavery, Religion and Reform*. Ed. Christine Bolt and Seymour Drescher. Folkestone, Eng.: W. Dawson, 1980, 149–62.

Webster, John C. *Sir Brook Watson, Friend of the Loyalists*. Sackville, N. B.: Mount Allison University, 1924.

———. *The Journal of Joshua Winslow*. Saint John, N. B.: New Brunswick Museum, 1936.

White, Deborah G. *Ar'n't I a Woman? Female Slaves in the Plantation South*. New York: Norton, 1985.

Wilberforce, William. *Lettre à L'empereur Alexandre sur la traite des noirs*. London: printed by G. Schulze, 1822.

Williams, Eric E. *Capitalism & Slavery*. Chapel Hill: University of North Carolina Press, 1944.

Williams, George W. *A History of the Negro Troops in the War of the Rebellion 1861–1865*. New York: Negro University Press, 1969.

Wilson, Joseph T. *The Black Phalanx*. New edition. New York: Arno Press, 1968.

Wolfe, Brian. "All the World's a Code: Art and Ideology in Nineteenth-Century American Painting." *Art Journal* 44 (Winter 1984): 328–37.

Wood, Peter H. "Waiting in Limbo: A Reconsideration of Winslow Homer's *The Gulf Stream*." *The Southern Enigma: Essays in Race, Class and Folk Culture*. Ed. Walter J. Fraser, Jr., and Winfred B. Moore, Jr. Westport, Conn.: Greenwood Press, 1983, 75–94.

Wood, Peter H. (et al.). *Winslow Homer's Images of Blacks: The Civil War and Reconstruction Years*. Austin, Tex.: University of Texas Press, 1988.

Zanger, Jules. "The 'Tragic Octoroon' in Pre–Civil War Fiction." *American Quarterly* 18 (Spring 1966): 63–70.

INDEX